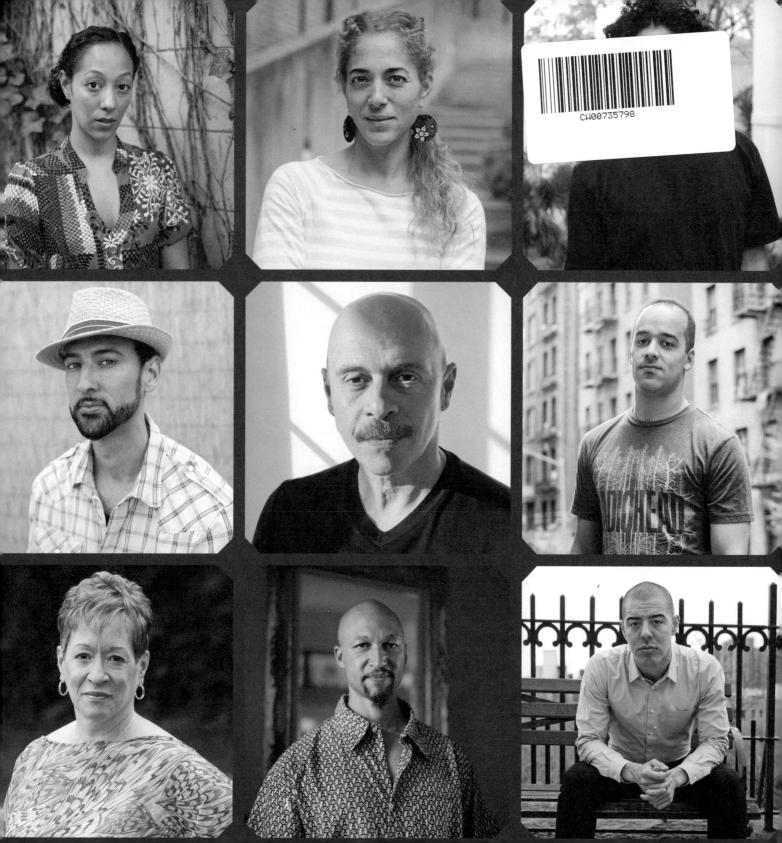

One Drop

PRAISE FOR ONE DROP

The one-drop rule has policed life both across and within the color line for centuries. Blay brilliantly and lovingly reframes our visions on the strength and vitality of our visual diversity.

> **Mark Anthony Neal,** author of *Looking for Leroy: Illegible Black Masculinities*

In this age of Barack Obama and Trayvon Martin, the conversation on the issue of race is sadly still very relevant. I salute Blay for revisiting this ever-growing and thought-provoking discussion.

> **Jamel Shabazz**, photographer, urban anthropologist, and author of *Back in the Days*

One Drop is an open and honest dialogue that will hopefully begin the shift in our thinking about race and skin color. We are all one human race.

> **Marc Baptiste**, fashion and celebrity photographer

One Drop shatters the notion of a singular or unified Black experience. The first-person accounts ... raise a mirror to a new Black America, more diverse and dynamic than ever before.

> **Margaret L. Hunter**, author of *Race, Gender, and the Politics of Skin Tone*

I want everyone to read *One Drop*. ... Let the complexity of how we see each other and ourselves rise up and conquer the failure of imagination and humanity that is racism.

> **Bliss Broyard**, author of *One Drop: My Father's Hidden Life — A Story of Race and Family Secrets*

Blay broadens our ideas about what counts as Black and challenges readers to rethink Blackness not only as a category but as an experience. ... Not only a must-read but a must-share.

> **Amy DuBois Barnett**, Editor in Chief, *Ebony*

The world is smaller, what it means to be Black is in flux, and [Blay] helps us understand this process ... brilliantly.

> **Tukufu Zuberi**, Lasry Family Professor of Race Relations, Professor of Sociology at the University of Pennsylvania, and host of the PBS series *History Detectives*

One Drop is a powerful exposé into the perception, classification, and identity of people across the vast African Diaspora ... Accessible to both the casual reader and scholar alike.

> **Steven F. Riley**, MixedRaceStudies.org

The poignant first-hand accounts read like pages of a personal diary. What emerges is a remarkable book that negotiates the complexities of life stories on race.

> **Deborah Willis**, author of *Posing Beauty: African American Images From the 1890s to the Present*

It has become quite chic to write off discussions of racial identity as passé. One Drop chin-checks that hasty notion. Hard.

> **Joan Morgan**, cultural critic, writer, and author of *When the Chickenheads Come Home to Roost: A Hip-Hop Feminist Breaks it Down*

One Drop is a new telling of the consequences of one of America's oldest pathologies and should be required reading for all who think they "get" this thing called race.

> **Ayana Byrd**, co-author of *Hair Story: Untangling the Roots of Black Hair in America*

A gorgeous and evocative book. The reader is brought on a journey exploring both the borders and the depth of the complicated racial category "Black."

> **Imani Perry**, professor at Princeton University's Center for African American Studies and author of *More Beautiful and More Terrible: The Embrace and Transcendence of Racial Inequality in the United States*

With each page, another tablecloth in the proverbial Big House is shaken off, and the crumbs of our systematically dismantled cultural identity are powerfully, lovingly, and proudly pieced back together.

> **Nicole Ari Parker**, actor

One Drop is a quintessential milestone in the American identity journey ... a profound work of literature, destined to redirect the flow of racial discourse.

> **Ronald E. Hall**, co-author of *The Color Complex: The Politics of Skin Color in a New Millennium*

SHIFTING THE LENS ON RACE

Yaba Blay
with photography direction by Noelle Théard

Beacon Press, Boston

BEACON PRESS
Boston, Massachusetts
www.beacon.org

Beacon Press books
are published under the auspices of
the Unitarian Universalist Association of Congregations.

24 23 22 21 8 7 6

Text design by Maori Karmael Holmes. Jacket and cover design
by Maori Karmael Holmes and Carol Chu.

Library of Congress Cataloging-in-Publication Data

Names: Blay, Yaba, author.
Title: One drop : shifting the lens on race / Yaba Blay ; with
 photography direction by Noelle Théard.
Description: Philadelphia, PA : Beacon Press, 2021. | "Originally published
 by BLACKprint Press: First hardcover edition, 2014"—Title page verso. |
 Includes bibliographical references.
Identifiers: LCCN 2020045545 (print) | LCCN 2020045546 (ebook) |
 ISBN 9780807073360 (hardcover) | ISBN 9780807073377 (ebook)
Subjects: LCSH: African Americans—Race identity—History. | Blacks—Race
 identity. | Black race.
Classification: LCC E185.625 .B53 2021 (print) | LCC E185.625 (ebook) |
 DDC 973/.0496073—dc23
LC record available at https://lccn.loc.gov/2020045545
LC ebook record available at https://lccn.loc.gov/2020045546

To my daughter, Imani,
who was gracious enough to share me with the world
so that this project might be completed.
Congratulations on your first book.

Contents

Author's Note

black v. Black

Throughout this book, I have chosen to capitalize both "Black" and "White" when describing people. Lowercase "black" and "white" refer to the colors found in a box of crayons. Uppercase "Black" and "White" instead speak to lived, racialized, and politicized identities, and as such, I consider them proper adjectives. By capitalizing the terms, I acknowledge that they constitute groups of people no different in organization than those ethnicities whose names are capitalized, such as African American, Caribbean American, Latino, and the like. I also, however, capitalize the terms "Biracial," "Mixed," "Mixed-race," and "Multiracial" (as well as "Negro" and "Mulatto" when used for historical accuracy) because they too reflect lived identities.

"Black" is used around the world to signify people of African descent. While it often prefaces a person's ethnicity — Black American, Black Brit, Black Puerto Rican, etc. — it is also used as an identifier in and of itself. In fact, based on the interviews I conducted, I surmise that "Black" is likely the preferred self-identifier of many Black people. Whereas "African American" is now the politically correct term of choice, people of African descent from other regions of the world such as the Caribbean and Latin America are not American, which means they are not African American — they are Black. At the most basic level then, capitalization is a matter of reality and respect — respect not only for other people but for myself. One of the most basic English writing lessons we learn as children is to capitalize things that are important. My identity is important, and therefore I capitalize it.

Many scholars who capitalize "Black" maintain that "white" should remain lowercase because most of the people to whom the term refers do not conceive of themselves in this way. I am not sure that I agree. Although many Whites make reference to their ethnic identity — Italian American, Jewish, Irish American, etc. — I would

argue that most do not. They, like the rest of the racialized world, understand that they are "White" and not just "white." The option that they are offered by the United States Census Bureau, for example, is "White," just as the option we are now offered is "Black, African American or Negro." Therefore, I have chosen to similarly capitalize "White" just as I capitalize "Black" when referring to people.

Beyond capitalization, in sharing contributors' personal narratives, I have made a conscious political decision to privilege their self-identity above the conventions of standard written English. For example, whereas the identifying term "Colored" is antiquated and may in fact offend some people, Angelina (p. 144), who was born in 1908, uses the term to self-identity, and therefore that is the term that is included in her narrative. To honor the narratives of Liliane (p. 190), Kamau (p. 194), and Guma (p. 198), who are all from and live in São Paulo, throughout the text I use the spelling "Brasil" rather than the English transliteration "Brazil." joshua (p. 80) and jewel (p. 154) choose to write their names in lowercase, so that is how their names appear here. There are no periods in LA's (p. 54) name because her name is not an abbreviation. She was named after her maternal grandmother, whose own mother wanted to name her LA but was told by hospital staff that she could not name her child with initials, so she named her "Ellie." LA's name fulfills her great-grandmother's wishes and memorializes her grandmother's intended name. There is meaning behind the way each of our 58 contributors chooses to self-identify. Out of respect, their names and other identifying details are written exactly as they expressed (and spelled) them.

Intro

In 1977, Susie Guillory Phipps and her husband began planning a vacation to South America. In order to travel, they would need current passports, and in order to apply for passports, they would need official copies of their birth certificates. Phipps requested a copy of her birth certificate from the Louisiana Bureau of Vital Records but was told that it could not be issued because of an apparent discrepancy — her race, as listed on the birth certificate, was different than the race she had indicated on her application. She soon discovered something about herself that would make her physically ill for the three days that followed: She was "Colored." For 43 years she had lived her life as a White woman, because in her mind and in the minds of at least two generations of her family, she was indeed White. However, on her birth certificate, both of her parents were designated as Colored. For that reason, she too was Colored.[1] So began the unsuccessful, five-year, $20,000 court battle between Phipps, her six siblings, and the State of Louisiana. Not only did they want their racial classification changed on their birth certificates — from Colored to White — but they wanted the state's 1970 racial classification statute declared unconstitutional. The law read:

> In signifying race, a person having one-thirty-second or less of Negro blood shall not be deemed, described, or designated by any public official in the State of Louisiana as "colored," a "mulatto," a "black," a "negro," a "griffe," an "Afro-American," a "quadroon," a "mestizo," a "colored person," or a "person of color."[2]

According to a genealogist hired by the state, Phipps had "3/32 Negro blood." Her great-great-great-great-grandmother was a Black woman by the name of Marguerita who was enslaved by a French Louisiana planter named Joseph Gregory Guillory. Many of Phipps' ancestors were classified as "Quadroons," "Mulattos," and "Colored" up until the time of her birth in 1934, and during the court case, one of her first cousins testified that her uncle, Phipps' father, "was a Colored man, just like the rest of [them]."[3] "When I found out about ... this Marguerita person I was so sick. I was so sick," said Phipps.[4] "I am White. I am all White. I was raised as a White child. I went to White schools. I married White twice. My children are White. My grandchildren are White. Mother and Daddy were buried White. My Social Security card says I'm White. My driver's license says I'm White. There are no Blacks out where I live, except the hired hands."[5] Although it was the only state in the country at the time to do so, with its 1983 ruling, the State of Louisiana continued to quantify racial identity — Phipps lost her case, and later lost her appeal. And although the state repealed its statute on racial classification that same year, the

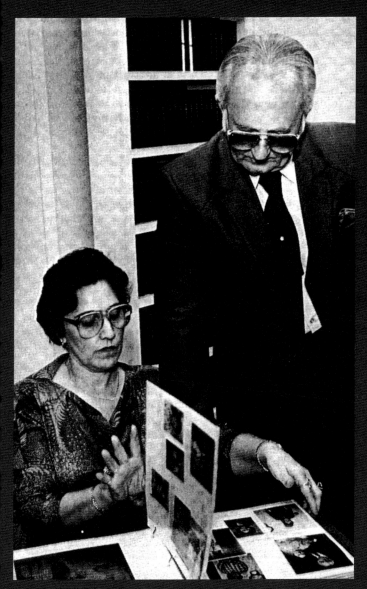

Susie Guillory Phipps and her husband, Andy. 1982. **(Norman J. Berteaux).** Courtesy of the Times-Picayune Publishing Corporation.

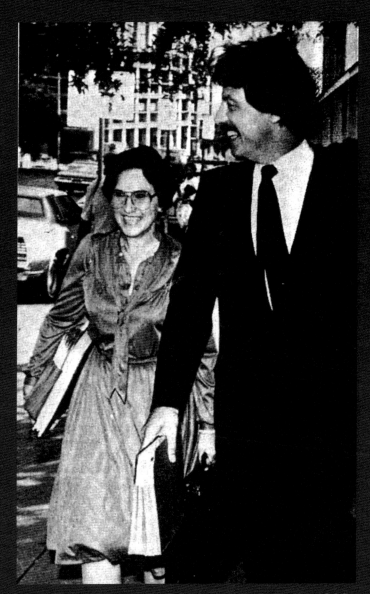

Susie Guillory Phipps and her attorney, Brian Begue. 1982. **(Bevel Knapp).** Courtesy of the Times-Picayune Publishing Corporation.

repeal was not retroactive.[6] As such, Susie Guillory Phipps, if she remains alive, remains Black by law. But is Susie Guillory Phipps *really* Black?

Twenty-five years after Phipps' "unfortunate discovery," the United States elected its first "Black president" in Barack Obama. Even before he was elected into office, the nation was set afire in heated debate about his identity: Is he "Biracial?" Is he African American? Is he even American? Despite having the option to check more than one box and self-identify as "Multiracial" on the 2010 Census form, President Obama checked only one box — "Black, African American or Negro."[7] Once, when asked publicly how he self-identifies, President Obama responded, "I self-identify as African American — that's how I'm treated and that's how I'm viewed. I'm proud of it."[8] Still, because he was born of a White, American mother of English and Irish descent and a Black, African father from Kenya, the technicalities of his racial identity are regularly noted. He is often referred to as "Biracial" or "Mixed," and the idea that he is the nation's first Black president has been publicly questioned if not outright rejected. President Obama says he's Black. That should be enough, shouldn't it?

Three years after Obama's election, Oscar Award–winning actress Halle Berry, whose father is Black and mother is White, told *Ebony* magazine that she feels like her daughter Nahla is Black, despite the fact that Nahla's father, French-Canadian model Gabriel Aubry, is White. Her justification? The "one-drop theory,"[9] as she calls it. While Berry thinks that Nahla's identity will be based largely on how the world identifies her, ultimately she believes her daughter will have to decide her identity for herself. But will it be that simple for little Nahla? Is identity *really* a choice? It has been rumored that Aubry does not like the idea of his daughter being considered Black because, in his estimation, her father is White, therefore she is White.[10] We all know Nahla is *not* White — at least not by U.S. standards. Somehow we seem to be clear about what Whiteness is, or rather what Whiteness is not. But is she Black? Mixed? Multiracial? Other? What is she?

What exactly is Blackness and what does it mean to be Black? Is Blackness a matter of biology or consciousness? Who determines who is Black and who is not — the state, the society, or the individual? Who is Black, who is not, and who cares?

In the United States, historically a Black person has come to be defined as any person with *any* known Black ancestry. Although this definition has been statutorily referred to as the "one Black ancestor rule," the "traceable amount rule," and the "hypodescent rule," it is more popularly known as the "one-drop rule," meaning that one single, solitary drop of Black blood is enough to render a person Black. Said differently, the one-drop rule holds that a person with *any* trace of Black ancestry, however small or (in)visible, *cannot* be considered White. Unless that person has other non-White ancestry

Black by Law: One-Drop ("1/32 Negro Blood") Racial Genealogy (Kelcie Ulmer)

they can claim — such as Native American, Asian, etc. — they *must* be considered Black.[11]

A method of social order that began almost immediately after the arrival of enslaved Africans in America, the one-drop rule became a legal reality in the state of Virginia in 1705,[12] and by 1910, it was the law of the land in almost all southern U.S. states.[13] At a time when the one-drop rule functioned to protect and preserve White racial purity, Blackness was both a matter of biology and the law. One was either Black or White. Period. One hundred years later, however, the social and political landscape has changed. Or has it?

Constructing the Color Line

The U.S. Census reveals much about the country's perspective on race. It counts people according to how the nation defines people, and historically, those people counted as Black have been those people with *any* known Black ancestry. Blacks are defined by the one-drop rule. No other racial or ethnic group is defined in this way, nor does any other nation rely upon this formula; the one-drop rule is definitively Black and characteristically American. It should make sense then that the origins of the rule are directly linked to the history of Black people in the United States, and as such, our discussion of the one-drop rule begins during the period of colonial enslavement.

Within the context of colonial enslavement, Blackness — prototypical and phenotypical African features such as dark skin, a broad nose, tightly coiled hair — were the undeniable markers of inferiority. These features served to immediately communicate one's position within the social power structure, and in the context of enslavement, whether one was free or enslaved.

If you were White, you were free; if you were Black, you were enslaved. Simple.

However, this seemingly simple social order soon became complicated by the rampant increase in amalgamation — the mixing of the races. The lines between White and Black, free and enslaved, became more and more blurred. Even though the mixing was extensive and extremely common, from the beginning it was always discouraged. For example, in 1630, only 11 years after the first enslaved Africans arrived in Virginia, "colonist Hugh Davis was sentenced to be soundly whipped 'before an assembly of negroes and others for abusing himself to the dishonor of God and shame of Christianity by defiling his body in lying with a negro.'"[14] Any White person, male or female, suspected of interracial sexual contact was publicly punished.[15]

Racial mixing posed a number of potential problems. At a time when Blacks far

outnumbered Whites, Whites were afraid of losing control over the enslaved population. But what really lay beneath their physical fears were their psychological ones. In order to maintain White supremacy,[16] Whiteness had to remain "pure." White anxieties about racial mixture were rooted in eugenics and scientific racism, both supposing that the White race was the superior race, that physical and mental traits were tied to heredity, and that racial mixing thus not only lowered human quality but further threatened the survival of the White race.[17] Within this framework, Blackness was considered a contaminant, one poisonous enough to taint and further cripple an entire gene pool. As will become clear, the one-drop rule would be critical not only in the defense of the White race but in the concentration of White power.

Given the shamelessly disproportionate amount of power and privilege assigned to Whiteness, the lines between who counted as White and who did not had to be unquestionably clear. Maintaining a firm color line would require the institution of what would later be called "anti-miscegenation laws" — laws that defined marriage (and sometimes sex) between the races as criminal. Because Blacks were already enslaved, in reality these laws reflected an attempt to police the behavior of Whites:

> In many of the colonies ... interracial marriage was formally prohibited; those who engaged in interracial fornication paid a double fine; those who intermarried were banished; those who performed marriages for mixed couples were punished; Whites who engaged in interracial marriages were enslaved; offspring of such marriages followed the slave status of the mother if the mother were Black and were enslaved anyway if the mother were White.[18]

The idea that children born to enslaved mothers would take the status of the mother reflected a significant break with traditional English common law that held that children take the status of the father. However, as we will continue to see, laws changed frequently to maintain White supremacy. Essentially, if a White man were to impregnate a Black woman, the law took him off the hook; he did not have to support or even claim that child. At best, if the mother of the child was his property, he gained not a child but additional property and another source of labor and income. Thus, the law inadvertently sanctioned the sexual abuse of enslaved women. In fact, on some plantations, a select number of enslaved women were reserved specifically for breeding with White men since Mixed-race "slaves" brought higher prices at the market.[19] Defining White-descended children born to enslaved Black women as "slaves"[20] suited the need to control the

population, increasing the number of exploited laborers while limiting the number of free Blacks. By limiting who had access to privilege, particularly that of freedom, Whites were able to further concentrate White power.

The punishment for White women who had consensual sex with Black men was much more severe than the penalties given to White men who raped Black women. The responsibility of maintaining the purity of the White race lay in the hands (and wombs) of its women, the literal bearers of the next generation. White women who had children by Black men were not only disgraces to their race but to their nation. Many were banished from the colony; many others were themselves enslaved.[21] Conveniently, traditional English common law was upheld in these cases, and Black-descended children born to White women took the status of their Black fathers. In both cases, racially mixed persons would be assigned to the status of the lower group, thus the term "hypodescent" — "hypo" meaning under, defective, or inadequate. A White mother could give birth to a Black child, but a Black mother could never give birth to a White one.

Obviously, White/Black sexual liaisons continued, and the Mixed-race population grew rapidly. The general term used during the antebellum period to describe people of mixed racial heritage was "Mulatto."[22] Taken from the Portuguese and Spanish term *mulato* meaning "young mule," the term reflects not only the disdain with which the referents were held but the way in which race was conceptualized at the time. As we know, a mule is the offspring of a horse and a donkey — a hybrid of two different animals — and as hybrids, they are sterile. To refer to children born of interracial sexual relationships as "Mulattos" pointed to the conviction that Whites and Blacks were two distinct beings and the related belief that if they were to mix, their offspring would be sterile and thus useless. True, we know that those of mixed racial heritage were not at all sterile; but this process of naming reflected a projected value system more so than an actual truth. Again, what lay beneath their physical fears were their psychological ones.

What would happen if one's social status — free or enslaved — were no longer obvious based on physical appearance? What exactly were "Mulattos"? If there were only two racial categories, White and Black, which one did they belong to? By one colonial observation, Virginia was "swarming with Mulattos," a situation that likely forced the state to quickly put laws into place to address the "problems" it posed.[23] Virginia was the first state to outline a formulaic definition of race in its ban against interracial marriage. In 1705, it defined a "Negro" as the child, the grandchild, or great-grandchild of a "Negro" or anyone who was at a least one-eighth "Negro."[24] By this definition, "Mulattos" were Black. Other states soon followed. At different times up until the 20th century, Indiana, Maryland, Missouri, Nebraska, North Carolina, North Dakota, and South Carolina all

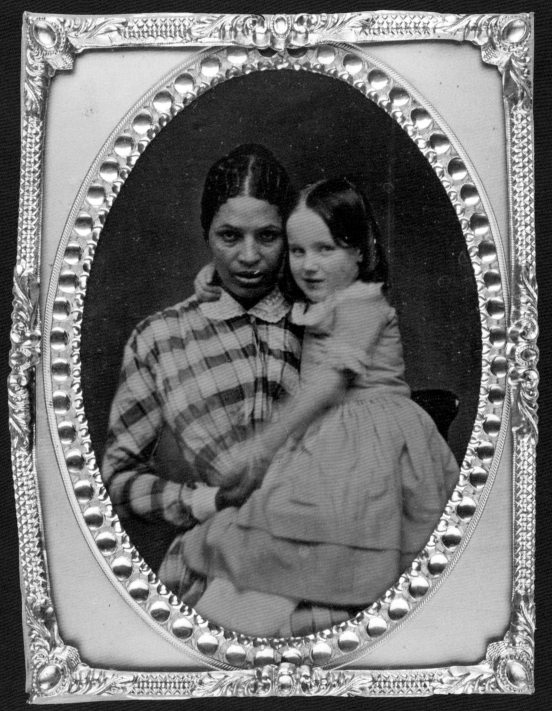

"Martha Ann 'Patty' Atavis with Alice Lee Whitridge," ca. 1856. (Unidentified photographer).
A young Alice Lee Whitridge sits with her "Mulatto slave," Patty Atavis. Courtesy of the Maryland Historical Society.

relied on a one-eighth rule, while Alabama, Arkansas, Georgia, Kentucky, Louisiana, Mississippi, Oklahoma, Tennessee, and Texas defined anyone with "any blood of the African race in their veins" as Black.[25] While legally many Mixed-race individuals were considered White in many states at various points of time, socially most Whites regarded anyone with any Black ancestry as Black. The message was clear: No matter how White you may appear, if there is but one drop of Black blood in your lineage, you will be considered Black and treated accordingly.

The New Orleans Exception

The specific case of New Orleans presents a quite different history of racial classification. There, a multi-tiered system developed wherein Whites held highest status and Blacks held lowest status, while the *gens de couleur libre* (free people of color), also known as Creoles of Color and more popularly referred to as Creoles, hovered loosely between the two in an intermediate position, enjoying the privileges of freedom since the beginning of French rule in 1718. The term "Creole," from the Latin *creare*, means "to beget" or "create."[26] Creoles were indeed "created," the result of generations of inter-mixing between Europeans (French and Spanish), Africans (enslaved and free), and Indigenous peoples. Unlike other regions of the country, in colonial Louisiana, amalgamation was widespread, tolerated, and sometimes encouraged, and thus Whites rejected the one-drop rule.[27]

Creoles functioned as a buffer class that helped Whites to maintain their dominant status and keep unmixed Blacks in their place. White fathers often acknowledged their "Mulatto" children, and many granted their children their freedom. To maintain the wedge created between the groups, laws were set in place to keep them separate. Creoles were prohibited from mingling with the dark-skinned Blacks.[28] Furthermore, under Louisiana law, Creoles were presumed free; Blacks were not. Having received the acknowledgement and favor of Whites, Creoles emerged as an elite class, and thus, like Whites, Creoles considered themselves superior to Blacks.

> Often possessing more white blood than [Negro], and quite often on good terms with and publicly recognized by their white relatives, most members of this third caste in Louisiana were reared to believe that they were a race apart from the [Negroes], who occupied the lowest stratum of society.[29]

"Portrait of an Unidentified Creole Man," year unknown. (Unidentified photographer).
Daguerreotype. Courtesy of the collections of the Louisiana State Museum.

Although Creoles were not given the privileges afforded to Whites, they were given many more privileges than were Blacks. For a Creole, then, having White ancestry was socially advantageous. The fact that Creoles were assigned privileges on the sole basis of their White ancestry only helped to further legitimize the superiority of Whiteness.

Rather than being defined by the one-drop rule, Creoles were defined by the exact amount of Black ancestry they possessed. In Louisiana, the term "Negro" applied usually to one of full "Negro" blood. A "Negro" and a White produced a "Mulatto." If a "Mulatto" were to reproduce with a "Negro," their offspring would be referred to as a Griffe, and if that Griffe were to reproduce with a White, their offspring would be referred to as Sacatra. A "Mulatto" and a White produced a Quadroon or Quateron. A Quadroon and a White produced an Octoroon or *Sang-mêlé*, and so on and so on.[30] And a person "sufficiently light-skinned to pass for White" was considered *passe à blanc*. Whereas the term *passé á blanc* points to how others perceived a particular person, the term *blanc forcé* was used to refer to someone who was intent on being seen as White "by force." Interestingly enough, however, when pronounced in New Orleans dialect, the term sounds more like *blan fo'cé*, and as such, the descriptor could also derive from *blanc foncé*, which means "dark white" in French.

In recognizing multiple categories of non-Whiteness, Louisiana established a distinctive and complex caste system. Just as Whites considered themselves superior to Blacks on the basis of skin color, so too did Creoles. Whites approved of and often encouraged Creoles' erection of and adherence to this "color line of privilege" — "this separation was encouraged by the whites as a means of dividing the Negroes and making it easier to control them. ... By law the light-skinned free Negro was barred from mingling with the dark-skinned slave."[31] Under an 1846 Louisiana law,

> a person of color may be descended from Indians on both sides, from a white parent, or mulatto parents in possession of their freedom....the probability that a colored person [is] free [is] so great that he ought not to be deprived of freedom upon mere presumption.[32]

Thus, Creoles were presumed to be free; Blacks were not. Although never explicitly stated, these and similar statutes gave Creoles both social and legal permission to consider themselves a race separate from Blacks, and in many ways, their skin color served as their passport to freedom.

The multi-tiered racial classification system that created the Creole also created

NEGRO
Usually applied to one
of full Negro bloood

SACATRA
7/8 Negro – 1/8 White

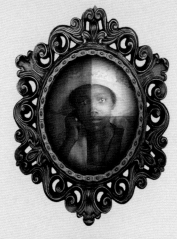

GRIFFE
3/4 Negro – 1/4 White

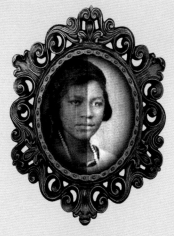

MULATTO
1/2 Negro – 1/2 White

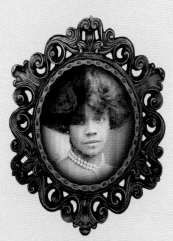

**QUADROON or
QUATERON**
1/4 Negro – 3/4 White

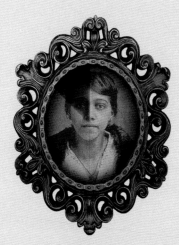

**OCTOROON or
SANG-MÊLÉ**
1/8 Negro – 7/8 White

QUINTEROON
1/16 Negro – 15/16 White

**PASSE À BLANC or
BLANC FORCÉ**
"some Negro blood" but
sufficiently light-skinned
to pass for White

"What are you?" Colonial Louisiana Definitions." (Kelcie Ulmer)

an elite class of people, many of whom were as financially secure as Whites, if not more so. In New Orleans, Creoles made up a significant portion of the city's doctors, lawyers, businessmen, and other educated professionals. Some were successful enough to own their own "slaves." Their very ability to work for wages, operate businesses, and receive inheritances was due to their racial and social approximation to Whites. Having a European-like phenotype — light skin, straight or loosely coiled hair, aquiline features, etc. — marked people elsewhere categorized wholly as Black as privileged, with the amount of privilege assigned based on how much White blood the person possessed and/or how much White blood it *appeared* that the person possessed. Thus, among Creoles themselves, each of these subcategories represented jealous and fiercely guarded distinctions.[33] This caste system would set into motion a history of "bad blood" (no pun intended) between Louisiana's Creole population and browner- or darker-skinned Blacks based largely on ancestry and appearance.

Recognizing the social power and freedoms established by Whites simply on the basis of skin color, many Creoles began to take extreme pride in their own light skin color and often went to great lengths to "maintain the race" by either preserving or lightening the skin color of their descendants. The responsibility of maintaining the race fell on the shoulders (and wombs) of Creole women. Efforts to "improve the race" often involved Creole women engaging in sexual relationships with White men and in turn producing lighter-skinned offspring. At the time of its inception, the French *Code Noir* dictated that children resulting from French/non-French (read: White/non-White) unions assumed the status of their mothers.[34] However, the French fathers oftentimes freed their Mixed children and their common-law (Black) wives. The privileges associated with White ancestry and skin color thus made "alliances" between Black women and French men both attractive and inevitable.[35] More formally referred to as *plaçage* ("placement" in French), this system afforded French men "respectable companionship" in a place where there was a shortage of European women, while offering Creole women the opportunity to improve not only their own social standing but that of future generations of their families. With the option of legal marriage denied them, Creole women within *plaçage* entered into long-standing formalized relationships with White European men. This practice was so common yet so threatening to the social order that laws were written in an effort to prevent it. In 1908, the Louisiana State Legislature "passed a bill ... making concubinage 'between a person of the Caucasian race and a person of the negro race a felony, fixing the punishment therefore and defining what shall constitute concubinage.'"[36] Because the act stipulated that concubinage between Whites and Blacks was against the law, it left the doors open for various interpretations, given Louisiana's multilevel racial classification

system. Most Creoles did not consider themselves Black. Thus, the system of *plaçage* flourished, in spite of legal sanctions. How could laws against a race be enforced when that race could not be identified?

white Blacks, black Whites

As the "Mulatto" population grew nationwide, and as the system of enslavement came under international attack, Southern states were put on the defensive. Having to now answer questions about the apparent inconsistencies in the system such as the double standard of White versus Black sexual morality, the different statuses of "Mulattos" in different states or regions, and the enslavement of people who did not look Black, Southern Whites needed to demonstrate that the boundaries between freedom and enslavement were clearer and more consistent than they actually were. The behavior that caused the apparent confusion needed to be addressed.

It is during this period that the term "miscegenation" was invented. Although we now refer to the laws instituted to prohibit the mixing of the races as "anti-miscegenation laws," the term used prior to 1864 was "amalgamation." Amalgamation, by definition, refers to the mixing of metals. During the presidential election of 1864, politicians argued that it was important to have a term that referred specifically to the mixing of races.[37] Combining the Latin *miscere* (to mix) with genus (race, stock), they created a term that sounded not only more scientific but more ominous. Miscegenation rang more like "mistaken mixture."[38] The term quickly became popular and helped to solidify the belief that racial mixing was "unnatural." States began enforcing their anti-miscegenation laws more rigorously, especially insofar as they allowed for the punishment of Whites.

The one-drop rule became pivotal in the South's defense of enslavement, as it helped to demonstrate clear boundaries between enslavement and freedom. It is during this time that we begin to see a more widespread and consistent adoption of the one-drop rule across the entire Southern region.[39] By way of the one-drop rule, either you were White or you were Black. If you had *any* amount of Black ancestry, you were Black. If you were White, you were free; if you were Black, you were enslaved. It could not get any clearer than that. No longer considered Quadroons, Octoroons, or anything else — at least not by law — the esteemed Mixed, and thus middle, class was now Black. Rather than suffer as Black, many instead chose to "become White" by "passing" into White society in order to gain social, economic, and other opportunities. No easy decision, passing involved taking many risks, including arousing suspicion, being "discovered," and being

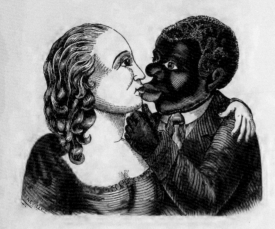

· WHAT MISCEGENATION IS !

—AND—

WHAT WE ARE TO EXPECT

Now that Mr. Lincoln is Re-elected.

By L. SEAMAN, LL. D.

WALLER & WILLETTS, Publishers,

NEW YORK.

"What Miscegenation Is!: And What We Are To Expect Now that Mr. Lincoln is Re-elected," 1865. Book cover. Courtesy of the Boston Public Library.

forced to return to Blackness. Successful, full-time, or "continuous" passing[40] required that the person who passed for White relinquish all family ties and loyalties to the Black community, and their success often relied on their family's cooperation in protecting their new identity. Those unable to completely abandon their families and identities often practiced "discontinuous" passing.[41] This part-time form of passing usually involved passing only under specific circumstances or for certain occasions (e.g., to attend a White college or university or to work in a "Whites only" establishment). Passing was not always a conscious and concerted effort. Many may have passed without even knowing it, for every time a person was mistaken for White, s/he passed.

Ironically, it was the Confederacy's one-drop ideology of Blackness that was at the crux of many of the arguments against enslavement. White abolitionists began a photographic propaganda campaign in the fight to dismantle the institution. The way to arouse sympathy for the enslaved was to portray the White ones.

For example, in 1848, abolitionist Henry Ward Beecher organized an anti-slavery auction in Brooklyn, N.Y., to raise enough monies to pay the ransom for two "escaped slaves" — sisters, who despite their "apparent whiteness," had been born into enslavement in Maryland and were scheduled to be sold in New Orleans.[42] Dressed in the finest linens, the girls stood before the congregation as Beecher asked, "Shall this girl — almost as white as you are — be sold for money to the first comer to do as he likes with?"[43] The answer had to be no. Beecher raised over $2,200 and was able to buy the girls' freedom. From this perspective, Southern slavery was a threat to the freedom of all White people. If these girls could be enslaved, so too could any other seemingly White person.

Similarly, on January 30, 1864, *Harper's Weekly* featured an enlarged, full-page illustration of a group of eight Louisiana students bearing the caption *"Emancipated Slaves, White and Colored."* In an attempt to raise funds for Colored schools in Louisiana, the American Missionary Association in connection with the National Freedman's Relief Association submitted the photograph to the political magazine for publication. The organizations understood that the way to garner sympathy for Blacks was to show those with substantial amounts of White blood. Adding descriptions of each of the students, the accompanying article told readers of the hardships the children had endured under enslavement and how they had been turned away from the St. Lawrence Hotel in Philadelphia. Describing the "slaves," the editor noted that:

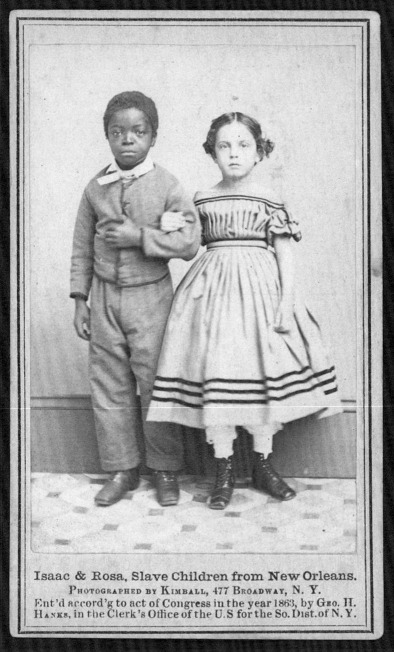

Isaac & Rosa, Slave Children from New Orleans.
PHOTOGRAPHED BY KIMBALL, 477 BROADWAY, N. Y.
Ent'd accord'g to act of Congress in the year 1863, by GEO. H.
HANKS, in the Clerk's Office of the U.S for the So. Dist. of N.Y.

"Isaac & Rosa, Slave Children from New Orleans," 1863. (M.H. Kimball). Portrait of Isaac White and Rosina Downs. Courtesy of the Library of Congress.

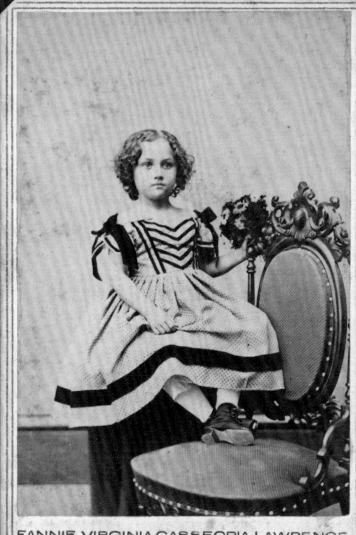

FANNIE VIRGINIA CASSEOPIA LAWRENCE,

A Redeemed SLAVE CHILD, 5 years of age. Redeemed in Virginia, by Catharine S. Lawrence; Baptized in Brooklyn, at Plymouth Church, by Henry Ward Beecher, May, 1863.

Entered according to Act of Congress, in the year 1863, by C. S. Lawrence, in the Clerk's Office of the District Court of the United States, for the Southern District of New York.

"Fannie Virgina Casseopia Lawrence," 1863. (Unidentified photographer). An Octoroon child "redeemed from slavery" in Virginia by abolitionist Henry Ward Beecher. Courtesy of the Library of Congress.

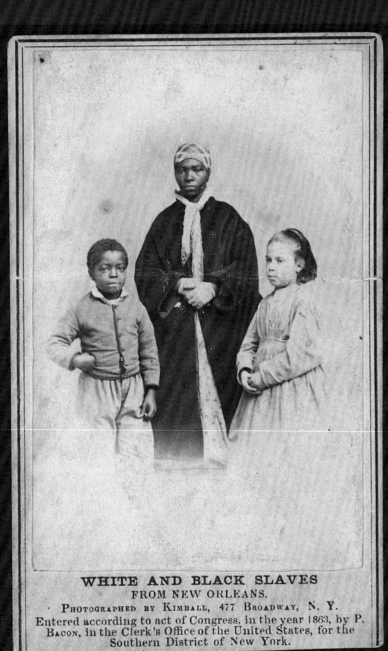

WHITE AND BLACK SLAVES
FROM NEW ORLEANS.
Photographed by Kimball, 477 Broadway, N. Y.
Entered according to act of Congress, in the year 1863, by P.
Bacon, in the Clerk's Office of the United States, for the
Southern District of New York.

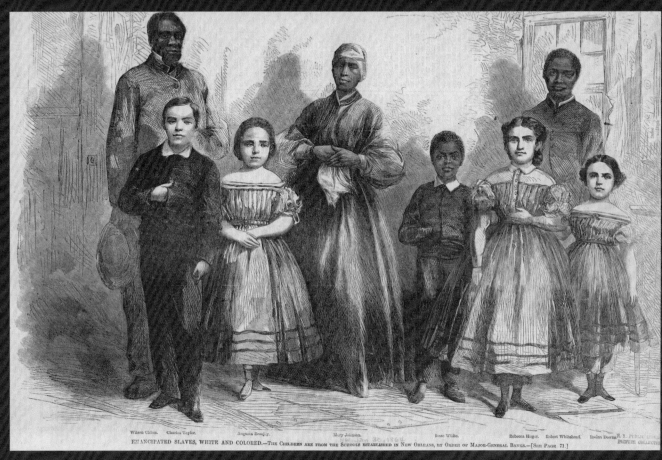

"Emancipated Slaves, White and Colored," 1864. (Unidentified artist). As featured in *Harper's Weekly: A Journal of Civilization* on January 30, 1864. Courtesy of the Picture Collection, the New York Public Library, and the Astor, Lenox, and Tilden foundations.

These are, of course, the offspring of white fathers through two or three generations. They are as white, as intelligent, as docile, as most of our own children. Yet the "chivalry," the "gentlemen" of the Slave States, by the awful logic of the system, doom them all to the fate of swine; and, so far as they can, the parents and brothers of these little ones destroy the light of humanity in their souls.[44]

Black by Law

Once the institution of enslavement was abolished, Whites and Blacks found themselves in newfound competition, especially for jobs. The need to maintain Blacks in the lowest social position intensified the nation's need to define and categorize them. Thus, at the turn of the century, more restrictive definitions of Blackness and thus race began to emerge. In the landmark 1896 case of *Plessy v. Ferguson*, the United States Supreme Court not only endorsed segregation by advancing a "separate but equal" doctrine, but in declaring plaintiff Homer Adolph Plessy Black, the court inadvertently defined Blackness. In a series of pre-orchestrated events, Plessy, a New Orleans Creole of Color who was light enough to pass for White, purchased a first-class train ticket, boarded the train, took his seat, handed his ticket to the conductor, and announced, "I have to tell you that, according to Louisiana law, I am a Colored man."[45] Surprised, the conductor told Plessy that he would have to move to the "Colored car." Plessy refused and was arrested. Under the direction of a group of prominent New Orleans Creoles, the *Comité des Citoyens* (Citizens Committee), Plessy plotted his own arrest so that he would be able to challenge Louisiana's Separate Car Act, which required that all railroads operating in the state provide "equal but separate" train car accommodations for Blacks and Whites and prohibited passengers from entering accommodations other than those to which they were entitled based upon their race. According to his petition, Plessy was seven-eighths White (Octoroon) and "the mixture of colored blood was not discernible in him."[46] He contended that because he looked White, he should be entitled to "every recognition, right, privilege and immunity secured to the citizens of the United States of the white race by its Constitution and laws."[47] Notably, members of the *Comité des Citoyens*, largely influenced by the French Revolution and its ideals of equality under the law, sought equal treatment not because they were of a different race but because they were human beings. Generations ahead of their time, by way of Plessy's case, they sought to fight racial categorization altogether. Unfortunately, however, their White lawyers were constrained by the racial concepts of

the time, and their arguments focused excessively on whether or not Plessy should be categorized as Black given his White appearance. Thus, Plessy's attorneys accepted race as a category at the same time that they argued that the law ought not use it as a basis for determining citizens' rights. In the end, the United States Supreme Court upheld the constitutionality of the Louisiana Separate Car Act and took "'judicial notice' of what it assumed to be common knowledge — that a Negro or black is any person with any black ancestry."[48] One need not look Black in order to be considered Black. The United States Supreme Court sanctioned the one-drop rule. By 1925, almost every state had some form of a one-drop law on the books.

As the one-drop reality set in to the American consciousness, already tenuous relationships between and among the races continued to shift. Southern Whites lost their alliance with the Mixed-race class they once relied upon to serve as a buffer between them and unmixed Blacks. As a result of being cast out of White favor, the "Mulattos" and Creoles of pre-Civil War America were forced to become more allied with the general Black population, which undoubtedly spawned a transformation of their self-identity — individuals who had never before imagined themselves as Black became Black. And Blacks, who had long been untrusting of the "Mulatto" elite, seemingly set differences aside for the sake of solidarity towards a common cause — the struggle for freedom and racial justice.[49]

The End of a Rule?

In 1958, Richard Loving, a White man, married Mildred Jeter, a woman of Black and Native American descent, in Washington, D.C. The couple lived in Virginia but traveled to D.C. to marry because interracial marriages were illegal according to Virginia law. Virginia's 1924 Preservation of Racial Integrity Act prohibited marriages between a White person and a non-White person. The act also required that every person's race be recorded at birth. There were only two classifications: White and Colored.[50]

Shortly after the newlyweds returned to their home state, the sheriff and two deputies entered their home in the middle of the night, hoping to find them engaged in the act of sex, which was also illegal between Whites and non-Whites. Although Richard Loving attempted to explain that the two had been married, they were arrested and charged with violating state law. After spending several days in jail, the Lovings pleaded guilty. According to the Racial Integrity Act, "miscegenation" was a felony punishable by a prison sentence of one to five years. Under a plea bargain, however, their prison

sentences were suspended on one condition — that they leave the state and not return for at least 25 years.[51]

The Lovings moved to Washington D.C., and after eight years and a series of lawsuits, their case reached the United States Supreme Court, which in a unanimous decision overturned their convictions on June 12, 1967. In its ruling, the Supreme Court concluded that anti-miscegenation laws and the one-drop rule were unconstitutional.[52] Despite the ruling, however, such laws remained on the books in several states, although they were ultimately unenforceable. Louisiana was the last state to repeal its law on racial classification, which it did not do until 1983;[53] and Alabama was the last state to repeal its law against interracial marriage, which it did not do until the year 2000.[54]

Is this sordid history of racial categorization completely behind us? Since the Loving case, the Multiracial population in the United States has reportedly grown dramatically, with projections that it will continue to increase at exponential rates. But does this increase in numbers represent a true demographic shift, or does it simply reflect a shift in available options for racial categorization and thus self-identity? Does this "shift" in numbers reflect a more widespread shift in racial consciousness? Some projections estimate that by 2050, one in five Americans may identify as Multiracial.[55] However, as with trends in interracial relationships and marriages, Blacks identify as Multiracial much less than do Latinos or Asians.[56] Does 19th century logic about Blackness still affect 21st century realities? *One Drop* sets out to explore the extent to which historical definitions of race continue to shape contemporary racial identities and lived experiences of racial difference, particularly among those for whom the legacy of the one-drop rule perceptibly lingers.

Beyond the U.S., Beyond the One-Drop Rule

Although the one-drop rule has functioned historically as the defining criterion for Black racial identity in the United States, in no other nation or society does this "logic" ring true. In fact, in many places, for a person of African descent, any "one drop" of something else is enough to render that person "something else."

Latin America. Similar to the United States, the history of race and racial mixing in Latin America reveals much about the regard for Blackness in the region. Often outnumbering European women at rates as high as eight to one, early European colonists formed "relationships" with Indigenous and enslaved African women, some with consent,

many others by force. Expectedly, as was the case in the United States, a Mixed-race population emerged. Social attitudes towards racial mixing, however, were markedly different in Latin America. Although both regions ultimately sought to maintain White supremacy, they each pursued different strategies in doing so. Whereas in the United States context Whiteness was defined as "pure," Blackness was viewed as contaminating, and thus racial mixing was seen as a threat to the White population, in the Latin American context, Whiteness was viewed as cleansing and purifying, and thus racial mixing, in so far as it "diluted" the Black population, was seen as a benefit to the entire population. In fact, many countries attempted to "whiten" their populations via a political agenda known as *blanqueamiento* ("whitening"), which ranged from the personal, individuals being encouraged to reproduce with those who were lighter or whiter than themselves, to the political, countries encouraging European immigration for the expressed purpose of raising the probability of racial mixing.

In this context, one's racial identity depends largely upon one's phenotypical appearance. Here, the idea of "passing" would be as foreign a concept as the one-drop rule — one is what one looks like. In Brasil, for example, racial categories are predicated not only upon one's looks but on socioeconomic class. As a popular Brasilian saying puts it, "*o dinheiro embranquece*" ("money whitens") — the higher your social class, the more likely you will be treated as someone of "lighter" race. As would be expected, Brasilians use a wide variety of terms to identify race and many more to describe skin color, all of which are framed in relation to one's approximation to Whiteness or distance from Blackness. In 1976, the agency responsible for gathering statistical information, the Brasilian Institute of Geography and Statistics (*Instituto Brasileiro de Geografia e Estatistica*), conducted the National Household Sample Survey (*Pesquisa Nacional por Amostra de Domicilios*) and asked participants to note their own skin color.[57] Data indicated that participants used over 130 terms to self-identify, including *amarela* (yellow), *amarelada* (yellowish), *branca* (white), *branca-morena* (darkish white), *branca-suja* (dirty white), *branquiça* (a white variation), *cabocla* (mixture of White, Negro, and Indian), *clara* (light), *esbranquecimento* (mostly white), *escura* (dark), *escurinha* (semi-dark), *miscigenação* (miscegenated), *mulatinha* (lighter-skinned white-*Negro*), *meio-preta* (mid-Negro), *negra* (Negro), *parda* (dark brown), *parda-clara* (lighter-skinned person of mixed race), *preta* (Black), and *pretinha* (Black of a lighter hue).[58] Over 30 years later, the use of multiple color identifiers — none of which conform to any pre-formulated rules and most of whose meanings are abstract, if not ambiguous — continues. Who and/or what is Black to one may be "dark brown" or "semi-dark" to another; and who is considered White in Brasil could easily be considered Mixed, if not Black, in the United States.

Many Latin American countries have boasted long-standing histories of miscegenation as evidence that they are race-blind and as such are also without racism.[59] In these countries, the dominant racial ideology of *mestizaje* ("race mixture") positions the *mestizo* ("Mixed-race individual") as the reflection of an ideal national identity, a prototype that allegedly transcends race and color.[60] Yet in framing Whiteness via *blanqueamiento* as the source of racial improvement and the *mestizo* identity as some sort of achievement, *mestizaje* as both an ideology and practice is as beholden to eugenics, scientific racism, and White supremacy as is the one-drop rule. Furthermore, in supporting the primacy of a national identity over a racial one, despite the fact that these nations are undeniably racialized, *mestizaje* discounts the fact that racial and color hierarchies do in fact exist and that people indeed have very real and lived experiences with racism and colorism. It is not that race and racism do not exist in these countries; quite the opposite — they exist, but their very discussion is itself considered racist and thus discouraged, if not silenced.

The Caribbean. Blackness in the Caribbean is similarly dissimilar to the United States context. Although the two regions share parallel histories of enslavement and racial mixing, unlike the United States, where Europeans would settle permanently, the Caribbean consisted more so of colonies of exploitation, and therefore housed a substantially smaller European population. Established primarily to serve colonial economic needs, the Caribbean plantation system relied heavily and increasingly upon free and cheap labor sourced exclusively through the exploitation of Indigenous peoples, enslaved Africans, and indentured laborers from India, China, Southeast Asia, and elsewhere. This highly multiethnic population and the intermixing that took place between groups would come to impact unique notions of identity and belonging in the region.

Despite having percentages of African descendants larger than that of the United States, many Caribbean nations project racial mixture as the core of their national identities. Still, social hierarchies organized around skin color remain. Although Jamaica's national motto proclaims, "Out of many, one people," social, political, and economic power there has been concentrated historically in the hands of those who occupy a middle category of Mixedness — those who are considered "Brown." So while in theory Jamaica celebrates a national identity that is multiracial and multicultural, in practice color and class are inextricably linked, and as such, discriminatory treatment based upon skin tone persists.[61] Similar color-coded social structures exist in places such as Trinidad and Tobago and Guyana, where identifiers such as *coolie* (someone of East Indian descent), Creole (from the Spanish *criollo* meaning "of local origin, native"), *dougla* (someone of mixed

African and East Indian descent) and *chiney* (someone of Asian descent) are based more in phenotypical appearance (skin color and hair texture) than they are in actual genetic makeup.[62] Given the reality that those who appear to be primarily of African descent (Afro-Trinidadians or Afro-Guyanese) remain at the bottom of the social hierarchy,[63] in many ways, these terms denote not only difference but distance — from Africa in general and Blackness specifically — both racially and socially.

Continental Africa. Across the world, definitions of Blackness all seem to reference a genetic and cultural connection to Africa as an identifying marker for Blackness, yet oddly enough, within the Continent itself, Blackness is not thus defined. Race is perceived in terms of wholes rather than parts — either you are Black or White or Asian, etc., or you are not. One's racial identity is a simple matter of appearances — if you look Black, then you are Black. But even what Blackness looks like in Africa is much different than what it looks like in the United States. Many Black people who might be recognized as "light-skinned" in the States would be assumed to be "half-caste," if not "White," in many parts of Africa. Still, in areas where the population appears more racially homogenous, such as West Africa (the region of origin for most people of African descent throughout the Diaspora), race is not the defining characteristic of one's identity as it is in the United States. There, ethnicity contributes more to a sense of being and belonging, so as the racial norm, one's Blackness is hardly a matter of discussion.

In areas where the population is seemingly more racially diverse, such as South Africa, however, there exists a middle category of Mixedness similar to that found in Latin America and the Caribbean. During the apartheid regime, South Africans were categorized into four mutually exclusive racial categories: European/White, Asian, Coloured, and Native/Black.

> European included all whites, whether descended from Dutch (later know as Afrikaner) or British colonists, or more recent immigrants from eastern Europe, Australia, and the United States. [Asian] largely referred to indentured laborers and their descendants brought from South Asia and China from the nineteenth century onward to work on sugar plantations and in gold mines. Coloured was a common racial designation for the descendants of mixed marriages and sexual liaisons between Europeans, African peoples indigenous to the Cape region (mainly speakers of Khoisan languages), and enslaved peoples brought from Southeast Asia, South Asia, Madagascar, East Africa, West Africa, and elsewhere during

27

the Dutch colonial period (1652-1810). Native referred to the majority African population, most of whom spoke Bantu languages as their mother tongue.[64]

These categories were organized into a legally and socially sanctioned hierarchy whereby the White minority represented the ruling class, Asians and Coloureds represented the buffer classes, and the Black majority represented the disenfranchised underclass.

The process by which South Africans were classified into these categories lends greatest insight into the perceptions and understanding of race in South Africa. Early proponents of apartheid argued that race was a biological fact, one that should be determined by blood. Accordingly, racial purity would define both Whites and Natives (Blacks), while those of mixed blood would be categorized as Coloured. From this point of view, because racial difference could be measured, racial classification would be a matter of historical and scientific fact. Ironically, however, what became law was a "deliberately more flexible, elastic approach to the definition of racial categories … one that gave official standing to long-established social readings of racial difference."[65] As much a judgment about one's physical appearance as it was about social status, racial classification was considered a matter of common sense — a determination that could and would be made according to public opinion and general acceptance. Although all citizens were required to submit to the national census and thus provide information about themselves including a photograph, it was the census taker who ultimately determined a person's racial classification, often based upon variable, self-determined, and self-relative criteria. In addition to skin color, many census takers took such things as skin texture, facial shape, bone structure, height, hair texture, and hair length, as well as area of residence, language spoken, eating and drinking habits, employment, and socioeconomic status into consideration when recording a person's race.[66] So arbitrary was this method that it was not uncommon for someone to contest their official racial classification, a process that offered the person upward racial mobility if the appeal was granted. Nevertheless, the large majority of South Africans did not contest their assigned race, and thus an imprecise method of racial categorization precisely determined one's lot in life. Although it was during the apartheid era that these classifications had the most direct bearing on a person's access to social, political, and economic institutions, White supremacy lingers in contemporary South Africa, as does racialized distribution of power.

As we have seen, racial categories take on variable and complex meanings across the world. In form and function inverse to those historically accepted in the United States, elsewhere one drop of "other" blood distinguishes a person of African descent as

Other. We have also seen that there is seemingly no certitude in how racial categories are established or recognized abroad. While many countries throughout the African Diaspora construct Blackness distinct from Mixedness, do all people of mixed ancestry in those countries similarly construct their own identities as mutually exclusive to Blackness? In the absence of a definitive framework through which to designate race, how do people in these countries understand their own racial identities, if at all? Furthermore, what happens when people of African descent migrate to the United States from these various global locales? Do they maintain culturally specific conceptualizations of self? Do they conform to American ideations of race and simply become Black? Or do they negotiate between the two and create melded identities? While this book gives particular attention to self-reflective notions of Black racial identity in the United States, *One Drop* additionally explores the racialized lived experiences of people of African descent from throughout the African Diaspora, particularly from the perspectives of those whose racial identities are perceivably ambiguous.

Introspection

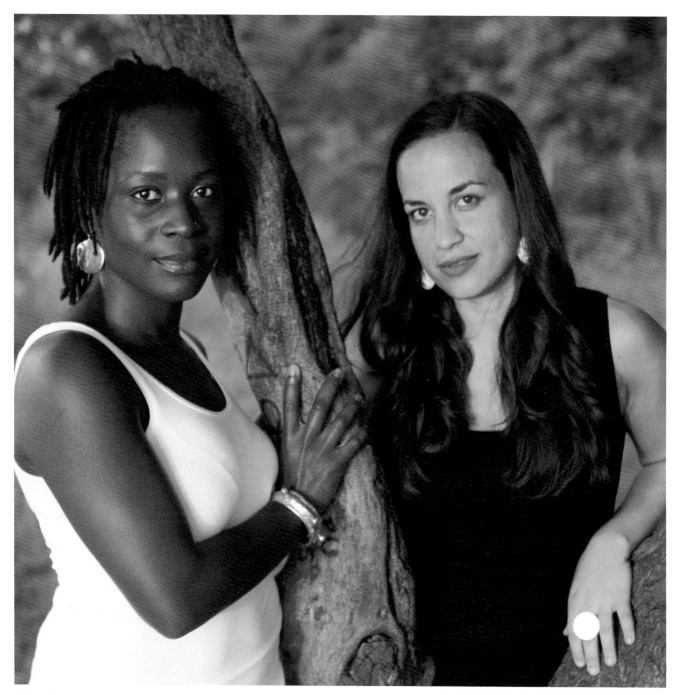

Yaba Blay (left) and Noelle Théard. Brooklyn, New York. September 2011. (Jamel Shabazz)

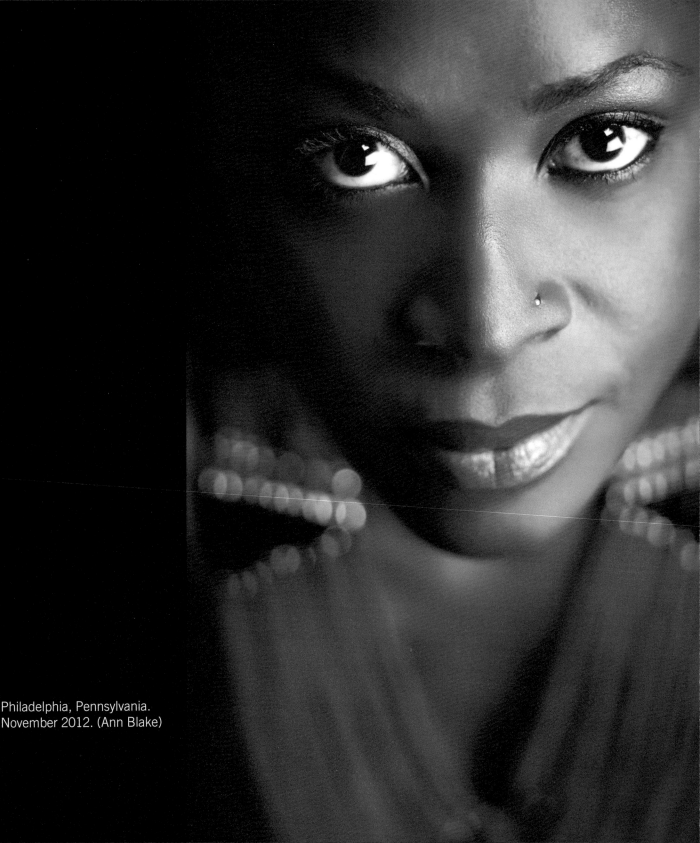

Philadelphia, Pennsylvania.
November 2012. (Ann Blake)

YABA BLAY

Philadelphia, Pennsylvania

◆

"Black / American-born Ghanaian / African"

I can attest to this. I am a first-generation American-born Ghanaian, and I grew up, black as I am, in New Orleans, a city now well-known not only for its Creole population, past and present, but for its palpable sociopolitical history of colorism. Creoles often pride themselves in their "pretty color 'n' good hair," and in many ways socially and politically, they continue to segregate themselves from the masses of "regular" Black folks. In my own family, we're all dark-skinned, so there was never any conversation about it. But when I walked out of the house, I became painfully aware that I was *very* dark-skinned. Having immigrated to this country, my parents were primarily concerned that I take full advantage of the opportunities available to me. How to navigate a social space wrought by colorism was not something they were necessarily prepared to teach me how to do. So I struggled. I remember not being invited to the birthday party of one of my very best friends because she said her mama said I was too dark. I also remember not being invited to an adult colleague's wedding just 10 years ago for the same reason.

In my experience, folks who had the privilege of identifying as Creole did; and in my estimation, they were just saying that they were Creole so they didn't have to say they were Black. One of my favorite pastimes became "picking out Black people" — those who everybody else may have thought were White or "something else" but who I knew for a fact were Black. Somehow. Whether it was the curl in their hair or the specific tint of their skin, the cadence in their voices, or the sway of their steps, somehow I knew they were Black. Even as a child, I understood, accepted, and championed the one-drop rule, and somehow I made it my mission to identify Blackness any chance I could get. Maybe it was my way of retaliating against those who didn't want to be associated with "my kind" — those who I felt rejected me because of my Blackness. Whatever the reason, anytime I saw someone who looked Creole coming, I already knew what to expect — or so I thought.

Then, in 2010 I was invited by the Caribbean Cultural Center African Diaspora Institute to be a panelist during their fifth annual Redefining African American conference. The title of that year's program was "Beyond the Brown Paper Bag Test: Deconstructing Black and Brown." I was asked to address the prevailing color divide that exists within the African Diasporic community. One of my co-panelists was Rosa Clemente (p. 224), hip-hop activist and 2008 Green Party vice presidential candidate. For as learned and

as well-versed as (I thought) I was in global skin-color politics, I found myself somehow taken aback, distracted even, each time she identified as a "Black Puerto Rican woman from the South Bronx." I mean, yes, I knew Puerto Ricans were of *some* African descent, but I certainly didn't know they claimed it. Perhaps I should have known, but there wasn't a large Latino community in New Orleans when I was growing up. One was either Black, White, or Creole.

Still, the more she talked, the more I checked myself for questioning her identity, if even only in my mind. I was, after all, a professor of Africana Studies — I knew the difference between race and ethnicity. By that time, I had been teaching college students about the concepts of race and the African Diaspora for over six years. But this wasn't an academic conundrum; it was a personal one. What I realized is that I had not even put myself in a position to be open to the possibility that my one or two or even 10 experiences with Creoles in New Orleans were not necessarily representative of the experience or perspective of all light-skinned folks in general or people with multiple identities in particular. There are people of African descent all over the world who, despite their appearances or maybe even because of their appearances, embrace their Blackness, and it has nothing to do with any number of drops or any legal designations.

As I confronted this reality and consequently confronted myself, I knew that I wanted to do something with my feelings that could be useful to others like myself. I wanted to meet and talk to as many people like Rosa as I could. And so began my journey into *One Drop*.

Method — What I Did

From February 2011 through March 2013, I interviewed 70 individuals representing 25 different countries. The large majority of them live in the United States, and eight reside in Brasil, Canada, Saudi Arabia, South Africa, the Netherlands, and the United Kingdom. From the everyday person to the international celebrity, the final pool of contributors consists of 34 women and 24 men who, at the time of interview, ranged in age from 21 to 103 years old.

Although contributors use a variety of terms to self-identify, they all see themselves as part of the larger racial and cultural group generally referred to as "Black people." All of them have had the experience of having their identity called into question simply because they don't necessarily fit into the "Black box" — dark skin, "kinky" hair, broad nose, full lips, etc. — and most have been asked either "What are you?" or the more politically

correct "Where are you from?" time and time again.

A number of the contributors I had already known personally — friends, former classmates, former students, a former professor, my best friend's father — while many others were friends of friends and referrals from other contributors. Others I contacted through Facebook based upon their profile pictures, while a few others volunteered after the project website launched in September 2011. In speaking with each of them, I wanted to get a better sense of how they identified and why they identified as they did. Interviews were formal in that they were audio-recorded and later transcribed verbatim, and informal in that they each functioned as a conversation. Although each interview and conversation was unique, all contributors were asked to respond to the following questions:

- How do you identify? Racially? Culturally?
- Upon meeting you for the first time, what do people usually assume about your identity?
- Do people question your Blackness?
- What is it about you that causes people to question your identity?
- Has your skin color or racial identity affected your ability to form/maintain social relationships?
- Many people assume that with light skin comes benefits. What benefits do you realize or have you experienced? Similarly, what liabilities/disadvantages have you realized or experienced?

Using the interview transcriptions as guides, I wrote and edited each contributor's narrative and attempted to capture what I believe to be the essence of each of their stories. The process was collaborative, and I invited contributors' input into the creation of their memoirs and sought their approval before going to print.

Methodology — Why I Did What I Did

All research is personal. This research is personal, yet this project is not about me. I speak very personally about my own experiences because I want to demonstrate that in order for us to deal with some of the issues that we face in our communities, we have to be willing to "put our stuff out there" and confront ourselves. So, I begin with my own self. As a researcher, however, I take an approach referred to as phenomenology, whereby the participant is the expert on his or her experience. The aim of taking this approach

is to describe the lived experiences of a particular phenomenon for those individuals involved in or with the phenomenon. In this case, the phenomenon is racial identity as mediated by skin color politics. So, as we ask the questions "Who is Black?" and "What is Blackness?" we seek answers in the lived experiences of those individuals whose physical appearance, and in most cases skin color, renders their racial identity more ambiguous than others'. Equally, if not more important than contributors' lived experiences, are the meanings they attach to those experiences. This is not a quest for an "empirical truth" — one that can be measured, cross-checked, and verified. This is a fluid exploration of multiple truths, from the inside out, all valid in their own right.

Although much of the reason I prioritize qualitative research is because it facilitates my being involved in the experiences of the people I interact with, when using the phenomenological approach, I have to be careful not to lead the research or to inject my own hypotheses or truths into the exploration. So while I too have my own lived experiences related to racial identity and skin color politics, my job as the researcher is to *follow* the contributors and allow them to reveal *their* truths as *they* see them. In presenting participants' views of reality, then, I encourage those who are unfamiliar or inexperienced with the phenomenon to better understand what it is like to experience or *live* it.

Following this approach, it was very important to me that I include participants in the process of creation, so much so that I refer to them as contributors rather than participants. I shared transcriptions and memoir drafts with each of them, inviting their editorial feedback and requesting their approval. Noelle Théard, the director of photography who created most of the portraiture featured here, took a similar approach to the project. Informing contributors that she wanted to *make* their portrait *with* them, rather than *take* their portrait, she encouraged them to dress and accessorize as they pleased and asked them to consider the portraiture process as an extension of their interviews, an additional opportunity for them to represent themselves. This collaborative style of portrait making was as important, if not more important, than the technical specifications of the photography.

Of the total pool of people I interviewed, some asked that their personal stories not be shared publicly. Their reservation recalls and calls attention to the highly sensitive nature of this project. The fact that the featured contributors are willing to share their personal stories deserves acknowledgement. That they have faith in me to present their stories to you is an honor. It is a responsibility that I do not take lightly or for granted.

Shifting the Lens

What is most important for you to understand is that this project is *descriptive*, not *prescriptive*. It is not my goal to tell people how to identify. I am not the Blackness Whisperer, nor am I the Blackness Hunter. However a person chooses to identify is just that — their choice. My aim here is to challenge narrow yet popular perceptions of what Blackness is and what Blackness looks like. If we can recalibrate our lenses to see Blackness as a broader category of identity and experience, perhaps we will be able to see ourselves as part of a larger global community.

As a professor of Africana Studies in the United States, I believe that it is becoming increasingly important for all people, not just people of African descent, to recognize the existence of a global Black community. In my experience teaching students about issues related to the African Diaspora, I find that they have a particular level of difficulty assigning the category and thus the identity of Blackness to people throughout the world, even when those people themselves identify as Black. Their difficulty rests in their preoccupation with prototypical — dare I say stereotypical? — American Blackness. In that way, an identity such as Afro-Latino/a is quite difficult for them to understand, particularly in cases in which they can't readily recognize the "Afro-" (no pun intended). In their inability to recognize Blackness, they are left believing that Black people are indeed a minority, and as such, are "naturally" relegated to subjugated positions. As this book demonstrates, there are Black people all over the world. We are not a minority — we comprise a global community.

In the pages that follow, you will read a variety of imaginings of Black identity and witness multiple renditions of the Black experience. You will see portraiture that illustrates the complexities of Blackness, as both an identity and a lived reality. While the book is loosely structured thematically, grouping contributors into broader sections of Blackness — Mixed Black, American Black, and Diaspora Black — these categories are not fixed. In fact, I created these sections largely for the sake of organization. There is much overlap and fluidity between these categories, and many of the contributors' backgrounds and experiences could easily position them in multiple categories simultaneously. Unless otherwise specified in the caption, all portraits in the book were created by Noelle Théard. Each contributor is identified by their name, current city of residence, and their answer to the question: "How do you identify? Racially? Culturally?"

It is my hope that this purposeful combination of portraiture and prose encourages each of you to envision multiple possibilities for Blackness above and beyond the one-drop rule. Perhaps if you *see* Blackness differently, you will see *Blackness* differently.

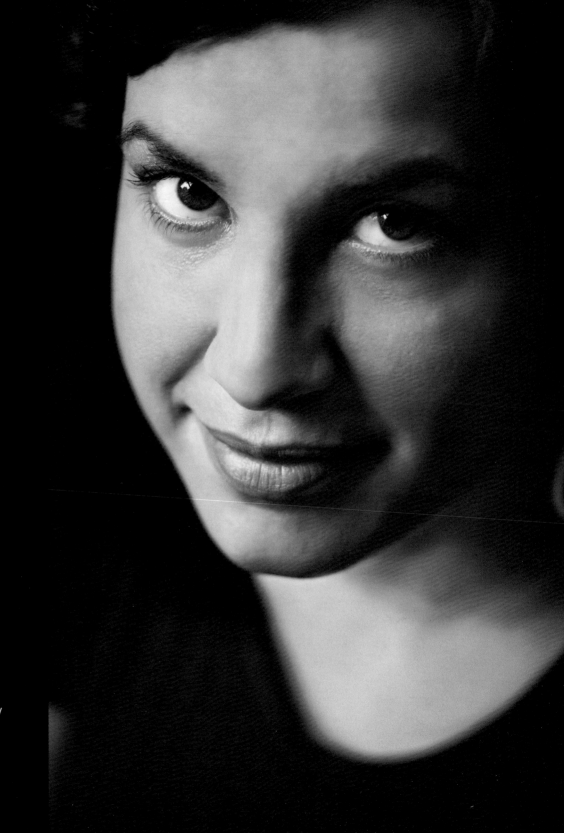

New York, New York. July 2013. (Ann Blake)

NOELLE THÉARD
Miami, Florida

"Haitian"

Photography has become such an important part of how we come to know the world. Portraiture in particular has a powerful pull because we as viewers are drawn into the eyes of the people photographed. Behind their eyes lives their truth. Their story. In creating *One Drop* and opening a dialogue about race and identity and skin color, Yaba knew that it would be important to pair imagery with words — to show so as to tell. When she approached me to be a part of the project, it was not as a potential photographer but as a contributor. But by the time my interview was over, we agreed that I should make the portraiture. Although my story is not presented here in the way that other contributors' stories are, who I am connects to why it was so important to me to be a part of creating this project.

In some ways I think that identifying as Black is a political choice; in other ways I don't think it is a choice at all. I was born in the border town of El Paso, Texas, which is 90% Mexican. Culturally, I grew up speaking Spanish. Growing up in a place where the large majority of the people were Brown, questions of race and ethnicity really didn't come into play. The norm was one that I fit into without having to ask or answer any difficult questions. I remember registering for school — I think it was the fifth grade. I had to bring in my birth certificate, and there it was, right in front of me: "Mother: Caucasian. Father: Negroid." That word "Negroid" is something that has always stuck with me. It let me know where I stood in terms of the history of the United States of America. In the context of my surroundings, looking like many of the people in my community, I probably could have denied or rejected it, but I honestly never had to address it. It really wasn't until I left El Paso and went to college in Austin that the lines became very clear to me. Austin is still a very segregated city, so I was immediately politicized — I was Black.

My father's mother was Haitian and German, and his father was Haitian, so he's what they would call Mulatto. The one-drop rule kind of works backwards in Haiti; one drop of White blood is enough to make you "Other" at the very least. But my father identifies as Black. I think his coming into a particular consciousness about race had a lot to do with his coming to the United States in 1963. He was of a lighter complexion, but once in the American context, it was very clear that he was a Black man. But then he married a French woman. A White woman. My mother. And so I came out even lighter

41

than him.

Being Haitian has always been an important part of my identity, but for me, the path to understanding what it means to be Haitian has been complicated. In the Haitian context, it seems absurd for me to identify as Black, especially since I don't look like what they would consider Black, which is what the majority of the Haitian population looks like. Like my father, I am considered Mulatto; and given the history of colonialism, as well as colonial violence in Haiti, my skin color is associated with privilege. So for many people, it doesn't make sense for me to identify as Black. I'm rejecting privilege — who does that? It is only in the American context that my identification with Blackness makes sense — the "one drop." But my racial identity is complicated by my cultural identity. Haiti is the world's first Black republic. It's the epitome of Blackness. In most minds, Haitian is Black. I'm Haitian; but to most, because I don't "look Black," I don't look Haitian.

By identifying as Black when most people would identify me with many other groups, I constantly have to explain my position and really try to engage the politics of that position. For me, identifying as Black has been more about politics than about skin color. It's about making conscious choices. In college, I studied journalism because I wanted to actively contribute to telling a different story about people of color. After college, I got an internship at the *Miami Herald* under the auspices of "diversity." I remember feeling uneasy about the fact that for them, my Blackness was an asset, one that could be accessed when necessary, when in reality, in my day-to-day experience, my Blackness was obscured, especially in Miami, where most people read me as White or Latina. That experience only activated my sense of responsibility as a Black woman even more.

I went on to earn a master's degree in African Diaspora Studies. Now that I teach, I am able to break down preconceptions of race by simply being who I am — a woman who could pass for almost anything, but one who chooses to identify as Black. For me, being Black is more about consciously identifying with what Blackness has come to signify in a political sense than it is about skin color or phenotypic appearance. For me, being Black is about being aligned with progressive struggle, so I understand the power of my choice and the responsibility that comes with it, especially because there are many people who would consider the very fact that I can choose to be a privilege. It's part of the reason why I've dedicated myself to social justice issues, particularly those that deal with race and representation: I co-founded a nonprofit organization that empowers Haitians to tell their own stories through photography (Fotokonbit); I co-produced a participatory photography initiative that taught photography to rent strikers so that they could document their living conditions (Galeria del Barrio); and now, I've collaborated with

Yaba to create *One Drop*.

In photographing *One Drop*, I had to take into account historical representations of race, including the legacy of anthropological photographs that reduced people of color to mere phenotypes — objects to be studied and looked at. Black photographers have traditionally worked against these stereotypes, and researchers, most notably Dr. Deborah Willis, have brought the legacy of Black photographers to light. What makes the images of Black photographers different is their subjects' sense of agency. Black photographers have allowed their subjects to pose, to present themselves to the camera in the best possible light. Inspired by this legacy, I approached *One Drop* as a collaboration, not only with Yaba but also with each of the contributors that I photographed. It was important that each contributor felt that they were in control of their own image and that they had some say in how they were represented. In thinking of the power of the portraiture to tell our contributors' stories, we decided that their gaze should be direct — that they should face the camera and look at us, the viewers, and directly challenge our assumptions about their identities.

The power of this project lies in its ability to incite conversation about issues that we are afraid to talk about. That the dialogue has the potential to be transformative stems from Yaba's willingness to begin with herself, to question her own assumptions and to create publicly engaged research that asks us all to consider what it means to be Black. Contributors, including me, were so willing to share our personal histories not only because we knew the importance of the project, but because somehow we knew that we could trust Yaba to tell our truth. It is my hope that the portraiture serves to affirm our truths while challenging others.

Mixed Black

One of the first interviews I conducted was with a woman I went to graduate school with. I remember very clearly that neither I nor any of my female colleagues took a liking to her initially, even though we hadn't yet been formally introduced or shared any conversation or interaction. We didn't know anything about her at the time, not even her name. It was just something about her. It was her vibes. She just seemed like one of *those* light-skinned girls — like she thought she was cute, too good to speak. Shortly before she graduated from the program, a professor encouraged me to connect with Danielle because of a paper she had written in his class, one that aligned with my interests in skin color politics. Shortly thereafter, a mutual friend introduced us. Much to my surprise, Danielle was "cool," and we got along fine.

Years later, as I began to identify potential people to interview for this project, Danielle was one of the first people I thought of. Although I did not know how she specifically identified racially, I assumed that because she enrolled in and graduated from the African American Studies department at Temple University, a program historically known for its resolute Afrocentric perspective, she at the very least identified as a person of African descent. What she shared about her background and experiences put everything I once thought I knew about her into perspective. She grew up in the middle of Pennsylvania in a Mennonite community, daughter of a White Mennonite mother and an African American father. In that community, it was painfully clear to her and everyone else that she was Black — so much so that she didn't have a lot of friends and was ostracized in school. Later, when she moved to Philadelphia to attend Temple, not only was her Blackness called into question, but she experienced a new type of ostracism: retaliatory pain inflicted by browner-skinned Black women. It wasn't that she thought she was cute or too good to speak. Quite the opposite — she would have loved to connect with us. But given her experiences, she in many ways felt socially awkward and felt the need to be cautious when entering social situations. We proved her right, and she proved us right. Or so we thought.

Like Danielle, a number of contributors are technically Biracial, with parents of two different races. Their experiences reveal that the issue of language is an important one. For some, the term "Biracial" obscures their lived experience as well as their identity. In Jay's (p. 54) estimation, the term "implies or buys into a concept of someone who's Mixed being half Black, half White in a way that doesn't really correlate with [the] experience of being a human being." Lena (p. 58), who is quite adamant about not self-identifying as Biracial, believes that in the global context, the term is "part of the machinery that seeks to divide and conquer oppressed people and marginalize and isolate people of African and

47

Indigenous ancestry." While the term "Biracial" is offensive for many, most contributors seem accepting, if not embracing, of the term "Mixed." For Jozen (p. 66), saying that he's Mixed is just "stating a fact, answering the question as it was asked." Culturally, however, he identifies as Black. For him, as for many other contributors, Mixed is not mutually exclusive from Black and/or African American, and some use the terms simultaneously and interchangeably to self-identify.

Whereas in the contemporary moment someone of Mixed-race parentage would be given the option to select "all that apply" or check "Other" and fill in the blank, in years past there were only two options: Black (Colored/"Negro"/Black/Afro-American/African American) or White. Adopted as an infant in the 1950s, and having grown up "in North Carolina with the Klan," C.B. (p. 70) didn't learn that his father was White until he was 12 years old; and still, for him, that didn't change his lived experiences as a Black man in the South. Born in the late 1960s to an Afro-Cuban mother and a White Australian father, María (p. 74), better known as Soledad O'Brien, was always told that she was both Black and Latina from a very early age — and from her perspective, her parents did her a "huge favor" in doing so. Perhaps this marks a generational difference — parents issuing their children's identity to them. Perhaps this was a simple necessity given the racially charged times.

Many Mixed contributors have had to face and address questions of belonging throughout their lives. While Perry (p. 82) recognizes that Whites may be more comfortable with him than they might be with someone of a darker complexion, from his experiences, White people are clear — "You're not us. You're Black." — and treat him as Black. Tigist (p. 86) has had a different experience in that she finds that she is more comfortable in White spaces. However, in African American spaces, she is often made to feel like an outsider; it is rare that other Blacks "see [her] as a 'sista.'" By the time Zun (p. 90) discovered that he was actually (biologically) of African descent, he was in his mid-30s and had been self-identifying as Black for much of his adult life. For him, identity was connected to a sense of home, and he had always felt "at home" in Blackness. Self-identification for many people of Mixed heritage is as much predicated on social realities as historical or genetic ones. And for many of our contributors, their Blackness was never an option.

However, as we will witness in more detail in the final section, Diaspora Black, when we examine Blackness in regions outside of the United States, we glean a different relationship between Mixedness and Blackness than what American history reveals. Elsewhere, being Mixed of Black ancestry does not automatically signal Blackness. Despite often being mistaken for White in the United States, in Jamaica, Deborah (p. 94)

is regarded as "Brown," a social (and class-based) category often regarded as distinct from Black. Ariel (p. 98) sees his Blackness as his choice — a conscious political choice, especially given that in his home country Cuba he could easily take on any number of identities, none of which would *have* to be Black. James Bartlett (p. 102) experienced cross-national differences in social/racial realities firsthand when he traveled to Ghana. Although he had often been mistaken for Puerto Rican or Italian at home in the United States, he had never been mistaken for purely White. In Ghana, where one is either Ghanaian or not, Mixedness is more aligned with Otherness in general and Whiteness more specifically, and thus most Ghanaians assumed that James was an *oburoni*, a White man or foreigner.

The space between their presumed identity and their self-identity is one that a number of contributors have had to consistently navigate. Kathleen (p. 110), who appeared on *The Donahue Show* in the 1990s in an episode entitled "Blacks who Pass for White," once imagined herself "trapped in the body of a White woman," but through a variety of life experiences she has now come to appreciate the "pale wrapper the Creator put [her] in." Mei (p. 114), whose mother is Asian and father is African American, remembers visiting the Whitney Museum as a child and receiving what would become her favorite pin — one that read "I never imagined wanting to be White," which captured her inner feelings perfectly. Brandon (p. 118) is often asked why he would identify as African American when he could easily "pass" as something else. In response, he says that he "live[s] by the words of Frederick Douglass: 'I prefer to be true to myself, even at the hazard of incurring the ridicule of others, rather than to be false and incur my own abhorrence.'"

What the narratives featured in this section reveal is that what it means to be of Mixed race is not at all the same for everyone.

DANIELLE AYERS

Philadelphia, Pennsylvania

"Black and Mennonite"

Race was never, and I mean *never*, discussed growing up. There was never a talk about "You have a White mother and a Black father. How do you feel about that?" Never. So it wasn't until college that I started thinking about it and feeling like I had to decide for myself. I had always allowed my surroundings to identify me. My small town didn't have many Mixed people in the early '80s. In fact, I didn't know any Mixed people growing up. I was Black because in a lot of ways, for a long time, I was the darkest thing a lot of these people had ever been around. It was my Blackness that made me stick out. It was very clear to me, and no one questioned it. It wasn't like, "Are you Mixed?" It was "You're Black!" And that was it.

When my father — the only person who was Black in my world — died when I was 13, I had no more access to Black culture. I remember every year growing up, a few weeks before Easter we got our hair micro-braided in the "big city." My dad took us there. My sister and I would be so excited. It took seven to eight hours to braid it in these little micro-braids. We would wear it for a couple weeks, and then my mom would take it out the day before Easter. And on Easter Sunday, every year, we would have our outfits on and our hair would be "crimpy." That was the only time of the year I felt Black. The only time. Because I had micro-braids, and that's what Black people did. And I used to be so proud at that time of the year. The dresses that we wore came from my dad's mother in Indiana. She would send them with matching socks and shoes. A lot of that went away with my dad. My grandmother was still very involved in our lives, but we just got older. We didn't wear Easter outfits anymore. We didn't get our hair braided. My mom didn't know where to go. She didn't think about those things and we didn't know how to communicate them.

I went to an almost all-White school — one of four or five Black kids in a fairly nice-sized school. I didn't adjust well. I wasn't accepted in school. And it wasn't the kind of racism that you can point to. No one called me names. I was invisible in a lot of ways. I wasn't acknowledged. So I didn't have anything concrete to explain, *This is why I'm hurt.* But every day I was hurt — I mean, destroyed. No one was mean to me, but no one was nice to me either. The one thing people did come to me for is if they had a problem with someone else. Because I was the Black girl. I knew how to fight, right? I always knew when someone was like, "I have to talk to you after class," it was because they had a problem

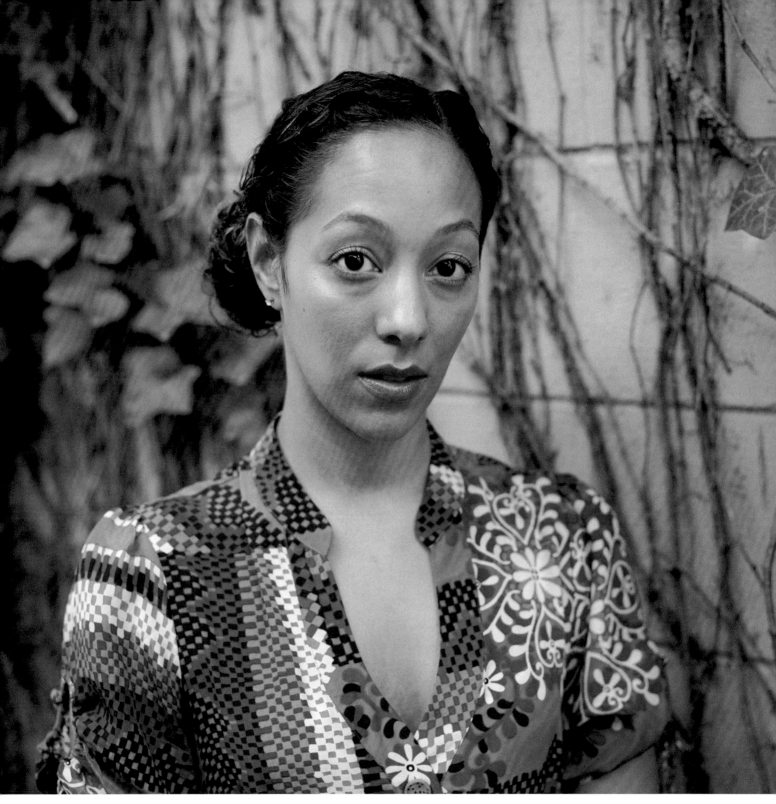

Philadelphia, Pennsylvania. July 2012.

with someone else and thought that I was gonna beat this person up. I had never fought. Ever. But what I quickly determined was that I didn't have to, because this other person also thought Black people could fight. So, all I had to do was have this person's back and go with them and confront the person, and they would be scared and that would be it. I thought that was gonna be my way to gain friends. And I was happy to do it if it meant a slumber party here or there or whatever. But it never resulted in that.

In 11th grade, I stopped attending high school. I just had no idea where I was and how I fit, and so I got stuck. I just stopped moving — like stopped getting out of bed. Diagnosed with depression. I wasn't suicidal; I just wanted to go to sleep. My mom convinced the school that I was mentally incapable of coming to school. So, they sent me a tutor — two days a week to my house for two hours at a time. That was my junior year. Two hours, two days a week. Senior year I only had to go to school a half day because I had enough credits to get out early. That's how I graduated. I had my mom pushing me to get a diploma and saying to me, "If you do not go to college, you will not get out of here. You have to go. Don't you want to get out of here?" That is the only reason I went to college. She told me this is how you get out. And so I left. That's when I started to feel like I needed to figure out who I am. Then my life began.

In the first few years, I went through all these experiences where people would ask me, "Well, are you Puerto Rican? Are you Italian?" And I was floored. I could not believe that it wasn't clear to people. The only times I've felt hurt by it is when I didn't feel Black enough. I started hearing, "Oh, you from Amish country? Oh yeah, you're not Black." Other times people just wouldn't believe me: "You're not Black." And even when I tried to explain that I'm Mixed: "That doesn't make you Black. Where'd you grow up? No. You're not Black." You know, people telling you you're not who you think you are. Joking, but very serious about it. And so I would say, "If I'm not Black, what am I? Mixed?" There's not enough identification in that to me. I started feeling not so comfortable saying I'm Black, and I had to decide what that meant to me and where I really fit. I ended up coming back to the same reality: No, I am Black. I just needed to define it for myself and be able to talk about it.

What brought everything full circle was when I took an African American Studies class in college. I realized I knew nothing. So, I decided during that class that I needed to think about not starting my working life right after graduation. I decided that I would do a master's in African American Studies and learn more about me. The reason why I'm happy today is because I did those two years of really learning about myself and being in an atmosphere where I was constantly feeling like I was doing me justice. It wasn't a short unit on Black History Month or a semester-long college course. It was two years

of soaking myself in the Black experience and reading and writing about it. And it really changed my life. It brought full circle everything that I felt up until that point.

More recently, I've started to be more curious about understanding the connection to the Mennonite part of my culture. I grew up in the Mennonite Church. My mom's family background is Swiss German Mennonite. I think of them as a village of people who do things a certain way, like the way they earn money and operate their lives. They are very insular in terms of how they live, but they don't exclude others from taking part in that. So, I grew up with a lot of those values and in that community. I think that my experiences, at least my healthy and positive experiences growing up, came from that community, because it's the only place where I didn't feel left out. The only place. And I've been understanding how that connects to my dad's side. His family is very much like the Mennonite community. So this is the first time I'm saying this, because I've always identified as Black, but I guess I feel more accurately that I am Black Mennonite.

I feel very comfortable in Blackness. I'm working on my Whiteness because I felt like it was holding me back from being comfortable in my own skin for so long. Now it's really important to me to embrace it. I may not feel White, but it is still part of me. And you can't deny any part of you, because it will eat at you. I sometimes wonder about people who identify as Biracial and say, "I'm not gonna identify as Black." Part of me feels like there's something that they're not opening themselves to. And maybe it's because they don't want to make it seem as though they're not embracing the other part of themselves, but I don't look at it as either/or at all. I know what I am. I know what beats in me. It's been a long road, but I'm now at a place where it's not something that's distracting, and there's no sadness in it. I had to let go.

LA BLOCK
Brooklyn, New York

"Biracial / Mixed"

Identifying as "Biracial" is something that's more recent for me. Growing up in Brooklyn, I went to schools that were almost all Black, and I was always the lightest one in my class. I always wanted to be darker because I didn't want to have to tell people that I'm Black. I just wanted them to be able to tell. So I felt like it was important for me to identify as Black just because I already look White. I always made it a point to say that I was Black. I wanted people to know that I was like them too. Then I went to a high school that was more diverse with different cultures and different races, and then it felt OK for me to be both. Now I say that I'm Biracial just because I think it's important to embrace cultures and I think the language of "Biracial" reflects everything that I am.

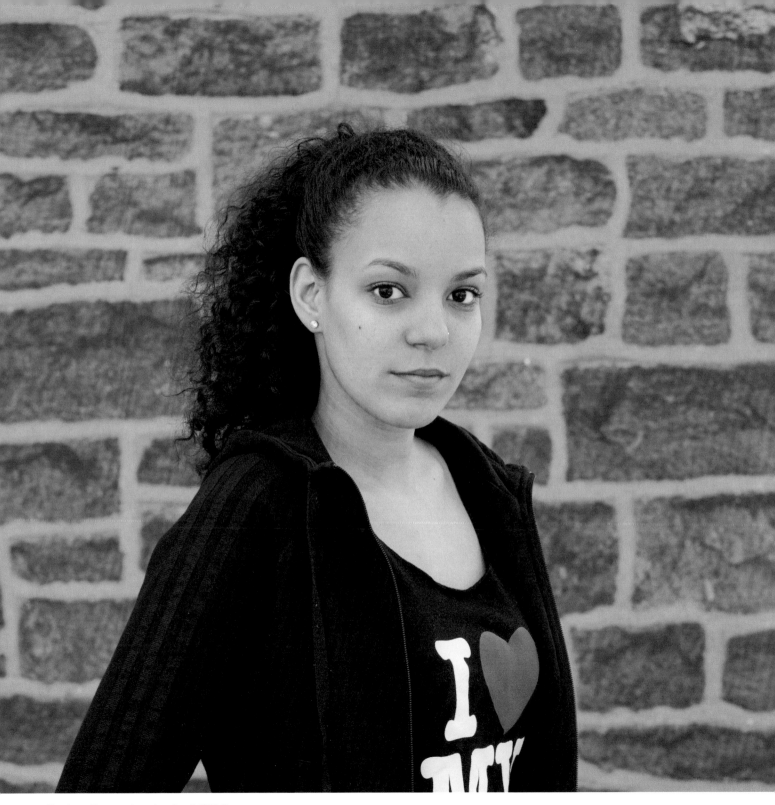

Easton, Pennsylvania. April 2012.

JAMES SCOTT
Atlanta, Georgia

"Appalachian African American"

My father was a very powerful force in my life. Although he, an African American, married my mother, a blonde-haired, blue-eyed beauty queen, he pretty much subscribed to the one-drop rule. And at the time, society was structured that way. It was clear that we were considered Black, and so we were raised Black and proud of it.

I grew up in Athens, Ohio. It's kind of a cultural oasis in the midst of Appalachia. I remember I had a best friend, his name was Rocky. We played kickball together. Then one day in the fourth grade, he was really distant. He didn't want to play with me, and we were sitting separately. The teacher says, "Rocky, why aren't you and Jim sitting together? Is there a problem?" He looked around and he said, "I don't want anything to do with him because he's a nigger!" Everybody turned and they looked at me. Suddenly I was outed. I was ostracized. I was different, and I was despised. And I was one of the better students. I was popular and I was a good athlete, but all of a sudden I was a nigger.

Somebody might look at me and question my Blackness or feel like I don't have the right to speak for African Americans because I don't look Black. They might even assume that I don't experience racism because of how I look. But I'll tell you, growing up, people may not have initially realized that I was African American, but I never tried to pass. I never denied who I was, but I didn't always go around advertising it either. I was just myself. I had White friends, and sometimes they would talk about something that was of a racial texture, and then I would speak up and identify myself as a Black person. I probably received more resentment than somebody who they would have known was Black from the beginning, because I had been invited into their confidence. They had trusted me as being one of them, and I had seen beneath the veneer of what they were really like. Suddenly I had betrayed them. So, I've felt discrimination. I've felt the shun of "You're not welcome here anymore" — very deep resentment towards me because I had found their secrets out. It wasn't that I was trying to portray myself as anyone different than I was. They just didn't know who I was, and that really bothered them.

I'm sure I've been mistaken for almost anything. Or maybe it's not even a mistake — because we must remember that in many ways, the racial classifications that came out of slavery are a Western invention. There are so many intersections in each individual's being that to define ourselves only by race is to exclude so many things.

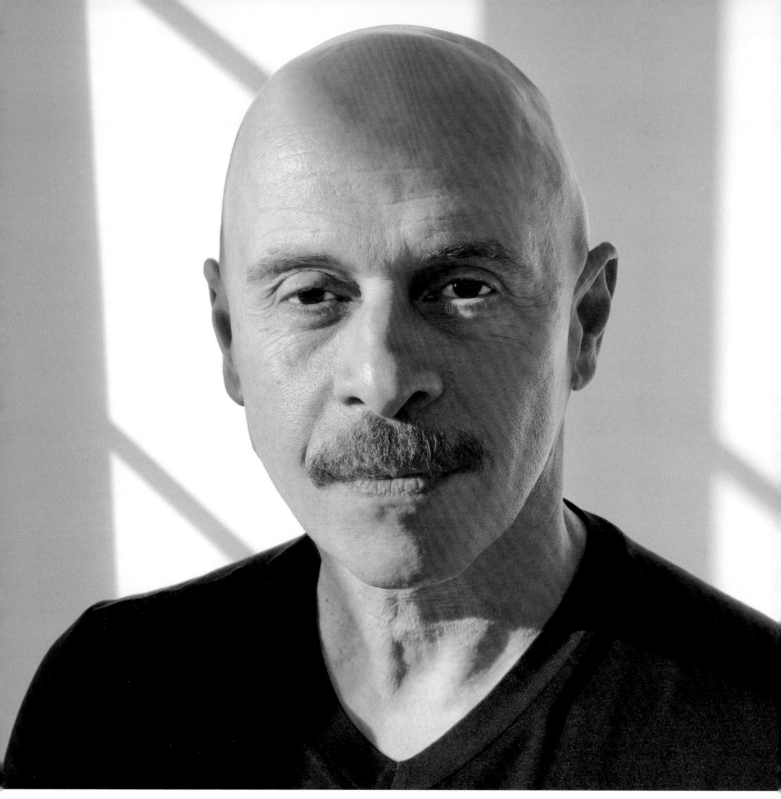

Atlanta, Georgia. December 2011.

JAY SMOOTH

Brooklyn, New York

◆

"Black / Mixed"

I identify as Black first and foremost, but also Mixed. Essentially, out of the many Black experiences, mine is colored, no pun intended, by being Mixed. I don't think of them as mutually exclusive. When people ask, I usually just say, "My father's Black and my mother's White," to avoid all of the other "What are you?" or "Where are you from?" questions. People can mean so many different things, and that usually just takes care of it. I'll tell you the facts of what my ancestry is; you can put whatever label on it you want.

I think a part of why it was always obvious to me to think of myself as Black was because I grew up in a big Black family. On my father's side of the family, I have a lot of cousins my age. My mom doesn't have a lot of family around. So it wasn't like I had a Black family and a White family. Plus, my mom is like a jazz person and she was pretty much always around Black people, so she's sort of culturally Black too. I can see where someone with my background with different circumstances might not think of themselves as Black, but for me there was nothing else for me to see myself as but Black.

I definitely don't judge other people for whatever term feels most natural for them. Like Tiger Woods. Everyone got on him when he said he was "Cablanasian," but if he grew up in circumstances where that's how he relates to himself, I don't see why he should be judged for that. It was like, "Why don't you just call yourself Black? Isn't it good enough to be Black?" Which I can understand to an extent. I feel like that's natural. But I don't think you can assume too much, especially as far as someone's self-identity. There could be so many different reasons from their own experience why they identify a certain way.

"Biracial" has personally never really resonated for me. To me, it sort of implies or buys into a concept of someone who's Mixed being half Black, half White in a way that just doesn't correlate with my experience of being a human being who's Mixed. I'm not split down the middle, dissected White and Black. It's just not what it is for me. And I don't have anything against "African American." It's just that it's seven syllables and kind of clunky. I feel like people hardly ever use it except when they feel obligated to as a formality. To me, "Black" just works onomatopoetically. It's very effective and it honors the particular culture that we have developed here. There's nothing but pride to be taken from our connection to Africa, but I don't think we need to legitimize ourselves strictly by that. There is a Black American culture that we've developed here, and that's what I

58

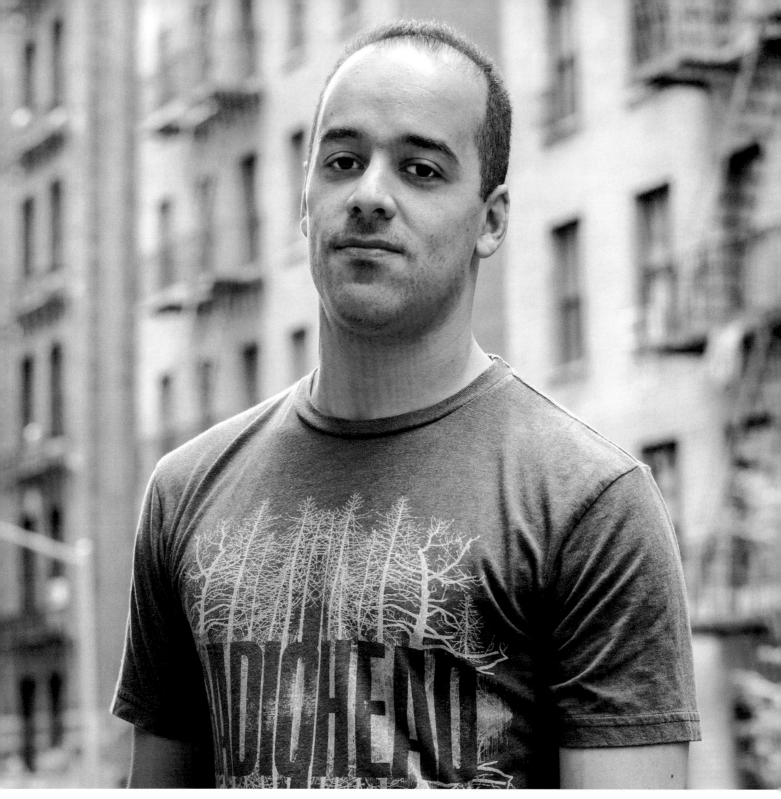

New York, New York. September 2012.

feel the most immediate connection to. So Black feels like the closest thing to who I am.

People have a wide range of initial thoughts about what I am from seeing me. Even if it wasn't verbalized, I'm always aware of that split-second uncertainty. And I never thought about this until I was thinking about having this conversation, but the question of how people perceive me when they get to know me is complicated by the fact that I've spent all of my adult life in the media, especially being on the radio since I was 16. So, throughout my life, I've been connected with people through them just hearing my voice. That's been a totally different experience. All of the uncertainty in that context is taken out. I think my way of speaking signifies Black, so people who get to know me through the radio have never thought to question it. A lot of times, whenever I've met people in person who knew me from listening to me on the radio, they'll say, "Oh, I pictured you like Barry White." I had never thought of it this way, but it may be that a part of the reason finding my voice in radio was comfortable was that it took that initial uncertainty out of my engagement with people.

I think that there are times that I enter a room and it doesn't initiate that "Oh, there's a Black person" process. I think the world is set up for White people to see themselves as the default category. Unless there's a compelling reason not to, they think of the regular person as a White person. They see me like, *Alright, he's a regular guy. He's White*. So I think it's true that there are circumstances where you could say I benefit from residual White privilege to the extent that I'm able to just blend in or be invisible or I don't set something off in people's minds where they're considering that I'm "the Other" and grappling with that in whatever way. I don't feel like that's a product of me trying to pass. But in most social situations, if the topic doesn't come up, I'm not gonna walk in the room and say, "Hey everybody, I'm half Black! Just so you know!" I mean, that would be weird. So, it just happens and there's nothing you can really do about that. If we're in a conversation and somebody says something off color, in a manner of speaking, a lot of times I'll just let that pass. I hear people say things that most Black people won't be in the circumstance of hearing. White people will commiserate with me like, "You live in that part of the city? There's a lot of Blacks in that neighborhood." I'm not gonna use my identity to play "gotcha!" on you right now. Whenever it's things like that, I don't say I'm Black partly because I'm enjoying the private joke in my mind of how they just played themselves. I just let it sit there. I don't say anything. And maybe I should take the opportunity to educate them, but I think as a rule, I don't think people of color should ever be seen as having an obligation to teach other people who are ignorant. It becomes problematic to act from the assumption that we're always supposed to teach everyone. I think you gotta pick your battles. This is an issue that's constantly in my life and in my

awareness, so it gets tiring. Any conversation I have, it's gonna be the thousandth time. I discuss it on the Internet constantly. Having that conversation with people, especially White people who are most likely to have just never thought about these issues before, is gonna be painful. It's gonna be 10 or 20 steps to get past before they're really hearing what I'm saying, because they've never thought about these things before. Defense mechanisms come up and so on, etc. I gotta really be in the mood to tackle this if I'm gonna tackle it. And a lot of times, it'll be an older person. I'm not gonna try and teach this 75-year-old woman in the line at CVS. They're a product of their generation. Let them live out their lives. It is what it is.

People who've never thought about these issues before will say things like, "Well, why don't you just be White since you could?" And it's hard for me to even articulate why that would never be in my mind as within the realm of possibility or desire. But for someone else who hasn't lived this, it's a natural thing to ask questions. That seems like an obvious question to me. I feel like a lot of people relate to the one-drop rule in a way that implies that it's taking away your right to avoid being Black. They often think of it from the exclusionary aspect of *You don't get to be White*. But to me, the converse of that is that it sets up Blackness as an inclusive category, which I think is a positive thing that's worth upholding and embracing.

Our concepts of race don't derive from science or anything, so there's always gonna be some subjectivity to it. How I self-identify and how people perceive me are two separate things. So someone else thinks, *Well, you're not Black*. This comes up sometimes with President Obama, that we shouldn't really call him Black. I don't even necessarily think someone is wrong when they say that, that's just how they perceive the issue. But that's a distinct thing from my identity and who I am. OK, you think I'm not Black. It's not even relevant enough to me for me to feel like I need to correct you or argue with you. I'm still who I am, and you can think of it however you want to think of it.

I think race is always gonna be one of the defining issues in this country and in this culture. As much as it seems like we always wanna reach the point where we're done with race, I don't think that's realistic or even desirable really. And by "we," I mean America in general. Instead of trying to move towards color blindness, we should be trying to move towards color clear-sightedness and be able to be comfortable with thinking about it and discussing it when it comes up, which is always gonna be often.

LENA DELGADO DE TORRES

Brooklyn, New York

— ◆ —

"Black Latina"

My mother's parents were from Jamaica and Cuba. My father was from Spain. But I am not Biracial. I am a Black Latina.

The identity of "Biracial" makes no sense to me. It implies that two people of two different races reproduced to create a hybrid person, and that's a very biological understanding of human reproduction. It's the latest manifestation of White supremacy. In the post-Reconstruction era, it became necessary to isolate the Black community in order to maintain White supremacy. The one-drop rule, for example, was an effective way of imposing segregation since White people outnumbered Blacks. Nowadays, however, census predictions indicate that Whites will be the minority at some point in the future, and Blacks, "Mixed-race" people, and Latinos will be the majority. So now it's convenient to create a whitened category for Mixed-race people and for Latinos that is decisively not Black — Biracial. The Biracial category is simply another attempt to consolidate White supremacy. It is all part of the machinery that seeks to divide and conquer oppressed people and marginalize and isolate people of African and Indigenous ancestry. So, I would never identify as Biracial. It's devoid of cultural resonance, and what's really at work in human life is culture. I identify as a Black Latina, not only as a way to encapsulate all of my cultural identities but also as a conscious rhetorical and political move.

When I was growing up, my mother taught me that I was neither White nor Black but in the middle — "Mixed." I suppose she always felt that she too was in this middle position, unaccepted by either side. When I started elementary school, I was stuck in the middle to a certain extent. Black kids used to say I was White, and the White kids used to ask me what I was, Puerto Rican or Black? I tried to stick with the Mixed-race identity, but as I matured through high school and college, it became more difficult. Finally, when I got to college, one of my friends was just not having it. We were sophomores in college, about 19 years old. We used to have long discussions about racial identity in our dorm rooms, and I used to stubbornly claim this Mixed-race identity. She's also light-skinned like me but identifies unequivocally as "regular Black." I remember her screaming at me at the top of her lungs, "But you're Black!" And I remember being terribly confused. *What am I?* Then it all came together for me the summer after sophomore year when I went to visit my mom and I found these records by Mongo Santamaría, an Afro-Cuban artist. It

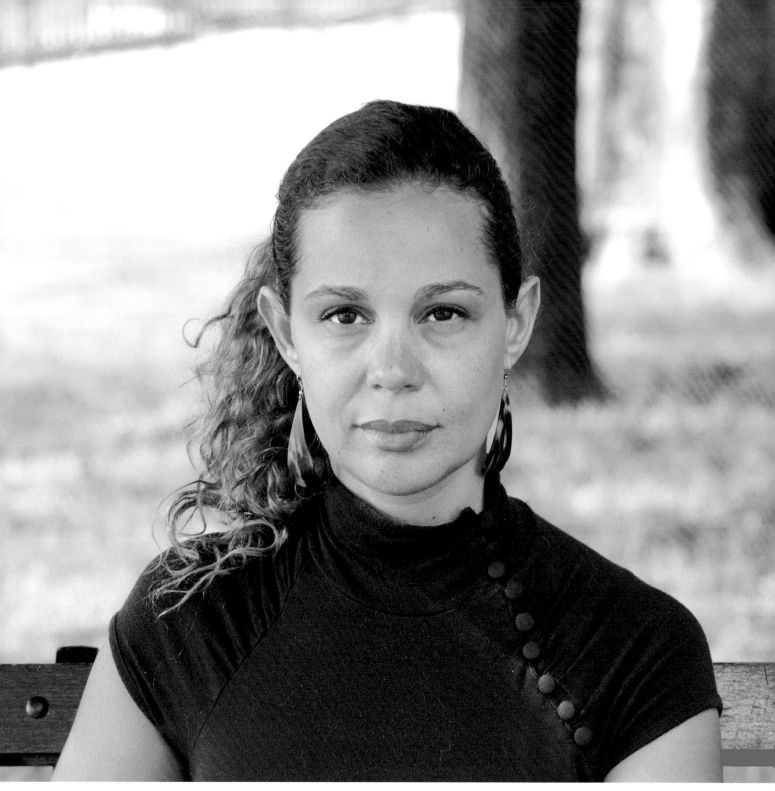

West New York, New Jersey. September 2011.

was just straight drumming, and that's what made me realize that there's this link. This is African. And that then helped me to make the connection to myself, my ancestry, and my own identity, and I was like: *Yes, OK. I'm Black. That's what I am.*

Later on, I was able to work through a lot of these identity issues in my academic work. I did some research on *mestizaje*, or miscegenation, and that helped me to embrace more of a Black identity. There's a historical reason why people are more mixed in Latin America. It was essentially planned, and that plan was called *blanqueamiento*, or whitening. In Cuba, for example, during the late 19th century, nationalists such as José Antonio Saco suggested government subsidies be put in place to encourage immigration from Spain and the Canary Islands with the goal of having White immigrants reproduce with Black slaves in order to create a whitened, non-slave labor force. The Spanish conquistadores and slave owners had a long legacy of sexually preying on Indigenous and African men and women, and a "Mixed-race" population grew very quickly very early on. So biologically, Latin America has been whitened for hundreds of years. From this framework, miscegenation is understood to produce a whitened identity, and "mestizo" is just code for White, or non-Black. Many Latin Americans have reclaimed this term and transformed it into a resistant identity. But for me, once I saw the history of this Mixed-race identity and where it comes from, I just completely rejected it. At least the Whitened version of it. If anything, if I'm going to embrace any aspect of it, it's going to be the more Blackened history, the African or Indigenous part of that identity.

Every single person questions my Blackness. Whether it's here in the United States, whether it's in Jamaica, whether it's in Cuba. People just laugh when I say I'm Black. "You're not Black!" I used to get really angry and get into fights with people, especially in Jamaica when they'd be like, "White gyal!" In my own mind, I thought that I blended in perfectly, but it became clear over time that my image of myself was dissonant with how people see me. And that's always a strange feeling. Black people, Black men especially, try to cast me into this White woman position. They might expect me to be their "White girl," with all that goes along with that. You can pimp a White girl. A White girl will let her man get away with anything. These are the kinds of stereotypes of White women that some people believe, and I certainly don't want to be forced to carry that baggage. I don't want to be used as the cream and sugar in any man's coffee — or his bloodline, for that matter. I don't want to be put into the position of being the White benefactress for anybody. But I don't really fight with people about it anymore. I just make sure that they understand where I'm coming from. I'm very careful to point out that I am not a White woman because I don't want them to be disappointed when they figure out that I'm a Black radical and a Pan-Africanist. So at this point, I take it all in stride. I don't take

offense. I can't really be bothered anymore, otherwise I'd end up going crazy.

While there are obvious advantages to being light-skinned, there are also disadvantages. People will say, "Oh, it's so easy for you." And it's really not. Just because you have light skin, it's not automatically so easy. Don't assume that just because someone is light-skinned that they're privileged. Or that they're going to think a certain way or be a certain way. It's about your culture and your politics. Your values and your ideology. That's what really determines who a person is and how they live their life. It has to do with how willing you are to tow the line. How willing you are to cross over to that other side and claim that Whiteness and that privilege. And I'm not willing to. I could have just married a White man and had White children, and the whole *blanqueamiento* project would have been complete. But I didn't choose that path for myself. This is my choice. And I know that in the context of White supremacy, having that choice is a privilege in itself. Darker-skinned people don't have that choice, and we have to acknowledge that. But at the same time, I'm clear that White supremacy works to shut us all out. Having just a drop of Black blood is enough to cause your rejection by the larger White society. We should be uniting instead of allowing the system to divide and conquer. We were all colonized and enslaved by the same White Europeans. So, telling me I'm not Black — what's the point of that? How is that strengthening Blackness in any way? If anything, it's divisive. You can't deny someone their ancestry.

JOZEN CUMMINGS

Harlem, New York

◆

"Mixed"

I tell people that I'm Mixed. That's the first thing I say, because people probably wanna have a conversation, and that's my way of gauging how interested they actually are in wanting to know what I am. By saying I'm Mixed, I don't feel like I'm shunning other parts of me. Not at all. I just feel like it's stating a fact, answering the question as it was asked. Then they'll usually ask me, "With what?" and I'll say I'm Puerto Rican, Black, and Japanese. Then they'll say, "Well, how's that work?" Usually they're shocked by the mixture — like how in the world does that work? To me it wasn't an unfathomable thing. A Puerto Rican and Black guy meets a Puerto Rican and Japanese woman, and they have a baby, and that's me.

I learned I was Black very easily when I was reading an illustrated history of Dr. Martin Luther King Jr. and the civil rights movement and I saw a picture of a fountain for Coloreds only and for Whites only. I knew I was Black, but I'm looking at my skin and thinking, *Hmmm*. So I asked my mom, "Mom, which one would I … ?" And she said, "You're drinking out of the Colored one." I always knew that I was Mixed, but culturally I identified as Black, and that was never tested. I grew up in Seaside, Calif., and all of my life it was a Black city. It's not so Black and White in California. It's not just about race — it's about culture. I grew up seeing Samoans and Filipinos act no different than Black folks, so I never felt like an outsider.

When I got to Howard University as a freshman, I was confronted with a lot of questions about who I was and what I was — a lot more than I ever thought I would be. I always joke with people that Howard is Blacker than you think it is. It's *really* Black, so my authenticity was often questioned. "What are you?" came at me 100 miles per hour. So many times. More times than I had heard it in my life. I would just say I'm Black and just look at people like, *What do you wanna say? What do you wanna do?* You're not gonna be able to do or say anything that makes that wrong because (a) that's not something for you to determine, and (b) that's a fact. That's nothing that you can really contest. I remember being so frustrated about it, complaining to my roommate, and he was like, "Dude, what do you expect? Get over it." And that was funny to me because I didn't have a counterargument. Later I met this cat named David who is Black and Mexican and looks as Mexican as anyone who says they're Mexican. Of course, we found each other. He

Harlem, New York. April 2013. (Zun Lee)

was older and he told me to just take it. He said: "People are gonna ask you questions, people are gonna say things, and you have to understand that's part of how we are as Black people. Once we get into a situation where we're the majority, we will make other people feel like the minority, and you will have to just deal with that the best way that you can." I don't think that that meant that I was gonna be a social outcast, and I certainly wasn't a social outcast, but it did mean that I was going to get the questions. And I got those questions all the time, and that was something that I learned to laugh about and to eventually be OK with in ways. Because people don't know. I believe that if there is such a thing as looking Mixed, I look Mixed. But once people got to know me, once people actually talked to me, they realized that my looking different didn't necessarily mean that I was different.

Black people are only 12% of the population, right? And we don't really have enough people out there speaking for our vastness. I get that. But that doesn't necessarily mean that you have to work so hard to put yourself on the inside. It took me a long time to realize that, because for a while I wanted to be accepted as Black. It's like the Tupac line: "I remember Marvin Gaye used to sing to me. Had me feelin' like Black was the thing to be." I wanted to be *that* Black. I wanted to be the Marvin Gaye Black. I wanted it hard because it was gonna make my story of coming up all the more sweeter. And I think a ton of Black folks identify with that struggle. I struggled, but I don't think that my struggles necessarily have to be because I was Black. And I've been thinking about that for a long time. Like doing an essay of sorts about never being called nigger and what that's like, and how I just have to get used to the fact that I probably will never be called a nigger. I don't have the experience of that kind of pain, but that doesn't mean that I don't have the experience of being Black. It just makes for a different kind of Black experience, and I'm OK with that now.

I'm at the point now where I like the questions. The only alternative is you making assumptions. I would rather people ask me than not ask me at all. You also have to understand the asker. Who's asking the question? Why are they asking the question? It never comes from White people; 90% of the time that I get that question it comes from another Black person or a Latino. I'm so comfortable in my own skin that when I do go up to people and I talk to them like anybody else that's come up to them and talked to them, they're always kind of taken aback. Like, *Why is this dude so comfortable? What is he?* A lot of times with Latinos it comes up when they try to talk to me in Spanish. Because I don't speak Spanish, they'll usually be like, "Well, what are you?" And then when I'm around Asians and I'm saying something that I can relate to or talking about my Japanese grandmother, that's when they'll be like, "Oh, I didn't know." To me, this is the beauty

of being Mixed — I can move in different worlds and pass in a lot of places, in New York City especially. I can talk to a lot of people and have these conversations as people, as humans. And for me, I think that I'm trying to find a way to do that in a way that I haven't before. I'm not trying to identify less as a Black person. I'm definitely not trying to disown anything or distance myself. I'm actually trying to be more a part of something. I'm just really trying to figure out how I can be a person of this earth — of this world, of a truly global community — and take my Blackness everywhere, because I'm not just trying to do it in a vacuum of other Black folks. I'm trying to be around as many different people as I can and present myself as the person that I am. I'm not trying to be different; I'm just trying to put myself in as many situations as I can in which I can be authentic. My identifying as a Mixed person is essentially me trying to identify as a person of this world across all walks of life.

You can have all the pride in this world about who you are and you can even let that dictate how you identify, but if you want people to take you seriously as a person, you have to be able to relate to folks and not come at folks like, *I'm Black. And you are what?* OK, *now let's have a conversation in this way because the media tell us to.* No. When I talk, when I express myself, I don't know what you're gonna think that I am. I don't know how you're gonna put together the way that I communicate with the color of my skin. It's probably gonna prompt you to be like, *What are you?* And I don't really care about what you think I am because I realize that there's no controlling that 100%. But if you're talking to me, we're not gonna let what I am dictate how we interact. We can let who I am dictate how we interact but not what I am. I want us to get past that surface-level conversation and talk about who we are as individuals.

There's nothing wrong with talking about race, but when we're talking about race, what are we really learning? I want to talk about culture because I think that's what makes us people and that's what brings life to all of us.

C.B. CLOUD

Dover, Delaware

◆

"Black"

I could have grew up in different surroundings and identified a different way, but it just so happened that I ended up with a Black family. My mother was Black, but my father was White. In those days, when I was born, my mother's father felt that he couldn't have me in the house because of pressure he might get. I don't know if he was thinking about the Black people in the neighborhood or what White folks was gonna think with this White baby running around. So he made her get rid of me. And it just so happened that the people next door said, "Hey, we'll take it." I could have easily lost my life if I had not been adopted. At one point, my father was coming to the house and was asking to take me. Had he taken me, I'd have been a different person altogether. I'd have grown up in a White surrounding. But Mama said, "No, I got him. I'ma keep him."

Now, as I understand it, things started happening because this White guy started coming by the house. They asked him what was going on and it came out that he had raped my mother in the church. My mother's mother worked there as a cleaner. So when she got to be 16, she started going with her mama to clean the church. After a while, she finally broke down and told them what this White man had done to her. She couldn't say nothing because she knew this was gonna hurt her mother, gonna hurt her family. So once that got out, his father, the White Catholic priest, was asked to leave town by the Catholic clergy. But even after he left, he would still call her just to see how I was doing.

My mother didn't tell me what happened to me as a child with my birth and adoption and all of that until I was 12 years old. But in the neighborhood that I grew up in, the people around the corner were my cousins. They knew, and I didn't. The kids that were my age knew. And it was a thing where some of that was brought down on me. "Hey, there's the White boy!" or "Come here, White boy!" And the names they had for me, I didn't know why they were doing that. I couldn't figure it out. I knew I was a little different than them, but that's all the people I ever knew. So when my mama finally told me, then it made sense. That was kind of shocking. At first, I couldn't understand why she didn't tell me. But I can't blame her; she wanted me to fully understand why.

I really didn't know how to react, to tell you the truth. The first realization that I had of the situation itself, I think I was probably about 15 or 16. It was a misperception of the whole thing, but the way it struck me was that my mama didn't want me. So I broke

Dover, Delaware. September 2011.

down and started crying. It had to be like a year or two where I just went through this depression. Thinking that my mama didn't want me, my grandfather didn't want me, my whole family didn't want me and they just put me off on these other people. But as I got older, I kind of figured out that my granddad didn't have the best education in the world. He'd been in this thing all his life dealing with Blacks and then having to deal with the White folks that he went to work for. And knowing how things would sometimes happen that the White folks would do to us that you couldn't explain. He was actually afraid for me to be in the house. He was actually afraid that something was gonna happen to him or his family, or the White folks was gonna come around and do this to him because he had a White baby in the house. I couldn't fathom that, but back in those days, that's all he knew.

In the place that I grew up, there was White only, Black only. That was visible to me as a child. I grew up in North Carolina with the Klan. And the more and more I understood it, the more and more I rebelled against it. And not only that, but in those days, in the section of town that we grew up in, we really had no need to go over to the other side of town. We had everything we needed. I went to school at a all-Black school until I graduated. Never knew nothing about integrated schools. Never knew nothing about going to school with White folks. When I went to college, they was all Black at Albany State down in Georgia. There wasn't no White folks down there. I didn't know nothing about that until I got to the military. So, I was full of Blackness. And then, you know, we were going through all those times, the civil rights times. When I was in school I used to work for VISTA. We would actually go out to rural areas and round up Blacks and let them know where they could go to vote and what they needed to do. We were actually run out of places by the Klan. But I can remember people asking me, "Are you White or what? Did the VISTA people ask you to come out with the Black people to do this?" I said, "No, I'm Black too." But other than that, for the most part, in that context, when things were segregated White/Black, it was clear for everybody else that I was Black.

Throughout my life, though, a lot of people have said, "You mixed with something." I think visually, people see me as Hispanic. But then when the name follows — Cloud — of course, they think I'm American Indian. But I'm neither one. Don't too many people know my story. Matter of fact, I was ashamed to tell the story until I was in my 30s. I was just ashamed of how it happened. Some of it was what I had felt before about my family not wanting me. Some of it was about how I came about with the rape and all that. Some of it was just the whole White thing. So whether or not I told the story had a lot to do with what I thought a person could handle. I would tell them that I was Cherokee and that's how I got my color, that my people were Cherokee. My mama, the lady that adopted me, was actually my color, and she was a full-blooded Cherokee. And my dad, who was

probably a reddish-bronze, was a full-blooded Cherokee too. That's how I got the name Cloud. My birth name was Brimmage.

If I had wanted to, I probably could have passed. But I would have had to change my whole demeanor, because my background wouldn't allow for it. I'd have to change the way I talk, the way I carried myself. But I know a couple people did tell me, "You know, man, we thought you was White." And at times that's what made me feel as though I needed to go out of my way to be another way. To overly compensate. To make people really, really understand that I'm not White or that I don't feel like I'm better than anybody else because I am light-skinned. But I'm at the point now where I don't care what you think. It don't matter. And that definitely came with age and experience. At some point you realize that you can't please everybody and that's what you were trying to do. *This guy thinks I'm this. What do I need to do to change his mind?* Back then, maybe I'd bop a little harder, talk a little rougher, do whatever I thought maybe would change his mind or make him realize I am Black. But now I ain't gonna change his mind. He's gonna have to take me as I am.

MARÍA DE LA SOLEDAD TERESA O'BRIEN

New York, New York

◆

"Black / Latina"

People ask me, "What are you?" all the time. People tweet me that question. I used to take great offense, like immediately get annoyed, partly because I didn't think the question came from a very good place. I think I read it as questioning my value and my reasons for being wherever I was. But now I think it's twofold. One, I think that because I'm a journalist, people are really just trying to understand who I am. *You're somebody I see on TV, but I don't know you in person, so who are you?* So often, it's not really about the question. It's about *What side are you on?* and *What perspective do you bring?* Then two, I think that part of my job as a journalist is to educate people about stories, and some of these stories I'm a part of. I'm part of *Black in America* even in the context of who is the filter of the story. So, I've really gotten much better at taking that question, and I've stopped hating it so much. It's my job to elaborate and explain for people who I am. My mom is Afro-Cuban. My dad is White and Australian. I'm Black. I'm Latina.

When we first did *Black in America*, my identity was definitely called into question. Not only "Who is she?" but "Why is she doing this?" Which is funny because when Christiane [Amanpour] would do a documentary on North Korea, no one ever said she's not North Korean. And we actually have a Korean reporter. But no one felt like Christiane shouldn't be doing a documentary because she's Iranian American. But I think, again, this was an indication that this is different, isn't it? Brittany Spears gets out of a car, no underpants on. White people everywhere do not say, "Oh my God. I'm so embarrassed for us. Can you believe what Brittany is doing to us?!" They say, "That poor girl, I hope she gets help." But I remember as a kid, when a serial killer would be on the loose, my mother would literally say, "Lord Jesus, I hope he's not Black." Because there was a sense that the race of the person would affect us, would impact us as one of only two Black families in our community. White people really have a luxury in that they get a range of stories, that they're not defined by five stories. So, I think that the difference with *Black in America* was that the filter did matter. That there are only going to be five stories, and we want to know exactly who you are and what your credentials are to be telling our story. And I understand that.

People have stopped me in the airport and said, "What are you? Are you Black? My friend said you were Black, and I said, 'She's not Black!'" Other people would say,

74

New York, New York. March 2012.

"You don't look Black." OK, so color determines your race? Really? I can name some civil rights legends who are light-skinned. They're not Black? Or they'd say, "Well, you know, I never thought you were Black until you did Katrina, and then I thought you were Black." And then someone else would say, "Yeah, but she's married to a White man." And I'm thinking, *OK, so does that make me less Black? And how in your mind does that math work? You get points for who you marry and you lose points for where you live and how you speak? There's a certain number, and if you get below that number you're less Black?* I don't mind these conversations because they're illuminating and they really open up a conversation about race. I don't think you can do documentaries and opt out of the conversation. The same thing happens with *Latino in America*, but the bar is "Do you speak Spanish?" So, it was a very similar issue, like: Are you really Latina if you don't speak Spanish fluently? I really thought it was all a very interesting debate, even at times when it got very personal. People would put pictures of my kids up online and then circle the ones they thought were "ethnic-looking." One very famous African American woman said to me, "I'm so proud of you for not trying to pass," which I just think was such a heartbreakingly sad comment. And I've had more Black people say that to me than White people. I've never had a White person say, "Oh, wouldn't it be easier if you would just tell everybody you were White?" Only Black people tell me that. But I get it. I really get it. I don't think that the people who tell me that are particularly self-loathing people at all. I think that they look at it like the reality is for what I'm trying to do — it could be expedient, which I also think is inherently sad. But then they look at my hair and say, "But your roots — your roots would give you away." And that's true, in more ways than they know.

Up until I was doing the first *Black in America*, at the age of 41 years old, there was no conversation about whether I Black. The first conversation I had en masse about what I was, was really in *Black in America*. By then I was set. It wasn't a conversation I was having at 13 and 15 and ages where you're more malleable and you sit around and try to figure it out. There was no figuring out. I was Black. I was Latina. My consciousness about race was really implanted in me by my parents. I grew up in an all-White neighborhood, and my parents, as part of their protective mechanisms that they were going to give to us, made it very clear what we were. My mother would say, "Do not let anybody tell you you're not Black. Do not let anybody tell you you're not Latina." And I remember thinking, *She's so crazy. We're in Long Island. Everybody's White! Nobody's saying, "You're not Black!"* We stuck out! Back then, I thought her comments were so weird, but now I understand what she was going for. I am very grateful to those conversations because I think it implanted in our heads the perspective that my parents wanted us to have.

That encouraged me to really start having early conversations with my own kids

about their race. They're little, so they're not the most thoughtful, in-depth conversations, but we are absolutely having those conversations about race. It's a similar conversation as to the way I identify: I'm Black because my mother's Black, and I'm Black because my parents said I'm Black. My kids are Multiracial, and I tell them that they're Black. They're Black because their grandmother's Black. They're Black because their mom's Black. And we kind of go through it like math. I tell them, "You're Black, but because your dad is White and your grandpa's White, that means you're gonna look White." But what does that mean exactly? Because the little ones are 7, it can get very complicated, so that's about as far as we can get with that. But my kids will tell you, "I'm Black 'cause my grandma's Black," or "I'm Black 'cause my mom's Black." I meet a lot of kids who are Biracial who everyone is sort of like, *Well, you can pick*. And I get the sense that they don't feel like they're connected to anything. I think my parents did me a huge favor by saying, "This is who you are," when I was a kid. That was a great identity to glom onto and then grow into and understand.

I think you can be Mixed and Black. People often ask me, "Are you Mixed or are you Black?" Technically, I'm Mixed — I have one parent who's Black, I have one parent who's White. I identify as Black. I had a good friend in college who on paper had the same racial makeup as I did — her dad was Black, her mom was White. A girl who looked like me. And people would say, "Oh, you're Black?" And she'd be like, "Nope. Absolutely not." I never felt like it was up to me to take it a step further and say, "Well, you're denying your ..." I generally don't care. My thing is, *If you say so. You look Black to me, but if that's going to be your thing, OK*. The onus is not on me to call it as I see it. I don't really work to categorize people. I'm not about defining people. I like people to define themselves as they are. Sometimes I get the feeling that there are certain people who feel like they want to define Black identity. But they can't. It's a very wide identity, and those who try to confine it do so at their own peril because the demographics are changing. People are trying to hold on to these identities that are just shifting. Who's Black? Who's Mixed? Who's not? What does it mean to be Mixed? Those are all very interesting sociological conversations that I'd love to be a part of with a glass of wine and three hours free to BS with my friends about what it all means. But at the end of the day, I don't think you can come to a definition that is a reasonable definition. Any definition that limits you is inherently flawed.

ANDREW HOLMES
Coral Springs, Florida

———◆———

"Black"

I've never been put in a situation to have to think about how I identify. I don't exclude my Biracialness. I fully embrace my Caucasian roots, just as I do my Jamaican roots. When I'm at home and I'm looking at my mom and my dad and my siblings, I don't necessarily see a Black family or a White family — I just see my family. Some nights I have corned beef and cabbage, some nights I have curry goat. I never saw it as anything different, and it was never anything that I had to question or think about. But if there's a need for me to bubble in what I am, there's no hesitation — I bubble in "Black." That's just how I feel. I'm definitely not a White guy. People don't look at me and say, "Hey, look at that White man!" I'm excluded from Whiteness. Do I feel like people look at me and say, "Hey, look at that Black man"? No, but I feel like my identity is more Black than it is White.

Honestly, I don't think Blackness is something that you can define verbally with words. It's something that you are. And it's funny, because people will be able to tell you if you are or if you aren't. You don't have to say it. It's not the lingo or the dialect you use or even the accent you have. Either you're Black or you're not. It's something that's earnest and something that can't be faked into. It is what it is. Blackness is an inheritance. It's something that you don't have to work for. It's something that you're born with. You can tell people who have inheritances because they drive around in nice cars, their parents left them a lot of money, they don't have to work for it. And I think it's the same thing for Blackness. People can tell what it is and who has it by just the way that they are.

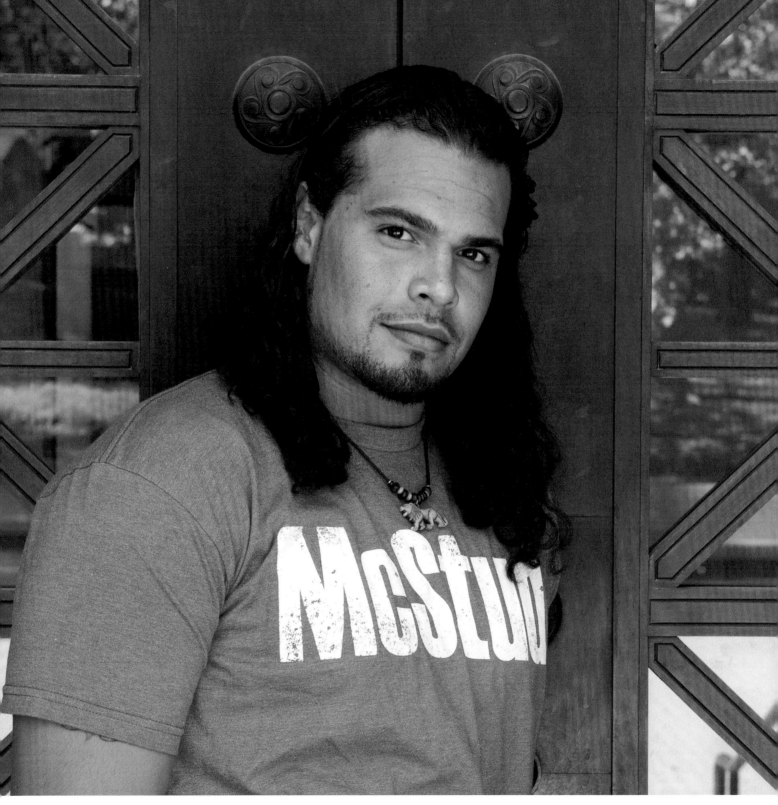

Easton, Pennsylvania. May 2012.

JOSHUA BEE ALAFIA

Brooklyn, New York

———◆———

"Mixed / African American"

Racially, I identify as Mixed because my father's African American, my mother's European American, and they both have Indigenous ancestry. Culturally, I identify as African American, because whereas the African American community is more of an open community that will claim me in being Mixed, the White community will never accept me as being White. So I wouldn't even think of it. Never. Most people assume I'm Latino. Caribbean. They rarely think that I'm African American. I've been mistaken for Middle Eastern. Every once in a while people think I'm Black and Asian. In Cuba, they would call me *Chino* but they thought I was Cuban. Same thing in Brasil. Until I open my mouth, they just think I'm Brasilian. A lot of places are like that. But when I went to Tanzania, folks were breaking my heart thinking I was straight-up Italian. When I was in Ethiopia, I got "Are you half-caste?" All the time. A couple times in Jamaica, I even got "White man." And that hurts. So, it depends on how people's eyes perceive. You can feel like you're Black as night on the inside but still be perceived as Other on the outside.

I think because I've always felt so alienated from any mainstream group, I've never felt like I needed to perform to make people know that I was Black. I've never felt like I've had to explain my Blackness. I remember in college, I really was digging this sista, and she was like, "Well, I don't date light-skinned dudes!" And I was like, "Damn. Why?!" She said, "Can you imagine if I married some light-skinned dude and then I'm like the mammy of the family?" And it kinda broke my heart. She was not trying to receive me, and just on my color. That hasn't happened a whole lot, but even within myself, I remember feeling more attracted to darker-skinned women, thinking in my own genetic-minded way that I would be lightening my progeny if I were to get with a light-skinned woman. Like I would water down the Africa. There's a very Afrocentric voice in my mind that at one point made me want to embrace Africa on a level where I wanted my children to be darker than me, where I wanted to really strengthen the African bloodline in my progeny. That played out in my choices of relationships to a degree. And it's self-hating. It is. To not embrace a woman who's a physical reflection, who is of your own ethnic mix, who's light-skinned? It's self-hating, but it's still a concern. It still affects choices to a degree. But I'm also at a place where the love has to be deeper than the surface.

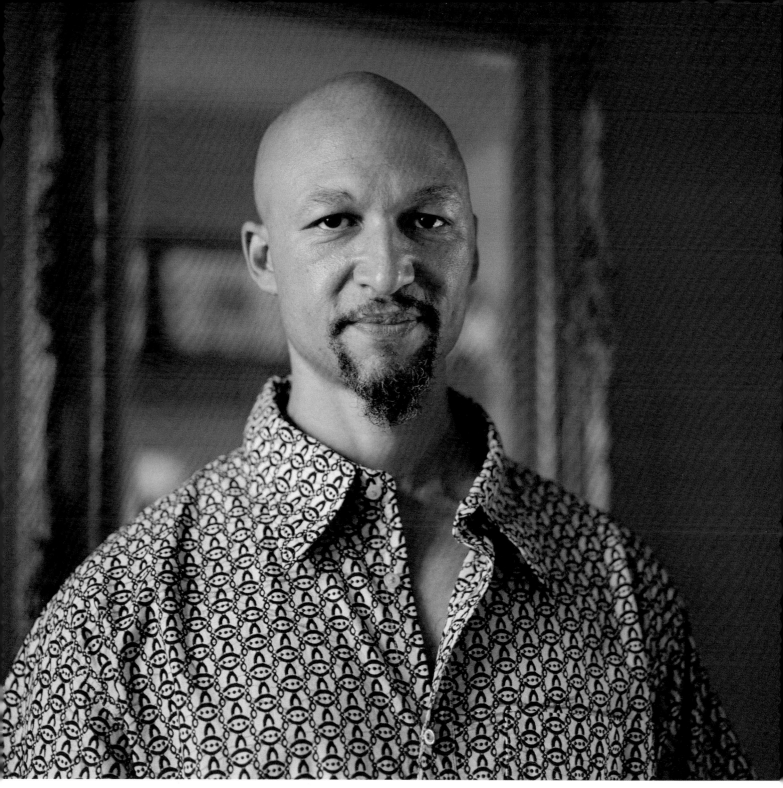

Brooklyn, New York. July 2011.

PERRY "VISION" DIVIRGILIO

Philadelphia, Pennsylvania

<center>◆</center>

"Black"

I come from a Black woman, and for me, that's it. It really is that simple. I'm Black because my mom is Black. If my dad was Black and my mom was White, I would say the same thing. If I was half White and half anything else, I would probably identify with that other half too. That's how it is, specifically in this country. I know the world looks at me as a man of color, so I would never say I'm White. And I would never just say I'm Biracial either.

Even though in my mind it's my mom who makes me Black, when I was very little she always told me, "You're Biracial. You're not Black." But that didn't work, even when I was 2 or 3 years old. My mother is dark-skinned — a beautiful woman, but she hates her skin color. I really feel like she wanted to be White, from the neighborhood that we lived in to the way she dressed to the way she tried to dress me. She has four kids older than me. She raised me; she put them away. She told me they were in boarding schools, but more recently I found out that they were in the system. We never talked about it. It's always been this secret. I guess my siblings were trying to save me from it; but this year, I sat them down and asked them to tell me the truth. And they did. I've never talked to my mother about it, so I don't know why she did it, but I have my theory. I think it was because they were fully Black, and I think she thought she could navigate the White world a little better with me. She's the one who forced colorism into my life. She had me believing that my Black family hated me because I'm light-skinned and my dad is White, but I later found out that that wasn't true either. Once I found out the truth, it really made me feel some kind of way, like I was the product of self-hate. But when I talked to my dad about it, he told me I was a product of love. He said, *"I love you."* And that's what made me feel better.

I grew up really backwards. My Black mom raised me in a White neighborhood; my White father raised me in a Black neighborhood. So, I caught hell wherever I was. I was a straight-up "nigger boy" and "monkey" five days out of the week when I was at my mom's house. I was getting my ass kicked all the time. I was the darkest of all dark-skinned people in my mom's block. But then on the weekends, when I was at my father's house, it was like, *Oh yeah, he's cool. But he ain't really one of us.* They never called me White racial slurs; it was almost like this affectionate neglect. But at least I wasn't getting jumped.

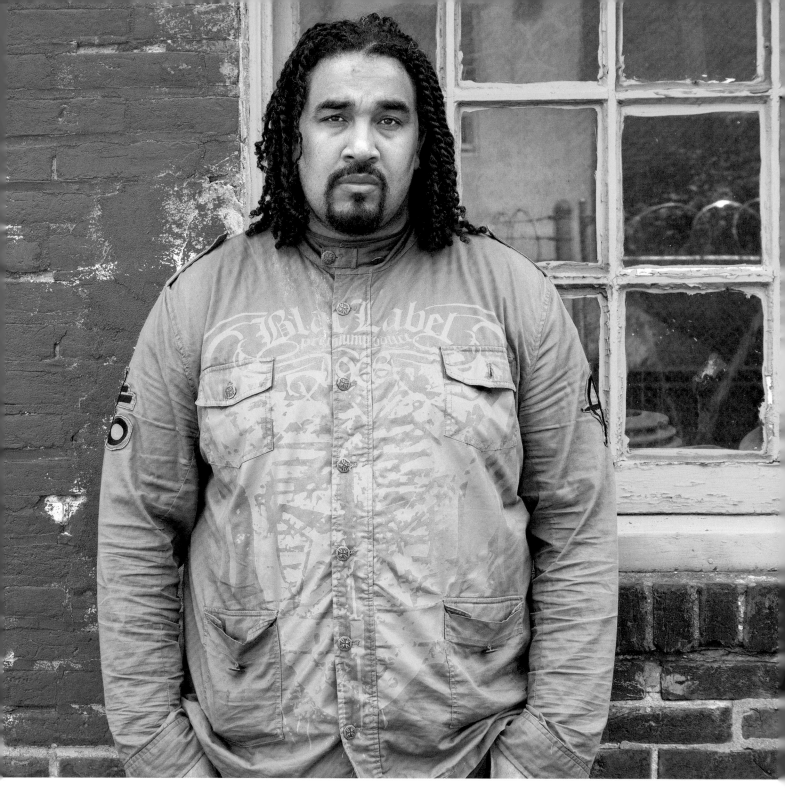

Philadelphia, Pennsylvania. April 2013. (Zun Lee)

Once I got to high school, then it became a lot different. There was no diversity whatsoever at my North Philly high school. My White blood is what made up the White student body. 100% Black. So my Blackness was never an issue in high school. It was more about what neighborhood I was from. And I was from the "right" block, so that's all that mattered. But I still went through the whole light-skinned overcompensation thing. People think that just because you're light-skinned, you're a pretty boy. Al B. Sure. Christopher Williams. We're still catching hell for El DeBarge. And that ain't me. I ain't in the mirror all day. I don't care about that type of stuff. There's a difference between a pretty boy and being light-skinned. I'm just light-skinned. But because that's a common perception, we overcompensate. For the longest, I rocked cornrows, white Ts, and Timberland boots because I felt like that made me look tougher. Even though as big as I am, nobody's gonna mess with me anyway. But in my mind, I needed to look a certain way so people didn't come at me.

My mother disappeared when I was 15. She's popped up twice since then, but I haven't spoken to her since 2003. My father, on the other hand, has always been very supportive. He's never judged me. He's always been there to talk to, even when I was trying to navigate my identity. He was just like, "You do what you gotta do to figure it out, but if you need to talk, I'm always here." And he never pressed the issue. Even when I was going through this stage where I didn't want anybody to know I was Mixed and I didn't want to claim him. I took an anthropology class in college and it blew my mind. It was the first time I learned that race didn't exist on a biological level. I went through this whole rebellious stage like, *I went through all this shit for no reason*! And I rebelled against my father too. I was real radical about it, but then I started to realize that I was hurting my father. And he never said it to me, but I could see it in his eyes and hear it in the questions he would ask me. So I checked myself and realized that I gotta watch my words. I can still have my thoughts on race but I gotta make sure that I'm always respecting my father as well.

People always say things like, "By saying that you're Black, you're disrespecting your father's side." And it's like, my dad doesn't feel disrespected because I identify as Black. The whole time my mom was trying to get me to be something else, my father was like, "Nah, you're Black. It's cool to be Black." This is my White father telling me this! My father is happy to have raised a young Black man. It was a struggle clearly. He doesn't know what it's like to be a Black man. But he doesn't feel disrespected. My father was raised in a Black neighborhood, in Black culture. No, he's not "White chocolate" or trying to be something that he's not. He's White and he knows it. He was just born and raised in North Philly and happens to have a little bit of swag. That's just who he is. But if anything,

84

given who my mother was, it was my father who was the conduit to me feeling secure in my identity. And in my eyes, I owe him everything.

If somebody were to ask me, I would say I'm a Biracial Black man. Sometimes I'll leave the "Biracial" out, but it's always "Black man." For me, it's just who I am. I'm Black and I just happen to be Biracial. And although there's clearly more comfort with me than somebody who's darker, when it's just me, when I'm getting harassed by cops, I don't get harassed half. When I was with my boys on the block chillin', the cops didn't come by and harass me half as much. It doesn't work that way. Cabs don't pick me up. I get racially profiled all the time. I've been places where I was the Blackest person in the room: *You're not us. You're Black.* That's it. Yes, I'm privileged as a male, and yes, I'm privileged in some ways as a light-skinned Black male. But the thing is, I feel like I receive more privilege from Black folks than anybody. Whatever "privilege" I get comes more from Black folks.

Somebody once told me, "If you're dad is Black, then that makes you Black." And I was like, "Well then there's a whole lot of descendants of slaves who ain't Black then. 'Cause they daddies was White." People think they have the keys to Blackness: *Alright, this is what I think, so this is what it has to be.* And there's no room for negotiation. *No, you're not Black; you're Biracial.* Cool. So, make sure you don't claim Frederick Douglass or Booker T. Washington during Black History Month. We'll have our own.

TIGIST SELAM

Harlem, New York

━━━━◆━━━━

"Ethiopian and German"

I personally identify as Black racially, Ethiopian and German/American culturally. I never say I'm Black except for in political context, because I don't even know what that means. Like *being* Black? What is Black culture? Is it African American culture? Is it African culture? Is it Caribbean? To me, culture is very specific, and I'm multicultural. So, when I identify as Black, I'm making a political statement; I'm not trying to simplify my own cultural complexity.

My father was born in 1945. That's the end of World War II. He still had the swastika in his passport and on his birth certificate. And my mom, she survived Haile Selassie and Mussolini. Both of my parents are very proud to be German, very proud to be Ethiopian, respectively. Very, very strong people identity-wise. But they're not very sensitive when it comes to race. To them, everybody else is an idiot. And that was really helpful growing up because my mom never backed down. When she didn't get seated, she would say something or not pay for the meal. My dad took me voting when I was 11. I was forced to watch international news everyday. So me and my brother got politicized at a very early age. But it was also the experience of living everywhere — Nigeria for two years, Argentina three years, Germany 10 years, and now America off and on for 10 years.

We went to Germany when I was 5, and my father's family was like, "Hello?! I can't believe this is your wife and you're bringing her to the house!" After two years of resisting, my grandmother and aunties finally accepted it. That experience was traumatizing, but it makes me respect and love my father even more. He would've given up his own family for us.

I remember the little kids there were like, "Why is your mom Black?" I was like, "I don't know. Is she?" Because to me she was Ethiopian. Some kids didn't wanna play with me, but I wasn't quite sure what that was about. But I was everybody's favorite at the same time because I got exotified. I had this long curly hair and I was cute. I got more aware of certain things when I was 12 or 13. That's when I realized, *OK, I'm not like them, and that's why some people treat me like that*. And, you know, as a teenager you're just figuring stuff out, so I got really political. When I was 16, I told my mom, "I gotta go." I wanted to have a place of belonging. I wanted to actually be around people that looked like me or were into the same things as me. But also I was very aware that my career choices and opportunities

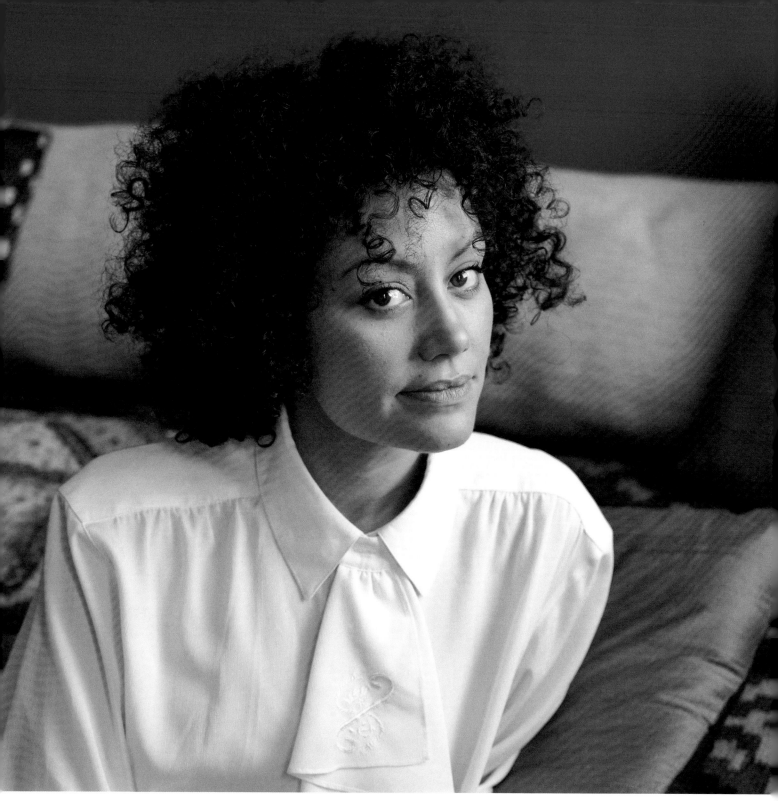

Harlem, New York. September 2011.

as an artist were limited in Germany. So I needed to leave. My mom cried, but she let me go because she understood. Now I realize how much of a privilege it is to have a Black mother when you're Mixed-race. I've heard some horror stories from Mixed-race people in Germany with White mothers and an absent Black father. They had no connection to being Black. Treated as second-class citizens and got the worst of racism because of their dark skin, but yet nobody to protect them. I always felt like my mom protected me.

Up until that point, I was so convinced I was Ethiopian and German. Then I got to South Sacramento, and all of a sudden it was like, *OK, people see me as Black*. And you just adapt. You're thrown into that and you act real quick. So it wasn't really about choice. That choice was made for me, by Black people and White people. They didn't even know where Ethiopia is, let alone Germany. Like, "What? Germany? They got Black people there?"

My New York experience has been very different. People assume I'm Middle Eastern, Latin, Jewish, Southern European. I get all kinds of stuff, but people never guess I'm Ethiopian and German. I mean, who's gonna assume that? Some Black people know that I have some Black in me. Some people don't. Some people don't really know what's going on. So I get that question every day: "Where are you from?" Maybe it's my accent. Maybe just the way I look. Depending on how I wear my hair, what I'm wearing, who I'm with, where in the city I am. Different people assume different things. I think my dating outside the race is actually a big issue when it comes to this idea of "she's not really Black." When I dated a White Jewish guy, a few of the people that knew were like, "Oh, so that's how she rolls?" I think Black men see me as betraying, like I'm sleeping with the enemy. But he looked like my Dad. And I love my dad fiercely, so for me it's not a betrayal. And no, I don't have daddy issues and I don't have an inferiority complex. I just don't discriminate. Why limit yourself?

Quite frankly, if I think about it honestly, I'm probably more at ease in a White environment than in an African American environment. Especially when we talk about political spaces. Super-conscious Black people — you know, "fight the power" Black people — they wanna fight me! I could walk into a room full of Black women and they would just dismiss me. Not see me as a "sista." My experiences are completely undermined because I'm so light. I know there's light-skin privilege. Absolutely. I've gotten jobs because of my light skin, for sure. But you don't have to rub it in my face and exclude me. It's like they don't recognize their own privilege because being "full-race," so to say, is a privilege in itself. I can't stand that. It's like, who are you? I wish more women would just have this conversation among each other, but when light-skinned women openly talk about it, it's almost like we don't have the right to be angry. If you're dismissive of our experiences, and Whites are dismissive of our experiences, then who do we run to? It's division and it's

exclusion, and I feel that a lot.

On the one hand, I believe in the right to identify as whatever you want. It's a certain privilege and freedom in itself. We really need to actually accept and not try to override each other's experiences. If you wanna call yourself Ghanaian, then so be it. If you wanna call yourself African American, then so be it. If you wanna call yourself African, then so be it. That's you. I'm not you. If it makes sense to you, then that's your truth, and I am nobody to judge. But on the other hand, the whole thing with identification is we gotta look at numbers. You know? And I know that being Mixed-race I can go to "Other" or to "Mixed-race." But at the same time, when it comes down to it, we gotta make that choice, and that choice is highly influenced by how other people look at us. And I don't think that will change.

Ultimately, though, I hope that we do come on common ground and really look beyond Black, White, and everything else — that we have honest discussions about our own fears, within our own families, within our friendships, within our relationships, within the Black community. But we also need to be in dialogue with White people. That's a dialogue that's missing. And there's a lot of healing on both sides that needs to be done. My whole thing is about conquering fear. And that's the core thing when it comes to race and to every disease of society. It's fear that's the opposite of love, and that's what's lacking in this society the most.

ZUN LEE

Toronto, Ontario (Canada)

"Black"

I identify as Black. And when I say "Black," it's not just based on race or color; it's about what feels most comfortable in terms of a sense of home. For me, I associate identity with home. Growing up in Germany, I was never made to feel at home there. So the question for me has always been about where do I find myself at home — i.e., at peace — spiritually, culturally, in terms of who I am. Blackness was always about the place where I was comfortable enough to just be myself and be surrounded by people that let me be myself. And to this day, that's been the only community that's been fully affirmative. But it's definitely been a process.

I grew up Korean. I don't even know what to hyphenate it with, because there's no such thing as "Korean-German." I grew up in a Korean household, and so while I always "knew" I was Korean, that wasn't part of my identity because I was in Germany. Germany does not define itself as an immigrant country — you're either German or you're not — so it wasn't like "What are you?" It was more like, "When are you going back home?" Even though I was born there. There's no hyphenated German identity, or at least that did not exist when I was growing up. It was more like, "Are you Chinese? Why is your skin so yellow? Why are your eyes so slanted?" People defined me in terms of what I was not, not in terms of what I was. Instead of a hyphen, there was a negation.

And then my parents never connected me to my Korean roots in a way that I ever had a basis to affirm myself as Korean. We were isolated — no other relatives, no meaningful sense of community to relate to, just my mom, my dad, my brother, and me. I didn't have any context of what it meant to be Korean other than that. Even though my parents taught me how to read, write, and speak Korean and they taught me Korean values, it didn't cement itself in a way that made me feel Korean. Plus, from their immigrant perspective, I had better appreciate what Germany had to offer me because it was better than being in Korea, where there was civil war, and poverty, political instability, and all that stuff that my parents left their country for. And that's certainly understandable in hindsight, but it was hard for me to "appreciate" Germany when I knew I wasn't really welcomed there. It just wasn't enough for me to really feel at home.

When I was a kid, nobody wanted to play with me in that little sandbox. All the German kids either bullied me or beat me up or avoided me. There was one Black kid

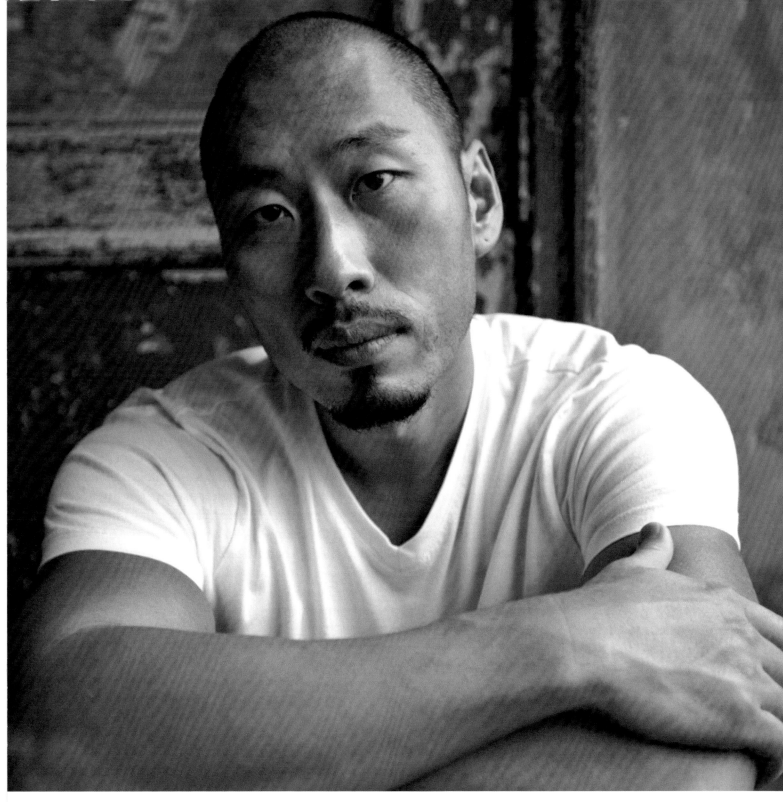

Brooklyn, New York. September 2011. (Carolyn Beller)

DEBORAH THOMAS

Philadelphia, Pennsylvania

"Mixed / Jamerican"

I'm Biracial. I don't usually use that term because it sounds almost like a disease in a way. I usually say I'm Mixed. My father is Jamaican, and my mother is American from Wisconsin. I identify myself as part of an African Diaspora, as a Jamerican, as Black in the broader conceptual sphere of Blackness, and as Mixed. I think the context that we live in always shapes the way you identify yourself and the way others identify you. When I was growing up, America was still operating on a sort of bipolar racial system, so it was quite clear that I was Black. In my neighborhood when I was living in Brooklyn, up to maybe the late '80s, early '90s, there was never a question. There was an acceptance of my "sistahood," so to speak. But once there was this enormous influx of Dominicans and other people from Latin America, more and more often people would be coming up to me speaking Spanish or just more confused about what I might be. So, I think that the time and the space and the context determines so much about how other people see you and I guess how you see yourself.

I don't think my students know what they are seeing when they're looking at me usually. So sometimes I'll just shake them up and say "we" in relation to some kind of African Diaspora discussion, see what they do, and then use that as a way to teach about the indeterminacy of race and the fallacy of trying to map bodies in relation to racial categories. I was telling my students the other day that the most frequent question I get is "What are you?" People just randomly on the street: "What are you?" I used to get really annoyed and militant about it. I've never been sure why people are so bold, because I would never. So I used to respond, "Human!" But now I just try to figure out what it is somebody's trying to know. But like any person of color in this country or anywhere in the West, you just have to steel yourself. You have to be really certain inside who you are, what you're doing, what your agenda is, and what your motivations and objectives are. The people who matter know you.

Oftentimes, people try to make something that is fluid and uncertain more certain. They want to be able to put it in a box, and in this context, those boxes have been legislated and have really defined the history of this country in a different way from anywhere else. People always say we have a bipolar racial system here and that the Caribbean and Latin America have something that's more fluid since there's always this

94

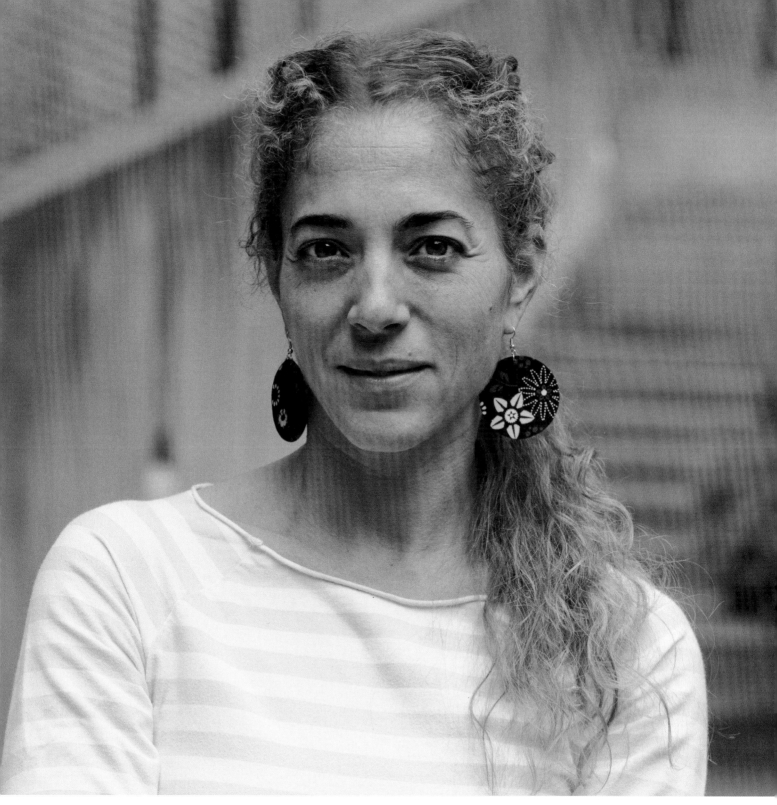

Philadelphia, Pennsylvania. September 2011.

middle category between Black and White. But I actually think that our color issues create that kind of category here as well, and it's something that people don't really talk about or acknowledge because politically segregation has been the main defining factor. But there has always been colorism and a system of color hierarchies within the Black community in the U.S., and so the ways that we understand the relationships between race and class here in this country are actually very similar to the ways those relationships are codified in a Caribbean or Latin American context.

In Jamaica, Brown is that middle category of Mixedness. It is typically associated with middle-class status and a particular orientation toward respectability and progress and education. It's that sector of the middle class that took over political leadership around the time of independence, and so it's not just a color category. It's a lifestyle category and it's a social class and status category as well — to the extent that if you're trying to identify somebody's color as brown and say they're middle-class, both of those things can be taken care of with the one word "Brown," but you couldn't just say "Black" and have it mean upper-class too. You'd probably have to tell somebody that that's what you mean. So, for my family, there's a class disconnect. My father would be understood as Brown, but he grew up with nothing much to speak of in rural Jamaica. So, when I'm in Jamaica, people sometimes assume by my color that I must be from some big-name family, and I'm very decidedly not.

Though in certain contexts, people will see me as White, I've never tried to pass. I don't know why one would. I mean, obviously sociologically I know why one would, but it's just never been an option to me. I used to dance with a company called Urban Bush Women, and I remember one time we were reading a review of one of our performances somewhere in the Midwest in the newspaper and the reviewer mentioned how diverse the company was because they even had a White person. I was like, "Who's that?" and the director said, "They're talking about you, idiot!" "Oh yeah! Right!" It's like how everybody jokes that West Indian students come to college in the U.S. and find out they're Black for the first time, but it's the opposite. In this case, you go into a milieu where people don't have as much familiarity with phenotypical racial variation and you find out you're White for the first time. But, I mean, what can you do? I look how I look. I came out how I came out. I can't make anything clearer one way or the other for people, and I really can't wish it so either, because this is what I got. To not be identified or understood as who you are as a totality or who you feel you are or what your historical experiences have been always stings, but it's not comparable to the kinds of violent racism that darker-skinned people go through. Everybody has identity issues one way or another.

I think the really important conversation today in America is about how much

the past lives on in the present. This whole notion of us somehow being post-race is completely fallacious. It's impossible. It's not even desirable. White parents of Biracial children have said things to me like, "Oh, we just want our kids to be color-blind." Why? I don't understand that, because what does that mean? That color is bad and you shouldn't see it, acknowledge it, celebrate it, understand it, know the history? Why would we not want to see each other and to know each other and to understand something about each other? Well, the reason one would say that is because of the very negative associations with the history of race and racial identity in this country. But I don't think it's a goal. I don't think it's a goal to be color-blind or to be "post-racial." The goal is to have a much deeper understanding of how the past lives in the present and how it influences the ways we think about everything and why we make certain kinds of assumptions. Why we see somebody and think we know what we're seeing. Why we make categories in the ways that we do. There's a history behind that, and it doesn't just disappear, because race is the foundational question of the Americas. Period. This is the first place in the world where racial categories were institutionalized and linked to laboring bodies. That does not ever go away. And it doesn't have to be solely negative either. We can acknowledge everybody's internalized racism and call it part of the socialization of what it means to be in the Americas in the last five centuries and then figure out what we're going to do about it.

The election of Barack Obama, as we have seen, does not eradicate race, because even if people aren't clamoring about whether he's a citizen or whether he's really a Muslim, the constant "no, no, no, no, no" about any initiative, not allowing him to be in a leadership position and take a political stance, is all about him being a Black man. That is all about his racialized presence and people's unconscious responses to it. At least that's my take on it. So it's important that we have a much more capacious conceptualization of history and the effect of history on the present, and that we not see race as something we have to get over, but instead as something we have to engage and confront and learn to move through somehow.

ARIEL "ASHO" FERNÁNDEZ-DÍAZ

Brooklyn, New York

◆

"Afro-Cuban / Black"

I consider myself Black before Cuban. Yes, Cuba is the country where I was born, but I am a Black person. My history is related to Blackness; it's related to Africa. I often feel more interconnected with the Black Diaspora than I do with a lot of Cubans. I can deny my Blackness if I want — I can consider myself *Mulato* or Mixed-race — but I don't.

My mother is Black, my father is White. But my father is not the typical White European. He looks more like a light-skinned Arabic person. But he can definitely pass as White. In contrast, my whole family on my mom's side is Black. Descended from Africa with a history of slavery. I was raised by my Black family in Black culture, so that's why I identify as Black.

Considering myself Black is also a political decision. It's conscious. When I see the two sides of me in the context of history, I see the role that White people have played in the history of the nation. The Spaniards conquered Cuba. They killed all the Native Americans that were living in Cuba. They brought Africans to work in the Cuban sugar plantations and to build the cities of the new colony. People were working in really harsh conditions. These White people were killing Blacks. These White people, in the name of the Spanish empire, were stealing people's identity. It's not that I have something against White people per se. It happened. These are the facts. So when I look at myself and who I am and what ethnicity and history and race composes me, I really feel more empathy with my Black side. Because I see there has been a lot of injustice that has happened to them. I see that there is work needed to bring back honor to my Black side and to my heroes and to rewrite history. When I look to my White side, there is nothing I can be proud of. I feel ashamed of what those people have done. And there is nothing that I need to do for them. It's a history of privilege, it's a history of power, and it's a history of oppression. When I look at them, they have it all. So, if I need to fight, I definitely need to fight for my Black side.

In Cuba, some people don't see me as Black. Even Black people will deny my Blackness. Since I was a child, people gave me different names like *el Chino*, because when I was younger I was really looking more like a Chinese. And then they called me names connected with my race and my ethnicity like *Mulato* or *Moro*. They tried to emphasize that I was different because my skin is Black but my hair is "White." So for many people in

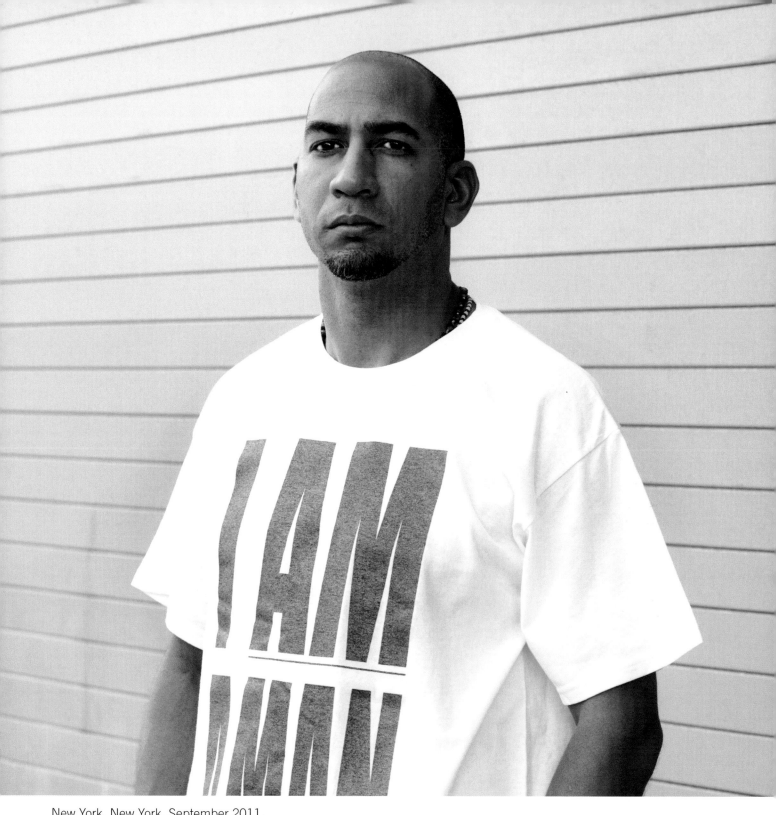

New York, New York. September 2011.

Cuba, I am *Mulato* or I am Interracial. They don't consider me Black. I think it goes back to the plantation days when slaves had a child with the owner, and for being less dark that child would have a better job and a better position in society. Cuba has a long history of Whiteness in that sense. Many Black people consider themselves as moving forward in society when they marry somebody White or when their kids are less dark.

Race consciousness and race awareness is not something deep in Cuban society. Race is not a problem for Castro and whoever is White in the government. They have never been denied entrance to a place because of the color of their skin. They have never been stopped by the police because they are Black. They don't know what it means to be Black and the consequence of racism. They've never experienced that, so why should they be concerned about race or racism? They don't "feel it" as their problem. They say that under socialism, as an "equal system," we fix and erase the race problem itself. For example, when the revolution took power, education became free for everybody. "This is the school, and the doors are open to everybody." But everybody's not walking in equal. You have a White person who had a better breakfast that morning before going to school. You have a White person who has a better pair of shoes to walk into that school with. Black people have 400 years of unequal treatment, yet you say, "Oh, you guys all share the same place." Yeah, we share the same place, but we don't share the same place in the same way.

One of the reasons why they say they don't want to talk about race is because Cubans, no matter the color of their skin, have something that is more important than the discussion of race, and that is Cuban sovereignty: "Let's defend Cuba first. Let's protect Cuba from U.S. imperialism first." Which is true, but at the same time, it has been a manipulation of the Whites in power to create a false idea of unity and patriotism in the country. Of course, as a Black Cuban, I care about somebody taking over. I care about some foreigner trying to tell me what to do, but I also care about the fact that you are denying the history of my people and you are denying me the right to identify myself how I think I should be identified. So I basically need to choose between a country with a foreign administration or a country with a local administration when neither want to talk about things that I care deeply about, like racial identity and history. For many White Cubans, like Castro, who descend directly from Spaniards and who come from the privileged class, sovereignty is the priority and the motivation behind their politics. For me, sovereignty goes hand by hand with anti-racism and historical justice for Blacks. Both are a matter of respect and dignity.

At the end of the day, yes, I'm Cuban. But what does that mean if in the land that I live I cannot celebrate my culture? My heroes don't have the respect they deserve in

100

society, so what type of freedom is this really? Whites in Cuba want to be respected as Cubans. They want to be respected as citizens. They want to be respected by their history. I want the same, plus recognition and respect for all those Black people within the history that we all share. They make the argument that Black people made those contributions as Cubans, not as Blacks. That's insane!

It gets difficult when I try to have this discussion with Black progressives and Black liberals. I'm criticizing the government that is giving political asylum to Black leaders unjustly prosecuted in the U.S. I'm criticizing the government that sent troops to assist in the liberation of Angola and the ending of apartheid in South Africa. They might feel that I'm against them or against their heroes. And I'm not. Yes, I care about their struggle and I care about their history and I lend my support, but Cuba is *my* country and I am entitled to care about my people and issues of race in Cuba. The reason that my government is giving asylum to your heroes is not a reason for me not to fight for the freedom and the respect of Black people in Cuba. You say you care about Black people, but I am seeing that you only care about *your* Black people. Because you don't care about the issues of other Black people in Cuba as long as the Cuban government brings protection to your heroes. So, it seems like a lot of times, some so-called progressive African Americans don't give a damn about race in Cuba. They just look at the book by the cover — Cuba as a symbol of resistance to imperialism, Cuba as a symbol of an alternative for capitalism, Cuba as a symbol of another country helping Africa. They all care about that symbolism, but they don't suffer and they don't pay the price of that symbolism. I am the one who pays for that.

Defining myself as Black denies other people the right to classify me for their own political convenience. It's not a contradiction or a denial of my citizenry but a reaffirmation of it. Yes, I am Cuban; yes, I am Afro-Cuban; and yes, Cuba is the land where I fight for Black people's respect and dignity — not only because I was born there but also because my ancestors contributed to the formation of the nation and they rest in our soil. But if I need to choose between being Black and being Cuban, I choose to be Black. Because it connects me to more people around the planet and it connects me with a global history of the African Diaspora. This is my choice. This is how I feel comfortable. This is what I have passion for. It is what it is.

JAMES BARTLETT

Brooklyn, New York

"Black"

I consider myself Black, but no one ever knows what I am when they first see me. I've gotten a lot. I usually get Arab or Hispanic. Puerto Rican or Dominican. It really depends on where I am in the world. I've been in Jersey and people thought I was Italian. In New York, it depends on the neighborhood, but it's usually either Puerto Rican or Dominican or some type of Middle Eastern. Growing up in Kentucky, most people know that I'm Black and White. Because that's pretty much all there is in Kentucky. Black, White, or some mixture of the two. Most of the time, I can tell — somebody's either just looking at me or they just flat out ask me, "What are you?" I can't tell you how many times I get that question. It's funny, because now most people either say, "I thought you were X-Y-Z when I first met you," or "I didn't know what you were until you started talking and then I knew you were Black!"

When I went to Ghana, they thought I was from Lebanon. Or just White. Little kids running around yelling, "*Oburoni! Oburoni!*" I got a whole lot of that, which was actually unique for me because other than somebody thinking I'm Italian every once and a while, it's very, very rare that people think I'm White. People think I'm a lot of things, but just straight White usually isn't the case. It was an interesting experience to be called White without even interacting with people, and it was definitely a little challenging because it's almost like somebody telling you you're not who you are.

Race, to me, is something we make up. In America, the old saying is, it's the one-drop rule. If you got a drop of Black in you, you Black. In Ghana, you got a drop of White in you, you White. So I understand why they call me *oburoni*. I identify as Black from an American context. I don't deny my European heritage. I don't mind saying I'm Biracial as well. I just identify more with my Black side from a cultural heritage perspective. For most of my life, I've been around more Black people. Those are my associates, those are my friends. I think when I was in the context of having both the choice of hanging out with Black people or White people, I tended to gravitate towards hanging out with Black people. On a subconscious level, I always felt more accepted by Black people. And it could be me injecting race into it when it's not even there, but when I was friends with more White people, I always felt a little bit outside of the group. I remember reading the book *Why Are All The Black Kids Sitting Together in the Cafeteria?* my freshman year in college,

Brooklyn, New York. September 2011.

and it really summed up how I get perceived by the world and how I interact with the world.

I think the reason I consider myself more Black culturally is because Black culture is so pervasive throughout the world. It's easier to be Black culturally than it is to be White culturally. Like, what is it to be White culturally? Because I know I'm German, I know I'm Irish. I've got red hairs in my beard. But I don't know any German or Irish people. I didn't grow up around any German or Irish people or anyone that identified with Ireland or Germany culturally. So I don't even know what that is. True, from a DNA perspective, from a "race" or color perspective, I know that I am more European than I am African because of the fact that my mother is 100% European, and with my father being African American, I know he has some European in him. But to me, that has nothing to do with which culture I identify with.

I want people to be defined a little less by race and more by culture. It bothers me that it bothers people that a Black person "acts White" or hangs around with White people. They might have grown up around all White people! What's wrong with that? Because they don't identify with Black culture or identify with their African heritage, why does that matter to you? Let them live their life. And the same with so many conversations with Black women about Black men dating White women. It's like, you don't know these two people. I can have the conversation in the broader context of yes, self-hatred is often involved, there's no denying that. But for it to universally piss you off to see a Black man with a White woman — those types of things bother me. At some point we gotta get past these type of things.

Personally, I have never dated a woman that wasn't Black. Not because I wouldn't, but I don't even have any friends that aren't Black. Again, it's a cultural thing. It's just who I'm more comfortable around. To be honest, and I'm trying to say this from a humble perspective, but my interactions with women have been largely defined by the fact that a lot of women have told me I'm a good-looking man and have initiated things. I was shy when I was young, and still quite, but from a young age, Black women showed me a lot more interest than White women or other women. And that might also be a reason why I gravitated towards them. To this day, I feel like Black women definitely pay me a lot more attention than women of other races. Now, I don't know that that is because of my skin color. I'm sure that's a piece of it because that's part of what I look like. But I've never felt like it was because I'm light-skinned.

Personally, I don't think people really perceive me as being light-skinned because I'm so ambiguous. They perceive me as something different than just a light-skinned Black man. When I was younger I think I definitely did things subconsciously to let people know

I was Black. For example, I remember in elementary school, if we had to do a report on a historical figure, nine times out of 10 I was doing Malcolm X or Booker T. Washington or somebody. And then somewhere around high school, I think I subconsciously took on a more Black dialect. It was never a "proving I'm down" situation. I think it was more so giving subtle cues that this is where I belong and this is how you can interact with me.

Since I could remember, my skin color has always been a defining piece of my life. And obviously I'd say that's more unique to me than to Biracial people as a whole, because someone else might look more like one race than the other. Somebody like Barack Obama, people just think he's Black. Me, I'm lighter than everyone except for White people, so people don't always know. And I'm aware that I'm not subject to the same stereotypes or even perceptions that people of a darker skin color are. But then at the same time, I'm not completely immune from that either. When I'm out with people, I'm always out with people of darker skin colors than me. So, for example, I went to college in a little town in Indiana. All White. And it was a tiny little school, like 60 Black people in the whole college. But we were always together. And so when we went to the Wal-Mart, we got the looks. And I got the looks like everybody else. So, I have experienced it, but obviously I know that it varies — just like people of darker complexion don't have to deal with the same questions I have to deal with around "What are you?" I don't look at it as a positive or negative in either direction. It is what it is. It's just something that's just a part of my life. It's a question that I'm comfortable answering, and I know I will have to answer it for the rest of my life.

NUALA CABRAL

Philadelphia, Pennsylvania

——— ◆ ———

"Black / Mixed / Cape Verdean"

My grandmother is very light-skinned and she doesn't call herself a Black woman. She calls herself a "woman of color." What I've learned in talking to her about this is that when Cape Verdeans came to this country, they were perceived as Black first, before they even opened their mouths, so obviously they were treated as Black. Because they realized the discrimination that came along with being Black, I think a lot of Cape Verdeans were quick to say, "Oh, I'm not Black. I'm Cape Verdean." And to this day, there are some Cape Verdean people who are very clear that they're Cape Verdean. If someone were to be like, "Are you Black?" they'd say, "I'm Cape Verdean." For them, there's a distinction there.

I identify in more than one way. Black, Cape Verdean, Cape Verdean American, and Biracial. It depends on how specific I want to get. Some people, they don't know what Cape Verdean is, and I don't feel like explaining. Sometimes I'll just say I'm Mixed. But not as a way to distance myself. There are some Biracial people who don't identify as Black. They only say, "I'm Biracial," or "I'm Black and White." If you say to them, "Oh, you're Black," they'll correct you. For me, I feel that there's what you identify as and then there's how people perceive you. I may identify as a Biracial person — I'm Black and White — but if people see me as a Black woman, that's how I'm treated. So I identify as a Black woman because I move through the world as a Black woman.

I do think there are limited definitions of race, but I don't think people have a right to tell you what you are either. Let people identify how they want to identify.

Philadelphia, Pennsylvania. April 2012.

MELANIE STATON
St. Pierce, Florida

◆

"African American"

I identify with my African American side more, yet I don't really even know them. I was raised by my mom, who is Czechoslovakian. She and her whole family, they just look like White people. So when people would see me with them, they thought I was adopted. When I would go over to visit the Czech Republic, they just thought I was Gypsy. It's kind of sad — growing up with my White side of my family, identifying as a little Black girl, and never really knowing my Black side of the family like that. As I've gotten older, I'm not as uncomfortable. I've gained my own self-confidence. It's to the point now where I don't care what anybody thinks when they see me with my mom. But every now and then I still feel it a little bit. I feel the eyes, and I can tell people are wondering what's going on.

I don't think ever in my life someone has looked at me like, *I think she's a White girl*. But I'm not sure people always look at me at as African American either. I guess it doesn't dawn on people that the African American race can come in so many different shades.

Philadelphia, Pennsylvania. April 2012.

KATHLEEN CROSS
Los Angeles, California

————— ◆ —————

"Mixed / Black"

My parents split up when I was 3. My mother, who is White, raised us in Altadena. It was a mixed community, but the block that I lived on was mostly Black. My playmates were Black. My mother's friends that came to the house were Black. And I was considered Black. Mixed, but Black. I think if my mother had moved us into the suburbs surrounded by all White people, I probably would have a very different proximity to my Blackness. But the people who loved and nurtured me, the people whose knees I sat on and whose stories I listened to, were Black people.

I can remember people making this comment to me when I was a little girl and I thought it was a compliment. They would say, "You're the best of both worlds." It was this idea that when you mix the "races," you get something better. You get something more to celebrate. And when I was little, I did celebrate that. I thought that was awesome. But then, when I was 8, my mother became a Baha'i, and the animating principle of the Baha'i faith is that humanity is one. Not just that all humans are equal but that we are all one creation. I think that concept of our interconnectedness as people just took on a whole new life inside of me. So, I had to rethink that whole "best of both worlds" idea. I knew God didn't create me superior to anyone, so whenever someone would say, "You're the best …" I'd be like, "So, you're telling me the fact that my Black father and my White mother got together makes me superior to the baby two Ethiopians had together? Or two Scandinavians?" I started getting militant about it. And of course, people stopped saying that to me.

Living in Los Angeles, most Black people assume I'm Black, and it's probably because I'm often in a setting with other Black people and we're all vibing. Plus, most have had some experience with Black people who don't look Black, so they figure I'm Black. But when I lived in Portland, Oregon, it was a completely different experience for me. I had to explain myself, all the time, everywhere I went. In a place like Portland, where you see three to four times as many Black men per capita in interracial relationships, I think many of the sistas there, at least when I lived there 20 years ago, were much more defensive about my presence in the Black community. That experience was very intense — like when a sista asked me not to come to the annual Black Women's Gathering because of the color of my skin — but I also think it was very geographic. It was a smaller

Los Angeles, California. September 2012. (Janet E. Dandridge)

community and more close-knit. I don't have that experience here in L.A., but in Oregon it was my norm for many years.

I remember sitting in a restaurant with my husband and our three kids on my eighth wedding anniversary. There was a table of sistas making hurtful comments loud enough for all of us to hear: "That shit gets on my last MF-ing nerve. Every time I see a brotha, he's with a White woman." And even in retelling the story, I have a difficult time navigating the conversation because I don't like the stereotype that Black women are bitter against White women. I hate that stereotype, because Black women who loved my White mother nurtured me and influenced me intellectually and spiritually and have filled my heart more than any women in my life. So, when I am the target of that kind of anger, I try to recognize where it comes from. I don't think it's jealousy. I think some sistas are angry at a White supremacist construct that renders me supposedly more desirable. So sometimes I get to be the recipient of that anger. And I understand its roots.

I will say this much about my interactions with Black women: There is an uncanny inner knowing whether someone is sincere or phony. So, even if I'm met with a "Who does she think she is?" vibe, once I've had a chance to interact one on one, within minutes we're cool. We're sisters with different experiences. Once, I was in a nightclub with my best friend, who is Black. We're sitting at the table and a brotha comes over and asks me to dance, so I go dance. When I come back, my friend tells me that this sista at the next table went off in my absence, saying, "I can't stand these sorry-ass N-words! They see a White bitch and trip all over themselves!" My friend angrily informed her, "She's not a bitch and she's not White. She's Black." The woman left the table and was gone while my friend told me the story. When she returned to her table, she moved her chair around so her back was to us. So I took my chair and dragged it around in front of her and I sat down facing her. I said, "My friend told me what happened. Let's talk about it." And at first she looked at me like I was crazy. But I wasn't OK with the fact that she was hurt and angry. And I wasn't OK with the fact that I was hurt and my friend was angry. There was all this emotion and all this rage that could have turned into a fight. We ended up in a three-hour conversation about her skin color and how big a part of her life it was. She said, "I wish I had a dollar for every time a Black person has said to me, 'You sure are pretty to be so dark.'" Here she and I are, kind of on opposite sides of that coin. My lack of pigment was a big part of my life, and I felt a different kind of discrimination. I said, "I don't know what it feels like to feel your hurt 'cause I'm not moving in the world in the same way you are. But I have a kind of hurt too 'cause I'm sitting over here knowing you're my sister. ..." I'm so glad I opened my heart and mind up to her because I learned so much from that interaction. And many years later, that same woman wrote a gracious letter to *Ebony*

magazine describing the incident. She said, "Meeting Ms. Cross opened my eyes."

I do recognize that my phenotypic proximity to Whiteness protects me. It shields me from discrimination every single day of my life. And I get it. There's no way I can deny it. It is unfair that in this life I've had, I've gotten to appreciate everything that's so awesome about Black culture without having to experience everything that is so devastating about White racism. I was asked, if there were a pill to give me instant pigment, would I take it? And there have definitely been times when the answer was yes. Not because I want to feel the full effect of White racism and discrimination, but because for once, I want to know what it's like to walk into the spot on Crenshaw and 43rd without these blue eyes and white skin and ask for a red pop and a snapper sandwich and not represent the oppressor.

A Black writer once described me as a "voluntary Black person." Like, why would I identify as Black? Like I had to be crazy or motivated by something else. And I get it. I get where she was coming from. But I say, "What about my brother, who has the same racial makeup as I do, but has brown skin? Is he volunteering?" If I passed into the White world and never claimed to be Black, then I'd be defending myself against why I'm passing. Sometimes you can't win for losing.

I've been "invited" to join the "Multiracial movement," but I find that there is a political agenda attached to that term that is supremacist and divisive. I love humanity — all of humanity — and I'm not interested in a catch-all category of "Coloured but not Black" like apartheid South Africa created nearly a century ago. I'm not eager to erase my Black or White ancestry to create a catch-all. Today when I'm asked about my "race," I say, "My father was a Black American man who descended from stolen Africans. My mother is an American of Irish and English ancestry." I let people do what they will internally with that, which is what they are going to do regardless of the terminology I give them.

In 1990, I wrote an article for *Ebony* magazine called "Trapped in the Body of a White Woman." Twenty-plus years later, I want people to know that I know I'm not trapped. This pale wrapper is the one the Creator put me in, so it is the perfect one for my soul. After the article was published, I appeared on *Donohue* and *Oprah* and I ended up being asked to speak about race at a university in Oregon. When my talk was over, a line of people waited to meet me. A White guy in a wheelchair sat very patiently in that line, and when he finally reached me, it took him a very long time to express himself because he had a severe case of ataxic cerebral palsy. His limbs jerked around uncontrollably, his mouth would barely cooperate, and he could not lift his head from his shoulder as he very slowly said these words to me: "Kathleen, I just wanted to let you know I'm so glad that you can say what's in my heart."

I never used "trapped" to describe myself again.

MEI CAMPANELLA

Atlanta, Georgia

"African"

I've always known I was Black. I can't explain it. It's just always been a feeling in me. It's like how you know where home is. It was never a question. I never thought about not being Black. That never occurred to me. I remember when I was maybe 12 years old and we went to the biennial at the Whitney in New York. They gave us one of those little metal clips that you put on your clothes, and for this particular art exhibit, the clip said, "I never imagined wanting to be White." And even though I had often been called Puerto Rican up until that point, and even though I had thought being Puerto Rican might be "easier," I never wanted to be White. So I really loved that button. I think I still have it somewhere. It just captured it perfectly.

All the time, people ask me, "Where you from?" And I'm like, "What do you mean where I'm from? I'm from Brooklyn!" "No, what are you?" Sometimes I say different things. Really it depends on how I feel in the moment. Sometimes I don't feel like it's any of your business. Sometimes I'll say, "African, by way of Brooklyn." Other times, I'll answer factually: "Chinese and Black." But my answer is not necessarily how I identify. It's just my answer to the question. I don't have any deep emotional reaction to other people's ideas. That's your hang-up, not mine. You're trying to figure something out, and I've already figured it out. I've known all different types of Black people and I'm very secure about what Blackness is. It doesn't matter what you think. I already know and I'm good. But it wasn't always like that.

As a child, I didn't understand why I looked the way I did and my mom didn't look like me. So I would ask her if I was adopted: "Are you sure I'm not adopted? Are you really my mom?" Because at that time, I didn't have a relationship with my biological father, who's Black. I grew up with my mother and my stepfather, who is Jewish, and I would be totally embarrassed by them. I went to an all-Black elementary school in an all-Black neighborhood, and all my friends were Black. I remember one time my friends asked me if that was my mom who came and picked me up, and I was like, "Nope. That's not my mom." I was deathly embarrassed that I did not fit in. And — don't you know? — my mom found out. She came to me crying, and I didn't know what to do. I didn't want to be associated with them, but I didn't want to break my mom's heart either. So I just said to myself, *I guess you're gonna have to get used to being embarrassed.* And I was embarrassed

114

Bladensburg, Maryland. September 2011.

for many years. Because in the 'hood in Brooklyn, it wasn't cool to be White. And when you're younger, you care a lot about people's opinions. But I had to let all of it go. I hurt my mom a lot. I was young and stupid and arrogant and I can't apologize enough to my parents, who, no matter what, continue to be supportive. I think that was the beginning of a lot of changes in me, and I learned not to care about what other people think.

Growing up, I wasn't insecure about being Black; I was insecure about not being Black enough. Not being Black enough physically so that the world could see. I wanted to have afro puffs. I wanted to be darker. Some people wanted to be bourgie; I wanted to be like any other easily identifiable Black girl. I used to hate all the attention my skin and hair got me — like really hate it. And then I came to hate myself. Almost like the reverse of what dark-skinned people go through. So I wanted to get rid of every kind of vestige of this icon of beauty. I would do all kinds of things to not draw that kind of attention to myself. And I know I overcompensated. And any man who liked me because I was Redbone, I didn't like him. Like men who say, "We would make pretty babies." No, we wouldn't. You can't love me just for my outer. If you can't look past the fact that I wear glasses or I don't wear a lot of makeup or I don't do my hair or get it done and I wear baggy clothes, then you're not to be with me. And I'm OK with that. I want a man who loves Black women. Who loves natural hair. Who loves kinky hair. Who loves Brown skin. Who's down for the cause. Who loves Black people. That's the kind of man I want.

People make a lot of assumptions about what it's like to be light-skinned. But you have no idea what goes on in here. You don't know whether people like you for you. And then you come to find out that some people hate you because you're light-skinned. Especially in the South. A lot of Black women judge me based on what I look like. They assume that I actively seek the benefits of my light-skinnedness. That I somehow take some kind of pride in being light-skinned. But it's the same thing: That's your issue, not mine. You feel some type of way about skin color. And I can't help you.

For me, the journey of life has not been to become something but to accept everything that I am. Because you have no idea how much I hated this. I didn't want to be me. I hated it. And it affected my self-esteem. I would downplay who I was to make other Black people more comfortable. I couldn't have the perfect outfit. I couldn't have beautifully done hair because then I just called way too much attention to myself. But I had to let it go. I don't want you to feel bad about yourself, but I'm not going to be blamed for any way you feel about your own self. I'm not participating in it and I'm not gonna be your whipping board. This is what God gave me. And I'm not going to hide it. Not anymore.

All my life, people have either questioned what I am or they've tried to tell me what I am. This is my thing: Who am I to tell somebody what they are? And likewise, who are you to tell me who I am? What you believe about yourself, you are.

BRANDON STANFORD

Philadelphia, PA

———◆———

"African American"

Although I might interchangeably use the terms "Black" and "African American," how one conceptualizes "Black" can take on many meanings, and it's usually used in the description of the complexion of one's skin. In my particular situation, being extremely light, if I choose to use the term "African American" or "Afro-American," in my mind it relates me more with the cultural, civilizational, and historical elements of African people, both Africa and America, and it doesn't limit me to just the experience of one's complexion. The race concept is very complex, and its meaning is much deeper than just the physical differences in phenotype. This is part of the complexity of language and terminology. Whatever term allows me to share more of the history, the traditions, the language, and the civilization of Black folk, where all complexions are included, I'm down with using that.

My consciousness never really allowed me to think of myself as anything else but Black or a person of African descent. Anyone who has had the opportunity to get to know me never questions my race. They never question me being Black. Never. Regardless of my complexion. But for those who don't necessarily know me, based on my phenotype and their perception, I've had some interesting experiences. I used to work as an account executive traveling many places and seeing many different things. I had many interactions with Black, White, and Hispanic folk. When visiting Hispanic offices, I would oftentimes be perceived as Hispanic or Puerto Rican, and those folk would automatically start speaking Spanish to me. When encountering White folk, a majority of the time they would automatically perceive me as White and nothing else. Sometimes I had a little fun with it and played the game a little bit. And when I say "the game," I mean basically just not letting people know exactly what I am until a little ways into the conversation. Some Whites would talk a certain way whenever the conversation circled around Black folk, and then I'd have to catch them quick and put them in check — like, "Oh yeah, by the way, I'm one of them." Their reactions were priceless. But I never try to pass and I have never willingly passed in my life, but I play the game just to see where people are going to go in the conversation, see people's real thoughts and feelings when they feel comfortable amongst "their own." But I've always made it very known that I'm Black. I've always put it out there. I take pride in myself and I take pride in being Black.

Philadelphia, Pennsylvania. September 2011.

For the most part, my experience with other Black folk has been beautiful. Once they realize that I'm Black, they usually embrace me with open arms. How you choose to present yourself can influence how people think about what you may or may not be. So, the way that I present myself will oftentimes dictate the way that I'm treated by others. My mannerisms, the way that I carry myself, the way that I speak, all of these things matter. It's sort of a reciprocal relationship that exists amongst people — the vibe that I put out there is the vibe that I bring in. So, when I show love, off the bat, I get love. So, not a lot of people have questioned who I am when I stay true to myself. Yet I have had people who think I'm joking and don't believe that I'm Black. Then they see my father and my brothers who are darker than me and realize that I am Black — like, "Wow, you look just like them." It's almost like they have to have significant proof. But then I've also had the opposite experience where people tell me, "You're one of the Blackest people I know!"

Interestingly enough, I grew up as an athlete playing many sports and I had the opportunity to excel in all of them. I would get a lot of stereotypes, misconceptions, and generalizations thrown at me once folk saw me perform: "You have to be mixed with something. There's no way you're White. You gotta be Black!" The whole "superiority of the Black athlete" stereotype. "I knew you weren't just White. I could tell by the way that you move, the way that you cut on the court, by how fast you are." They associated my skills with being something else, and most of the time it was with being Black.

I have been treated differently because of my complexion. I know I don't necessarily get discriminated against as much as somebody with a darker complexion. I don't know if I've faced the same levels of oppression that somebody darker than myself has faced. But is that what it means to be Black? I see an element there based upon the history of oppression here in America, but there's a deeper element. There's more to us than just our experience of slavery in America. To only look at our people through that lens is extremely limiting and misleading. You're not just defining yourself by your oppression or your existence here in America, but by your cultural and historical legacy.

I've had people, both Black and White, ask me why I would identify as African American. My answer is "Why would I not?" And I've also had people, both Black and White, ask me, "Why would you choose African American Studies as your major?" Again, my answer is "Why would I not?" It was my major in undergrad, I got my master's in African American Studies, and now I'm working on my Ph.D., yet people still don't understand the path that I'm on. This is who I am, and I embrace who I am. I don't deny myself. I've always had this consciousness about who I am. When people ask, I identify myself as African American, and I'll also let them know my mother's Irish and my father's African American. It seems to me that anytime I've had the experience of someone asking

me why I would want to identify as Black, that it's based upon my complexion. Almost like, *Why wouldn't you just pass your way through the world? Why would you want to put yourself in that position?* And again, for me, the question is why would I not? Why would I not want to be who I am? I've got a calling, not a career in wanting to be a professor of African American Studies. I live by the words of Frederick Douglass: "I prefer to be true to myself, even at the hazard of incurring the ridicule of others, rather than to be false and incur my own abhorrence."

CHRIS CLARKE

West Los Angeles, California

"Black man with a White mother"

Most of the time, I think how people see me all depends on my hair. Like Paul Mooney said, "People are suckers for skin color and hair." The hair on my head is not quite straight. It's just the slightest bit of wavy, so when I have my hair at a certain length, some people think I'm Puerto Rican, especially if I'm in New York. I've had people think I'm Italian, Middle Eastern — it just depends. But more so than anything, people usually think I'm Mixed. Some people say, "I know you're Black mixed with something." But some people say they have no idea. In one week, I had a Persian lady tell me she couldn't believe I had any Black in me, because to her I don't look Black. And then four days later, I'm walking down the street with some Black people, and this sista walks right up to me and says, "Peace, king. Black man, let me talk to you about our people," and went into this whole thing. And I looked at my friends like, *See*? I laughed, but she looked at me and saw Black. And in my experiences, most Black people look at me and they see my color's a little different, but they know. I also think it depends a lot on my beard. That's another factor among men — how people determine a man's race has a lot to do with his beard. I had one of my friends who's a Moor explain to me how my beard is Black. He said, "Any real Black man would know you're Black if they look at your beard. When you grow your beard, everyone knows you're Black." And I think it's true, because when my beard grows out, I don't get a whole lot of questions. Personally, I feel like when you look at me, what you see has a lot to do with what's inside of you.

I don't necessarily feel bad about people asking me questions, but the type of person I am, I really don't like to be confused for something that I'm not. And so while I love my Puerto Rican people, for example, I'm not Puerto Rican. When people ask me "What are you?" how I answer depends on who they are and my mood. I usually say I'm Mixed, but if I'm in an abstract mood, I'll say I'm a dance-floor king. If I'm not in the mood at all, I just won't answer the question. When I was younger and people would ask me, I would just say I'm Black, because I didn't even want to get into it. But I always would sit there and think like, *Yo, that's disrespecting my mother, my grandmother, my cousins. ...* It isn't, but it made me start answering the question in a way that I think acknowledges and honors my family: a Black man with a White mother. And see, when you say the word "mother," you automatically command respect, because in saying the word "mother"

Los Angeles, California. September 2012. (Janet E. Dandridge)

you've expressed the difference between a person who respects their mother on the highest order versus somebody who's just aware that they have a mom. "I'm Black, my mother is White" — there's no counter to that, end of conversation.

My father is Black and my mother is White, so yes, I'm Mixed, but I identify more with Black. It's not that I don't identify with the White; I just identify more with the Black. I can relate to all people, but my heart is where the Black is at. It just makes more sense to me. I relate more to Black men than White men. My father is Black, I'm a man, and most men identify with their fathers. My father and I also happen to look exactly the same, except I'm a little lighter. It's funny, because I've had people throughout my life sit me down as if it was their business to say, "Now, you know you're Black. Your daddy's Black, so that makes you Black." And I've had other people say, "Now, Chris, you're White because your mom's White." People have all these opinions and all these theories, and it's just like a religion. People take on the beliefs and they go with it. But the thing is that people don't want to get specific enough and really break it down. There's too many factors that go into making people who they are — not just genetically, but culturally and spiritually. You meet certain Black people whose skin color is dark as hell, but they have nothing radiating from them on a spiritual level that's Black. You don't feel the vibe. It's like you're born with certain stuff, and the rest of that stuff is developed. So, there are Black people that were born more genetically Black than me, but they aren't as Black as me, so to speak. They haven't developed their Blackness as much as I have. And it's not something that I've had to work on; it's just something that I've embraced and pulled in that blossomed in me.

I got a friend who calls me Black — like, "Yo, what up, Black?!" And I dig it. Because he's the only guy I know that calls me Black. And I'm Black. And I dig it because I miss the days when people used to say that to each other. That was beautiful. So I love that he calls me Black because it reminds me. I wonder if I start running around saying, "What up, Black?!" to everybody, people'll be like, "Oh, look at Chris. There he goes. He got his Zulu Nation beads on and now he's calling everybody Black." And there's nothing wrong with that at all, but sometimes people stereotype you like you're trying too hard, almost like they think you're performing or something. People need to learn that this is ours to use however we choose. For instance, depending on the context, when I'm speaking, my Blackness is not always at 100%. And it's like that for every Black person I have ever met and all other cultures with their accents and their choice of phrases. Culture is like volume — we know how to turn it up. And so does everyone else, from Japanese to French people with their respective vibes. You can equate it to working out: When you're walking, you're not at 100% speed, but when you're running, you are. Your cultural vocal inflections and

vernacular decisions are kind of like adrenaline, and they can get worked up. We turn up everything. We turn up our attention level — one minute you're unfocused and another minute you're paying attention — and it's the same with your Blackness. People are so protective of culture that they can't see it that way. They could see it as you *trying* to turn up your Blackness, but my ability to sound Black is because I *am* Black. Black people that are fully Black can turn their Blackness up or down, so why is it if a Black person is Mixed, it gets questioned?

I don't particularly get in the habit of proclaiming my race because race is some earthly stuff. It's a small formality. It's like, yeah, OK, I'm Black. Yeah, my mother's White. Yeah, my father's Black. But me, I look at it more like my father's Stanley, my mother's Carolyn, I'm Chris.

American Black

To some degree, we can understand the identities of people who are technically "Biracial" (each parent is of a different race) coming into question, especially since for many of them, their phenotypical appearance aligns with popular perceptions of what Mixed people are *supposed* to look like. Perhaps because the larger society does not expect them to "look Black," neither does it expect them to identify as such. But what happens when a person looks how we expect a Biracial person might look, but they are in fact not Biracial?

Take for example contributor Kenya (p. 132), who says that her "parents are Black, their parents are Black, [and her] great-grandparents are Black, so that makes [her] Black." But because of her complexion, the texture of her hair, and the build of her body, most people assume she is "Biracial," often with such adamance as to argue with her about her own identity. Her experiences are not unlike those of Koko (p. 136), who believes that "because [her] color is lighter than Halle Berry's, and she has a White mother," most people assume that she "[has] to be at least half White." Although her son Angola (p. 140) has a complexion darker than hers, he too was presumed to be "Other" as a child growing up in Liberia — "not as White as little freckled redhead Tommy or Billy, but then at the same time, not Black. Not Liberian Black." This experience is apparently an intergenerational one among this group of contributors, as even our eldest contributor, Angelina (p. 144), who was born in 1908, remembers being asked whether she was White throughout her life, even up to the day before we met for her interview.

Contributors' experiences highlight the precariousness of language to define and describe race and racial identities. Given that the history of racial mixing in this country began with the history of Africans in this country, it should come as no surprise that most African Americans are of Mixed-race ancestry. In fact, research has shown that upwards of 77.6% of African Americans have at least 12.5% of European ancestry (the equivalent of one great-grandparent).[67] With this genetic reality in mind, what exactly does it mean to be "Mixed"? Who would count as Mixed? Or rather, who would get to count as Mixed and why? Although there are some people who would argue that the Mixed identity is not exclusive to those with parents of two different races and that it also includes people who are multigenerationally Mixed, or MGM, none of the contributors included here claim their genealogical Mixedness at the forefront of their identity. Although most acknowledge a family history that includes racial mixing, that mixing does not come to define their contemporary lived experience or the way(s) in which they self-identify.

Because of my own experiences growing up in New Orleans with people who self-identify as Creole, it was important for me to include New Orleanian voices. Kristina's (p. 150) family background includes the Louisiana admixture characteristic of "Creoles,"

however, she says that she "[sees] Creole as an ethnicity" and that she "[considers herself] Black first." Although generations of jewel's (p. 154) family are from Southeastern Louisiana, and she has a phenotypical appearance comparable to many women who self-identify as Creole in New Orleans, she makes it plain that she is decisively "not Creole. [She's] Black."

Many of us are so headstrong about our ideas about Blackness that when we see a woman who wears hijab, such as Sumaya (p. 158), we assume that she is of Arab or Indian descent. Why? Because our imaginings of Islam are incongruent with our imaginings of Blackness. Our literal understanding of race as color renders Destiny (p. 166), who lives with albinism, perceptibly White despite her clearly African-descended phenotype. This perspective likewise compels us to question the identity of someone with vitiligo, such as Sembene (p. 170), whose physical appearance often confuses people to the point of asking her which she was first, Black or White. For me, Joanne's (p. 174) story quickly puts to rest any uncertainties about the determinacy of racial identity based upon skin color. Like Sembene, Joanne lives with vitiligo. However, like Michael Jackson, she has lost all of her pigment, yet she is very clear that her vitiligo has nothing to do with her identity. As she so simply states, "I'm still who I've always been — a Black woman."

The contributors featured in this section are all Black American, or as Lauren (p. 146) puts it, "regular Black." Through their narratives, we gain insight into some of the physical and social variants that work to obscure their identities as Black people.

DENISE BROWN

Philadelphia, Pennsylvania

———◆———

"African American"

I come from light-skinned-race people, so there's no lack of clarity anywhere in my family about identity. I've always been Black and proud, and there's a way in which I inherited that and engaged around that. Within the context of my family, there's every color, so it's always surprising to me that people would think I was anything other than African American. Most Black people think we always know when other people are Black. I'm sure we don't, but it's like "race-dar" or something — like we know other Black people automatically. So to think I'm anything other than Black? Your race-dar must be off. But there have always been questions — "What are you?" and "Are both your parents Black?" or "Where are your people from?" I have had people ask me if I'm Mixed, but not necessarily in an "Is your mother White?" type of way.

Sometimes there's as much "stuff" within the family as there is outside. My father's second wife, my stepmother, who I've known all my life, is from New England. Her family is from Massachusetts and New Hampshire, and so they're like these old African American Yankees. Trust me, you've never met anything quite like this in your life. My stepmother's mother came from a large family, and so there are a lot of aunts and uncles. One in particular, Uncle Willie, lived in Europe post–World War II. He speaks fluent French and goes to the opera and that kind of thing. Most of my life I've worn my hair some form of natural because my mother didn't believe in chemicals. It really wasn't until I was in college that I ever had my hair straightened chemically. So I had my hair cut off and it was kind of spiky on the top and straight. I went to visit family in Massachusetts, and Uncle Willie happened to be there. So I was walking down the street and I got to the porch of the house, and Uncle Willie said to me, "Nisey darling, I thought you were a little White girl walking up the street. You look gorgeous!" Prior to that, anytime I was around Uncle Willie, he spent most of his time talking to me about how harsh my natural hair made me look. "You know, you are such a pretty girl. Why would you want to have all that nappy hair on your head?" So, sometimes it's not just about the questions that other people have of you. Sometimes it's about navigating family dynamics.

Philadelphia, Pennsylvania. April 2012.

KENYA CASEY
Atlanta, Georgia

"Black"

In the '70s, Black parents often gave their kids names they believed had meaning. My father believed that giving me an African name would create a path for me, a journey for me, and for him, it was important to give me that sense of identity. He also told me that he named me Kenya because he wanted people to know that I was Black.

My family is made up of different shades: My mom looks Native American, my father is my complexion — light-skinned with gray eyes — and my oldest brother is dark-skinned. My mom would say we were like Heinz 57 sauce — you know, we're made up of a little of everything. My race didn't matter as much growing up in Oakland, Calif., because Oakland was very diverse. In Oakland, I didn't have to think about how I identified, and my family didn't talk about race, although occasionally people would be curious. They would look at my older brother and then look at me and say, "That's your sister?" and be really confused. Or at times people would mistake my mom for my babysitter because she was also darker than me. But you know, as a kid, you don't really pick up on those things. It wasn't until I moved to Louisville, Ky., that I began to understand race and how my family identified and how I was to identify, because in Louisville there was only Black and White. Either you fit into the Black category or the White category, and I soon learned that I was definitely Black.

We moved to Kentucky when I was 9 years old, and transitioning from Oakland to Louisville was a struggle. I remember befriending a little White girl when we first moved. I remember wanting to go over to her house to play, and she told me that I couldn't because her family would not allow her to have any Black friends over. So I just hung around the kids in my neighborhood. But fitting in with the Black kids wasn't easy either. You know, sometimes kids can be cruel. Here I was, in this completely different environment, and they'd say things like, "Oh, you think you're too cute," or "She thinks she's better than us!" It wasn't that I thought that I was cute. When you're in middle school, you don't think you're cute. I had pimples on my face and everyone told me that I was too skinny. Cute was not how I saw myself. I was withdrawn, shy, and very insecure, so I didn't talk to many people. And when I did talk to people, I remember not fitting in because they said I "talked too proper." So, I consciously tried to lose my California accent and gain a Southern accent to fit in with the Black crowd.

I think one of the reasons why I chose to attend a historically Black university is

132

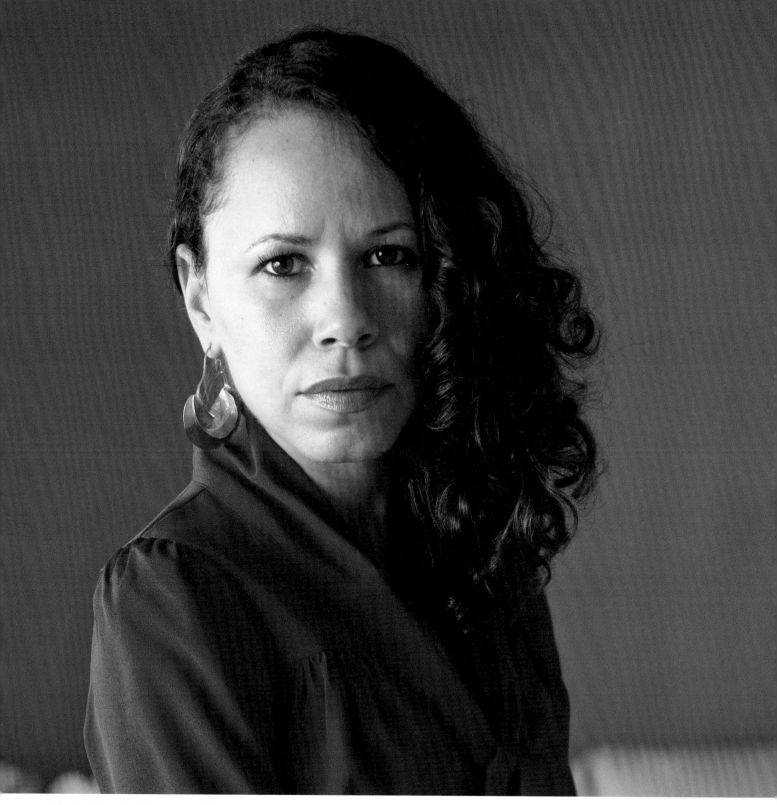

Atlanta, Georgia. December 2011.

because I had a hard time adjusting in Louisville and I wanted a different experience. I knew that what I experienced in Kentucky was not "the Black experience." So it wasn't until college that I really began to feel comfortable with who I am. I saw Black people of different shades, different backgrounds, and they were from all over the world, and that gave me a lot of self-confidence. I remember my mom came to visit me during my sophomore year and she said, "Who is this child?! You're so different!" I was just able to be myself. I became comfortable with people asking me "What are you?" and "Who are you?"

If you're at an HBCU, people assume you're Black, right? People might ask where you're from, but people just assume for the most part that you're Black. They assume that you have some kind of Black in you. So, in college, my racial identify wasn't as big of an issue. Now that I'm an adult, I'm asked what my racial and ethnic background is much more often and I think it's because our nation is more diverse than it was 20 years ago. So, I know that people look at me and make certain assumptions. People may hear me over the phone or know my name, and they automatically assume that I look a certain way. If I wear my hair curly or because I salsa dance, some people assume I'm Latina. Some people look at me and see White features and they assume that I'm Biracial. Even if you assume I'm Biracial, that still puts me in the Black category in my eyes. When people question me and I tell them, "No, I'm not Biracial. No, I'm not Latina," they say, "Well, look at your skin tone, look at your hair. You have to be something! You have to have White in you somewhere." As an African American, many of us trace White blood in our lineage to slavery, and my family background is no different. The bottom line is, my parents are Black, their parents are Black, my great-grandparents are Black, and that makes me Black. I know there are people who are looking and thinking, *She's not Black*. And that's fine too. At the end of the day, I'm Black because I'm Black. My complexion doesn't define my Blackness — I do.

My heritage, my parents, my lineage, and society have all played a role in shaping my cultural, ethnic, and racial identity. I know that people have judged me and they continue to judge me based on how I look, and people may quickly put me into a certain box or a category of experience. I understand that sometimes it's out of curiosity and sometimes it's out of ignorance. In both instances, before I get too offended or upset, I try to remind myself that these are teachable moments — even when people are projecting something onto me and I don't feel as though it's my place to try to convince them otherwise. I'm comfortable with who I am. If you interview me 10 years from now, I'm not gonna say, "Well, now that we're a multicultural society, I identify with my Native American and White and Black ancestry, and I'm …" No. I'm Black. And 20 years from now, I'll still be Black.

KOKO ZAUDITU-SELASSIE

Baltimore, Maryland

"African"

I've gone through some different kinds of things than most people because I did the African ancestry test looking at 500 years of unbroken DNA, and 99.7% of my DNA says the Hausa Fulani people living in Northern Nigeria. Now I have some kind of empirical evidence. But even before any "proof" about being African, I've always had an inclination towards all things African. It's my one pointed direction that always leads me back to myself.

I remember when I was writing my book, I always had to fight this battle with one of my reviewers. One of the questions he was giving me a hard time about was, "You keep saying 'African'. Don't you mean 'African Americans?'" I had to come up with a general definition: When I say "African people," I mean all people who have their heritage primarily situated in West Africa. And that's including the Diaspora. I really had to fight this battle with being able to determine the terms of identification that I identify with and really impose my definition on other people: I'm African, and all y'all are too!

When people who don't know me meet me, most assume that there is a White parent. Is it mother or father? Because my color is lighter than Halle Berry's, and she has a White mother. So if I'm lighter than she is, then I have to be at least half White. They're not thinking like it's anything somewhere way down down the line, like a great-grandparent. It has to be someone in the immediate parentage. So, they don't see me as totally Black. And that changes. If I'm in Africa — oh, I'm just totally White. There's no Blackness in me. And then, I don't even defend myself. Who are you? And at the end of the day, if you choose door No. 1, which shows me as a White girl, as opposed to door No. 2 that shows me as myself, what do you win? My identity is not dependent on somebody conferring it to me. Like I have to audition to get in my own group? That's pathological.

With my heritage, with all of my family members coming from New Orleans, we have different kinds of ideas about Blackness. Blackness is not merely color. It's color plus perception plus experience. Because when I was 9 and was going to the pool, it didn't matter that I had at that time blue eyes and straight hair and phenotypically not as many African features. But the woman could still look at me and say, " No, we don't allow little Negro boys and girls in our pool." In places where White people were in the majority, they could have something like a 1/32 rule, especially in New Orleans. You couldn't be White

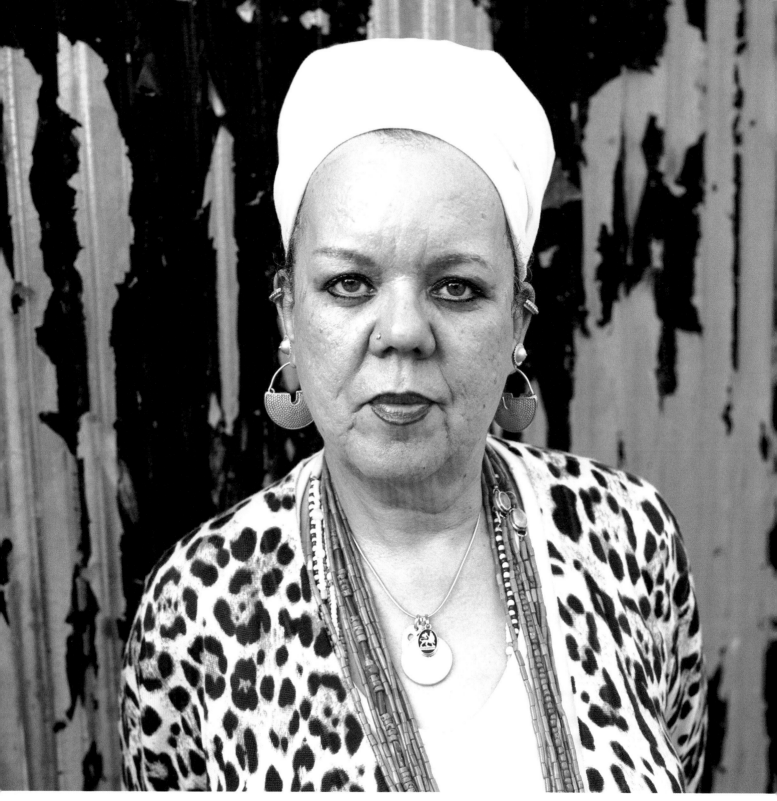

Brooklyn, New York. July 2011.

no matter if you looked as white as any White person. When I'm in Los Angeles and in New Orleans, it's the only time where I don't really have to say what it is because everybody in a certain space can look like me. There's a history of people that's like me there. But if I'm in Baltimore, which Johns Hopkins University says has the largest number of non-mixed African people outside of Charleston, then they not used to seeing Black like me. I'm, like, *real* light-skinned for this environment, but in my school I was the darkest person. So, it's relative in terms of what's normative in the environment.

These social categories are already fixed. You meet them. You enter. In places like Brasil, I may not be constructed as Black to them, but I don't give up my identity based on "Well, we don't really think you Black." In fact, I think that my hyper-Black stance has a lot to do with my hypo-pigmentation. I've never rejected Black; the only thing I could ever remember rejecting is White. White became an anathema. It became like, *Oh, I know you ain't call me White! How dare you try to exclude me?* And it's really not about your excluding me as much as it is your not including me with these people who are my mother, my father, and all my relatives. Nobody else ever has to question: Who am I? Your mama Chinese, you Chinese. Even one person in your family Chinese, you Chinese. Simple. And then it's like, "I'm Blacker than you." OK, good. And at the end of the day, that and 15 cents can't get you a Starbucks. So you won. At this point, it's pointless to take on a feeling that does not originate with me. I'm not really willing to let somebody have that power to give me any emotions. To use one of those old-people sayings, "People that mind don't matter. People that matter wouldn't mind."

At one point, I think I did try to accommodate people to make them feel more comfortable because I could see the pain of Blackness as an aesthetic for some people. I remember a time when I cut my hair. I was like: Oh no! Having two long ponytails is a distraction. It's really tearing other people up so bad, but it's nothing. But then after a certain point it's like, yes, I can grown long hair. And if that's really messing you up, then you gotta seek your help. If my hair is long and my skin is light, and if your hair is short and your skin is black, and if you look in that mirror and don't find some kind of reflection in those two things, then there's a distortion in your mind. But it doesn't have nothing to do with me because I'm just being.

Black people are the only ones who don't take whatever energy they're feeling towards anything on a color issue and ever look at Whitey. They are always self-implosive. They've always internalized it and felt bad about it, but don't never say, "Whitey, you the cause of all this." They always look at Black people like Black people have to explain themselves. Nobody ever asks the Man and puts him to task like, "Why you raped all those sistas? Why you didn't follow your Christian ethics and stay with your wife?" Now

you got all these mixed-up folks and all this tension within the race, and then the Man gets to go free? So, next time somebody ask me something, I'ma say, "Go ask them. Don't ask me."

If you really know me, then you understand that I'm always trying to have an agenda for liberating African people in all kinds of ways. I always refer to myself as revolutionary because I'm attempting to walk in the world wielding a set of definitions about myself intellectually, spiritually, and culturally. It's revolutionary in White supremacy to have any definition other than those that are consistent with the definitions that are meted out to you. I refuse to be defined or categorized and give anybody else the power to put me in a little check box. I am an African. I am an African. And that's it.

ANGOLA SELASSIE

Baltimore, Maryland

"Black / American African"

I'm Black in terms of skin color. I'm Black because of my ancestry. My parents are Black. Grandparents are Black. Great-grandparents are Black. So, I'm Black. Plain and simple. But since identity can be real complex, if need be, I identify as Black, African, African American, American African, Pan-African, Afropolitan, all of it.

From a youth, I always identified as a Black African. I grew up in a community that was African Nationalist, so the emphasis was on Black is beautiful. At the age of 6 or 7, I had an understanding of Pan-Africanism that stressed collectively identifying. So, when I moved with my parents to Liberia after they were inspired to live the political life of rematriates, I was quite disappointed that as much as I saw the little kids as my brothers and sisters, they saw me as Other. Not as White as little freckled redhead Tommy or Billy, but then at the same time, not Black. Not Liberian Black. They used to call me "red pekin," "red boy," and "red little rooster." Sometimes the kids would taunt me and call me "White man." "White man, long nose." I never got it, because I ain't have no long nose — slender maybe, but not long. It was just the fact that I wasn't Black like them. But at the same time, though, I don't think anyone questioned my Blackness culturally because I think one of the things you find in the Continent is that identity is not just how you look, but what you do and how you move. I grew up real 'hood. I was always speaking Liberian English, fighting, playing football, shooting slingshots, rolling my tire, and just typical little boy stuff. Getting in where I fit in. So, in that sense, I don't think anyone questioned my Blackness.

I came back to the States following the outbreak of the civil war conflict in Liberia and went to high school and college in Atlanta. Throughout the years, I've had opportunities to travel to various places on the African continent and throughout the Diaspora, so I've actually had a chance to see my identity operate differently on people, or rather, people operate with my identity in different ways. If I'm right here in Baltimore or in Atlanta, the average African American will be like, "What's up, my brotha?" and just take me as a regular brotha on face value. But then depending on how I'm dressed or how I talk, they might take me as a Black person from the Caribbean, or even the Continent. Just depends. Now, when I'm somewhere in Addis Ababa, because my skin tone is similar to the skin tones that you'll find prevalent amongst the Amhara people

Baltimore, Maryland. July 2011.

in particular, most people take me as just an average Ethiopian. And when I was in Cape Town, most folks just took me as a Coloured right off the bat. If I'm in Ghana, because I'm not dark-skinned, I'm automatically an *oburoni* (White man; person from abroad) or I'm *akata* (cotton picker). Just a nigga from America. I've been in some places in West Africa where I'm just a White man. I think sometimes the definition of White in those places is not just skin tone, but also status, access, and privilege. Sitting inside the five-star hotel somewhere having a $100 meal? That's White! I think people create their own narrative of you. At one stage in my life, it used to irritate me. I just thought it was a result of people caught up on the colonialism type brainwash of separating us. Like, you just can't tell Black is Black? Black come in a million shades, and it's 2,000-something, and if you don't get that, what's your problem? And it used to piss me off, especially in Africa. I would see certain things that would be real inconsistent. For example, in Accra, there could be someone belonging to one of the indigenous Ghanaian ethnic groups that will have the same skin tone or even a lighter skin tone than me, and folks consider them Black. But then looking at me, even darker than that person, I'm White. And I'm like, hold on! Black is Black! You ain't heard Peter Tosh say, "So long as you a Black man, you an African?" You already know it's a whole history of raping our women. Doesn't it make sense that we'd have all these different shades of skin tones? And even without the mixing, we'd still have gradations, so how come politically we not even conquering that beast by saying, "No matter what, you can't kill the seed. We Black!" It just seemed dumb to me. But then over time I just started to empathize. Bless them. I realize the struggle is way bigger than one Black person insisting on calling me White. The fact that you gotta be insistent about calling little ol' me White, it's like: *Dude. OK, you win. I'm White. Whatever.*

It's a real trip. In some ways, light skin receives a certain set of benefits, but then simultaneously receives a certain set of liabilities from the same folks that bestow the benefits. As a light-skinned male, the assumption is that you're weak, or that you ain't "bout it bout it," or you don't have as much game. And I find that everywhere. I think the sense of manhood is associated with darkness and Blackness. At the same time, I've interacted with sistas who ain't say nothing about my complexion but have talked about the "quality" of my hair. How our babies would have "good hair." I remember when I was in high school and first thing sistas would be like was, "You Indian? You got that good hair." And I just used to be irritated with them. *Get outta here with that!* It just felt like another attempt for Black people to try to move away from their own Blackness. The beauty that they did see in me, they didn't attribute it to Blackness but to something else. Some other group. Must be the White side or the "this" side or the "that" side.

People need to understand the utility of identity and be fluid with it. Understand

that you can use identity to serve a purpose. There's a time to be Igbo, but then there's a time to be Nigerian, and there's a time to be West African, and there's a time to be African, and there's a time to be Black. Likewise, all my "born in the USA," "up from slavery" Black folks need to make that "African" in African American that they're so proud about stand for something of added value and empowerment and stop feeling like because they don't know the name of their great-great-great-whoever's village that they can't authentically rep Africa to their benefit. Learn to be fluid with identities and how to really wield the utility of them all. Very much how these folks that we designate as White have been able to really employ their identity. When they come to America, they ain't talking about how they're Serbian. They're White! And they could be Serbian when they're at their restaurant or in their family home, but they're checking that one box for "White," not "Other," not "Mixed." And they're greeting the Italian as White, and they're here mixing with Anglo-Americans and learning how to employ their Whiteness for a certain utility which, for me, has to be about a sort of economic and cultural access and power. That's where we need to be.

The thing that we all have in common is our motherland, Africa. It connects us with the Black folks down in Brasil and in Colombia and in Jamaica and Cuba and London and France and worldwide. So, I see it as imperative to associate myself with the collective identity and history of Africa, the future of the African continent, and the state of Black people worldwide. I want to put myself in the largest aggregation of Black folks because we're trying to build power. So that's why I represent for Africa. And that's why I identify not just as Black, but as a Black African.

ANGELINA GRIGGS

(BORN IN 1908)

Fayetteville, Georgia

"Colored"

My father's father was White, and his mother was dark. My father's father owned the sawmill. He never claimed my father as his son, but he did see to it that they were taken care of. My father never laid on us about no "yella" or no light skin or no White or no passing or none of it. He told us we were Negroes. He would tell us about how the White people took advantage of his mother and how we needed to respect her. He said, "You see Mama? You see her color? If you disown that, you disown her." So, I never gave passing a thought. But my Uncle Felix passed. My father's brother. He left Florida and went to Ohio because he wanted to pass. Uncle Felix worked for the railroad, and I remember he would come in the dark of night just to make sure we were OK. He'd always give us a little something, but he could never stay. They woulda killed him. When we left Apalachicola for New Jersey, Uncle Felix got our train tickets. We had to sit way in the back by the engine, me and my sister. Can you imagine? Coming all the way up through the South like that? But Uncle Felix worked for it, so we knew not to say, "Hi, Uncle Felix." We ain't so much as look at him. But one way or the other he saw to it that we had food and something to drink. He saw to it that we could come up North to be with our parents. But once we got up North, we never saw Uncle Felix again.

When I was in Florida, I went to public school. They treated me so bad my mother took me out and put me in the Catholic school. At that time, Colored people would say, "Black is honest," and "Yella is dishonest," and so they was hard on me. They used "yella" a lot. Used "yella" to call me all kinds of names. They didn't trust me, but they knew better than to mess with me, because I'd fight them. But when I got older, a lot of fellas paid attention to me, and I had a lot of boyfriends. The women still bothered me all the time, though: "You think you something 'cause you yella!" I guess 'cause I had a lot of fellas. I didn't care. I didn't fool with women that much anyway.

All my life, people ask me, "You White?" I say, "No, I ain't White. I'm Colored, just like you." 'Cause we all different colors. They got so many colors of Negro, so you can't say you Negro and I ain't. Some of these Negroes wanna be up here and pass and all that stuff. I just look at 'em and know. You can't hide from everybody. You sho' can't hide from your grandmother. And you sho' can't hide from yourself.

Fayetteville, Georgia. June 2012. (Akintola Hanif)

LAUREN JANE HOLLAND

Washington, D.C.

——◆——

"Black / Guyanese American"

People often ask me, "What you mixed with?" and I can tell some people are actually disappointed when my response is "No, not mixed, just Black." I used to get bothered by it. It just felt like people were too caught up on what I looked like versus what I might have to say or any value that I possess besides the physical. Sometimes before I even get asked what my name is, it would be, "Excuse me, what are you mixed with?" Sometimes I think that people just want you to be something else, as if being regular Black isn't good enough, which is a sad throwback to an ugly time in history. In my opinion, the disappointment shows ignorance on the part of the asker and definitely doesn't show the most self-love. While I take pride in all parts of my heritage, at the end of the day I am Black. And that's better than good enough — that's fabulous!

I appreciate the way I look, and I'm very comfortable with myself, but frankly, I don't love the attention. Light skin, long hair, and "chinky eyes" evidently attract a lot of attention that I don't necessarily want from people I wouldn't otherwise talk to or from people who perhaps wouldn't talk to me if I looked differently. Some people might see the extra attention as a privilege, but I don't. Physical attraction alone hasn't gotten me more meaningful relationships or more love. There's no foundation — it's not real.

On the other hand, I'm very aware that with light skin and long hair come stereotypes, like being stuck-up or thinking that you're better than dark-skinned Black folks. For example, I've always been involved in organizations that have a community focus and showcase our culture. There have been times, though, when I felt like I was being viewed as "too cute to be down," as if looking a certain way automatically precludes you from certain volunteer jobs or meetings. I've never explicitly been told, "You aren't Black enough to be doing this," but I have felt unwelcoming vibes in certain spaces. I've never thought I was better than anyone based on my skin color, and I've never considered myself any less Black than a person with a darker complexion. There are Black people all along the color spectrum who are down for Black people and work hard to uplift the community — that's what's important. So I've never been dissuaded from my purpose. My work speaks for itself.

Philadelphia, Pennsylvania. April 2012.

ANITA PERSAUD HOLLAND

Ardmore, Pennsylvania

"Guyanese American"

When I met one of my husband's cousins for the first time, he didn't say anything to me, but after a while and kind of off to the side, he said to my husband, "She's not a regular old nigger is she?" It's funny, but that epitomizes the way I am perceived by some people. Most times, people are not so impolite as to inquire about my ethnicity. But sometimes they do. They ask whatever they can ask to find out where I come from. And I don't think there's any specific thing they assume I am, just that I don't look exactly like any other group. I'm not African-looking. I'm not truly Indian-looking. I'm just kind of a blend — like a lot of America's becoming these days. For the most part, they just assume that I'm "different." I get "different" more than anything else. I guess because of my coloring. I am kind of pale, and my hair is usually straight more than not. And I guess I speak a certain way. I've always been taught to speak as proper English as I could because, as I grew up among accents, I knew that speaking to be understood was the point. But believe it or not, it doesn't bother me a bit. People are curious about people all the time, and if the people who are curious about me are important enough to me, we'll have a conversation.

People always look for something to distinguish, to either make somebody a part of their group or not a part of their group, in whatever their context. It's the people most similar to you that have one little thing different that are the most irritating to you in society. So, I don't know if dark-skinned people feel like there's been privilege given to people of every other shade but their own, but if you perceive that you've suffered discrimination more than somebody else, well, that would be a little bone you have to pick. And that's all there is to it. Why take exception to my Blackness? Is Angela Davis Black like you? Rosa Parks isn't Black like you either, right? But guess what? She got on the bus. And guess who they thought she was? Black. So I'm just as Black as you are, but in a different way. It's human nature to want to defend your position, but to me it's easier to have a bigger group. So, I think it's beneficial for more people to identify as Black than it is for less.

Ardmore, Pennsylvania. July 2011.

KRISTINA ROBINSON
New Orleans, Louisiana

"Black from Louisiana"

When people ask me if I'm Mixed, I feel like they are asking me if I'm Biracial. No, I am not. I'm Black. Both of my parents have "Colored" or "Negro" on their birth certificates. My father's father was from Pennsylvania and he was a very black Black man. My father's mother was a very white Black woman. My mother's family is completely Louisiana admixture: American Indian, French, and Black. Most people would call that Creole, but I identify as a Black person first.

What exactly Creole means varies. Different people have different interpretations. Some people would say that Creole is a separate race, and there are people who identify as Creole rather than Black. I don't think Black and Creole have to be mutually exclusive. I see it as a spectrum when it comes to identity. I think there's a degree to which you could see how for some people, Creole and Black are not the same without there necessarily being a denial of something. I know Creoles who are mixed to the point that they literally look like White people. That is going to produce a different experience in the world or how they'll be perceived in the world. I've also met people who would probably identify as Creole first who don't have a problem with their Blackness, so to speak. At the same time, I've also known people who identify as Creole first because they want to be distinguished from being Black. You seem to be obviously Black, to me and everybody else. Everything you come from is Black. Everybody in your family is Black, and you're clinging to whatever part of yourself that isn't Black. That's disingenuous, and that's what turns me off.

I feel like, for some Black people, if I identify myself as Creole, to them that would mean that I don't want to be Black or that I feel that Black is inferior. And that's why I don't identify like that, because I don't feel like that. I just resent the baggage that Creole identity comes with. Because racism is so insidious, Creoles are defined by colorism and prejudice. And I don't want to be associated with or defined by that. I do think Creole culture is a unique culture different from the larger Black American culture. It's not American — it came from another master, so to speak — and that's worth preserving. But is it worth a whole 'nother identity? I'm not sure. For me, I feel like my experience is closer to what other Black people might experience, so I identify as Black. In many ways, I see Creole as an ethnicity. Just like a Black person who's from Colombia — racially they're Black, their ethnicity is Hispanic. I'm a Black person, but ethnically I'm Creole.

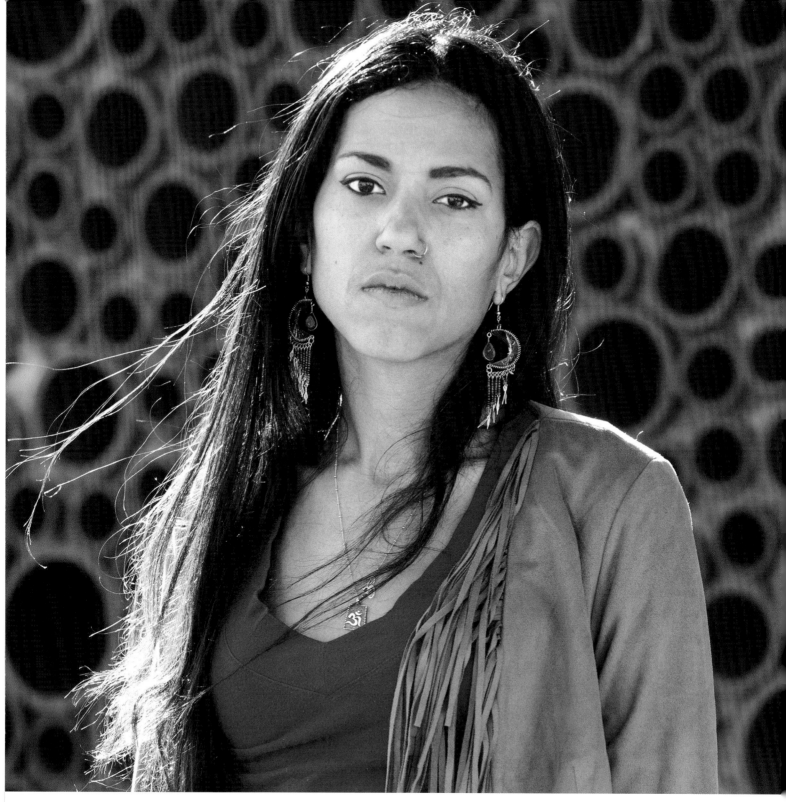

New Orleans, Louisiana. December 2011.

JEWEL MARIE BUSH

New Orleans, Louisiana

——◆——

"Black"

If I'm in Louisiana, there really is no uncertainty about my background or ethnicity. But if I'm in Louisiana and someone who is not from Louisiana meets me, often they'll ask, "Are you Creole?" Or if I'm in the South outside of New Orleans, it's "Oh, you're from New Orleans. You're a Creole." No, I'm not Creole. I'm Black.

When people see me and they assume that I'm Creole, 98% of the time I take offense. I don't think of it as someone appreciating people who have a mixture of African roots, Spanish roots, and French roots. I look at it as people who want to disassociate from being Black or having a connection to African ancestry. A lot of times when that term "Creole" is thrown around, from my experiences, it's been from people that feel like, "Oh no. You thought I was Black? I'm not Black. No, I'm Creole, see? I'm better than Black." That's why it comes off as so offensive to me. Black people just can't be a variety of complexions and have a variety of hair types? When you think of someone who's Black or from Africa — what, they have to be blue-black? Have a shaved head and coarse hair? No, there's a spectrum of people, of shades, of the way we look. So I get offended because people just assume that, "Oh, you're too this to be Black," or "You're too that to be Black." You have to be something else.

When I look at the history of free people of color in New Orleans, they enjoyed all these privileges that were not afforded to slaves, people who were of darker complexions. It was three groups of people: White, Creole, and Black or slaves. It wasn't like, *We're all people of color. Let's join so we can have this solidarity and fight this power structure.* It was more like, *No, I'm not like them. See? I'm better. I'm Creole.* That's the history that I use as my point of reference. I mean, there's nothing wrong with being proud of your heritage or your culture, but I don't view Creole as a separate race. Race is a whole 'nother story. Look at Homer Plessy. That case set the precedent for what became Jim Crow and segregation. But he wasn't saying, "I'm one-eighth Black, so see? I'm Black." No. He was basically trying to prove that he was closer to White than Black. So I don't view Homer Plessy as a freedom fighter. He was fighting to show a distinct difference between what it was to be Creole and what it was to be Black. So, I'm aware of that history, and that's where I draw my feelings from, and I don't like it and I never have.

When I leave Louisiana and go to other places, I know that's when more questions

154

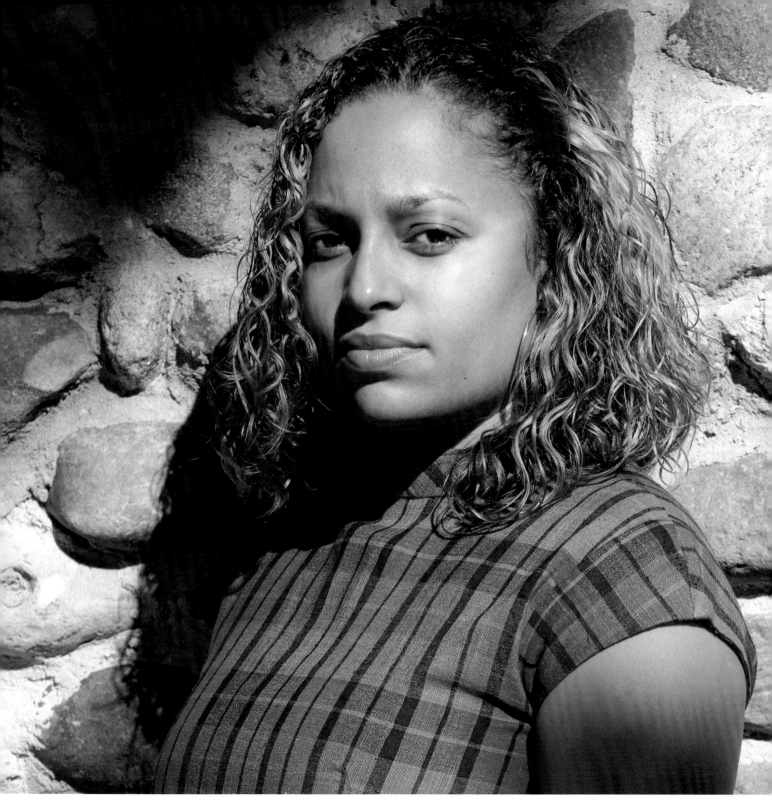

New Orleans, Louisiana. December 2011.

about what I am come into play. I remember when I was 12 or 13 years old, I spent a summer with my aunt who lived in New Jersey. She lived in an apartment complex. I remember going to the pool and there were other teenagers my age. We were all talking, and they were like, "Oh, so what are you?" And I'm like, "What? What do you mean what am I?" Since one of them was like, "I'm from Honduras," and another one was like, "I'm from Jamaica," I was like, "Oh, I'm from New Orleans." And they were like, "No, no, no. What are you?" And I was just like, "I'm Black, I'm from New Orleans. I'm New Orleans Black!" My 12- to 13-year-old world was me discovering Malcolm X. That's when people were wearing the Free South Africa medallions and the Malcolm X shirts. I read the *Autobiography of Malcolm X* and had the same consciousness-raising experience of anyone who's read that book for the first time. So I was just like, *Can't you tell that I'm Black*?! I think that was the first time I had other people of color asking me what I am, and the first time I actually had to think like, *Wow! What am I?*

From that point, I became aware of how other people perceived me, how other people saw me. A couple of years ago at one of my jobs, the first question one of my co-workers asked me was, "Are you Mixed?" And when I responded no, she was like, "Come on, seriously. Are you Mixed?" She was literally arguing me down, telling me that I must be Mixed. And I was like, "Look, I'm Black. My parents are Black. My grandparents are Black. I'm not Mixed. I'm not Biracial. I'm not part Indian. I don't have Indian in my family or none of that foolishness. I'm just Black." Whatever her definition of Black was, I just didn't fit.

In some instances, I have felt like it was a matter of kind of needing to prove how down I am. Or how Black I am. In high school, I had to take public transportation to school. And that bus route … I don't want to say it was dangerous, but it was dangerous. Everyone had on a different uniform, and you were identified and classed based on what school uniform you had on. The uniform I had on was clearly for my all-girl, all-Black Catholic school, and we were targeted. Girls from my school were being attacked on the bus. Girls were stabbed with pencils. I remember girls getting their hair cut. If you looked like me, you were perceived as an easy target. Like, *Oh, red girl*? *She scary* — meaning she's not going to defend herself or you could do her anything. You might be able to punch her and she'll just jump off the bus, because girls who look like me are not going to defend themselves, right? So for me, there was more pronounced posturing and a visible attitude like, *Look, I know you don't think you and your friends are about to sandwich me on the bus and I'm just gon' sit here and not do anything*. I never wore my hair down because I didn't want my hair to make me a target. So, back then it was clearly more of a performance, but I liken that to just knowing what the landscape was. It was like a survival mechanism.

Even now as an adult, I feel like some people have associated my hair being long and straight with me being shallow or not being Black enough. Like you can't have a Black consciousness. You can't be reading about Marcus Garvey. You can't support that. You can't be interested in Black Nationalism or Pan-Africanism because your hair is straight and you are the complexion that you are. You can't be down. So, unfortunately, in some situations with some people, I still feel like I have to prove just how Black I am.

Even though other people might not think I look Black or think I look something else, when I look in the mirror, I look Black to me. There's no way to mistake me for White, so I'm Black, and I identify very simply as a Black woman.

SUMAYA ELLARD

Atlanta, Georgia

———————◆———————

"Black American Muslim"

I started covering my hair when I was about 14. It was an adjustment for me because in our society, especially within the Black community, we define ourselves very deeply by our hair. Your hair somehow identifies who you are, how Black you are, how beautiful you are, how polished you are, or your political inclinations. It was an adjustment because it felt like I was taking away part of my identity from people. The hijab itself can be a barrier in people's perception of you and how well they think they can identify who you are. And yet, I think that's the beauty of covering. You are forced to deal with yourself and your own self-identification. You have to do a little bit more delving into who are you, what beauty means to you, and what being attractive means to you.

In Islam, covering functions as a symbol of modesty. It is literally covering your beauty. It's similar to the Christian concept that a woman's hair is her crown and glory. However, in Islam, you cover what you consider your beauty to everyone who isn't a part of your family, particularly every man who isn't a part of your family or to whom you are not married. The covering goes beyond your hair. Typically, everything should be covered except your hands, your feet, and your face. So as a disclaimer, I generally note that I do not necessarily cover correctly.

Most people assume when they look at me that I'm from somewhere else, but there is no consensus about where that is. I think the general public's association with scarves is limited to Indian, Middle Eastern, or African culture. Most people don't know very much about Islam, and their limited associations are focused on the Middle East despite the fact that only 12% of the entire Muslim world lives in the Middle East. The media propaganda and imagery of Islam very rarely shows Black American Muslims, despite having very large populations of Black American Orthodox Muslims in this country. Consequently, because the imagery is so culturally restricted, most of the public has a difficult time processing Black American Muslims.

Often when I tell people that I'm Black, it becomes this kind of ethnicity hunt, like: "OK, what is your mom? What is your dad? What are your grandparents? What are your great-grandparents?" At some point, I just have to cut the conversation off. Really? I've explained what I am. Let it go. I'm Black. I'm Muslim, if the scarf is the thing that's throwing you off. Sometimes I feel sarcastic, like responding, "Strictly slave trade. Sorry

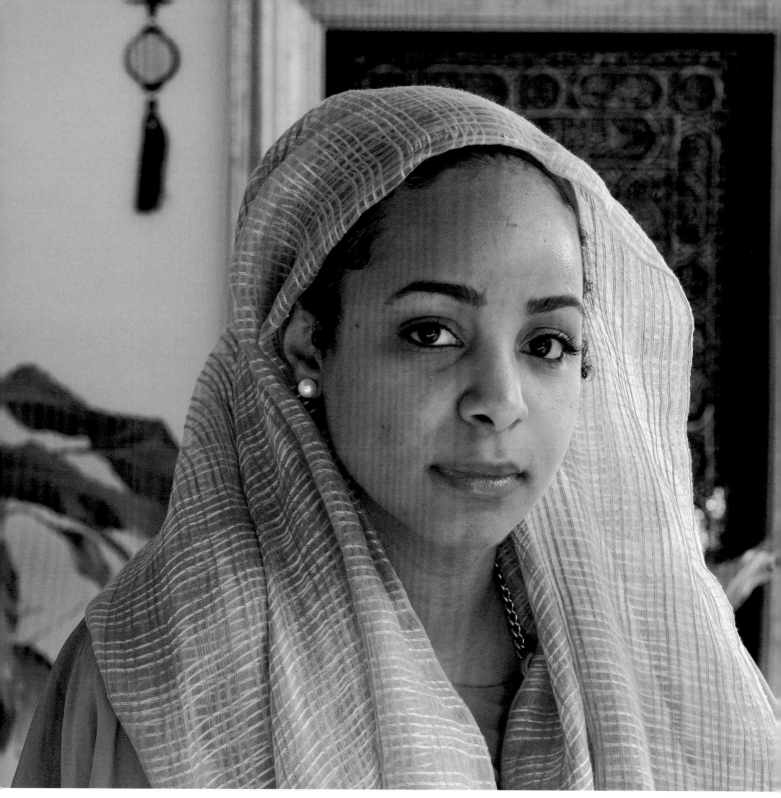

Atlanta, Georgia. December 2011.

if that is not as interesting." It's so strange because Black people are so varied that it seems odd that people have decided that there's one way to be and one way to look Black. And yet "just Black" seems to signify insufficiency because ethnicity has to be something greater, more interesting, and more exotic. So I also have to be conscious when I say, "just Black," because I don't mean it in that kind of condescending way. Instead, I mean I'm Black. That's it. Done.

I remember I had a conversation with a Jewish woman who I would see and interact with quite regularly. She expressed her discontent with what she considered the exclusivity of minority academic scholarships. I made a comment about receiving a similar scholarship for college and she was completely surprised I was Black. She spent the next five minutes telling me why I didn't look Black to her — specifically, my nose didn't look Black, my lips didn't look Black, and I didn't speak like a Black person. And I think she was 100% serious. She finished by saying, "Well, I've never seen your hair, so maybe that's why I don't know." I didn't even know how to respond. It was an extreme outlier conversation, but unwittingly she expressed an idea about which I have often wondered: Would people question my ethnicity if my hair was not covered? Still, part of me is offended by what I consider a kind of ignorance that tries to dictate one phenotypic, very exclusive way that Black people are supposed to look. Yet, the other part of me feels like maybe this person really doesn't know. Still, how do you live here and remain ignorant of the diversity? So I am conflicted in this mental battle between having a legitimate conversation to address what is being said and wanting to shut them down and the same time.

It's hard for me to disconnect how people perceive my ethnicity from my scarf because, as I stated, I have often wondered, if my hair was always visible, would they make those same assumptions? Is the scarf the source of confusion? The questions are complicated by the fact that I grew up in the South, where things were very Black or White, and often racist. And I have a tendency to get offended quickly by questions about my ethnicity because I assume the question is based on some limited understanding of what it means to be Black. As I have gotten older, I have been reminded, primarily by friends from New York, that questions regarding my ethnicity could be legitimate. Because half of America's "Black" population is indeed from other places like Dominican Republic, Puerto Rico, Guyana, Panama, not to mention any of the African countries, and, in turn, the question may be completely unrelated to the negativity underlying my personal experience.

At this point, I identify as Black. Black American Muslim. I used to say African American, but I stopped because I have so many friends who are second-generation Africans from the Continent, and "African American" felt like it more accurately described

them than it described me. It was hard for me to reconcile that our very different experiences could be described by the same identifier. I know people steered away from "Black" at some point because the word itself had negative connotations. Moreover, "African American" provided a sense of identity and connection to a pre-slavery source. That desire to feel a connection is understandable, but in my mind, I don't think there's anything wrong with being called Black. For me, it much more appropriately describes my experience, my culture, and my sense of self: I'm Black, I'm American, and I'm Muslim.

MARIANNA ROSS

Baltimore, Maryland

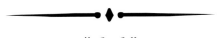

"Black"

As I've gotten older, I've definitely had male attention. A lot. I was walking to work a couple weeks ago and a guy on a bus stop was like, "You have such pretty hair. I love your hair." And my hair was in a little fuzzy bun. I'm talking about the most lazy thing I could have done to my hair that morning. It was nothing *done* about it except I slapped some gel on the edges. So what he liked was the texture. I think men, especially Black men, have a thing about this long wavy hair. I can take it back to slavery. It's like the forbidden thing that they couldn't have, they weren't allowed to have, they could be killed over — and now it's like, *I can have it and I'ma have all of it.* It's like they want the best of both worlds. They want the body of the Hottentot Venus with the head and specific features of various Puerto Rican, Asian, and White women. For them, you can't get no better than that. I remember when I was a teenager, a guy pulled up on me and said, "Girl, you should gimme your number. We should be together 'cause you got that baby mother hair." Are you serious? What kind of compliment is that? So, you want to have babies with me because of my hair texture?

Whereas Black men want to get with me, the overarching assumption from Black women is that I have an attitude. Like the age-old "Oh, she think she cute." I'd go to the hairdresser and she'd chop my hair up when I just asked for a trim. And it's almost like something in them is like, *No, you didn't come in here with all this real hair.* The same way I feel like there are the people who are abused. There are people who are used to being abused. Just because I may look like the people who have abused you does not make me an abuser. You're just projecting your own insecurities and feelings onto other people, almost like, *How could you not be thinking you cute? Deep down I think you really cute, so you gotta be thinking you cuter than everybody else.* No, actually I'm not.

For another Black person to look at me and tell me I'm not Black? That's like talking to a delusional person, and you can't rationalize with the irrational. Everything about me says I'm Black. It's no questioning that, you know? From my upbringing to my mama to the food I like to the music I listen to. You can't tell me I'm not. It's just so who I am. It's just really no discussion to be had about it. I'm Black. Are there any other questions?

162

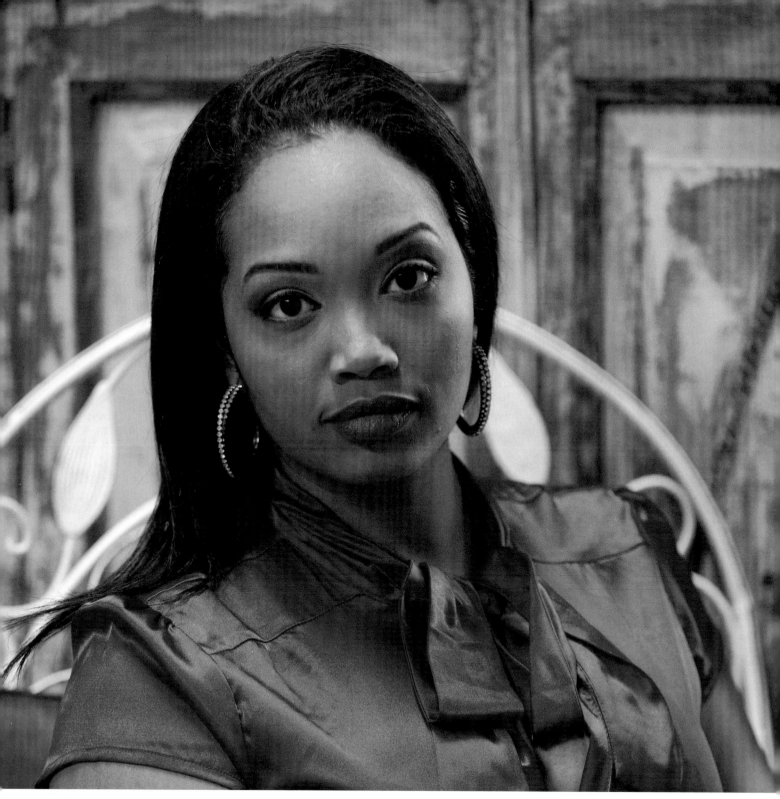

Philadelphia, Pennsylvania. April 2012.

SEAN GETHERS

Philadelphia, Pennsylvania

◆

"Black / African American"

A lot of Caucasians think I'm White because they've never run into somebody that has albinism. I'm in the nursing field, so a lot of the people that I deal with are older White women. As soon as they see my white skin, they become a little more comfortable. A White male that I cared for at work shocked me one day while we were talking about politics. He has issues with his eyes but he can recognize me and he recognizes my voice. He said to me, "So how do you feel about the president, President Barack Obama?" After I answered him, he said, "I don't get it. How do we, a White nation, elect a man like that?" In my head, I was like, *Oh my God. He's a racist*! I didn't say anything, so he just goes on and on with it because he feels comfortable with another "White man" around him. "You know, it's like we've got an orangutan in the oval office." I was floored. When they're around other White people, some White folks talk very freely about Black people. And I never knew that until that day.

At the same time, I don't feel like I'm passing. I can't hide being Black. My nose, my eyes, my lips, my cheekbones. Come on, ain't no white part of me except my skin. You can't judge a book by its cover. I know that's the oldest cliché in the world, but it's true. Don't judge me automatically because of the first thing you see. You see my skin and you automatically get your perceptions about what I'm about, but really you don't know me. So just ask and I'll tell you. I get approached at restaurants, gas stations, in the mall, everywhere. "I don't wanna offend you or anything, but ..." And before they can even say, "Are you ... ?" I'm like, " Yes, I'm an albino." Everybody asks me, "Are you Black?" "Do you have the same thing Michael Jackson has?" or "I don't mean to be in your business, but is everything that color?" I've actually had people date me because they wanted to find out if everything was that color.

Some people just don't understand that being a Black albino is part of my identity. Every culture has albinos — Black, White, Chinese, Korean, Spanish, everything. So I don't even really identify myself as a color, I identify myself as a race. I'm African American. If I say I'm a Black albino, accept me for who I am. My Blackness is important to me. I don't feel like I have to be over-Black. I don't have to prove who or what I am. I ain't gotta pull the ghetto out the trunk just to show that I'm Black. I know who I am and I'm comfortable in myself.

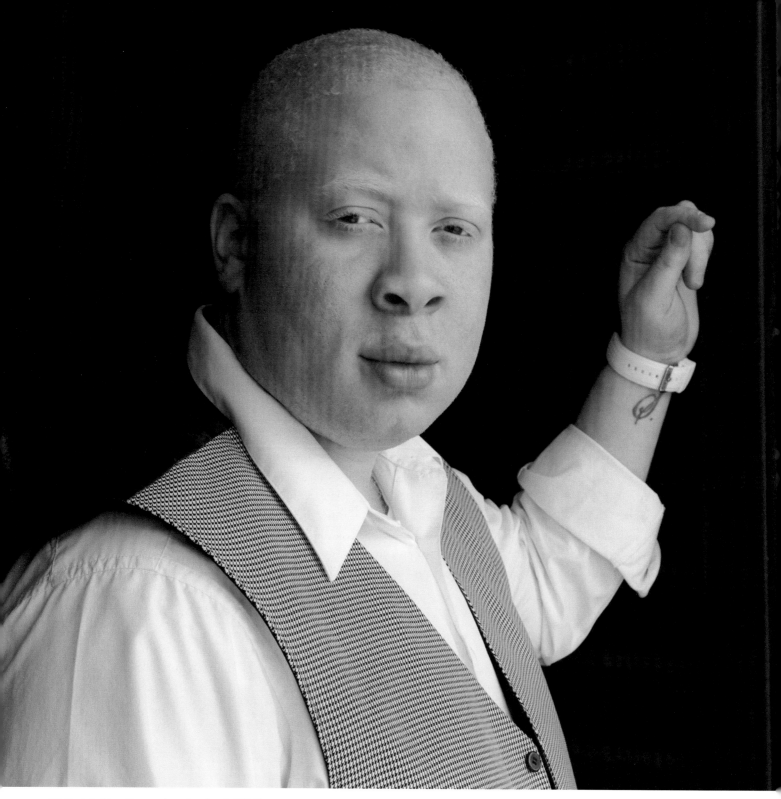

Philadelphia, Pennsylvania. April 2012.

DESTINY BIRDSONG

Nashville, Tennessee

❖

"African American / Black"

I remember a few years ago, my sister and I went to visit my mother at her school. She teaches preschool, and when we got there the children were running around, and one of the girls says, "Miss Birdsong, your daughter looks just like you!" My mother asked her, "Which one?" and she said, "The White one!" I thought that was cute. She didn't question the fact that I was my mother's child. Her language of description was about what made sense to her: *There's a White one and a Black one, and the White one looks just like you.*

Although as an adult no one has asked me, "What are you?" I'm not sure if it's completely clear to people that I'm Black. Sometimes when my boyfriend and I go out, people stare, and I get the sense that they think they're seeing an interracial couple. I don't get that as much anymore because I recently went natural, so now I think it's pretty obvious that I'm not White — my hair is not straight at all. But when I was in high school and still wearing my hair straight, I remember I went to the mall with my friends. When we walked outside to go to the car, it was raining. My two friends started running because they didn't want to get their hair wet. I think maybe one of them had just gotten her hair done. I hadn't had my hair done in months and it was already nappy, so I didn't really care. I was walking slowly. A White woman who was also coming out at the same time turned to me and said, "Why are they running? Don't they know that turds float?" That's the instance that I clearly remember being mistaken for White. But I didn't say anything to her. I think I was kind of in shock and I just walked away.

I've always had a fear of being mistaken for White because you have to deal with people's ignorance and hear things like that. It's a way that someone can use language to really erase who you are and your own past. When they're making references like that, it's not just towards the specific people that they're referring to; they're also talking about people in your family and people who you love very much. So it hurts to have to hear that ignorance like that is still present, and then have that ignorance directed against you indirectly without their knowledge. On top of all that, you also have to deal with having to explain who you are to this person who obviously doesn't know enough about phenotypes to understand that Black people aren't necessarily black. I feel disrespected because I feel so connected to my own Blackness that to be perceived as anything else is an insult.

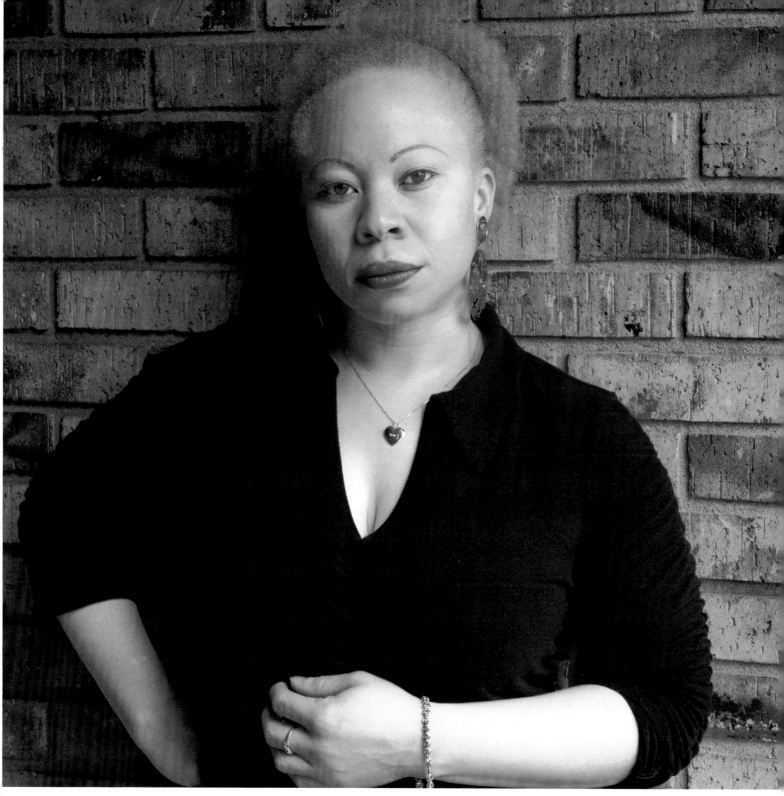

Nashville, Tennessee. December 2012.

SEMBENE MCFARLAND

Newark, New Jersey

———— ◆ ————

"Black / African American"

Vitiligo is a loss of melanin or pigment in your skin. They're not really sure why. They think it's an auto-immune disorder. The theory is that your body errantly identifies melanin as foreign and destroys it. For me, it's strictly cosmetic. It doesn't cause any other physical issues. I think mostly what I recognize as being the effects of vitiligo is psychological.

When I was 16 and it started, it was in fairly obvious areas — a small area on my neck and on my forehead. For whatever reason, it didn't bother me. I didn't focus on it. Which I guess is weird, because at that age you're usually like, *Oh my God*! But at the time, my mother had multiple sclerosis and her illness was progressing to such an extent that that was the focus of everything in my life. She also had vitiligo, the difference being she's very fair-skinned, so it wasn't as obvious as mine is.

During that time, I would lose my pigment in areas and then it would return, so I didn't pay attention to it. I was a rowdy kid, so I thought maybe I had some kind of rash or something. When I finally did realize, my father said, "You have what your mother has." And I still just thought, *OK, whatever*. Honestly, I didn't think about it very hard because I thought of my mom. I felt like it was really ungrateful and self-centered of me to sit around and feel sorry for myself. Had I not seen what she went through, I probably would have been like, *Woe is me. Why is this happening to me*? But because of her experiences, I told myself to suck it up.

When I went to college, it began in earnest. Spreading behind my ears and on the back of my neck. I never saw it, so I didn't pay attention to it. It was very, very gradual. About a year or so later, when I was around 19 or 20, the coverage became more significant, and that's when I became more self-conscious about it. I started wearing long-sleeve clothes no matter how hot it was. I was never into makeup, but I started wearing makeup. A lot of things changed. I didn't want to go places. The way I interacted with people changed. I stopped looking at people when I was talking to them. I didn't want to go places. I was very self-conscious of people looking at me, and I was very conscious of me trying to ignore that they were looking at me.

I remember meeting a gentleman once and he responded to me like he liked me. And I wondered to myself, *What if I had come in here without the makeup and just looking*

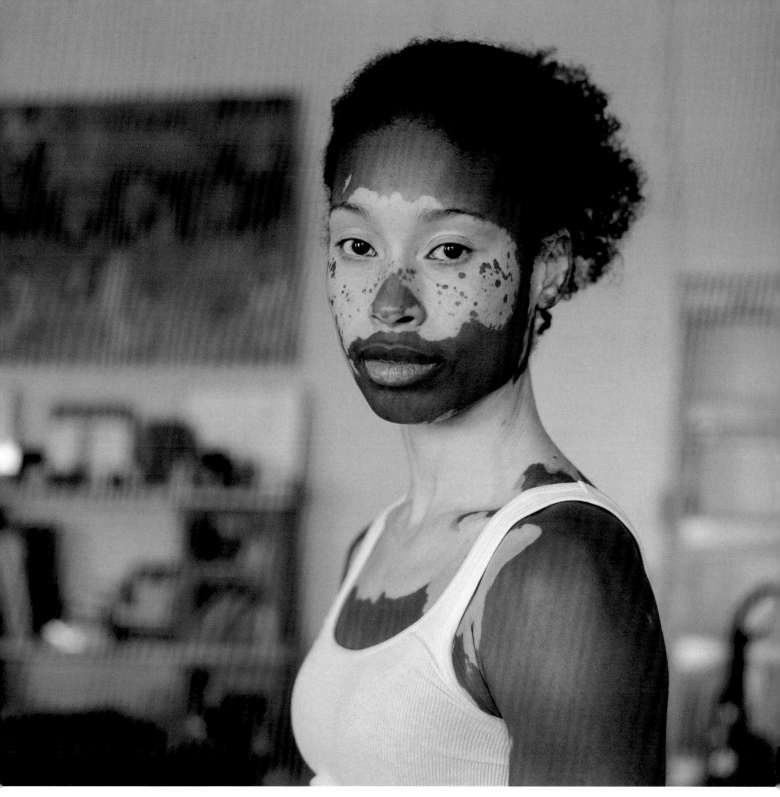

Newark, New Jersey. August 2011.

like myself? How would he have responded? So that got me to thinking, and it kinda upset me. I think I cried and boo-hooed and carried on over the weekend. Processing it. And then that was it. It was just two days in a weekend and I just said, *I'm done with this.* I threw my makeup away, and the next time I saw him, I just went as myself. And he was very standoffish. I just thought to myself, *I just weeded you out.* It's definitely been ups and downs since then, but that was essentially the end of it. I was sick of makeup being on my clothes. I was sick of hiding.

I try not to focus on people's responses too much. People stare obviously, so I stare. That's my response to it. I like children 'cause children will come right up to you and say, "What's that? What's that on your face?" One child said, "You look like a kitty cat." And I was like, "Yeah, I do. I do look like a kitty cat. You're good, kid!" But adults are kinda strange about it at times and a little silly. One lady said to me, "You know what? You would be so pretty if you got rid of the rest of the color. You would look Asian." I've actually had people ask me was I Black or was I White first. A White gentleman came up to me and said, "I thought you might be White, but then I saw your lips." Some people, it seems that the way they respond to vitiligo is to be like, *I don't know what to say. I don't want to offend her,* and for some people it loosens their tongue. I literally just have to smile and say, "God bless," because I don't know where that came from and I don't even want to devote the energy towards judging it. I would much rather you ask than stare or behave a certain way and then walk away and have no more knowledge than you did before you saw me. Ask the question that's on your face.

A lot of people just look and see skin color. *Your skin is White, therefore you're White. Or are you?* One girl said to me, "I've been wanting to ask you this question but I didn't feel comfortable asking you because I thought that you might be offended, but are you Black or are you White?" And I told her, "Well, I'm always Black." And it's funny because when we were done with the meat of the conversation, she laughed and said something about my hair and my butt gave it away. But she was just very literally looking at my skin and wondering if I was White. Since I moved up North, people always ask me if I have Asian ancestry, and I have no idea where that comes from. People definitely let you know that they view being Black as being very literal, the amount of pigment you have. I just think of that as some level of ignorance and not even in a negative sense. Just not understanding.

When I was actively seeking treatment for it, one dermatologist said to me off top, "So, what we can do is we'll give you this medication that you can put over your skin and it will gradually get rid of the rest of the pigment so it'll all be even." And I just kinda sat there and looked at him, because I had not said one word except the history of my vitiligo.

And I just said to him, "I could have that much Black left and I still don't want your cream. I'm here because I want to restore my color." He just looked at me like it had not occurred to him. That was obviously the first and the last visit.

It is possible for me to lose all of the pigment in my skin, and that does concern me. But I'm still always hopeful that it'll return to where it was, although it hasn't changed in many, many years. Honestly, I think that that would be another bridge I would have to cross, because I haven't considered losing all of it. I think I've come to a point where I've accepted where I am. This is what I still have left and I'm happy that I still have it. When I look back at pictures of how I used to look, honestly I don't know if I could really go back that way either because I've come to a point of acceptance. If it progresses, then I would accept that too and I would move on. Ultimately, in terms of identity, I don't think it matters. Even if I'm totally without pigment, it's not gonna change the way I see myself, and it's not gonna change the way people important to me see me.

Just like any of the other ways that people define being Black in a very tangible, "I can touch it, I can feel it" concrete sense, my vitiligo is a small thing. To have it and to lose it, dark skin color isn't what it is to be Black. To identify by something like physical features is extremely limited. I mean, look at me. And I'm Black.

JOANNE STEWART

King of Prussia, Pennsylvania

◆

"African American"

When I think of myself, I still think of myself as the color that I used to be, so I get a little bit annoyed when people look at me in a different way. My husband is dark-skinned, and sometimes, depending on where we are, when people see the two of us together they kind of look at us like they're trying to figure out who I am. One of his golf buddies that I met a few years ago said to him, "I always thought that your wife was White," which really surprised me because I look at myself and I see Black features. The only thing I see different is my skin color. So, it really puzzles me that people look at me and actually think that I'm White.

Recently, on two separate occasions, I was reacquainted with two friends from my past. Neither had seen me since I had lost my pigment. When I approached them, they both asked, "Who are you?" I was astonished by their response. When I told them who I was, they both said they recognized my voice but thought I was White. Of course, once I explained my circumstances to them, they apologized for not recognizing me right away. Another time, when I was in Florida a couple of years ago, this guy walked up to me and asked me if I was albino. And of course I said no. I don't think I look like an albino. Typically, albinos have light hair and their eyes are a different color. I have vitiligo. It's two totally different things.

I've had vitiligo since I was a young child. It was basically on the side of my face around my eye. And it would come and go. I didn't have that much of it. I had a couple spots on my legs, but it wasn't so much that it really bothered me. My parents took me to a doctor at a young age, but the doctors didn't know what it was back then. They had a name for it but that was it. They didn't know what caused it or knew anything about it. Later on, somewhere in the '90s, I started to lose a lot of my pigment, probably about a fourth of it. And it always seemed to start with my face. Or my hands. I found a doctor at the University of Pennsylvania who is Black and specializes in treating vitiligo. It's treated like psoriasis, where you take a drug and then you stand in a light box, and between the two, it activates the pigment cells. So I did that for probably about two or three years, three times a week, and I got all my pigment back. Then, around 2000, I started to get sick with diverticulitis and ended up having surgery to have part of my intestines removed. That's when I noticed that a lot of my pigment was starting to disappear. My doctor said

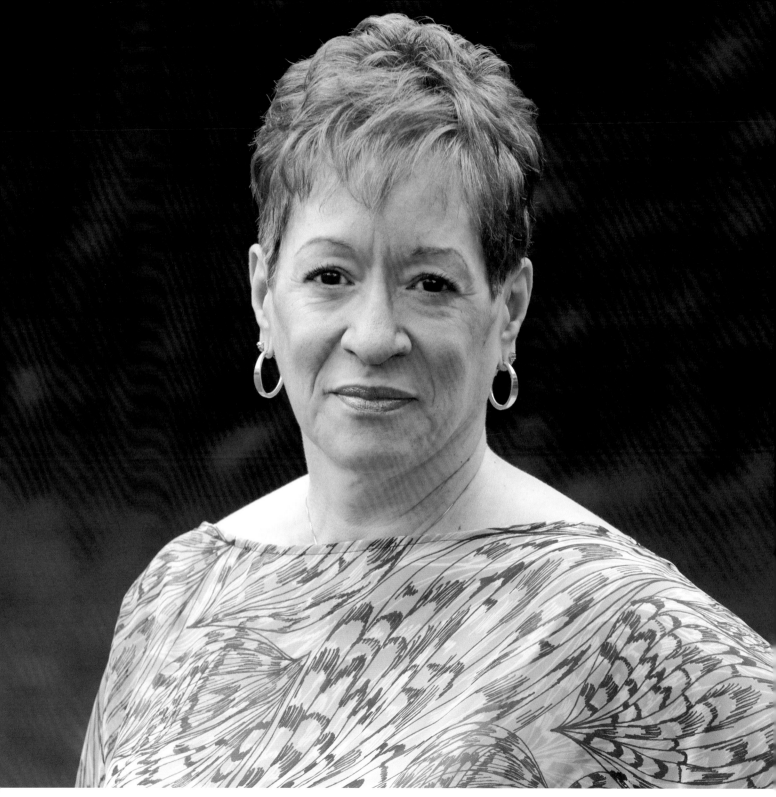

King of Prussia, Pennsylvania. September 2011.

that he thought the sudden loss of all my pigment was due to the stress of my surgery. I started wearing a lot of makeup and then I got to the point where I just said, "It's too much. I just can't do it anymore," and I stopped the treatments. By 2006, all my pigment was gone.

It was a hard thing to go through. People stare. People want to know what's wrong with you. I was constantly putting on the makeup and trying to cover up. I didn't want my skin to show. Sometimes my husband didn't know when I was going through it because I would get up in the morning and I would put my makeup on so that he never really saw it. I remember one of the doctors that I went to see asked me if I wanted to bleach my skin, but I told him no. I wasn't going to go through all that. After a while I realized that there are so many things that I have reason to be thankful for. It wasn't like I had anything fatal. I started thinking about things that other people were going through which were much worse. I used to pray about it a lot, and finally I just came to peace with it.

Whenever I hear people make negative comments about Michael Jackson or speak about how they think that he bleached his skin on purpose, I get really annoyed and become very defensive about it. They don't really know what his story was. I believe he had vitiligo. Nobody knows what he looked like beyond his hands and his face. His body could have been brown. Or he could have been all one color. Look at me. He was a very popular entertainer, and even though I didn't want to bleach my own skin, I could understand why he might want to do that. But I don't think that he did it just because he wanted to look White. I always feel the need to come to his defense: "I have the same thing that he had."

I really, really admire people that have vitiligo, especially on their face, and don't cover it up, because I have to admit, I wasn't like that. I covered mine. I was embarrassed. I was always very concerned with my appearance and how I appeared to other people. I was ashamed of it because of how people made me feel. But when I see someone like Sembene, she seems to be very accepting of who she is and what she is. And I just wish that I had had that kind of confidence. I wish I had had enough confidence where I wouldn't have tried to cover it up so much. I admire her strength for accepting herself the way that she is.

Vitiligo is not something that changes you as a person. I may not be the color I used to be, but I am the same person. I don't try to pass myself off as somebody that I'm not. I'm still who I've always been — a strong Black woman who is very proud to be a part of a race of people that have endured a lot.

Diaspora Black

Questions of Blackness — Who is Black? What exactly is Blackness and what does it mean to be Black? — are often complicated by varying constructions of Blackness throughout the world. As we turn our attention to our contributors who are from and/or live in other countries, the nuances of Blackness become more visible. In many ways, their experiences are similar to those of our African American contributors — in other ways, quite distinct.

Three of our contributors — Liliane (p. 190), Kamau (p. 194), and Guma (p. 198) — are from and currently live in São Paulo, Brasil. Whereas many scholars and journalists reflect on the seemingly ambiguous nature of race in Brasil as characteristic of a racial democracy, many Brasilians see racial politics as anything but democratic, especially those who self-identify as Black (as reflected in the terms *Negra*, *Afro-Brasileiro*, and/or *Afro-descendente*). Despite the fact that she is categorized as *parda* (a Portuguese term that encompasses various shades of brown) on her official birth record and is more often considered *morena* socially, Liliane self-identifies as Black. She notes that the indiscriminate use of *morena* — an ambiguous term meaning dark-skinned, or dark-haired, or simply brown that could be used to describe both of us alike — reflects Brasilians' subconscious attempt to distance themselves from "that negative heritage of coming from Africa," a practice she credits partially for the "whitening" of the Brasilian identity. Kamau, whose skin is brown and eyes are green, is also considered *moreno*. In his experience, people have attempted to dissuade him from self-identifying as Black because in their estimation, he's "not that Black." For Kamau, however, Brasilians' avoidance of the term "Black" only serves to mask their inherent racism — or at least they think it does.

What's interesting is that the conceptual ambiguity surrounding race in Brasil flies in the face of a quite pointed statistical reality: Brasil is home to the largest population of people of African descent *anywhere* in the world other than Nigeria. Even so, the exported imagery of Brasil has been decidedly whitewashed, particularly with regard to what Brasilians look like. One of our contributing photographers, Guma, is also the photographer behind the public campaign *Eu Africanizo São Paulo* (I Africanize São Paulo), which aims to provide greater visibility to Brasil's Black population in the media. Through his work, some of which is featured here, we are able to see Blackness in Brasil as a larger spectrum than what many of us have been exposed to.

Like Guma, two of our contributors — Brett (p. 202) and Rushay (p. 206) — have chosen to use photography as a tool through which to spark conversations about race and identity in each of their home countries, Curaçao and South Africa, respectively. Because so many people think of Curaçao as a Black Caribbean island, Brett, who was born and

raised there, is often mistaken for Dutch by the locals. In The Netherlands, his current home, his Curaçao identity is often questioned because, for many, he doesn't "look Black." Fueled by his personal experiences, Brett embarked upon his project Coming from Where I'm From to demonstrate that there is no one phenotype that comes from Curaçao. Similarly, Rushay, who is from and lives in Port Elizabeth, South Africa, launched his project Coloured: A Profile of Two Million South Africans in an attempt to show the diversity of the Coloured identity in South Africa. While he identifies as Black "in the political sense," he is clear that his identity is also mediated by the South African racial context. As he says, "If I call myself a Black South African to a Black South African, that person will not identify me as a Black South African." And so in acknowledgement of the specificity of not only his biological ancestry but the social legacy that precedes him, Rushay identifies as Coloured. Through his work, he aims to paint a broader picture of who the Coloured people are, many of whom also consider themselves Black.

Unlike the large majority of our Black American contributors, many (if not most) of our contributors from other countries and cultures discuss their Black identity as a political identity. According to Marta Moreno Vega (p. 220), founder and executive director of the Caribbean Cultural Center in New York, "There are greater numbers [of people of African descent in Latin America and the Caribbean] than we have here in the United States. Yet these populations have been marginalized and are invisible in their own countries and to the broader global community." This is one of the reasons Rosa Clemente (p. 224), 2008 Green Party vice presidential candidate, finds it imperative to announce that she is a "Black Puerto Rican woman from the South Bronx," because in her opinion "it continues to be dangerous when 'Latinos' don't have a racial consciousness." Similarly, for Malene (p. 228), who hails from Trinidad, it is fine for us to be different culturally, "but sociopolitically we need to stand with each other around the issues that affect us as a people in the United States." And while Biany (p. 232) identifies as both Afro-Dominican and Afro-Latina, whenever she is questioned, she vocally identifies as Black because "[she knows] that [her] lived experience is not as a Latina. [She is] treated as a Black American first."

Along those same lines, some contributors note the interchange between their self-perception and the perceptions of others as they navigate the politics of their identities. Divino (p. 242), who identifies as both Afro-Dominican and Afro-Latino, says that he started identifying with his Haitian heritage because everyone else in his family seemed to be avoiding it. Of course, given his appearance, his self-identification as Afro- does not go without questions; however, Divino believes that in their questioning of his Blackness, people are revealing their own relationship to Blackness and perhaps their relationship

to their own Blackness, but it has little to with him. Michael (p. 246), who identifies as Latino, finds the very act of asking someone their race racist, and for that reason, he avoids (as best he can) situations that require him to self-disclose such information. For him, the only thing someone could do with the answer to a question like "What are you?" would be to segregate, and he's simply not interested in assisting anyone in doing so. Crispin (p. 250), on the other hand, finds it necessary to announce himself as either Black and/or Mixed-race because "there are already hugely important parts of [him] that are invisible in mainstream society." However, whether or not people "approve" of his Blackness or "accept" him as Black is not his concern. As he says, "If they can't see me, it's not my problem."

Whereas Blackness is reflected primarily in skin color in the United States and as such is not an option for the large majority of people who are racialized Black, elsewhere Blackness also signifies cultural and political alignments and as such represents a decided identity. The experiences of contributors featured in this section suggest that while we are all connected genetically and culturally through an African homeland, our Blackness manifests differently and inherits variable and nuanced significance throughout the world.

KARINA DJIJO DAFEAMEKPOR

Centreville, Virginia

◆

"Ghanaian / Black / Mixed"

When people ask me, "What are you?" I usually say I'm Ghanaian. But more recently I'm finding that I have to specify what else I am because I always get that cross-eyed look, like, "*Oh, you're Ghanaian*?" Some people, especially African Americans, will say something like, "Well, most Ghanaians I know are really dark-skinned." Then I have to launch into the explanation: "Well, my mother is Ukrainian and my father is Ghanaian." And then they're satisfied. I don't think people really know what to make of me. I'm light-skinned with freckles, my features aren't necessarily what people associate with being "African," and depending upon how I wear my hair, it can either give them a clue or actually throw them off even more. So, it just depends on the situation, but I think most people assume that I'm either Black, Latina, or Mixed.

Growing up in Ghana, I was considered different. I stood out, and there was no way for me to totally blend in. I wasn't necessarily like other Ghanaians, and people made me aware of it all the time. I was called "half-caste" and *oburoni*, which basically means White person or someone from abroad. Some of the other kids thought that I thought I was better than them just because I was light-skinned. And I didn't. As an adult, it still seems like most Ghanaians who don't know me assume that I'm a foreigner. I get one of two reactions — either people seem to put a wall up, like they already have some kind of preconceived notion about me, or they are extremely enthusiastic and friendly. Sometimes when I go to the market to buy something, the merchants try to jack up the prices on me. And I say "try" because it doesn't always work. To get the fairer price, I just start speaking Twi as I approach them, just to show them that, *Look, I know what time it is. Don't treat me like I'm not a Ghanaian.* But then other times, I'll have the opposite experience. Recently, I took a taxi, and the driver was convinced I was White, even though I was speaking fluent Twi to him the entire ride: "*Eh! Oburoni! Me ware wo!*" ("Hey, White girl! I will marry you!") He was so excited! No matter what I said, I could not convince this guy that not only was I not White but that I was Ghanaian and that I was already married. I've had other men approach me who say things like, "Oh, you're so fair. You're so beautiful," out of nowhere. Even my own grandmother is excited to have white grandchildren. I'm not exactly sure what it's all about. I guess you have to trace it back to the colonial days, but in general, I think people have this belief that White people or lighter-skinned people are "better" and "better off." I mean, how else do you explain people that bleach their skin?

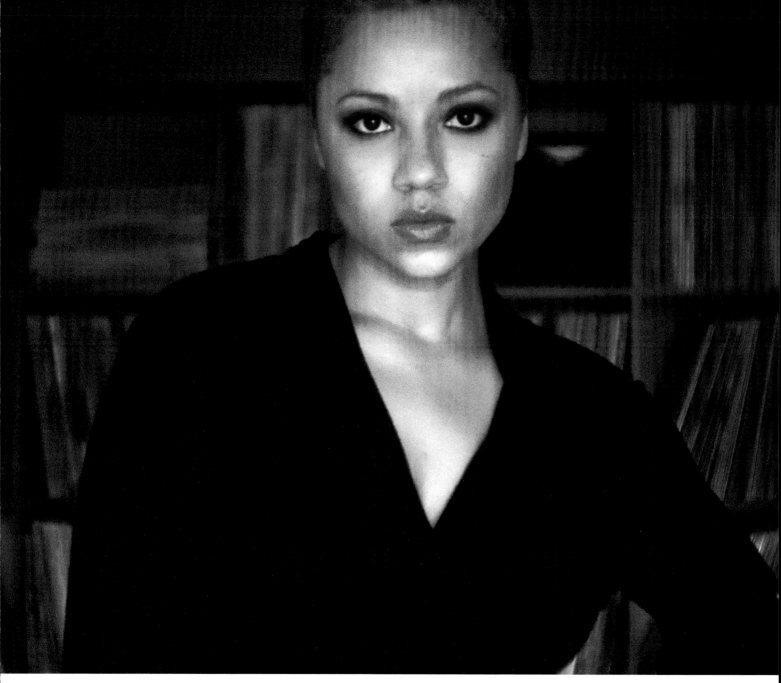

Centreville, Virginia. November 2012. (Karina Djijo Dafeamekpor)

KANEESHA PARSARD
Lynbrook, New York

—◆—

"Black / Multiracial"

In my experience, in Jamaica and other parts of the West Indies such as Trinidad and Tobago, the terms "Black" or "Negro" are often applied to people with mostly African descent, those who bear a "traditional African" phenotype. In Trinidad, *dougla* is the term used to describe people of mixed African and East Indian descent. The term is historically charged, derived from Hindi, and while the etymology is shaky, it connotes illegitimacy and can be equivalent with bastard. Phenotypically, *douglas* are difficult to describe. It refers to a brown, but I guess a deeper brown — not necessarily a lighter color, but a distinct color. They don't use *dougla* very much in Jamaica, but my dad has told me about a number of terms that are applied to Afro-Indians in Jamaica, such as *coolie*, *coolie royal*, and *kapar*, which he thinks may be similar to *kaffir*. The word *coolie* is rooted in indentured labor, referring to the Indians and Chinese peoples who migrated to the Caribbean in the 19th century and performed certain types of wage labor. They filled a void in the labor force that was left by emancipation — not very privileged forms of labor, like cutting sugar cane. So, in addition to being a racialized term, *coolie* really has a very classed dimension to it, and similar to *dougla*, it's historically charged.

People in my family have called me *coolie*. Although they're joking, it still makes me upset, not only because I'm aware of its origins, but because it marks a difference or a distance I don't feel from members of my family. There are definite privileges associated with being perceived as *coolie*. In Jamaica, people react positively to my appearance, saying that I'm very beautiful. But I never got the sense that they see me as a beautiful person necessarily. The beauty is associated with particular features I have like my hair and my skin, and in that sort of beauty lies a distinction from other Black Jamaicans. For a long time I struggled with it. I was affirmed, but it was tied to phenotype in a way that I was uncomfortable with. Most of the discomfort lies in the fact that the most influential women in my life identify as Black and are dark-skinned. I always saw myself in them. That's why questions like "What are you?" surprise me, because I associate myself with my mother and maternal grandmother and my mother's sisters. It's strange because, for a long time, I didn't realize that that was a question that my appearance demanded. The question made me feel as if people might be more interested in my difference than they were in me.

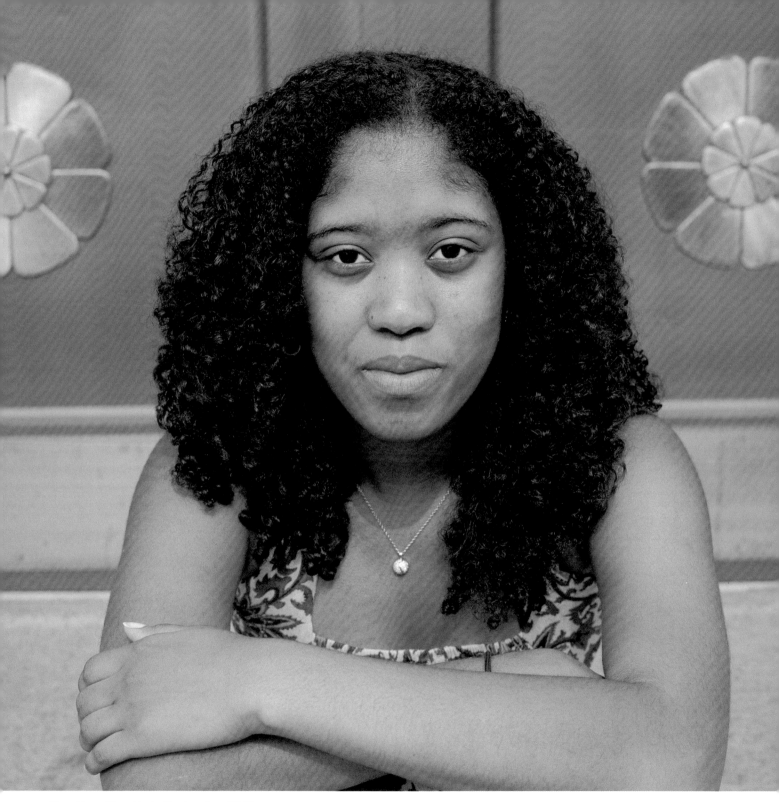

Brooklyn, New York. September 2011.

I tend to believe that being Black — like choosing to identify as Multiracial — is not about phenotype as much as it's about feelings of belonging and identification. I'm Black because I feel the memory of the Middle Passage and slavery most strongly. I'm Black because when I look in the mirror I see my mother, her mother, and my aunts. Maybe my reasoning wouldn't be strong enough for somebody who might have an immediately negative or dismissive response to my phenotype, but our cultural memories have the same roots. Their lack of acceptance doesn't compromise my Blackness. Interestingly enough, in the same way that it's the political and familial belonging I feel that influences my Blackness, it's the absence of those sorts of ties that encourages me to identify as Multiracial. I don't know my Indian family well, but my Indianness or Multiracial identity remains. It's not something that they can take away from me. Most importantly, I understand that being Black and being Multiracial are not mutually exclusive categories.

LILIANE BRAGA

São Paulo, Brasil

"Black"

Although my mother is Black and my father is White, they both come from mixed backgrounds. My mother's family is Black mixed with the Indigenous people, and my father's family is White mixed with the Indigenous people. Oddly, they are both listed as "White" on their birth records, but in society my mother is considered Black, or *morena*, and my father is considered White.

When a child is born, it's not the parents who declare the race; it is the registrar who declares the race. They look at the parents, usually the father, and if they consider the father Black, they put the child as Black. And you have that category for the rest of your life. Even though I identify as Black, the category listed on my birth record is *parda*. The term *pardo* is only used in the official policies, like the census. But on the streets or in daily life, people wouldn't mention *pardo*. For the general population, *morena* is the most used term. People would call me *morena*, but they would also call someone of a darker skin *morena* because subconsciously they believe that being *morena* distances them from that negative heritage of coming from Africa. The majority of the Brasilian population has been whitened because of this.

However, in the last 10 years or so, there have been a lot of discussions in Brasil concerning affirmative action, and the media is discussing issues of race a lot more. So nowadays more people who are educated or from higher socioeconomic backgrounds would recognize themselves as Black or having an African heritage. The results of the last census show that for the first time, the majority of the Brasilian population has not declared themselves as White. In the past, people would tell the census interviewers "I'm White" or "I'm not Black." Now, in the last 10 years, more people are saying, "I have an African heritage, so I'm Black." So, this shows how people have changed and are changing their minds about their heritage and racial category.

People of my color can be considered either Black or White, but it would depend on the situation and it would also depend on the social and educational condition of the people who are seeing you. So, what happens is that when someone of lower socioeconomic status sees me, they would treat me as White. But if I go to a high-class restaurant, where the people are of a higher status than me, people treat me as Black. Usually the general thought for Brasilians is that the place for Black people is in the kitchen or on the soccer

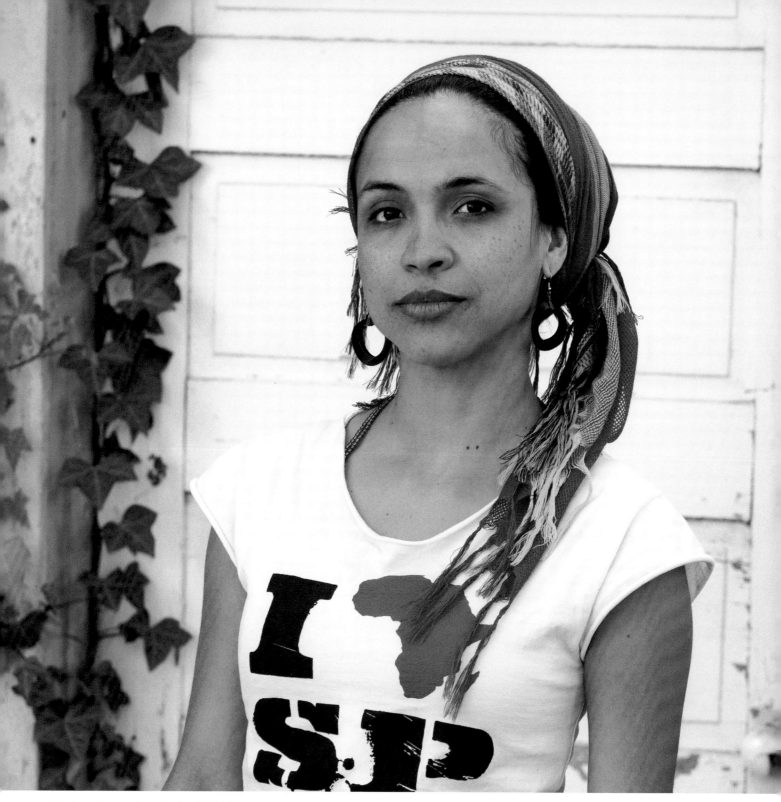

Easton, Pennsylvania. April 2012.

field or in samba. So, if you are not in one of those places, it's like, *Who are you and who allowed you to be here*? And you can feel it.

From the time I was a small child, I realized there was something different going on with me that would not make it possible for me to consider myself White or closer to my father's heritage. When I was little, I had straight hair. Then at puberty, I guess because of all the hormones, my hair become curly. Everyone made such a big deal. People didn't know how to help me deal with my hair that was changing. And I realized that to them it was changing for the worse. I remember someone saying to me, "It's a pity it's changing." Then, when I was 5 years old, I went to visit an orphanage with my parents and a group of people from their Catholic church. I was the only kid with the group. When it was time to go back to the bus to go back home, a woman who was part of the group thought that I was one of the orphans and told me that I could not enter the bus, that I would have to stay there. I didn't know why that woman treated me like that at that moment. Now I know that her mentality was that Black people's place is not here among us, and she probably felt like that about my mother too. So, that day I realized there was something different going on. First of all, all of the other kids inside the orphanage looked like my relatives, like my cousins. I thought that they were my family. And then at the same time, none of the other adults in the group were Black besides my mom. So, I felt something really different there. I identified with those kids, but I didn't identify with those adults on the bus at all.

I was also aware of how difficult my parents' marriage was because of the way my father's family treated my mother. From the beginning, my mother couldn't get along with my father's family. My father's mother didn't like the fact that he married a Black woman. She called my mom a monkey when she found out my father was dating her. She also said their marriage wouldn't last more than three months. It lasted for 19 years. My father tried, but it was not possible to have my grandmother around. I think I saw her four or five times in my entire life and she didn't live far from us.

So it feels like I've always known something was different. But in my family, this issue was never addressed by anyone. So I became curious about race. Until I was 11 years old, I studied in a public school, which means it was for free. Then my parents sent me to a private school. At the private school, I realized that there were only two other Blacks in the classroom besides me. But at my public school, 95% of the students in the class were Black. And I felt that difference. So even though I was a little girl at the time, I started relating skin color with economics from that moment. And then when I went to the university, I realized that my Black friends were also rare to find. I studied anthropology and sociology and started studying Brasilian culture and fell in love. And then I did a

master's degree in social psychology. I think because of all of my education, my family feels more comfortable talking about race with me now. Now they've started to address the issues because I let them know we have to talk about these things. Now they ask me things. They didn't know how it is in society. They didn't know the history. And nowadays we talk about that openly.

My understanding of Blackness is that it is related to your heritage and also to how people see you and treat you in society. Although I might not call the same attention as a black-skinned person because I'm lighter, I have no doubts that I am seen as Black when I'm out of my group. When I look at myself in the mirror, I see myself closer to my mom's characteristics than to my father's. And I know people see me like that too. They look at me and they see that my hair is not really straight, my nose is not thin, and I have big lips, so I cannot be White. I'm Black. I feel myself as Black. I identify as Black.

MARCUS VINICIUS A. SILVA
(aka KAMAU)
São Paulo, Brasil

"Black"

My mother always tells me a story about when I was 6 years old. I used to like a little girl at my school and we used to hang out. We just held hands and sat next to each other. And one day she just came to me and said, "We can't date because if we get married, our child will be half Black and half White, and that can't be." And I was like, *Damn. How can she say that to me*? I think that's when I really realized what it was to be Black.

Most of the time people are afraid to call you Black in Brasil. They don't wanna show how racist they are so they try lighten up the weight of the words — they say *mulato, crioulo, neguinho, moreno*. The different words hide the meaning, but if you look, the real intention is there. When I say I'm Black, they'll say, "No, you're not that Black. Péle's Black. You're not Black. You're light-skinned. You have green eyes. You're *moreno*." They call me *moreno* because they think if they call me Black, I'll be offended. But that's what I am. I don't want to *not* be Black. I wanna be who I am. But there are people that prefer not to be labeled as Black. For example, Bahia is the Blackest state outside of Africa, yet there was a recent poll that reported that only 5% of the people in Bahia said that they were Black — because they identified as *morenos* or whatever color they wanted to. I think sometimes you realize in life that it's not that good to be Black, so you just identify yourself as something else. People say, "Nah, I'm not Black. I'm Bahiano." Because it's way better to be Bahiano than Black.

Some people think that Brasil is a paradise for Black people because Black people here kinda just fit in, but I think this makes us weak. Racism here is masked. They don't say it to your face, but whenever you get to a place, like you try to get into a bank or you try to just walk on the streets, police just stops you for nothing. Because you're Black. In the U.S., it seems to me that Black people are a minority, but they fought for their rights. And we don't have those rights here because they didn't allow us to fight for our rights. They always told us that it would be alright, so we don't have to fight for our rights. But we don't have a lot of rights. I know for sure. In most cases, we don't have chances to go to good schools. We don't have good education. And I think it's a well-thought case because this way Black people can't reach higher places. I don't want to say they brainwashed us,

194

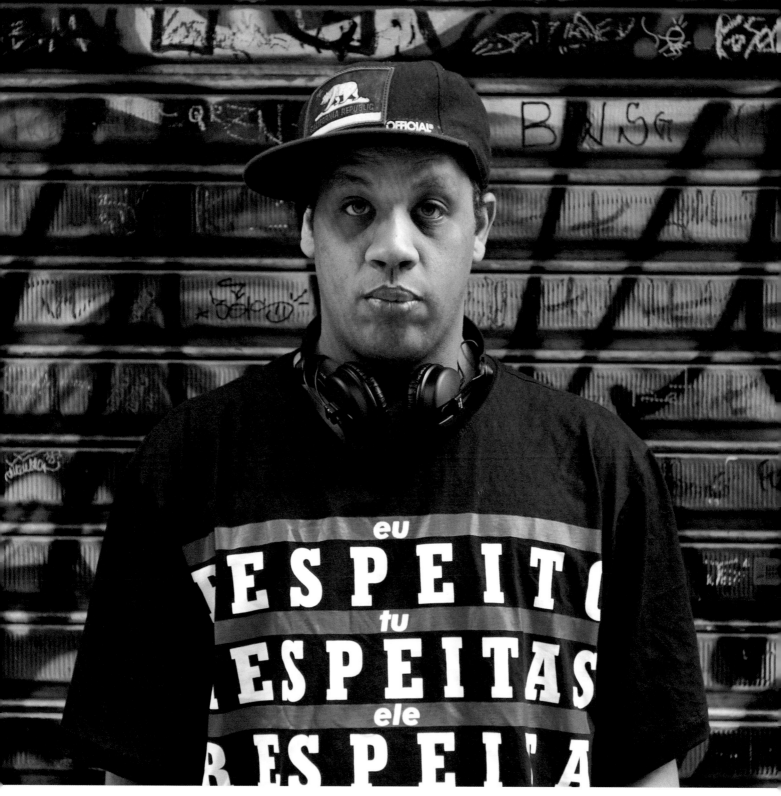

São Paulo, Brasil. October 2012. (Guma)

but they definitely planted that idea on us. There are a few people that really stand up and say what has to be said. I don't think that we could have an Obama because we don't have a lot of Black senators or representatives. We just have soccer players and musicians. That's all we see. All the politicians represent the interests of the higher classes, and when the soccer players and musicians reach a higher place, they're like, "Yeah, I'm here." I don't see Pelé fighting for the rights for the Black people. If Pelé was from the U.S., he would be a lot different. But Pelé is more like Tiger Woods — everything but Black. He doesn't stand for his people. And so that said, Brasil is not as racially equal as people paint it to the outside world.

Sometimes when you talk about race, people label you and just put you aside. So, as an artist, I talk about it. Not like NWA or Public Enemy, but I talk about it because I talk about who I am and how I live, and I can't talk about who I am and how I live without saying where I come from and what I look like or how I'm treated in my own country. I just recorded a song called "I Want More" where I say I want more than to be called the right words. I want my rights. I want the right stuff for me and my children — not to just be called the right word. Because that's just a little fight, and we gotta fight for bigger things. I say that I want more than a president, I want more than medals, I want more than crumbs, I want more than just a little quota of people who can get into the universities, I want more than that. I want a good education from the beginning. I want more than a main actress in a soap opera or on a magazine cover. I want more than that. I'm trying to teach my listeners that I'm not here to be a yes-man to a lot of things that happen. We have to fight for more than just being able to walk into a bank without being searched. We have to fight for a lot things. Fighting so that somebody won't call you a nigger? You can't achieve that. That's not the hard part of living. You have to fight for more and aim for more.

On the other verses of "I Want More," I talk about how I want more than just to be a rap artist. I want my music to really be heard. I want my audience to be inspired to fight for more, even if they see themselves in the song or not. There's a lot of White people and Japanese people that listen to my music, and they know what I'm talking about. I talk to them in the song. They respect the artists, but when I wasn't an artist and I was just another Black person on the streets, I wasn't that respected because I'm Black. So I want them to respect me and people that look like me. Not just to respect me as an artist, but the people that look like me.

I could be *moreno*, just to fit in, but I don't wanna fit in. I wanna stand out. I wanna make a difference. I'm Black. That's who I am. And to be honest, I feel stronger this way. I know my people came from Africa, and that's who I identify with. Even though some of

the Black people say I'm not that Black, they embrace me more than separate me. I know there's a lot of people in other parts of the world that would say, "Nah. You're Mixed. So you're not with us." But here in Brasil, I think the Black people who know we're Black embrace each other more because we know we have to unite to be stronger.

GUMA

São Paulo, Brasil

◆

"Afro-Brasilian"

In Brasil, people know who you are by where you are. I grew up in a poor district of Greater São Paulo. I remember when I was a child, I was on the streets with shorts and flip-flops. I had no shirt on. I was with a friend who was Black and we were going to buy a kite. I was happy — I was going out to buy my kite. Then a police officer stopped the car and put a gun to my head and said, "What are you laughing at Black boy?" I was a child, no more than 12 or 13 years old. A child. It's like I didn't deserve to be happy because I was Black. It's something that I remember until this day. It's something I think about until today. But that adult police officer did not question whether I was Black. He *knew* I was Black because of where I was — in a poor neighborhood. Now that I am an adult and I am in many different places, at first sight people look at me and already put me on the other side: *He's not Black; he's whiter.* Because I do a lot of activism and work in Afro-Brasilian culture, sometimes people look at me like, *What is he doing here? This place isn't for him.* So then I have to show them who I am.

I consider myself Black, and of Black descent, but I have other roots as well. My grandmother's mother was an Indian. My grandmother's father was Northeastern, Pernambucano, which is that *caboclo* mix — Black and Indian. From all that miscegenation, I consider myself an Afro-descendant. As much as we have African origins, we aren't African. That has to be perfectly clear. We are a mix. We live something else here. We don't live in Africa. In fact, we don't know what it's like in Africa. It's really different. For example, we have capoeira Angola. Capoeira has an African origin, but the way it is today, it's Brasilian. I think it's the same with us. We understand where we came from, but we know that we are different. We live in a different reality, so we can't say we're African. We're Afro-descendants. We're Afro-Brasilian.

Through our work with *Eu Africanizo São Paulo* (I Africanize São Paulo), we want to provide greater visibility to Brasil's Black population in the media. We also want to contribute to the self-esteem of the Black population and let everyone know that we identify with our roots and we are proud.

198

São Paulo, Brasil. October 2012. (Guma)

Eu Africanizo São Paulo
(I Africanize São Paulo)

by Guma

BRETT RUSSEL

Amsterdam, Netherlands

———◆———

"Yu'i Korsou (a child of Curaçao)"

Even though I was born and raised in Curaçao and I spoke the language, at first sight people always thought that I was Dutch. When I was growing up, the people would call me *makamba*, which is the word for Dutch in Papiamentu. It's not that I really minded them calling me that; it was more that it was not accurate. I wasn't *makamba*. Curaçao is mostly Black, but you have a lot of Dutch people living there. And there, race is very much linked to economic status — basically the whiter you are, the richer you are. So to the locals, the Dutch are known as being White and having a lot of money. And I just wasn't that. It was confusing to me as a child that they didn't understand that I was born there too. For them to call me *makamba* it was obvious that they were only basing it on how I looked.

Then, when I came to Holland in 2001, the people saw me as "the immigrant." All of a sudden, I was "the Black guy." It was frustrating. There was no explanation for it, and I realized how little I had actually thought about myself in the context of race. People would start talking to me thinking I was from some place that I'm not from. When they would hear me talk, they would recognize the accent and that would change everything because here in Holland, Antilleans don't have the best reputation. The media portrays us as criminals. In Curaçao, whenever you get to talk to people, the racial issues go away more quickly. When people think I'm *makamba*, I start talking to them, and within five minutes I'm one of them. But in Holland, no matter what you do, you're still an Antillean boy.

At one point it seemed like every day, a couple of times a day, someone would ask me, "Where are you from?" And when I would tell them, they'd say something like, "You're from Curaçao? How can that be? or "You ain't Black." It's amazing how little the Dutch know of where I come from for it to be a former colony and still be part of the kingdom. Whenever you say, "I'm from Curaçao," people automatically think Black. That happens in Holland and in Curaçao also. Having that experience over and over again is the reason I made the series Coming From Where I'm From, to show the diversity of the people from Curaçao. I want people to see that there is no one phenotype that comes from Curaçao.

Amsterdam, Netherlands. October 2012. (Richard Terborg)

Coming From Where I'm From
by Brett Russel

205

RUSHAY BOOYSEN

Port Elizabeth, Capetown (South Africa)

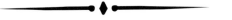

"Coloured South African"

In the South African context, Coloured is not a race. It's an amalgamation of various races and cultures. Depending on what part of South Africa you're in, you'll find that Coloured people have different mixes. If you go to Durban, the basic mixture would be Indian, European, and Zulu. On my end of South Africa, it would be a mixture of European, the indigenous Khoisan/San people, and Bantustan. It becomes complex because you have some Coloureds that have more Malay blood in them, some have more Chinese blood, some have more Indian blood. Then you have different looks. Skin color and hair texture have also played a role in categorizing South Africans. The lighter you are, the prettier you are considered to be. Back in apartheid days, they had something called "the pencil test." Basically they stick a pencil through your hair and if the pencil slid right through without any interruptions, you'd be categorized as Coloured. But if the pencil stopped along the way, you'd be categorized as Black.

Coloured is an identity that's based not only on what you look like but also on the specific cultural context. You'll find a person that would be categorized as Black South African and then you'll find a South African Coloured that is just as dark, with some of the same features, but in the cultural context, depending upon the language they speak and how they speak it, you're able to put them in different categories. So it becomes very refined. And confusing. I dated a girl — her mother is a Black Tswana and her father is Polish. Within our cultural context, she is not considered Coloured because she's not the seed that comes from this generational line that's been here for hundreds of years. She's just a mixture of Black and White. She doesn't necessarily consider herself Coloured, but a Black South African viewing her might call her Coloured. It's tricky, and because of all these differences, it's difficult for someone like that to place themselves within this new post-independence South Africa.

The model of apartheid also created a divide between Coloureds and Black South Africans. You had Whites at the top, and then you had Asians, and then you had Coloureds, and then you had Blacks at the bottom line. Coloureds received a bit more than Blacks, but neither was ever well off. So there's been tension between the two groups. Not to the point where you can say they hate each other, but there is definitely a feeling of "you people," both referring to the other as the opposite. They don't see each other as the same,

206

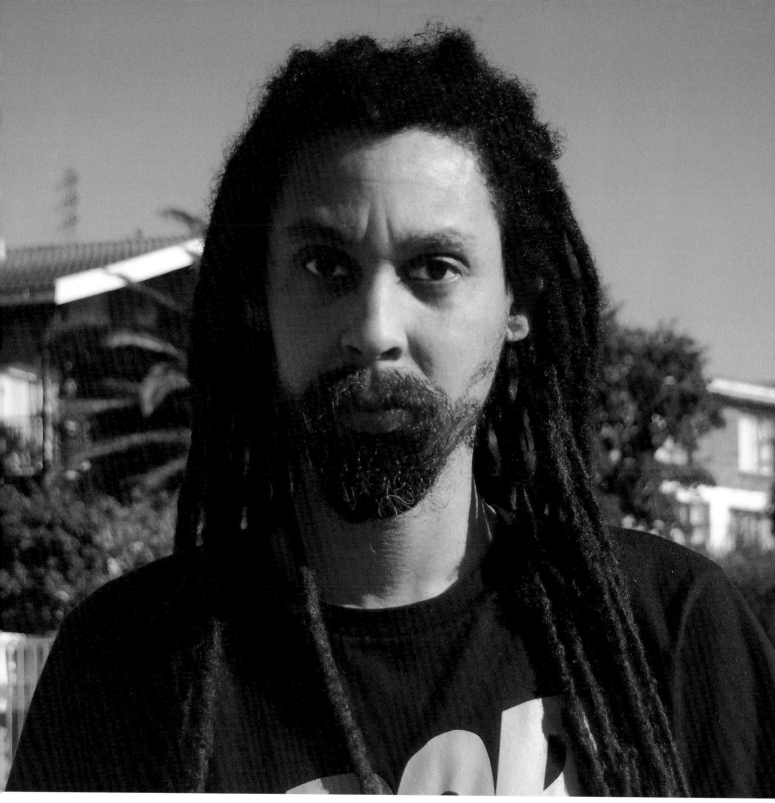

Port Elizabeth, South Africa. May 2012. (Rushay Booysen)

though historically they share common heritage. These boundaries have been created, and apartheid played a huge role within it. Lately there's been a shift in the relationship between the two, which has been very tense. With the end of apartheid, the South African government also introduced policies like affirmative action, which places Black people in front of Coloureds, and that has caused a lot of tension.

As for me, people are not able to place me in a box. Most of the time they think I'm foreign — I think because I don't necessarily fit the Coloured stereotype. Apartheid is gone, but people still group themselves. I'm around all sorts of people. I have friends from various races and cultures. I've been to the Black townships when it was not considered safe to go there, but I've always been interested in exploring and understanding my country. The first time I went to a Black township, the kids called me *mlungu* ("White man") and they all asked me for hugs. People are especially amazed by my hair, maybe because they think I'm White, and White people are not supposed to have this hair. I went once to Soweto with a friend of mine, and she was speaking Sotho with one of the guys. Obviously I know some of the phrases, and the guy asked her, "Who's this White man?" And I responded, "Where's the White man?"

There's a strong attachment to ethnic grouping in South Africa. If you're Zulu, if you're Khoi, if you're San — whatever it is, people are proud to proclaim that. And unfortunately you cannot just go into a group and proclaim it. In the political sense I definitely identify as Black, but if I call myself a Black South African to a Black South African, that person will not identify me as a Black South African. Because for as much as these identities are about so-called race, they are also about class and about culture. Coloureds are the product of Black, White, etc., etc., and whatever comes in between. We are the product of these, but we are not any of these, and we've faced rejection from both sides. In most cases, the exact mixture isn't even traceable. It's like five generations or more. So in the South African cultural context, I must identify as Coloured.

Anytime I travel, especially to the United States, I know how shocking it is for Black Americans to hear me call myself Coloured, so I always take the time to address my identity. This is who I am, this is my history, this is my struggle. But I know it's very confusing for them. Once you say you're Coloured and you say you're not considered Black, there's obviously a tendency to want to think that you're trying to shy away from your Black history or your Black heritage. People become very offended, but it's important for me to relay my history so that they can understand. I've never tried to assimilate to make it easier for me. I think one problem that I've viewed a lot in South Africa is that we assimilate a lot into American history and we're not able to counter with our own history. So it's important for me as an African from the Southern part of Africa to be able

to depict our own history. I'm very proud of my history, my heritage, and I want to share that with more people around that world.

Everybody's got their own history, and I'd like people to respect that. When I view a person in my community that is of Malay descent, I don't want to force on them, "You're Khoisan. You have Khoisan in your bloodline!" Yes, they might have it, but you have to respect that person's historical background as well. That is why taking these portraits has become a mission for me. For me, it's a matter of respecting a people's heritage and history.

My own project Coloured is named after a book written in 1977 called *Coloured, a Profile of Two Million South Africans*. It explains a lot about the history and complexity of the Coloured category. It has stories from Coloured families. The book was actually banned at one point. Even though we think we're over two million now, I wondered how I could depict us all. Because when I look around me, when I look at my family, I see all different shades, different complexions, different hair textures, and I wanted to show the beauty of us all. So I started collecting these images, and I'm still collecting. I'm building a collage that I hopefully can use as part of a larger discussion about African identity. Because when people think Africa, they just think Black Africans. Dark-skinned people. They don't see a variety. They don't know that we can have so many looks and features.

Coloured: A Profile of Two Million South Africans
by Rushay Booysen

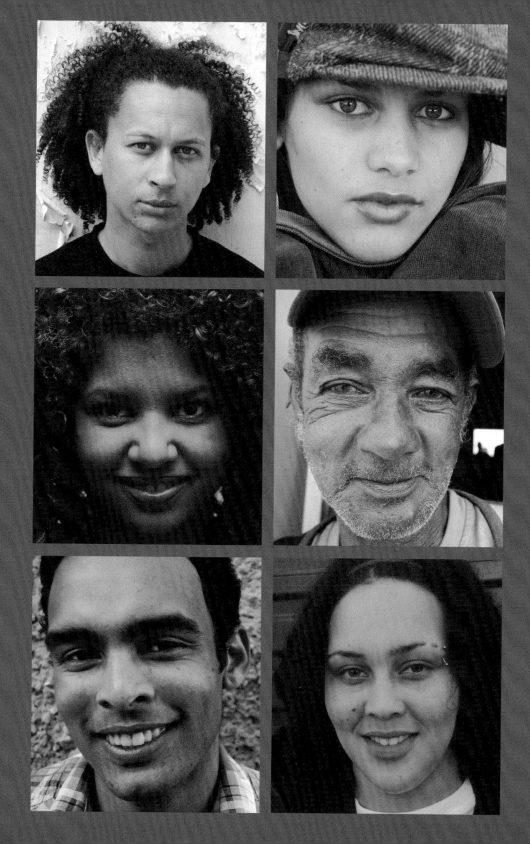

211

DENISE BEEK

Philadelphia, Pennsylvania

———— ◆ ————

"Black / West Indian"

I'm Black. And that's what I tell people. But then I always have to break it down because I get "the look." You know, kind of like skepticism, like, *You're not really all Black, are you? Are you sure?* And so I say, "My mom's Jamaican, my father is Bermudian." And then it's like, "Oh." I don't really think about what people are thinking about, but I'm assuming they probably instantly think I am Mixed — that I have to be Black and something else. And with that, I think they assume all kinds of things about my personality and my attitude.

I've only been to Jamaica once, but I've been to Bermuda several times, and Bermuda is like a hodgepodge, a melting pot. The community is diverse, so nobody's asking any questions about who I am or where I fit. But here, people definitely ask questions. Maybe not to my face, but I know they have questions. At work, my White counterparts don't really know how to place me and I can just tell that they spend a lot of time trying to figure me out. It's not something that they'll necessarily say or do, but I can just tell. If I say certain things or talk about the weekend I had or the family time I spent, they look at me like, *Oh, I didn't know that you would do that.* I don't want to say I'm indifferent about it, but I'm just like, that's their problem. I don't have the space to try and figure it out for you. And if you can't ask me, then I can't help you. And the thing is, I wouldn't mind being asked. Just ask. I'm not offended.

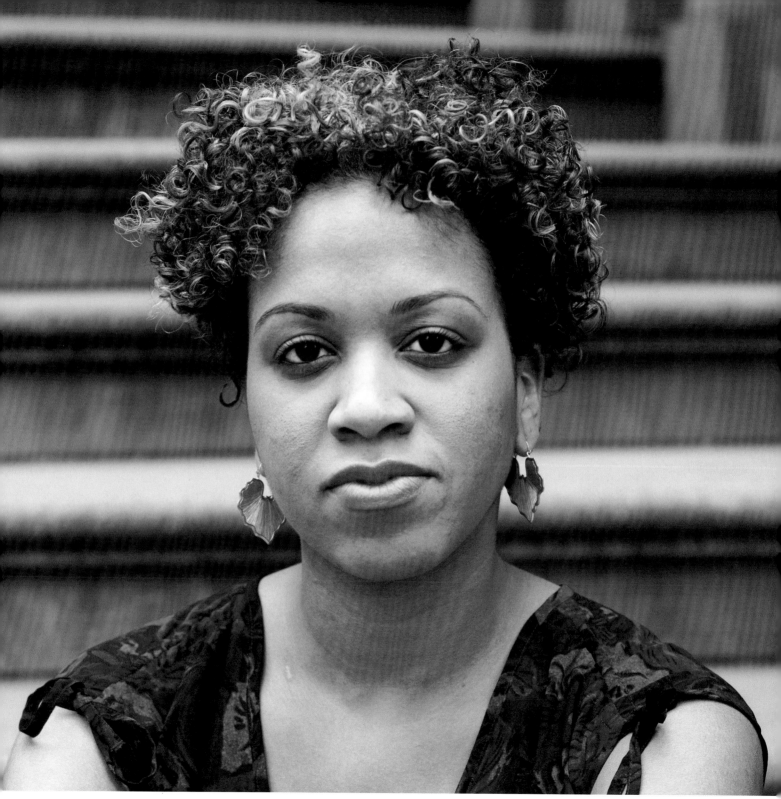

Philadelphia, Pennsylvania. April 2012.

TONY MUHAMMAD
Miami, Florida

"Original / Aboriginal Man"

In Cuba and many Spanish-speaking islands, they have a song in which the question is asked, "*Y tu abuela, donde está?*" ("And your grandmother, where is she?"), which stems from a practice of hiding the grandmother whenever there would be a visitor. The grandmother would have some obvious Black or African features and she would be hidden in the room or in the closet because they did not want whoever was visiting to see the grandmother with her broad nose, full lips, and kinky hair. In my own family, I have an uncle who was born with golden curly locks, but after he turned 3 years old, his hair started getting dark and it became "nappy." My grandmother did not like the texture or the color of his hair anymore, so she bleached it. And she continuously did it throughout his youth. There's been such a strong effort to get away from Blackness and Indigenousness in Cuba for generations that they've been able to get away from a racialized identity. There were no White women from Spain traveling to Cuba prior to the 1800s, so who were these Spanish men having sex with? And having children with? Definitely not anyone White. Over the centuries, that offspring became lighter and lighter. And the lighter they became, the more they hid the fact that they were of African or *Indio* descent.

The way I came into the realization of my identity was really through listening to the hip-hop music of the late '80s and early '90s. I started listening to certain songs, and certain people would be mentioned like Malcolm X. I read the *Autobiography of Malcolm X* when I was in high school, before the movie came out. That was the first book I read cover to cover out of my own choosing. After that, I continued to study and at that time, because I wasn't really aware of my own history in terms of my Latin American or Cuban background, the names that kept on being mentioned in the music were the names I wanted to research — the Huey P. Newtons and the H. Rap Browns. Later on, when I was in college, I started looking closely into the Hon. Minister Louis Farrakhan, and it was through my exposure to the Nation of Islam that I began to understand that our identity has to be linked with the Creator. It's like when a painter paints a picture, that picture is named after the artist. When you see a painting by Picasso, typically you don't say whatever name Picasso gave it. No, you say that's a Picasso. So if God made us, then who are we the mirror reflection of? We are the mirror reflection of God. So I would identify myself as an Original Man. An Aboriginal Man. Black and Brown people are the original people of this world, and that's whom I identify with despite my light hue.

Miami, Florida. February 2012.

SOSENA SOLOMON

Brooklyn, New York

———— ◆ ————

"Ethiopian"

In my experience, it's been my hair that's been more of an issue than my skin color. People totally change the way they treat me when my hair is different. When I wear my hair straight, people don't look twice. I look normal, and I guess I'm safe. If my hair is straight, people think I'm Indian. Then it's like this whole other situation with a whole other set of stereotypes. But if my hair is curly, it's more risky. Then people are like, "Is she Black? She can't be Black. Is she Jamaican? Oh, she has some mix of something. But she's definitely got some Black." People always do that. But then people who understand Ethiopian features do call me out and say I'm Ethiopian. Most people are just very Black or White. "You're Black. Period. You're not White."

And I hate to say it but it's true — there's some privilege in my hair. I've heard "You have good hair" all my life. And I never really understood, like "What do you mean? I know a lot of people who have my hair." Especially when I was in Philly at Temple, a lot of women were like, "You're so lucky." Why does that make me lucky? Just because my hair is curly? I didn't really get it because I think it's all beautiful. Straight, curly, natural, permed. I remember at one point, I was pissed about it. Like why is everyone like, "Oh, you got that good hair." Especially the guys. I never had someone really break it down to me. Then I started reading books like *The Blacker the Berry* and I finally got it. I just think it's unfortunate. And I feel it in Ethiopia too. They just feel like I'm so lucky that I don't have to perm my hair.

Here in the U.S., people want to know color, but where I'm from, how you identify is by region or tribe. So I'd say, "I'm Amhara." That's how we identify because we don't have White people. That's all we are — we're Ethiopian. If I grew up in Ethiopia and never came here, maybe I would not feel Black. When you say "Black" in Ethiopia it just means "dark," it doesn't say anything about your identity. It's just a color. Just a description. But growing up here, I've learned how Black really is an identity.

Brooklyn, New York. October 2011.

ADRIAN ROMAN

Brooklyn, New York

◆

"Black Puerto Rican"

For White people, it's easy for people to know what they are. For most African Americans, it's easy for people to know what they are. For Latinos, it's a little more complicated, especially if you're from the Caribbean. It's just a big mixture of people. When you're in Puerto Rico, people don't say they're Afro–Puerto Rican — they're just Puerto Rican. The dark-skinned people are Puerto Rican, and the light-skinned people are Puerto Rican. But when you come here, because White people are the majority, just saying that you're Puerto Rican is not enough. What does that mean? Are you White or are you Black? For me, the only thing that connects me to the Spaniards is my language. And, I guess, my light skin. I can't say I'm Taíno because I haven't lived that. The people that I come from and the culture that I've been raised in is more African than anything. So to me, I'm Black.

Who I understand myself to be has a lot to do with where my ancestors are from, my understanding of my history and my culture, the way I was raised, and my consciousness. So, the label I choose to put on myself has to reflect all of that.

Brooklyn, New York. September 2012.

MARTA MORENO VEGA

Bronx, New York

———•◆•———

"Afro–Puerto Rican"

The cultural nuances that define me are branches of the same tree. How I identify at any given moment depends on the forums I'm in and the strategic political situation being addressed. And depending on the circumstances and situations, different parts of my experiences kick in. So when people try to develop one definition of identity that is static, it makes no sense because our lives are not static. They are constantly evolving and are fluid. I'm a woman, mother, aunt, grandmother, educator, cultural advocate, arts administrator, author, and institution builder. I live multiple lives and have multiple realities. All the identities I embrace are connected to my realities and I can flow through them all without them being at odds. It's a constant growth process. My experiences continue to add to my thinking and to my narrative: I'm a descendant of Africa, born in *el barrio* of Puerto Rican parents who lived their lives honoring being Afro–Puerto Ricans and instilling that pride within me. I'm Afro–Puerto Rican. That's a long way of saying it.

I grew up in East Harlem surrounded by friends that were African American, West Indian Caribbean, and Spanish-speaking Caribbean. We grew up on the same block, in each other's homes, eating each other's food, listening to Frankie Lymon and the Teenagers, Tito Puente, Little Richard, Fats Domino, and Machito. That fluidity was always there, but the civil rights and Black power movements gave us voice. The process of identifying who we were as Afro-Boricuas as the civil rights movement evolved became critical in defining my racial and cultural place. For many African Americans, we weren't Black. Yet for Nuyoricans, those of us brought up in New York, we were clear that we were Black. We lived within two worlds. The process of self-identification was about claiming our space as Afro–Puerto Ricans and as part of the civil rights movement. We're Black *and* Puerto Rican. All these years later, it's still confusing for a lot of people.

Oftentimes people assume that I'm African American. I'll go to a bodega and I'll speak to the employees in Spanish. They will look at me and respond in English although they can barely speak it and are the same complexion as me or darker. But it doesn't bother me. I know that whoever is talking to me is either denying themselves or denying the presence of Blacks in their own countries. So my response is, "*Yo hablo español. Yo soy Puertorriqueña. Tú tienes Negro en Santo Domingo!*" ("I speak Spanish. I'm Puerto Rican. You have Blacks in Santo Domingo!") And they're like, "No, no, no. You look like

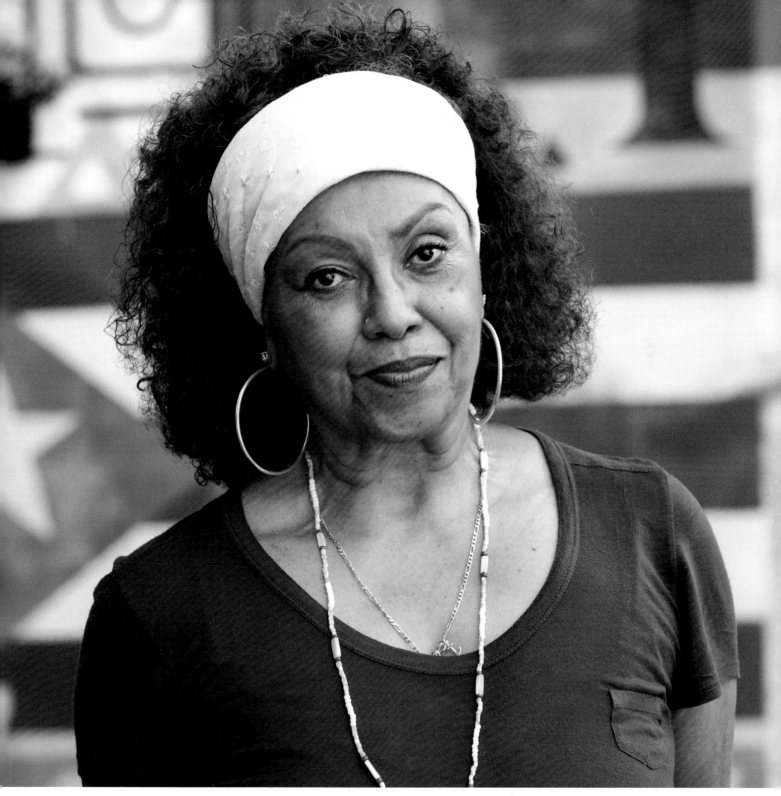

Harlem, New York. October 2011.

an American." But I know that it is racism and a way of denying their racial identity and status. Maintaining a Spanish accent is a form of sustaining a separation between Black Latinos and African Americans.

In Latin America and the Spanish-speaking Caribbean, there are so many countries, so many racial and cultural mixtures, and so many nations that have different political realities. All of these countries received African enslaved peoples and all of these countries now have African descendants. There's an estimated African-descended population of 250 million people throughout Latin America and Spanish-speaking Caribbean. There are greater numbers there than we have here in the United States. Yet these populations have been marginalized and are invisible in their own countries and to the broader global community.

Racism and skin color are major issues wherever African Diaspora communities are, and that includes Africa. We're a product of colonization. And what was colonization? Imposing a foreign system that degraded us and our culture to say that we're not good enough unless we look and act like them. So that now when you go to Puerto Rico, for example, all of the public media representatives are light-skinned, bleached blondes. In Africa and throughout the Caribbean and Latin America, the harmful bleaching of skin is a common practice. You visit offices and everyone of authority is very light-skinned or a light tan complexion, but not much darker than that. Even in Cuba you see the same thing. The Cuban Revolution has not been successful in eradicating racism.

Years ago, the Caribbean Cultural Center African Diaspora Institute had an incredible concert at Carnegie Hall. We had Celia Cruz, Tito Puente, and a host of others. Our MCs were Malin Falu and Felipe Luciano, both of dark complexion and both award-winning artists. We went to one of the Spanish language stations and requested that they video the concert. The station said, "Well, we'll document it for you, but for the actual concert we want to change the MCs." I said, "Excuse me? Why would you want to change the MCs? These are professionals, these are award winners ..." "No, no, no. We want to use our MCs." When they identified the MCs, they were both Caucasian Latinos. I said, "No, well, then you can't do it," and I walked away. The next day I receive a call, "Marta, we have an idea. We'll film the final rehearsal with your MCs. Then at Carnegie Hall, we'll use our MCs." I again responded, "No!" Understand the decisions I had to make. We didn't have the money to pay Carnegie Hall to film the concert. What was the result? The historic concert was not filmed. How am I going to look at myself with respect if I act disrespectfully? The principles that my parents taught me matter to me, and there was no way I was going to let them put two so-called White Latinos up there to MC an Afro-Latin concert that I put together for our community. Integrity, principle, and self-respect are

critical.

We have the power to create whatever we want to create to address the issues we need to address as a people. I've created institutions and programs to reflect the principles that are grounded in the cultural legacy that I reflect, because I never felt that I fit within the structures that existed. Creating the Caribbean Cultural Center African Diaspora Institute was about connecting African Diaspora cultures with the cultures of origin on the Continent. It was about building an institution that dealt with the spectrum of who we were and are as a people. That is the work that inherently addresses issues of identity. Our experiences are rooted in the same place, but because of enslavement and colonization, our experiences in the Diaspora differ although part of the same root. I've always felt that when people understand that, then we can begin to dialogue and understand each other. That doesn't mean that we'll have an instant connection or that I'll love you instantly. But it does mean that rather than function from ignorance, we'll begin to understand the historical journey that defines each of our realities and move forward.

The impact of the Center and the work we have created has been far greater than anything I would have imagined. When we started, "Diaspora" was not a popular term. I would get calls from people telling me, "'Diaspora' is a Jewish word. You are not supposed to be using it. Don't you dare use it for the dispersal of Africans." Our own communities were not using it. Now most of the organizations focused on Africans, and Africans in the Americas have added "Diaspora" to their work. Now it's become a trend to use the word. Even though people are using the word, it's still not a practice to include African descendants from diverse cultures. At the Center, when we do programs, we work to ensure the inclusion of the diversity we represent. And it's purposeful. And I'm not only talking about Africa and the African Diaspora. I work in networks that include Asians, Native Americans, and Europeans. We have to understand where our needs and interests are similar. The key is working towards the same goals with intent. You have to have intentionality to make things happen. So Diaspora is not just a word — it's a work process that requires commitment.

ROSA CLEMENTE
South Bronx, New York

"Black Puerto Rican"

I identify as a Black Puerto Rican woman. I didn't really start calling myself that until I was in college and became very aware of pretty much everything I didn't know about my people. But I don't necessarily think there was a thought process involved.

I went to a high school that was half White, half Black, and me. I was the only Latina. My best friend, Tanya, was Black, and I remember she asked me to join the Martin Luther King Jr. Club, and I did. So by the time I had gotten to college, I had been hanging around mostly Black folks. And because I didn't speak Spanish and wasn't fully bilingual, I didn't really fit in with a lot of the Latino students.

Then in 1992, I met Marta Moreno Vega, the executive director of the Caribbean Cultural Center, who to this day is my mentor and a mentor to a lot of us. She came to our campus to give the keynote speech for Hispanic Heritage Month. When she gave the speech, she was affirming that she was Black and that she was African. And I had never heard that. After she spoke, it was silence. I remember we were in this huge room and it was like 500 people. Three people out of 500 stood up and clapped. Only three. Everybody's reaction was like, *What is this? This is Hispanic Heritage Month and she's talking about Africa, and Cuba, and Santeria?*

I stayed connected to Marta, and by the following year, I ran and became president of the Black Student Union. And it was a big deal. At that time, BSUs were critically important. If you weren't in the BSU, you were wack. We had 1,000 members that came on a regular weekly basis to meetings. So then I become the president. It was like, *Who's this Puerto Rican chick running the BSU?* The next day, some of the African American students were like, "She shouldn't be president." But the Constitution of Albany State University Black Alliance said "people of African descent." This means Puerto Ricans too. Then Latinos felt like I sold out. People were coming up to me, people were writing articles in the paper. Imagine if we had had Facebook and Twitter back then. I would have broken on the first day because the pressure would have been too much.

I remember one of my professors, Dr. Vivian Verdell Gordon, would always tell me, "You're bicultural." That's how she put it at that time. One day, we were talking about all the heat I was catching from everybody and she basically told me that that's what it means to be a leader in our community. If you're doing this kind of work, you have to

224

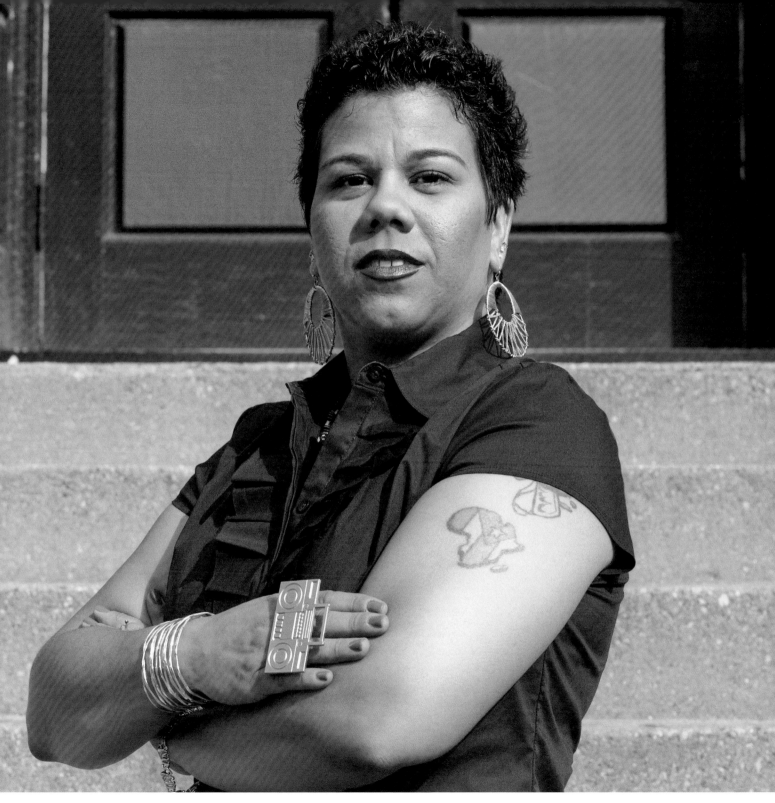

Amherst, Massachusetts. September 2011.

understand that everything is political. She helped me make that connection between politics and race. Then I just fell into a leadership role.

You have a lot of incredible Afro-Latino activists who still don't say that they're Black. What they say is that they're African-descended. They say they're Afro-Latino. But a lot of cats still won't say that they're Black. I think most of people's issue with calling themselves Black is psychological. It's fear. If you don't have to be Black, why would you want to say that? In this country, everything that's Black is negative. Again, I didn't start calling myself Black until I was a sophomore in college. Even though I grew up around Blacks and Latinos, I didn't know anything about our history. But once I learned the about the power of the Young Lords and the Black Power movement, I was like, *Why wouldn't I want to say I was Black*?

Obviously some of my sister-friends would say to me, "You don't know what it's like to be a dark Black woman. You still have privilege." And I had to be like, "No, you're right. I agree." I don't have the same experience as a dark-skinned sister. I have straight hair. I am light even for being Boricua. So I also have to humble myself. I see that now with a lot of younger Afro-Latinos, whether academics or activists or both. They don't humble themselves to that particular difference. There has been systematic White institutional slavery based on skin color privilege, so as a light-skinned African or Black person, you are not going to be dealing with even half the stuff that someone dark-skinned deals with. For the most part, we all are African-descended, but there's experiences that are different. And if you live in a country full of skin color privilege, you have to understand that you still have privilege.

But at the same time, that doesn't change the fact that I'm Black. Nor does it give you the right to think you're going to check my Blackness. In college, people came at me so hard, so I had no choice but to start deflecting that. I am not trying to prove to you that I'm Black. In 2001, I wrote an article called "Who is Black?" because of an experience I had within my organization, Malcolm X Grassroots Movement. I was in one of my meetings and one of my comrades said to me, "Really, Rosa, you're not really Black." And he was laughing, but I had heard that so much that I just went off on him. I know he didn't mean it like that because I know him, but it was just that moment where I was like, *I'm sick of this*! And I literally went and wrote that article. Since then, if that has come up, I probably told somebody off, because I don't even get to the point where I feel I need to explain that. If you say that to me, I'm walking away from you. Like, here's a book. Holler at me later. I'm not going to have this discussion with you. At all.

To me, being Black in this country is a political choice, because if we really want to get down to it and understand race as a social construct, we understand how even

White people who came out of indentured servitude had to become White. Then you start to understand that how you identify is a political choice that you're making. When the president hasn't said that he's a Black man since he ran for office, he is making a political choice not to offend White people who don't want to hear that. Every time I do a speech: "My name is Rosa Clemente. I'm a Black Puerto Rican woman from the South Bronx." And I've had many of my friends ask me, "Yo! Why do you always have to say that?" Because nobody's saying it yet. Because it's 2011 and we've got 20-year-old Black Dominicans and Puerto Ricans running around like they don't think they're Black. They don't have any relationship to their Blackness politically. And it continues to be dangerous when Latinos don't have a racial consciousness. "Latino" means nothing. "Latino" is a reaction to the word "Hispanic." It's supposed to mean some type of political unity. But when you don't understand race, how do you have political unity?

How you choose to call yourself, I would never disrespect that. I would never say that you're wrong. But what I am saying is that you're not being very smart politically. That's why we're in the situation we're in, particularly with the immigrant human rights struggle. Those cats at the borders are being attacked because they're Afro-Latino. Straight up. If those were all-White Latino immigrants, we all know we wouldn't be having this conversation. We understand why the institution of White supremacy is doing this. So even though they might not ever say that they're Afro-Mexican, we have to say that they're Afro-Mexican. "Latino" is now the worst thing we could be saying. But I also think it's easier for people to be on that one-third theory — one-third African, one-third Spanish, one-third Indigenous. Well, Black people in Mississippi are one-third everything too, but they're still Black. But again, because I never want somebody to tell me who the hell I am, I'm never going to tell them that.

MALENE YOUNGLAO

Brooklyn, New York

—◆—

"Black of Mixed heritage"

I think people choose to be Black. It's a sociopolitical choice, especially in today's landscape where diversity is acknowledged. Politically I'm a Black woman; my identity is a whole different conversation. I'm Black, but in reality I'm of Mixed heritage. I'm Trinidadian by birth. My grandmother is Martiniquan, of African and Chinese descent. My grandfather is White Venezuelan and Chinese, which makes my dad two parts Chinese, African, and Spaniard. On my mom's paternal side, they're African and Portuguese, but that mix is more like slave owner raping slave. On her maternal side, we're descendants of African slaves that fought on the side of the British during the American Revolution and were awarded their freedom. During that revolution, some Africans were sent to Canada, some were sent to Liberia, and others to the Caribbean, and my ancestors were a part of that bunch. So my ancestors are Chinese and they are Venezuelan and they are African and they are African American and they are White. It took me a while to become comfortable with saying I was of Mixed heritage and embracing that, because I grew up "red, black, and green," but it's never muddied my view on who I am sociopolitically.

I was politicized at a very early age. My mom is a radical, and I was raised with a very strict sense of my African self. When I migrated to the United States as a child, identity politics were a little bit more linear because there was a lot more going on. This was the '80s and it was like the middle of the crack era, Bush years, Reagan years, recession times, and things were so dire out here for people of color. Black people especially. I think in times of distress, like those times, we have to stick to the thing that holds us together — the thing that unifies us. And that's our Blackness. Our Diasporic Africanness. And even then, it was just our Blackness.

I spent my life back and forth between here with my mom and Trinidad with my dad. Trinidad was totally different than living here. Trinidad is a cosmopolitan nation, probably more racially diverse than the rest of the Caribbean. We have descendants of European enslavers, freed Africans and enslaved Africans, Chinese and other Asian migrants, and a small East Indian population. You have all these mixtures, and the mixtures are acknowledged. So I'm not Black in Trinidad; they consider me to be Chinese Creole. They use all kinds of terms to identify people based on their racial makeup: Indian, *Negro*, Creole, Chinese Creole, Spanish, *coolie*, *dougla*. A *coolie*, for example, is an East

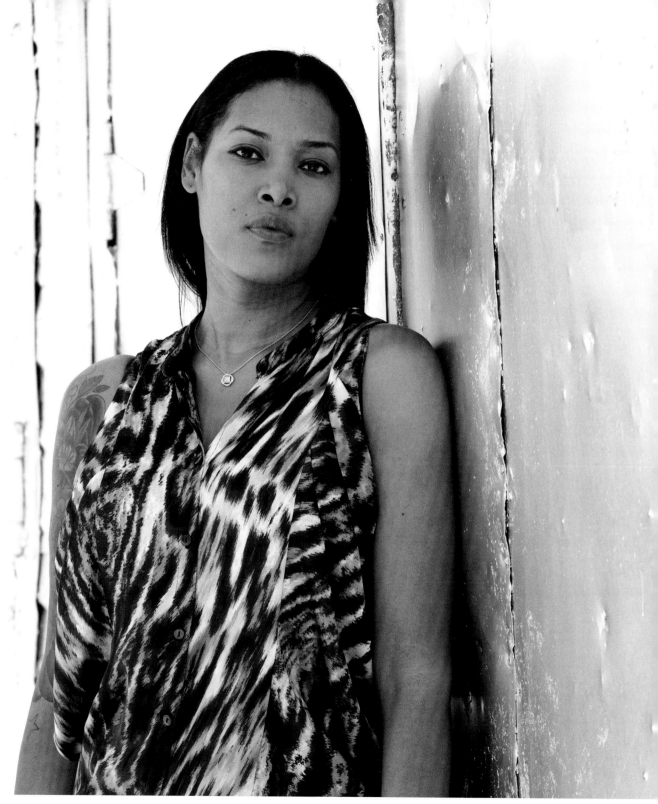

Brooklyn, New York. September 2012.

Indian. *Dougla* is the mix of Black and East Indian. There's really no difference between the two. It's like saying "nigger" and "nigga." To me, it's all offensive. All of it comes from hateful places.

My whole life, I've had my identity be questioned on a consistent basis. Asian people tell me there's no way I could be Mixed because I'm a Black girl. African Americans tell me, "You're not Black." When I'm in Trinidad, I'm too American, and when I'm in America, I'm too Trinidadian. Racially, I'm too Mixed to be Black, and then I'm too Black to be Mixed. In some spaces, the way I look works in my favor; in other spaces it doesn't. I know that there are certain things that I am afforded because I am light-skinned and my hair is long, like affection, attention, monetary opportunities. And because of those privileges, in certain circles, light skin ain't the right skin. For some brothas, like Nationalist Movement brothas, I'm not Black enough. I'm not dark enough. I'm not African enough. With some sistas there's beef. I walk into a room and there's hate. Everybody has insecurities, but based on society's celebration of Eurocentricity, some sistas get a really bad way to go, a hard row to hoe. So, hurt people hurt people, and I get that, but you will not try to make me feel guilty. Feel guilty for being me? Never. I love being me.

A big part of my issue is people's ignorance about what it is to be Black. It really bothers me. Blackness is not only a skin color. You have Black people that are light enough to pass for White, but they are Black. What separates them from somebody that does pass? It's a choice. Being Black is a choice. It is an acculturation. It's the music you listen to, it's the food you eat, it's the people you hang around, it's the stuff that you like, it's the way that you speak, it's the way you move. But there's a duality to everything, and I'll admit there have been times where I've been offended to have been called Black. It's like, *No, I'm Black but I'm of Mixed heritage*. I think it's wonderful to acknowledge where you come from. In my religion, we honor all our ancestors. And I can't just honor ancestors in my bloodline that come from Africa. My ancestors go as far back as China. I grew up eating bok choy. When I go to the family reunion, everybody looks different. I like that. I embrace that and I acknowledge that.

I think people need to stop being so politically correct and just be honest. The fact of the matter is, yes, we're African, but we are not Africans of the Continent. We're Diasporic, and that's what unites us. Some of us were left in Cuba, some of us were left in the United States, some of us went to South America, some of us were dropped off in the Caribbean. And there, based on whatever was happening indigenously in that part of the world, we integrated our own customs into the customs of our enslavers. It's twofold identity, which we as Diasporic Africans need to embrace. The Continental experience

is different than the Diasporic experience, and that's OK. It's not a dis to say that the Diasporic experience is different. It is different. When we come here to America, we are not just seamlessly integrated into African American culture. We are different and we are treated as such within the United States. However, racially there are issues that affect us as people of color in the United States, and sociopolitically we need to stand with each other around those issues.

BIANY PÉREZ

Philadelphia, Pennsylvania

◆

"Afro-Dominican"

I don't think people ever see me and think, *Oh, I should have known you were Dominican!* That never happens. Instead, I always get, "You speak Spanish so well!" I should — it's my first language.

I was on the bus a few days ago and I was on the phone with my mother. I was really upset about something and I was telling her about it. People were turning around staring at me. And I thought to myself, *I must be loud. Let me lower my voice.* But people were staring at me even more. I noticed this one woman, she didn't even care; she was just staring directly at me. In my mind, and probably on my face, I was like, *Can I help you?* I told my mom I would call her back, and the lady asked me, "What language are you speaking?" I was so surprised. I was thrown off. Doesn't everybody know Spanish at this point? She was just stunned that Spanish was coming out of my mouth, out of this Black body. And it wasn't a "Wow, she speaks Spanish." It was more like, "Why is she speaking Spanish?" It's interesting because I remember in high school, I was on the train, and there were these two guys sitting across from me talking about me in Spanish. They were Dominican dudes and they were my complexion. "Oh, she's pretty but she's too dark." And I was like, "I know what you're saying and I don't care. You're Black like me, and I'm Dominican just like you." I said it in Spanish, and they were stunned. I was really hurt because one, they were talking about me, and two, I felt very invisible. And I don't think that experience was any different from my experience on the bus a couple of days ago. It's the same thing without saying it: I don't belong.

I don't think people see me as Latina because there's this view of Latinas as sort of White and monolithic or as Biracial. Like the Jennifer Lopez. The Rosie Pérez. The light skin, "good hair" stereotypical Latina. Not people like me. I have to constantly be like, "Yes, there are people that look like me where I'm from. There are people that look like you where I'm from." It's annoying, because I'm sick of teaching people — I am Black. And I'm Dominican.

It sounds funny now, but I always thought I was really dark. I thought I was the darkest person in my family. When I was little, I was called *trigueña* because God forbid you call anybody in my family Black. *Trigueña* means "brown-skinned," like you're brown or you have color. When I was little my mom was really obsessed with it. She wouldn't

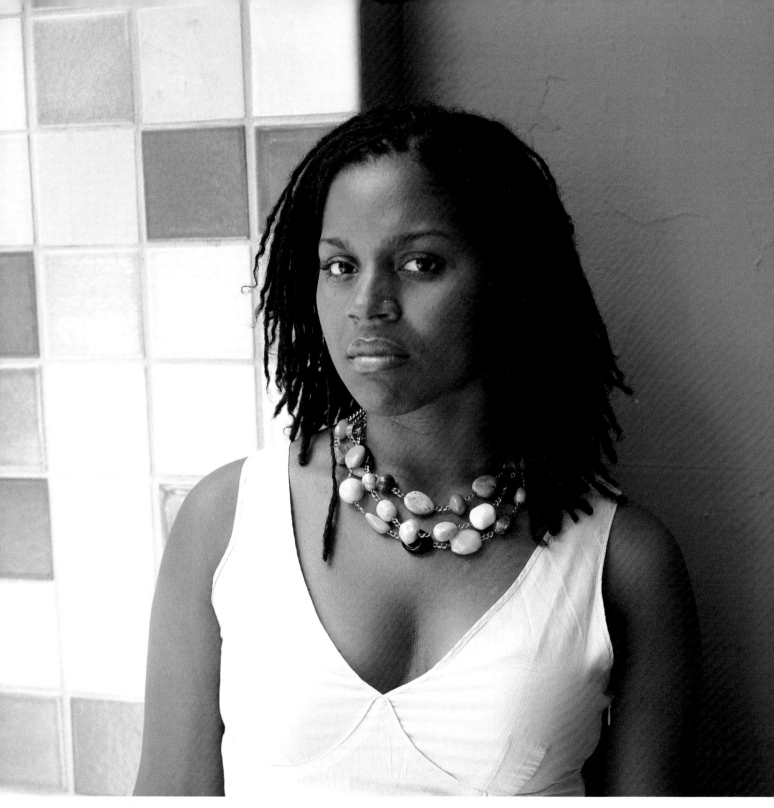

Philadelphia, Pennsylvania. September 2011.

want us in the sun too long. " No, get outta the sun. You're gonna get too dark." That was impressed upon us early on. From other family members it was, "Oh, you're so pretty even though you're dark," or "Oh my God, she's dark, but at least she got pretty hair!" Because if you're dark, that's fine. But if your hair is "good?" You're good. You're set for life. I remember this one torturous hair session when I was 16. My aunt was straightening my hair and she said to me, "Aww, you're gonna look just like a Chinese woman." And I remember sitting on the chair not feeling good about that, like, *I don't wanna look like a Chinese woman. I wanna look like Biany.* Now that I have locs, people definitely don't see me as Dominican. Dominicans are known for bone straight hair, and I don't fit that mold. When I went to D.R. last year, my family was very upset that I had locs: "Your hair's a mess!" They were just so distracted by it and really obsessing over it: "Oh, you're one of those kind of people! You think you Black." And truthfully, I felt very comfortable in my skin. Those were painful experiences for me because they highlighted that idea that hiding your hair texture, or hiding that part of you, makes you less Black. And less Haitian. Because if you're Black, you're Haitian. And then you're not Dominican.

And it feels bad saying. I just feel like I'm kinda airing out a lot of dirty laundry. Because I'm not really Dominican if I do that, and it makes me uncomfortable. I never felt Dominican, fully Dominican, because people say I'm always betraying our culture. That I'm siding with Haitians, as if we're not Haitian, you know? Dominican identity, the patriotism of being Dominican is rooted in being anti-Haitian, and because I'm not like that, it puts me as a traitor. Hearing myself, I always wonder, *Do I hate being Dominican*? And that's not true. I'm really proud of it. But I think we also have to talk about the things that make us ugly to get to the conversation about who we are.

Most times when people ask me, "What are you?" I say I'm Black. Although I do identify as Afro-Latina, I'm very careful about saying it because I want you to understand that I'm Black first. Yes, I'm Latina, but I know that my lived experience is not as a Latina. I'm treated as a Black American first. I'm Black first, and it is because of my experience. I also think that we have to be really careful about the language we use. Latino doesn't mean Spanish. Hispanic does, but Latino doesn't. There are communities that are using the terms interchangeably and they're not. We constantly talk about Hispanics, but what about Brasil? They don't speak Spanish. They're not Latinos, not Hispanic. Folks in Guatemala speak Garifuna. They're Latinos, not Hispanic. And they're all Black. Plus, if you think about it, the term "Afro-Latina" is an oxymoron in some ways. The word "Latino" itself means "diverse." It's rooted in African, it's rooted in Indigenous, it's rooted in so many things. So it's like saying the same thing twice.

I think for me, Black is more all-encompassing. It's not, *Oh, I'm Black and you're*

not! It's unifying. It unites me with my brothers and sisters in Brasil, and my brothers and sisters in Germany. So I really see it as a political term. It's rooted in our ancestry. I know that I have family that came from Africa and, yes, you see it in my phenotypical appearance. But I also know that some of my family is directly from Spain. That's something I can't deny, it's a part of me. For me, Black takes all of that into account.

TAMARA THOMAS
Washington, D.C.

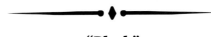

"Black"

I was raised in Trinidad and Tobago. And though we're a very mixed population, I grew up with Black people, people who identified themselves as Black. My family is mixed – one of my dad's great-great-grandparents was Portuguese; and on my mother's side, her great-grandmother was Carib, and someone else was either Scottish or Irish; but because everyone has Black in them, we grew up knowing ourselves to be Black. In the broader world, or at least in the U.S., you hear everyone trying to fight to be different things – *I am this and that* or *I'm more this than that*. But in Trinidad, or should I say in my family, we grew up knowing that if you're not White, you're Black.

In Trinidad, there are a lot of people like me. And different variations of people like me. We have a term called "mixed up." It describes people who look like they have elements of different races in them. You could be really dark-skinned and have straight or wavy hair. Most times, that means you have an African and Indian mix. Or you might have that and then also have Asian eyes. Or have a lighter skin with kinkier hair. Trinidadians come in all different phenotypes. So when I'm in Trinidad, I'm just a Trinidadian and I feel very comfortable. But here, I think people pick up on my different elements and they're confused by it. When I first got here, people would always ask me, "What are you? What are you mixed with?" And I would just say, "I'm from Trinidad." And they would be like, "Well, what does that mean? What are you?" And it made me start to question how people see me.

I remember when I went to Ghana on study abroad, we went to the slave dungeons. They call them "castles," but I call them dungeons. This particular time they had a ceremony at night, and one of the Ghanaian guys who I was talking with for a while said something about "you Whites," and I started to cry. And I don't think I've ever had that experience emotionally because I felt like, *You don't know your own history*. They have these dungeons there and they still don't really get it. I'm like, *I am a product of this and you're rejecting me*? When I started to cry, he couldn't understand what was wrong. I said, "You're rejecting me." And he said, "No, we love White people." And I just thought to myself, *You still don't get it!* Nobody had ever thought I was White until I went to Africa.

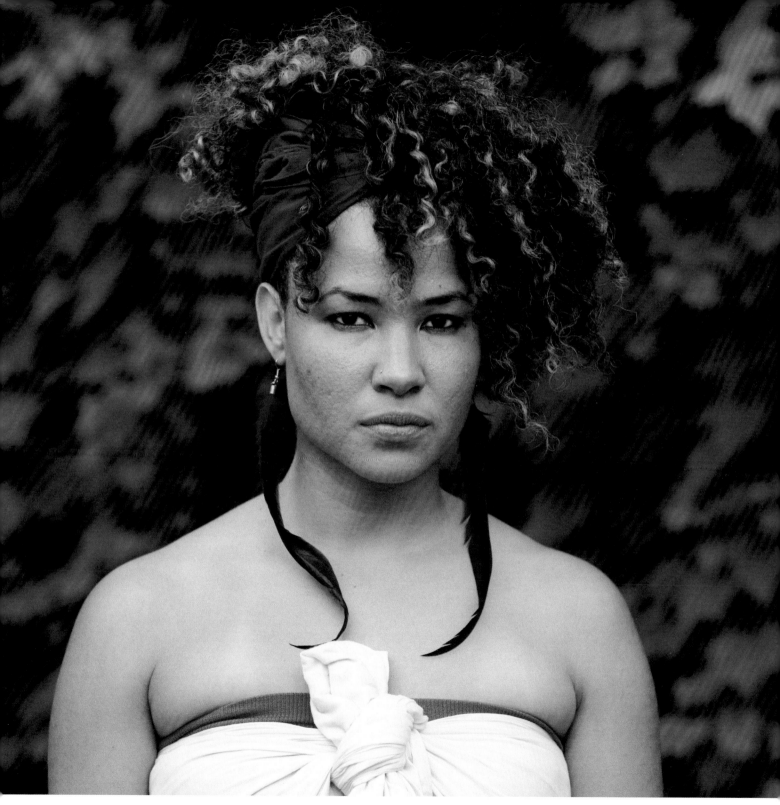

Washington, D.C. July 2012.

MERON WONDWOSEN

Washington, D.C.

———— ◆ ————

"Ethiopian / African/Black"

How people read me when we first meet really depends on whether they have ever lived in an area with a large population of Ethiopians. If not, they'll say, "Are you from Trinidad? Are you Guyanese?" People who are Indian or Bangladeshi, particularly in New York, will also assume I'm one of them. I've gotten Brasilian and a whole variety of other races. Sometimes it's simply curiosity. But in other instances, there is a sort of assumption of, *Well, no, you can't possibly be African.* There's this idea that there's only one way to be African. I remember I was in Brasil in 2007 and I was in a room with this brother who was very clear about what he considered an African or Black woman should look like. She had to have a particular skin tone, she had to have a particular body type, and she had to have a particular kind of hair. And I was sitting there with one of my girlfriends and we started laughing because what he described was not anything like either of us. So she said to him, "That's really interesting because there's only one person in this room who's actually born on the African continent and what you described doesn't fit her at all." I think it took him a while to understand that you can't just say that an African or Black person should look like *x*, and that is the beauty of Blackness. There is this amazing range of how we look in the same way that our histories across the Diaspora also vary. However, at the end of the day, regardless of how we look and as varied as our histories may be, we are all African.

Anytime I talk about race and identity, I use the example of a Tiger Woods versus a Barack Obama. You have Tiger Woods, who is very clear that he does not identify as Black; he identifies as a mixture of Asian, White, and Black, and whatever. Then you have Barack Obama, who is very clear about the fact that although he has a White mother, he identifies as a Black man. Looking at them on the surface, if neither of them was famous, with our ideas of what Blackness is or what Black people look like, no one is going to say, "Oh, Tiger Woods is not a Black man." So while self-identity is important, it's also really about how society views you. So for the person who would say I'm not African or I'm not Black — well, I don't know. The police think I'm African. The police think I'm Black. Everyone identifies me as African or as Black, but more importantly, I identify as African. I identify as Black.

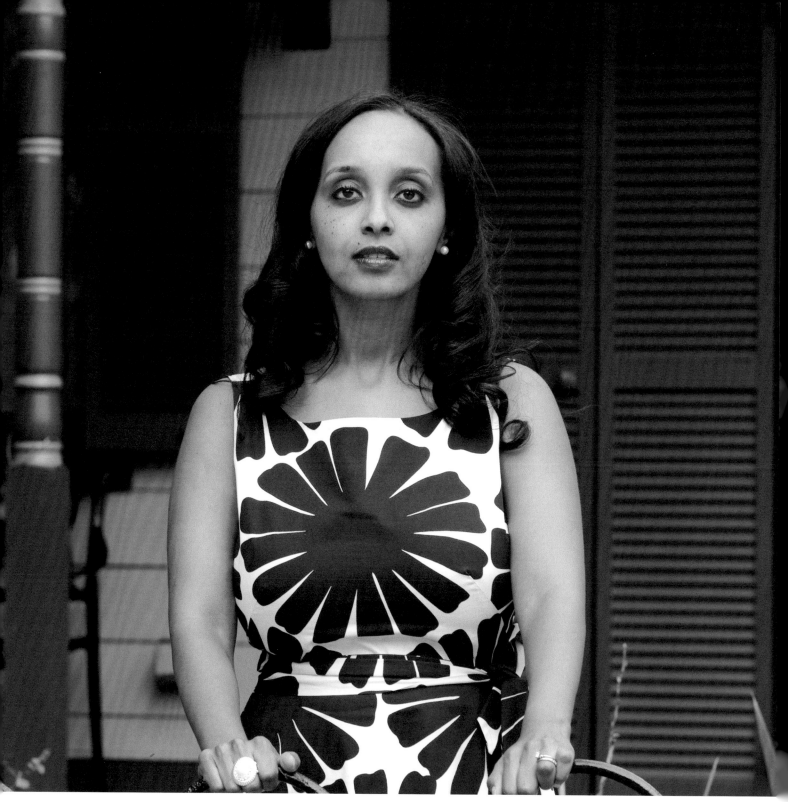

Washington, D.C. July 2012.

YAHAIRA PINEDA
Riyadh, Saudi Arabia

◆

"Black / Dominican"

A lot of times when I've gotten backlash for saying that I was Black, it's because people were like, *Why you trying to front*? I'm not saying I'm African American. I'm saying I'm Black — as in "of African descent."

Somebody might look at my picture, read a little bit about my story, and still be like, *Alright, Yahaira. Whatever. You're not Black*. I approach that like maybe there's things that they don't know that we need to talk about as opposed to getting my feelings hurt. "OK, let's talk about it. Why am I not Black?" And usually if you ask someone that, they don't know how to answer. They don't know why you're not Black. They just know that there's something about you that's not like them, and that's all they know. To me, what makes someone Black is just being of African descent. So explain to me how I'm not. My ship went here, your ship went there — same painful ship. Can't escape it. So how am I not just as Black as you are? I can just as easily turn the tables on you: Are *you* Black? Do you know where you came from?

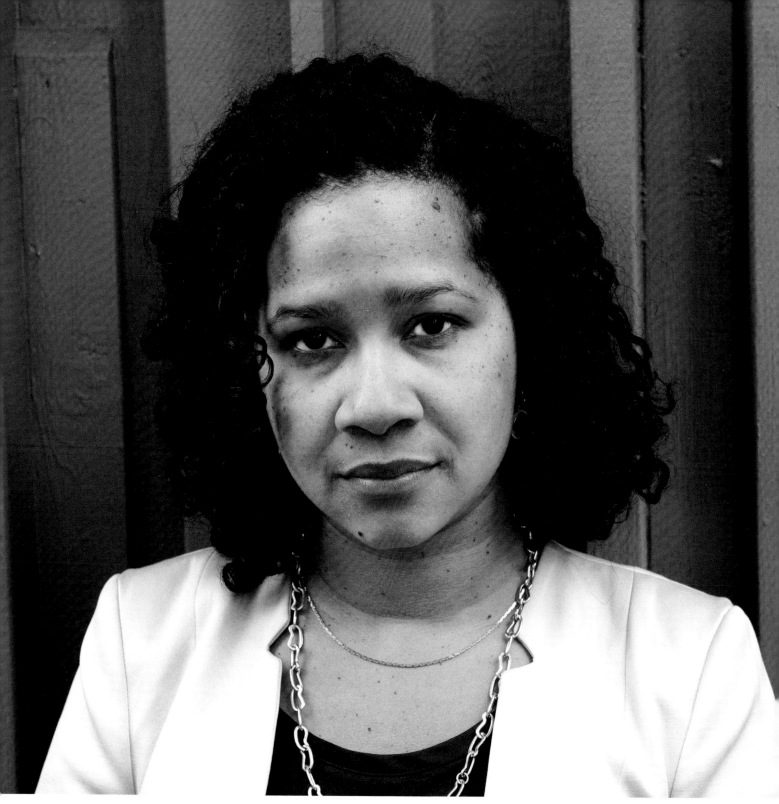

Philadelphia, Pennsylvania. April 2012.

DIVINO DENEGRO

Washington Heights, New York

———— ◆ ————

"Afro-Dominican / Afro-Latino"

My family is from Dominican Republic and Haiti, but I grew up uptown in the Heights. The one thing I could remember from the '80s before crack hit was that my block was very colorful culturally speaking, which was different for a block in Washington Heights in the '80s. Puerto Ricans and Cubans weren't as prevalent throughout this community as they were on my block — plus, we had Jamaicans and some Mexicans too. Growing up with all that around me, I thought it was all just the same thing. If somebody had asked me, "Are you Latino?" I'd be like "What?" To me, all we were was "niggas," just for authentic reference. That's it. That was the unifying term. And funny enough, the darkest ones were Dominican. I don't think I started being introduced to the politics of "you're this" and "you're that" until maybe high school. Up until high school, my whole world was Harlem and the Heights. I never had a reason to leave that area except for when I would go visit my family in Queens.

My father is very dark-skinned. Very. His father is obviously African, but his mother is one of the few Dominican descendants of the East Indian migration to the Spanish-speaking Caribbean. So my father has very dark skin, but he has like the real straight, wavy hair. If he could check "Other," he would be Other. My mother is what you would call *trigueña* — like a lighter brown — but she has very full lips and she takes care of straightening her hair every week. All of my siblings have different complexions. I'm the only one with a very light complexion. In one Dominican household, you'll see the whole spectrum of complexions, but we don't all identify the same.

I started identifying with Haiti because everybody else tried to dodge it. I remember going to D.R. when I was 14. I was growing my hair so, you know, I was rockin' the do-rags. And I remember one of my aunts saying to me, "*Pero tú te parece como un moreno con eso puesto.*" ("You look like those Black guys with the do-rag on.") And I'm looking at her like, *What are you talking about*?! Then some years later, I remember my father being really upset about something, and he came up to me out of nowhere and said, "I don't ever want you to bring a Black girl in this house." And again, I'm looking at him like, *What are you talking about*?!' I was stuck, but I was more so confused because I looked at him, and then I looked at my mother, and I didn't get it. Many years later, he and I got into this conversation and somehow or another the topic of Haiti came up and he said something

242

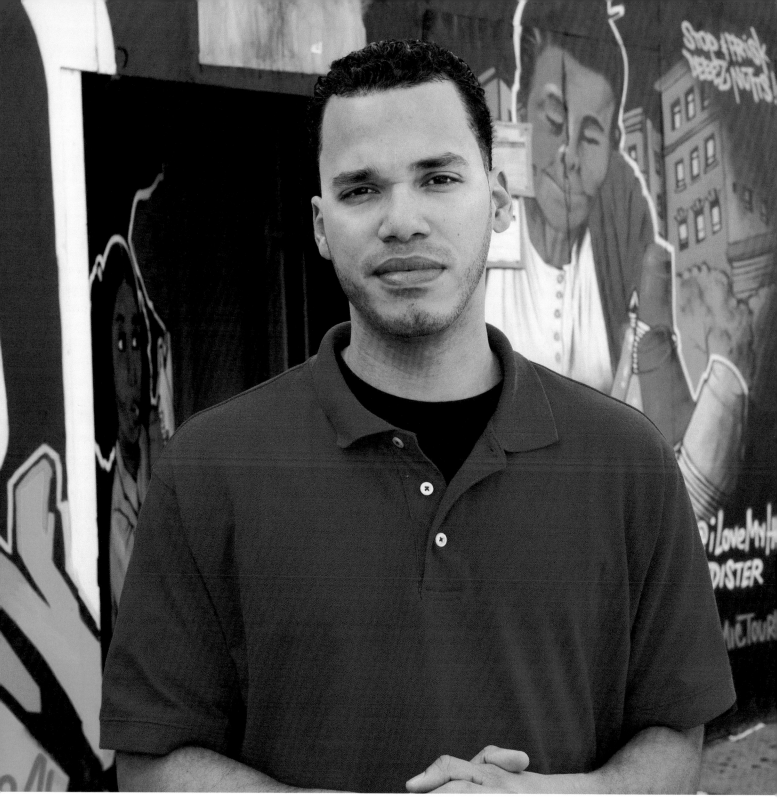

Washington Heights, New York. September 2012.

like, "Wait, your mother told you I was Haitian?" And I said, "No, but you did right now."

I found out that my father is from a town that used to be Haitian territory before Trujillo pushed the border. Trujillo ordered a massacre at the border, and thousands of people were killed. They killed people based upon how they pronounced the word *perejil*, which means parsley. Because of the difference in French versus Spanish accents, the soldiers figured that they knew who was Haitian and who was Dominican. Mind you, if you lived near the border, it didn't matter which side you were on, you all spoke a similar dialect with a similar accent. So it was a terrible way to try to marginalize people, but that's what they did, and thousands of Haitians and Dominicans were killed, and the border was pushed. So logically for my father, coming from that town, in order to survive you're gonna stray away from that as much as you can. And as long as you have the ability to disassociate yourself from Haitianness and Blackness, you will. The crazy thing is, on the island, it's all the same people who came from the Congo. But on the D.R. side of the island, Haitians are treated even worse than Mexicans are in the United States. It took some time for me to understand the history and also the propaganda the Dominican school system promotes. They really push the idea that Dominicans were in bondage and slavery under the Haitian regime like it's an actual fact. So, it makes sense that Dominicans treat Haitians like they're our rivals and that they're different from us.

You'll hear many dark-skinned Dominicans talk about how things are hard for them, but if you ask them, "Do you think it's because you're Black?" they'll tell you, "I'm not Black! What are you talking about?!" When you have dark-skinned people trying to disassociate themselves from Blackness, why would somebody who's of a lighter complexion want to be associated with that? So when people question my identity or my Blackness or my Africanness, I think it's more that they automatically see my identity as a challenge to the way that they see the world and the way that they see themselves. It has nothing to do with me actually. Dominicans are anti-Black, but at the same time, we're also extremely adamant about keeping the African culture, which is not called African of course, but that's all it is. When you see Dominicans holding on to *merengue*, *bachata*, *mambo*, *tambor*, *reggaeton*, and even hip-hop ever since the early '80s, that's all African. There are a number of people who do understand that we are of African ancestry, so it's not to say that we don't know; it's that we push it away. And Dominicans aren't the only ones. It's a popular thing throughout Latin American countries. It's a global program. But I think Dominicans take the heat compared to all the other countries because we push it so hard, yet we're so dark-skinned. People always thought I was Puerto Rican because I'm so light.

I think the term "Black" and the identity of Black is confusing for people in other

parts of the world. For some people Black means you're African American or Black means you're dark-skinned. And you gotta remember that the Dominican Republic hasn't had a Black revolutionary movement like African Americans had here. When you look at the '60s and '70s in America, that knowledge of where African Americans were from was as important as the movement itself because it helped establish some kind of foundation that they could tap into to be like, *Yeah, I'm Black*! But in the Dominican Republic, you just haven't had a revolution in a long time and especially not one that was racially and socially conscious about where we're from. But once you come to the States, you come to understand how people associate Black or anything relative to the word "Black" not just racially, but also socially and on a class level.

So as long as you understand, even subconsciously, that you're living in poverty, you're gonna identify with something that's far from White. If you don't identify with "African," you might identify with "Black." If you don't identity with "Black," you might identify with "nigga." And if you don't identify with that, you might identify with *Negro*. We might not agree on what these words mean, but one thing that we do understand is the definition that White people gave these words. And we apply them to ourselves. Black is automatically associated with poor, just like nigga is automatically associated with ignorance. So even though some Latinos might not identify as Black, they'll identify as niggas. So, it seems like the only thing that brings us to a general sense of consciousness is the fact that we have to struggle. And not only that, but we believe that the struggle is gonna continue on and we'll never actually be free. We may want to be, we may dream of it, but we don't actually believe that we'll be free. And that's part of the identity too. As much as people want to separate these things, they're all tied together.

How you identify depends on what your goal is. If your goal is just merely survival, then being conscious of your heritage and where you're from is not even necessary. All you gotta do is go for the money. But when we're talking about establishing a self-esteem that is based on concrete truth and knowledge, then you have to study your history. If you're gonna develop an organic spirituality that supports a confidence in yourself and also a peace within yourself while living in this Eurocentric structure, then you definitely need knowledge of yourself.

MICHAEL SHAWN CORDERO

Brooklyn, New York

—◆—

"Latino"

"What race are you?" At this point, that question is obsolete, being that everybody is such a mix of everything. There's really only three races you could be — Mongoloid, Caucasoid, and Negroid — and at this point, we're a mix of that. So, why are you asking that question? There's no point in the answer to that question. You don't get nothing out of it. So I don't answer that question too much. I don't wanna be in situations where I need to identify myself. Even on applications, it's like, why would you ask me that? What's the point of asking me that question? What are you doing with that answer? There's only one thing to do with that answer and that's to segregate. And why would you do that in any situation? Why would you group anybody in any situation based on their race? Asking the question is racist.

If you really wanna know who a person is, then the question is where are their parents from, where did they grow up, and what are their experiences? I think that's more important than race. Even if you're Black, or even if you're Latino, but your parents grew up in a high-end side of Boston, you're Latino, but you're not because of your experiences. You grew up around a lot of White people? Nah. I don't think you should identify yourself by race. Everybody should identify themselves by experiences, and you should experience your lineage and your culture. My parents are Puerto Rican, so I'm gonna go visit Puerto Rico because that's where they're from, that's where my family is from, that's where my lineage is.

Identity is very complex for Puerto Ricans, being that we were the first majority Latino people to migrate to New York. That's one. Plus, our country's a colony right now. That's another thing. Then the fact that there's so many Puerto Ricans living outside of the island that it kinda creates a separation between Puerto Ricans that live on the island and Puerto Ricans that live off the island. It's hard for people on the island to feel like they're connected to us. But we're all Puerto Rican — you can't deny that. And we're all of African descent. I identify myself as Latino because I've been lucky enough to travel to a lot of Latino countries and be around a lot more Latino cultures — not just Puerto Ricans. So I've lived in that world, and that's why I identify myself as Latino first.

My parents are from Puerto Rico, but I'm from the country of Brooklyn. And that's a different experience. That tells you something different about me from my parents. They

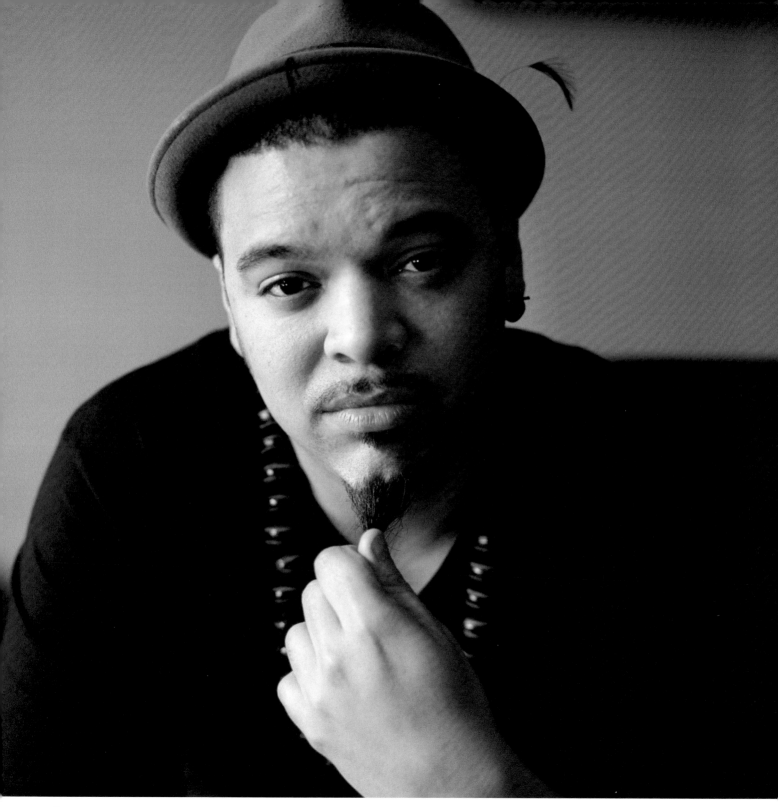

Brooklyn, New York. July 2011.

did a good job of keeping the culture very robust in the house and around us. We would go to Puerto Rico every summer and live out there for two months. Every year of my life. As soon as school was out, my mom would ship us out to Puerto Rico, and we'd all stay out there with my grandparents. Sometimes I say that I lived half my life out there 'cause that's what it feels like. If I grew up in Puerto Rico, I would probably identify myself more as Afro-Boricua. My experience would have been in the context of there being different Puerto Ricans and being treated differently because of it. But because I didn't grow up on the island, I didn't have that experience. I grew up in Brooklyn, where it's such a melting pot that people don't even have time to break me down that far. That's probably why "Afro-Latino" or "Afro-Boricua" is not the first thing I say. I think people put "Afro-" because they want to communicate that without having to have that conversation. It's like saying, "Let's just get it out the way." But I'm the type of person that don't give stuff up freely like that. I may not say that I'm Afro-something, but you see it in my face. You can tell by my skin color, my hair, my facial features. You can tell that I'm a few generations from Africa. But if you really wanna know? Then engage me.

At this point, where we are now in society, race is not our identifier anymore. Our cultures are so displaced in the world today that to just say I'm Black — what does that mean anymore? Some people grow up not even knowing they were Black. There's a movie with James Earl Jones and Robert Duvall. Robert Duvall finds out at like 60 years old that he's Black. He lives in Mississippi, he looks White, and he finds this letter from his mother after she died. And she tells him he's not her son and that his father got one of the helpers in the house pregnant, and she was his real mother. I forget what the plot was, but he finds this letter and then he travels back and finds his half-brother, who's James Earl Jones. It's an interesting movie, but in that case, he's not Black. If somebody finds out they're Black, but they grew up White, are they really Black? No. It's about the experience because you also experience how people treat you. If you're treated a certain way based on your skin color, that's part of your experience of being Black. So if you look White, and people treat you like you're White, then you don't have the experience of being Black. And some people try to take advantage of that too. *Oh, my grandmother was Black.* But are you really Black or you just trying to co-opt the experience of being Black for your own purpose? People seeing you as Black is part of the experience, but it's also about experiencing what your culture is.

I'm not offended if you can't identify me from looking at me. I mean, you shouldn't. I don't expect that. I don't know if it's a personal thing, but I like not having a title on the cover of my book; people have to open and engage with me to find out. And that's what you should do with everybody. You should never take anything as what you see it as.

ADÉ EGUN CRISPIN ROBINSON

London, England

———————◆———————

"Black / Mixed-race"

I have struggled and pushed for some form of Black identity that "fits" for years. Although my mum is White English and my dad is Black Jamaican, I grew up with just my mum and my sister in a largely White neighborhood. My sister — same parents, identical DNA — is way darker than me with tighter curls and fuller, rounder nose and mouth. It's completely obvious she's Black, she couldn't pass if she tried, whereas I am often mistaken for White.

I grew up always thinking of myself as Mixed-race. In the mid-/late '80s, in my late teens, hip-hop was blowing up. Public Enemy, Spike Lee, and the whole Afrocentric thing — that kind of fired me up. I had always listed to reggae music, conscious Rasta reggae in particular. I followed Jah Shaka sound for years. And the Afrocentric thing came on top of that. So that whole period was like a blossoming of my Black consciousness. I went through quite a Black nationalist, almost separatist period. It was kind of absurd, but that was the mood of the time. It got to the point where I was embarrassed of having a White mum. I was embarrassed I had so many White friends. I felt too English. I wasn't "Black enough." But then I reached a point where I just realized that, you know what? I'm not some dark-skinned Nubian brother, one. And two, the kind of choices of identity that were being offered to me were not the kind of choices I wanted to take on. I used to go to Nation of Islam and various other similar events, and it was very much like, *OK, you're Mixed-race, therefore you're Black. If you don't realize you're Black, then you're just an Uncle Tom. But if you do realize you're Black, you're not quite Black enough, so please just stand at the back.* Well, what kind of identity is that? So I was either a second-class citizen or a sellout? So I moved away from that kind of head space.

I would always say I'm Black, but I never felt completely "at home," so to speak. I'm so light-skinned that it just doesn't feel entirely true or accurate to say I'm Black. It's not that I feel like I am "letting down" my mother or "abandoning" my European heritage or anything like that. It's just that it doesn't really sit well with me. I always thought of it as more a political definition rather than a social definition. Other people in the street, Black and White, don't tend to see me as Black. And being so light-skinned, I can't do the "Black man give another Black man a nod" thing and just take it for granted, because people tend to think I'm White. Brothers usually give me that "Who's this White boy

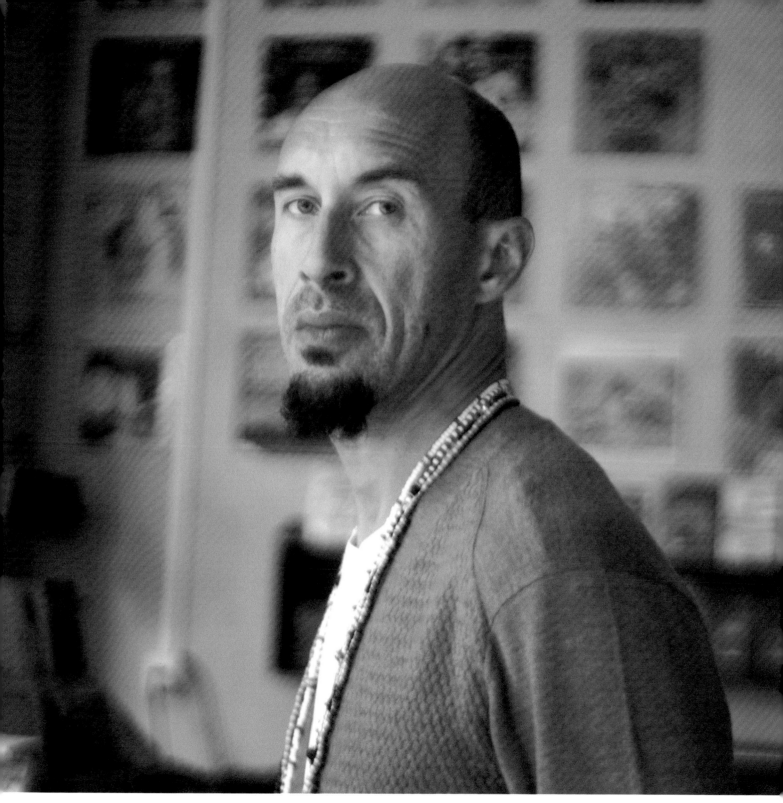

Paris, France. October 2012. (Ayana V. Jackson)

trying to be down?" type of look. So somehow "Black" doesn't fit. I could never describe myself as White, though. I'm very white, but I'm not White. That would feel like a huge denial of who I am. There are already hugely important parts of me that are invisible in mainstream society, so it feels important to me to always announce who I am. I'm Black and I'm Mixed-race. I consider "Mixed-race" to be a category of Blackness. And at this point the only label that feels true and accurate is to say that I'm a part of the African Atlantic Diaspora. I'm a Diasporic Redman and part of the Black family.

Leaving aside issues of social and political justice, I think that one's personal racial identity is complicated by at least two huge issues. Firstly, the relentless self-negating images and ideas about Africa and Africans that have been mainstream thought in Europe and America for centuries. You know the kind of thing: Traditional African religion is basically "devil worship;" African beauty has to be measured by a European yardstick so that only size 0, flat-buttocked, slim-legged, thin-nosed, white-skinned European girls with long, straight hair are "beautiful;" Africa has no history, no philosophy, no science, medicine, literature, nothing of cultural value etc., etc. And I think all of this impacts upon Mixed-race identity. In Obama's memoir, *Dreams From My Father*, he talks about how all the Mixed-race people he met who were adamant about their Mixed-race identity — *But why do I have to be Black? I'm Mixed*! — nearly always only ever associated with Whites, didn't have Black friends or much apparent connection to Black life. If they're distancing themselves from Black folk then perhaps their identity as Mixed is not as benign, color-blind, and universalist as they would like to think it is. It probably has as much to do with the negative stereotyping of Blackness and Black people as it has to do with their sense of being "Mixed."

I think the second thing that really complicates racial identity is the fact that race as a defining human category doesn't exist! It's a construct. To be sure, it's a construct that has very real and often devastating consequences for people, but that still doesn't make it any more real. I'll give you a great example. In my own family I have four children: two daughters who look Black/Mixed and two sons who look absolutely White — blonde hair, blue eyes, the whole deal. My daughters have an African American mother, which means they have three Black grandparents and one White grandparent. My sons, on the other hand, have a White English mother, which means they have three White grandparents and one Black grandparent. Are my daughters Black and my sons White? Are they all Mixed? Could my sons be classified as Black because of the one-drop theory? So, in my own little family you can see how absolute racial categories simply don't work. I'm more interested that they all learn to question White privilege and value Africa than identify as abstract categories of Black or White. Surprisingly for me, my daughters have mostly

identified as Mixed while growing up. Now they are young women at university, they are starting to think differently. But in the end it'll be up to them to find their own identity. No one can tell you who you are.

Black creations have always resonated with me — music, dance, wordplay, etc. I think in that sense then, for me, Blackness is a way of feeling, a vibration, a rhythm. Who feels it knows it. I've spent a lot of time and travel, money, and energy learning Orisha religion and culture and making Afro-Cuban batá music my own. I am now an initiated Orisha priest and a sworn drummer of eight years. I don't know what drove me to accomplish this. I think it is a calling, an ancestral voice. It is Egun. My Ocha name is Adé Egun, "Crown of the Ancestors." Something of Africa is inside me, and it is the biggest part of who I am and what I choose to do. I am a Diasporic Redman, a child of the African Caribbean and Europe with the distinctive and rare blessing of being able to move between both those worlds relatively freely. I'm able to partake of both White and Black riches. It is an identity and an inheritance that I am happy to embrace and I claim both sides without apology.

I used to try and seek Black approval, wanting to be considered "down." But that's no way to live, giving away your autonomy, putting your self-esteem in the hands of another. I've reached a point where I'm happy being me with all my beautiful complications, and I don't need anyone's sanction or approval — Black or White. I still get people who challenge my validity in claiming a Black identity. But I am not really interested in debating those darker-skinned Black "gatekeepers" who would deny me entry into the Black family. If they can't see me, it's not my problem. My skin tone and appearance is just a roll of the DNA dice. Being Black is bigger and more complex than just looking black.

Outro

I initially embarked upon *One Drop* to investigate, if you will, other people's Blackness. However, in the process of gathering, writing, editing, and compiling stories about other people's experiences with their skin color and racial identity, I have been forced to reflect on my own. The color of my skin is reflective of my Ghanaian ancestry, and by its dark tone, everyone I encounter knows exactly what I am — Black. Although I had lived most of my life acutely aware of the disadvantages assigned to my dark skin, especially growing up in New Orleans, it wasn't until I began having these conversations that I came to recognize some of the privileges my dark skin carries, the most profound of which is its ability to clearly communicate my racial identity — not only to other people but to other Black people. They know I am Black. I can rest assured that when someone in the room is talking about Black people, they realize that they are talking about *my* people. I also know that if I say "we" when talking about Black people, no one looks at me like I'm crazy, no one laughs at me as if I am somehow confused about my identity, and no one takes offense because they suspect I am somehow perpetrating a fraud.

I have never had to defend my Blackness. My Black is that Black that everyone knows is Black for a fact. Does that somehow make me more Black than someone of Mixed-race or a lighter complexion? Though peculiarly new in form, the question of who is Black is hauntingly familiar in function — categorization for the sake of separation with the intent of domination. In the historical past, the one-drop rule was functionary of White supremacy. It was predicated on the myth of White racial purity and thus served to protect and preserve Whiteness. The one-drop rule, then, became critical in the defense of the White race.

Many Blacks, American Blacks specifically, have embraced the one-drop rule with open arms and have in fact worn it like a badge of honor. As the saying goes, "Once you go Black ..."

We've come to see this as some sort of testament, if you will, to the power of Blackness, not the inferiority of Blackness. We didn't create it, but we've recodified it and given it new meaning such that somehow something genetic, cultural, and spiritual is transmitted through the blood that makes us who we are and connects us to one another.

Though we know that Black folks come in all shapes, all sizes, and all colors, even in our own families, we don't necessarily see all Black people as the same or even treat all Black people the same. Given the history of race and racial mixing in this country, as well as the history of colorism and passing in this country, the antebellum and Jim Crow distrust of lighter-skinned and Mixed-race people of African descent appears to linger on. Because historically many sought to separate themselves from the masses of Black

folk, over time the assumption has been that they don't see themselves as part of us or that they are only Black by default. The assumption is that if they *could* take on another identity, if they were *permitted* to take on another identity — Biracial, Multiracial, Mixed, Half-Black, Cablanasian, Other — that they would. Or the assumption is that in their lightness, in their Mixedness, that they see themselves as somehow better than the majority of us. In response or perhaps in retaliation, many of us turn the one-drop rule on its head. Instead of using it to define Blackness, we reject it to defend Blackness — to be Black requires much more than one drop. The argument is that if Whites can defend Whiteness, so too should we defend Blackness.

When people of African descent question or challenge the Blackness of someone of Mixed heritage or light complexion, what is it that we are attempting to protect and what is it that we stand to gain? True, we understand the racist notions of White racial purity and Black inferiority that the one-drop rule implies, but my question is: Does that necessarily mean we should reject it altogether? Where would we be as a community if we had relied on skin color and phenotype to determine Blackness 100 years ago? No W.E.B. Du Bois. No Mary Church Terrell. No Malcolm X. No Lena Horne. No Arturo Schomburg. The one-drop rule aside, have we now abandoned our cultural and political understandings of Blackness for more phenotypical ones? Do we mean to suggest that Herman Cain is more Black than Benjamin Jealous? I certainly hope not, or we're in a heap of trouble.

Although the one-drop rule may have been created out of bitter racism and ignorance, in many ways it served our community some good. It created the African American community as we know it and gave us some basic criteria with which to even recognize members of our community. Whether we like it or not, the one-drop rule united our community as a people and gave us the parameters around which to mobilize in the organized struggle against enslavement, Jim Crow, and racial oppression. We did not have the luxury of defining our community based upon what people looked like. Am I suggesting that we continue to rely upon the one-drop rule as a measure of Blackness? Absolutely not. What I am suggesting, however, is that as we question who is Black and what is Blackness, we construct our answers in ways that are ultimately beneficial to us as a community.

Perhaps we stand to learn something about Blackness from our brothers and sisters throughout the Diaspora. It is quite interesting to me that of all the interviews I conducted and all the conversations that I have had and continue to have as a result of this project, it seems that people from other countries and cultures are more likely to discuss their Black identities as political identities. Somehow they recognize the utility of seeing oneself as Black in a racialized context, irrespective of phenotypical appearances.

They seem to appreciate that perhaps the way in which we self-identify may in fact serve a function, particularly in the face racism and colorism. Perhaps instead of asking, "What is Blackness?" we should be asking, "What does Blackness do?"

At a time when so many people would rather delude themselves into accepting the fallacies of "post-racial America" than to face the continued legacy of global White supremacy, it may be as important now as it has ever been for us to consider, if not reconsider: Who is Black? Who is not? And who cares?

For me, I am no longer as concerned with who is Black in the ways that I once was growing up in New Orleans. Rather than focus my attention on those who seek to distance themselves from Blackness, I am now much more interested in connecting with those who embrace it.

Notes

1. "What Makes you Black?" *Ebony*, January 1983, 115-118.

2. Louisiana Revised Statutes, title 42, sec. 267.

3. "What Makes you Black?" 118.

4. Gregory Jaynes, "Suit on Race Recalls Lines Drawn Under Slavery," *New York Times*, September 30, 1982, 16.

5. "What Makes you Black?," 118; Ellis Cose, "Census and the Complex Issue of Race," *Society*, 34 (1997), 1.

6. "Color Bind: Louisiana Reforms, Sort of." *Time Magazine*, July 18, 1983.

7. Jason Plaks, "The One Drop Rule: How Black is 'Black?'" *Psychology Today*, April 7, 2011.

8. "Obama's Racial Identity Still an Issue," *CBS News*, February 11, 2009. http://www.cbsnews.com/8301-18563_162-3546210.html.

9. Amy DuBois Barnett, "On the Very Solid, Fantastically Full Life of Halle Berry." *Ebony*, March, 2011, 79-85.

10. Brittany Talarico, "Report: Halle Berry's Ex Gabriel Aubry Doesn't Want His Daughter Called 'Black.'" *OK Magazine Online*, February 4, 2011. http://www.okmagazine.com/news/report-halle-berrys-ex-gabriel-aubry-doesnt-want-his-daughter-called-black.

11. F. James Davis, *Who is Black? One Nation's Definition* (University Park, PA: Pennsylvania State University Press, 1991).

12. Christine B. Hickman, "The Devil and the One Drop Rule: Racial Categories, African Americans, and the U.S. Census," *Michigan Law Review*, 95 (1997), 1178.

13. Luther Wright Jr., "Who's Black, Who's White, and Who Cares?" In *Critical White Studies: Looking Behind the Mirror*, eds. Richard Delgado and Jean Stefancic (Philadelphia: Temple University Press, 1997), 165.

14. Hickman, "The Devil and the One Drop Rule," 1173.

15. Davis, *Who is Black?*, 33.

16. I define White supremacy as a historically based, institutionally perpetuated system of exploitation and oppression of continents, nations, and peoples classified as "non-White" by continents, nations, and peoples who, by virtue of their white (light) skin pigmentation and/or ancestral origin from Europe, classify themselves as "White." Although history illuminates the fabrication, changeability, and contingencies of Whiteness (e.g., the case of Irish and Italians once being denied entry into the White "race"), it is important to note that this global power system is structured and maintained not for the purpose of legitimizing racial categories as much as it is for the purpose of maintaining and defending a system of wealth, power, and privilege. Thus, it has been Whites who have constructed racial categories based on the economic, political, and social aspirations of Whites, for the benefits of Whites. In this way, Whites define who is White — a definition that has changed and will likely continue to change based upon the particular economic, political, and social conditions of the moment (e.g., the case of Egyptians now being classified as White when they were once classified as Arab and previously as Black). It is clear then that White supremacy is based less on racial Whiteness (as evidenced by skin

color) than it is on ideological Whiteness. For further discussion see Yaba A. Blay, "Skin Bleaching and Global White Supremacy: By Way of Introduction," *The Journal of Pan African Studies*, 4, (June 2011), 4-46.

17. Lawrence Farber, *Mixing Races: From Scientific Racism to Modern Evolutionary Ideas* (Baltimore: The Johns Hopkins University Press, 2011), 30-43.

18. Hickman, "The Devil and the One Drop Rule," 1178.

19. Patricia Hill Collins notes: "While not widespread, in some slave settings selective breeding and, if that failed, rape were used to produce slaves of a certain genetic heritage. In an 1858 slave narrative, James Roberts recounts the plantation of Maryland planter Calvin Smith, a man who kept 50-60 'head of women' for reproductive purposes. Only whites were permitted access to these women in order to ensure that 20-25 racially mixed children were born annually. Roberts also tells of a second planter who competed with Smith in breeding mulattos, a group that at the time brought higher prices." See Patricia Hill Collins, *Black Feminist Thought: Knowledge, Consciousness, and the Politics of Empowerment* (New York: Routledge, 1991), 178. For further discussion, see James Roberts, *The Narrative of James Roberts, a Soldier under Gen. Washington in the Revolutionary War, and under Gen. Jackson at the Battle of New Orleans, in the War of 1812: A Battle Which Cost Me a Limb, Some Blood, and Almost My Life* (Chicago: Author, 1858).

20. Africans/Blacks were not "slaves;" they were enslaved. The use of the term "slave" continues to reflect the White supremacist perspective that necessitated the enslavement of African people in the first place. Thus, in those instances where I must use the term, I employ quotation marks as a means not only to discursively reject the term but to further denote that it is not my own terminology.

21. Hickman, "The Devil and the One Drop Rule," 1177.

22. Because the term "Mulatto" is contemporarily regarded as pejorative, I use quotation marks to denote that it is not my own terminology but a more historically accurate term.

23. James Hugo Johnston, *Race Relations in Virginia and Miscegenation in the South 1760-1860*, 1970 as cited by Hickman, "The Devil and the One Drop Rule," 1178.

24. H. Leon Higginbotham and Barbara Kopytoff, "Racial Purity and Interracial Sex in Colonial and Antebellum Virginia," *Georgetown Law Journal* (August 1989), 1967.

25. Hickman, "The Devil and the One Drop Rule," 1178.

26. The term "creole" has had several meanings depending upon the time period in which it was referenced. In the 16th century, "creole" was understood as a "New World slave of African descent," but by the 17th century, the term was adopted to more generally identify persons native to the French colonies, including ultimately Louisiana, where the term was used more specifically to describe any product of miscegenation, including African and Native American mixtures. In the later 18th to 19th centuries, "creole" took on capricious meanings. In an attempt to distinguish themselves from Africans, racially and culturally mixed individuals began identifying themselves as "*gens de couleur*," which often translated to mean "colored people" or "Creoles of Color." In the 20th and 21st centuries, "creole" most often refers to the Louisiana Creoles of Color — a people of any combination of French, Spanish, Native American, and African descent. For a more detailed discussion and analysis of the term and the reflective identities, see Sybil Kein (ed), *Creole: The History and Legacy of Louisiana's Free People of Color* (Baton Rouge: Louisiana State University Press, 2000).

27. See Yaba Blay, "Pretty Color and Good Hair: Creole Women of New Orleans and the Politics of Identity," in *Blackberries and Redbones: Critical Articulations of Black Hair/Black Body Politics in Africana Communities*, eds. Regina Spellers and Kimberly Moffitt (New York: Hampton Press: 2010), 29-52.

28. John W. Blassingame, *Black New Orleans: 1860-1880* (University of Chicago Press, 1973), 21.

29. Gary B. Mills, *The Forgotten People: Cane River's Creoles of Color* (Baton Rouge: Louisiana State University Press, 1977), xiv.

30. Jay Dearborn Edwards and Nicolas Kariouk Pecquet du Bellay De Verton, *A Creole Lexicon: Architecture, Landscape, People* (Baton Rouge: Louisiana State University Press, 2004).

31. Blassingame, *Black New Orleans*, 21.

32. Virginia R. Dominguez, *White by Definition: Social Classification in Creole Louisiana* (New Brunswick: Rutgers University Press, 1986), 25-26.

33. Alice Moore Dunbar-Nelson, "People of Color in Louisiana," in *Creole: The History and Legacy of Louisiana's free People of Color*, ed. Sybil Kein (Baton Rouge: Louisiana State University Press, 2000), 3.

34. Joan M. Martin, "Plaçage and the Louisiana Gens de Couleur Libre," in *Creole: The History and Legacy of Louisiana's free People of Color*, ed. Sybil Kein (Baton Rouge: Louisiana State University Press, 2000), 59.

35. Ibid., 60.

36. Dominguez, *White by Definition*, 29.

37. Peggy Pascoe, *What Comes Naturally: Miscegenation Law and the Making of Race in America* (New York: Oxford University Press, 2009).

38. David A. Hollinger, "Amalgamation and Hypodescent: The Question of Ethnoracial Mixture in the History of the United States," *The American Historical Review*, 108 (2003): 1365.

39. Davis, *Who is Black?*, 41.

40. Arthé A. Anthony, "Lost Boundaries: Racial Passing and Poverty in Segregated New Orleans," in *Creole: The History and Legacy of Louisiana's free People of Color*, ed. Sybil Kein (Baton Rouge: Louisiana State University Press, 2000), 311; Dominguez, *White by Definition*, 200-204.

41. Anthony, "Lost Boundaries," 311; Dominguez, *White by Definition*, 200-204.

42. Stephanie Talty, *Mulatto America: At the Crossroads of Black and White Culture: A Social History* (New York: Harper Collins, 2003), 4.

43. Ibid., 5.

44. Charles C. Leigh, "Slave Children." *Harper's Weekly*, January 30, 1864, 66.

45. Harvey Fireside, *Separate and Unequal: Homer Plessy and the Supreme Court Decision the Legalized Racism* (New York: Carroll & Graf Publishers, 2004), 1.

46. *Plessy v. Ferguson*, 163 U.S. 537 (1896).

47. Ibid.

48. Davis, *Who is Black?*, 8.

49. Ibid., 58

50. Pascoe, *What Comes Naturally*.

51. Ibid.

52. Hickman, "The Devil and the One Drop Rule," 1163.

53. Anthony G. Barthelemy, "Light, Bright, Damn Near White," in *Creole: The History and Legacy of Louisiana's free People of Color*, ed. Sybil Kein (Baton Rouge: Louisiana State University Press, 2000), 253.

54. Somini Sengupta, "Marry at Will," *New York Times*, November 12, 2000, 2.

55. Jennifer Lee, Frank D. Bean and Kathy Sloane, "Beyond Black and White: Remaking Race in America," *Contexts*, 2 (2003), 27.

56. Edward E. Telles and Christina A. Sue, "Race Mixture: Boundary Crossing in Comparative Perspective," *Annual Review of Sociology*, 35 (2009), 129-146.

57. Edward E. Telles, *Race in Another America: The Significance of Skin Color in Brazil* (New Jersey: Princeton University Press, 2004), 81-85; "Race and Classifications in Latin America," accessed February 23, 2010, http://www.zonalatina.com/Zldata55.htm.

58. "Race and Classifications in Latin America."

59. Eduardo Bonilla Silva, *Racism without Racists: Color-Blind Racism and the Persistence of Racial Inequality in the United States* (New York: Rowman & Littlefield, 2006), 181-185.

60. Margaret L. Hunter, *Race, Gender, and the Politics of Skin Tone* (New York: Routledge, 2005), 102.

61. Christopher A. D. Charles, "Skin Bleaching in Jamaica: Self-Esteem, Racial Self-Esteem, and Black Identity Transactions," *Caribbean Journal of Psychology*, 3 (2010), 25-39.

62. Daniel Segal, "'Race' and 'Colour' in Pre-Independence Trinidad and Tobago" as cited by Aisha Khan, "Caucasian, Coolie, Black, or White?: Color and Race in the Indo-Caribbean Diaspora," in *Shades of Difference: Why Skin Color Matters*, ed. Evelyn Nakano Glenn (Stanford University Press, 2009), 98; Stefano Harney, *Nationalism and Identity: Culture and the Imagination in a Caribbean Diaspora* (London: Zed Books, 1996).

63. Josephine Lutchman, "Racialisation in Trinidad and Tobago," Working Paper, Center for Ethnicity and Racism Studies (CERP), (United Kingdom: University of Leeds, 2012).

64. Lynn M. Thomas, "Skin Lighteners in South Africa: Transnational Entanglements and Technologies of the Self," in *Shades of Difference: Why Skin Color Matters*, ed. Evelyn Nakano Glenn (Stanford University Press, 2009), 191.

65. Deborah Posel, "What's in a name? Racial Categorisations under Apartheid and Their Afterlife," *Transformation*, 47 (2001), 56.

66. Ibid, 58-62.

67. Henry Louis Gates Jr., *In Search of Our Roots: How 19 Extraordinary African Americans Reclaimed Their Past* (New York: Crown Publishing, 2009).

Acknowledgements

First, I must thank my comrade Rosa Clemente for simply being who she is. It was her voice and her unapologetic boldness about her Blackness that set my mind on the path towards this project. Just as each one of her speeches begins, "My name is Rosa Clemente. I'm a Black Puerto Rican woman from the South Bronx," my gratitude list begins with her. Thank you, sis!

I am deeply indebted to the additional 57 contributors to this project: Adrian, Andrew, Angola, Ariel, Biany, Brandon, Brett, Chris, Crispin, Daddy C.B., Dani, Deb, Denise Beek, Denise Brown, Destiny, Divino, Dr. Vega, Grandma Angie, Guma, James, Jay, jewel, Jim, Joanne, joshua (ROOTS!), Jozen, Kamau, Kaneesha, Karina, Kathleen, Kenya, Kristina, LA, Lauren Jane, Lena, Liliane, Malene, Mama Anita, Mama Koko, Marianna, Mei, Melanie, Meron, Mikey, Nuala, Rushay, Sean, Sembene, Soledad, Sosena, Sumaya, Tamara, Tigist, Tony, Vision, Yahaira, and Zun. There are no words that can fully express how thankful I am to and for each and every one of you. Thank you for teaching me so much, not only about you and about Blackness, but about myself. THANK YOU! Again and again.

To Noelle, my right-hand partner in creation — [screams] can you believe you're even reading this?! This has been quite a beautiful journey, and I give thanks that I have been able to take it with you. I hope that you are as proud of yourself as I am of you. Thank you, for everything.

To Carolyn Beller, Ann Blake, Rushay Booysen, Janet E. Dandridge, Guma, Akintola Hanif, Ayana V. Jackson, Karina Djijo Dafeamekpor, Zun Lee, Richard Terborg, and Kelcie Ulmer — thank you for sharing your art with me.

Publishing this book was no easy task. It truly took a community of folks to make the project, and thus the book, happen. To the Leeway Foundation for the initial financial seed with which One Drop was birthed. To the 245 backers of our 2011 Kickstarter campaign for believing in the project from the very beginning. To all of our online friends, thank you for posting, tweeting, sharing, and emailing — y'all are the best marketing team ever! To Melissa Adams, Amy Andrieux, Lumumba Bandele, David Blanchet, Tinashe Blanchet, Liliane Braga, Jewel Bush, Kenya Casey, Christopher A.D. Charles, Kiona Cloud, Janice Johnson Dias, Nicole Fisher, Lawrence Green, Roni Nicole Henderson, Anita Persaud Holland, Lauren Jane Holland, Tiffany Pogue, Celiany Rivera Velázquez, Marianna Ross, Brett Russel, Tanya Saunders, Joe Schloss, Nadine "Adjoa" Smith, Greg Thomas, and Salamishah Tillet for connecting me with potential contributors and photographers. To Ava Griffiths and Russell K. Frederick for opening a major door for the project just by talking it up. To Tina Matherson, Don Lemon, Soledad O'Brien, Michelle Rozsa, and the entire CNN in America unit — thank you for your support and for shining the spotlight on One Drop. To Dawn Michelle Hardy and Regina Brooks — thank you for your support and

for introducing me to the publishing industry. To Jamel Shabazz — for your continuous support and for lighting that final fire under my feet. To Emily Musil Church, Brittney Cooper, David Leonard, Sheena Lester, Kaila Story, and Rema Tavares — thank you all for your constructive feedback. To Shantrelle P. Lewis — thank you for your honesty and for "bucking me up" at all times. Thank you for also bearing with me with a smile (no teeth) — your support is immeasurable and invaluable. To Maori Karmael Holmes — for all of your creative insight and for designing a beautiful piece of work: thank you. Thank you for always being willing to "go Spartan" with me. To Akiba Solomon — thank you for your editorial input and direction, and most of all for your friendship and encouragement. To my editor, Shauna Swartz — you are amazing. Thank you for your hard work and meticulous eye. You have helped to make this a book that I am truly proud of.

To my parents and family — thank you for making it possible for me to chase the stars and follow my dreams. To my daughter Imani — I've already dedicated this entire book to you but I know that if I don't include you here you will surely remind me for years to come of how I forgot to mention my best friend in the acknowledgements section of my book. My bad. Thank you, my love.

Lastly, and most importantly, *Mo fo ire fun* Olofi, Orisa, and Egun. *Mojuba* Iyalorisa Oya Niyi, Iyalorisa Osun Koyode, Obaniliye, and Awo Orunmila Ifamola Intori Odun Oshebile. *Modupe*!

In truth, so many people have inspired, motivated, and contributed to this project that it feels difficult to acknowledge and thank them all by name. I give my sincerest apologies if I have forgotten anyone. Charge it to my head and not my heart.

One Drop would not have been possible without the financial support of the Leeway Foundation and the 245 people who backed our Kickstarter fundraising campaign in 2011. We would like to give special acknowledgement to the following donors for their generosity:

Aisha Stroop, M.D.
Ambrose Bemiah
Anthony Flores
Ari Johnson
Bakari Kitwana
C.B. Cloud
Caiphus Moore
Carl & Daphne Isom
Christopher Keith Johnson
Denise M. Brown
Dwana Smallwood
Eleanor M. Walker, M.D.
Elizabeth Waller & Steven Kovensky
Dr. Franz & Sofia Théard
Fabayo McIntosh
Gboyah Nkisi
Hans & Melissa Woolley
Ibram H. Rogers
Isoke Titilayo Nia Kierstedt
Jamel Shabazz
Janet Ohene-Frempong
Janice Bennett
Jonathan Morgan Lewis
Josh Wilder
Kaloma Cardwell
Kaylois Henry
Kameisha Jerae Hodge
Kashi Johnson
Kelli Y. Payne
KneeBaby Arts Miami
Dr. Kofi Blay
Kokahvah Zauditu-Selassie
Kwame Ohene-Frempong

Larry Hamlet
Lena Delgado de Torres
Leonardo & Sylvia Svarzbein
Lesley Jacobs
Mahseeyahu Ben Selassie
Mark Raymond
Martina Mols Curley
Meghan Masto
Micah Elizabeth Nance
Mike Meaney | UK
Nadine "Adjoa" Smith
Nicole Amarteifio
Nicole Fisher
Novella Ford
Nzinga Temple Tull
Olivier & Karine Théard
Rachel S. Blay
Richard Franklin
Robyn Schnieders
Russell Frederick
Sandra Jackson
Shantrelle P. Lewis
Shara D. Taylor
Stephen Proudman
Suzette Gardner
Tamara A. Mason
Tarana Burke
Tiffany D. Pogue

About

CONTRIBUTORS

Adé Egun Crispin Robinson (p. 250) is a freelance percussionist and ethnomusicologist completing a Ph.D. thesis at the School of Oriental and African Studies, University of London.

Adrian Roman (p. 218) is a New York–based mixed-media artist focusing primarily on installations, sculpture, and drawing.

After playing four years of collegiate football at Lafayette College, **Andrew Holmes** (p. 78) recently attained his bachelor's degree in government and law. Heavily involved with his church, he is a Christian musician with future plans of teaching and coaching football.

Angelina Griggs (p. 144), affectionately known as Grandma Angie, was born in Apalachicola, Fla., in 1908. Although she only gave birth to one son, over the years she has mothered many. Her portrait was captured by her great-nephew, photographer Akintola Hanif.

Reared and inspired by the African world, **Angola Selassie** (p. 140) is a sports business creative whose passions center on the global phenomenon of soccer. He is the co-founder/director of African World Football, a boutique sports marketing agency. Angola is also Koko's son.

Anita Persaud Holland (p. 148) is from Brooklyn, N.Y. Her interests include gardening, the arts, and travel. Her passions are cooking and spending time with her family. She is an active member of her church and a loving wife and mother of three, including Lauren Jane.

Havana-born **Ariel "Asho" Fernández-Díaz** (p. 98) is a New York City–based cultural critic, hip-hop historian, journalist, filmmaker, DJ, and event organizer. He has traveled around the country as an ambassador of Cuban hip-hop, presenting lectures at prestigious universities, colleges, and cultural institutions around the country.

Biany Pérez (p. 232) is a proud South Bronx native, feminist, doula, and educator. She received a Bachelor's degree in Human Development from Binghamton University and a Master of Education from Temple University. She lives and plays in Philadelphia with her partner and son.

Brandon Stanford (p. 118) is a doctoral student in the Department of African American Studies at Temple University.

Brett Russel (p. 202) was born and raised on the island of Curaçao and moved to the Netherlands by age 18. He is a self-taught photographer whose work has been exhibited at Rialto Theater Amsterdam, GRID Bi-annual Photo Festival, and WTC Rotterdam, and has been published in various magazines, newspapers, and websites, including 1nedrop.com.

C.B. Cloud (p. 70) is a retired veteran of 24 years in the United States Air Force as a C-130E and C-5A loadmaster. He is also retired with 18 years in the private sector. Originally from New Bern, N.C., he currently lives in Dover, Del.

Chris Clarke (p. 122) is an artist from Los Angeles. He is a writer, rapper, producer, director and occasional DJ.

Danielle Ayers (p. 50) was born and raised in the rural Pennsylvania town of Lititz, in Lancaster County. She currently resides in Atlanta, Ga., but fondly refers to Philadelphia, Pa., as one of her homes because it is where she received her bachelor in Public Relations and master's in African American Studies, and began her career in nonprofit leadership. Twelve years later, Dani continues to work toward effecting positive change in communities nationwide.

Deborah Thomas (p. 94) is a professor of Anthropology and Africana Studies at the University of Pennsylvania. She is the author of *Exceptional Violence: Embodied Citizenship in Transnational Jamaica* and *Modern Blackness: Nationalism, Globalization, and the Politics of Culture in Jamaica.* Prior to her life as an academic, she was a professional dancer with the New York–based Urban Bush Women.

The daughter of West Indian immigrants, **Denise Beek** (p. 212) was raised in Montclair, N.J. She has worked in marketing, arts, and culture for nearly a decade. Her experience includes the Black Lily Film & Music Festival, the Mann Center for the Performing Arts, and the Greater Philadelphia Film Office. She graduated from Temple University with a B.A. in Communications and currently resides in Philadelphia.

Artist, cultural organizer, facilitator, and strategist **Denise Brown** (p. 130) is passionate about using her skills and energies in supporting and illuminating projects like *One Drop* that are working at the intersections of art, culture, and social justice. She is currently the executive director of the Leeway Foundation in Philadelphia, an organization whose mission it is to support women and trans artists and cultural producers creating art for social change.

Destiny Birdsong (p. 166) was born and raised in Shreveport, La., but currently lives in Nashville, Tenn. She received a Ph.D. in English from Vanderbilt University.

A member of the Nation of Gods & Earths (aka 5% Nation), **Divino DeNegro** (p. 242) is a hip-hop writer for BrooklynBodega.com, co-host/co-producer for *Rise Up Radio* on WBAI 99.5 FM NY, and co-founder of a live performance collective in Washington Heights called The WHAT? Show. Very active in his community, he volunteers at the Malcolm X and Dr. Betty Shabazz Center in Washington Heights and is a member of the Washington Heights Artists Movement (WHAM), a nonprofit dedicated to offering arts education and mentoring to creative youth and young adults.

Leonardo Martins Galina received the name **Guma** (p. 198) through capoeira. He is a photographer and freelance photojournalist based in São Paulo, Brasil. He is the photographer behind the "I Africanize São Paulo" campaign, a slogan designed to bring greater visibility to the Black Brasilian population in the media.

James Bartlett (p.102) is an entrepreneur from Louisville, Ky. He now lives in Brooklyn, N.Y., where he is the executive director of the Museum of Contemporary African Diasporan Arts (MoCADA), and manages his two companies Media MVMT, a film production house, and Embassy MVMT, an artist development company.

James Scott (p. 56) is assistant professor of anesthesiology at Emory University Hospital Midtown. Scott is also the co-chair of the Emory University President's Commission on Race and Ethnicity (PCORE).

Jay Smooth (p. 58) is the founder of New York's longest-running hip-hop radio show, WBAI's *Underground Railroad*. His hip-hop video blog Ill Doctrine features his commentary on hip-hop and politics.

jewel marie bush (p. 154) a New Orleans native, is a writer whose work has appeared in *The (Houma) Courier*, *The Washington Post*, *The Times-Picayune*, *New Orleans Homes & Lifestyles Magazine*, and *El Tiempo*, a bilingual Spanish newspaper. In 2010, she founded MelaNated Writers Collective, a multi-genre group for writers of color in New Orleans dedicated to cultivating the literary, artistic, and professional growth of emerging writers.

Joanne Stewart (p. 174) is a retired telecommunications specialist who recently re-entered the workforce. She is a proud and loving wife, mother, and grandmother with faith that prayer changes things.

joshua bee alafia (p. 80) is a Brooklyn-based filmmaker who creates a diverse breadth of films spanning magical realism narratives to cinema vérité documentaries.

Jozen Cummings (p. 66) is a writer and editor living in Harlem. He is the creator of the popular blog Until I Get Married.

Kaneesha Parsard (p. 186) has spent her life traversing the Northeast Corridor, and Jamaica is ever with her. She is a doctoral student in American Studies and African American Studies at Yale University.

Karina Djijo Dafeamekpor (p. 184) is an artist and photographer living and working in the D.C. metro area and worldwide. She has worked in several mediums over the years but now focuses on using photography and film to express herself and to create fine art for her clients.

Kathleen Cross (p. 110) is an author, speaker, and mother who believes "we are the waves of one sea, the flowers of one garden, the branches of one tree." Her award-winning novel *Skin Deep* has been required reading at colleges around the country. She blogs at KathleenCross.com.

Kenya Casey (p. 132) is an international educator who counsels, mentors, and advises college students studying around the world. Throughout her career she has touched the soil of many countries and positively influenced the lives of countless young people. Kenya holds a bachelor's degree in psychology from Clark Atlanta University and a master's in social work from Howard University.

Koko Zauditu-Selassie (p. 136) is professor of English at Coppin State University. She is the author of an award-winning book of critical essays, *African Spiritual Traditions in the Novels of Toni Morrison*. Koko is also Angola's mother.

Kristina Robinson (p. 150) is a native New Orleanian and graduate of Xavier University, where she studied creative writing. She is currently at work on a collection of essays on race, class, and shape-shifting and blogging about race sexual politics on Life in High Times.

LA Block (p. 54) is currently a graduate student pursuing a master's in the art of teaching. She resides in Brooklyn, N.Y., where she's an elementary school teacher with the Uncommon Charter School network.

Lauren Jane Holland (p. 146) is a communications professional and cultural producer with professional experience in higher education and government. An aspiring yogini living in Washington, D.C., she is also Anita's daughter.

Lena Delgado de Torres (p. 62) holds a Ph.D. in Sociology from Binghamton University. Her dissertation is entitled *Swagga: Gender and the Will to Adorn in Jamaican Dancehall*. She aspires to be an intellectual, professor, sociologist, and author.

Liliane Braga (p. 190) is a journalist, educator, cultural producer, and founder of Quisqueya Brasil, African Diasporic projects in culture and education.

Marcus Vinicius A. Silva aka Kamau (p. 194) is a hip-hop MC and recording artist based in São Paulo, Brasil.

Malene Younglao (p. 228) is a singer/songwriter and aspiring environmental scientist based in Brooklyn, N.Y.

María de la Soledad Teresa O'Brien (p. 74) aka Soledad O'Brien, is the CEO of Starfish Media Group, a production and distribution company that creates documentaries and other scripted and non-scripted projects for various partners, including CNN and HBO.

Marianna Ross (p. 162) is a Baltimore-based makeup artist.

Marta Moreno Vega (p. 220) is founder and president of the Caribbean Cultural Center African Diaspora Institute. She is the author of *The Altar of My Soul: The Living Traditions of Santería*, *When the Spirits Dance Mambo* and executive producer of *Cuando los Espíritus Bailan Mambo/When the Spirits Dance Mambo*, a documentary film about the African-based religions of Cuba. She was featured on the HBO special *The Latino List*.

Mei Campanella (p. 114) loves God and tries to love all others, but she is also human. She is constantly changing and growing.

Melanie Staton (p. 108) graduated with a B.S. in international business but has chosen to follow her creative passions in acting and modeling. She loves to travel and has recently relocated to Ft. Pierce, Fla., where she is busy being a mom of two and embarking on entrepreneurial endeavors.

Meron Wondwosen (p. 238) serves as counsel for Young Doctors DC, a multigenerational mentoring, education and pipeline to careers in medicine program for high school boys in Southeast Washington, D.C. She has practiced law in a range of areas including corporate finance and securities, banking regulations, voting rights, and international human rights. Meron has written several reports to the United Nations on the state of human rights in the United States and Ethiopia. She is the author of an unpublished manuscript on her adventures as a Black lawyer girl on Wall Street. Meron is a mother, a wife, a feminist, and a fourth-generation *tej* brewer.

Michael Shawn Cordero (p. 246) was born and raised in Bushwick, Brooklyn, to first generation Puerto Rican parents. Brand architect of 1 Soul Designs, co-owner of Fresthetic, and brand therapist at MVMT, Michael has launched several successful arts and community-based businesses.

Rhode Island native **Nuala Cabral** (p. 106) is an educator, activist, and award-winning filmmaker. In 2010 she co-founded FAAN Mail (Fostering Activism & Alternatives Now!), a media literacy/activist project formed by women of color and based in Philadelphia. In addition to her media interests, Nuala is a founding member of the Black Feminist Working Group and board member of Stop Street Harassment.

Perry "Vision" Divirgilio (p. 82) is an accomplished poet, actor, and teacher. While poetry is his passion, he believes his purpose lives in the work he does with children. Vision is currently the artistic director for Philadelphia Youth Poetry Movement (PYPM), where he teaches poetry as an avenue for self-expression, self-esteem, public speaking, and peer mentoring. Vision's personal story and work with PYPM were featured on CNN's *Who is Black in America?* (2012).

Rosa Clemente (p. 224) is an Afro-Boricua hip-hop radical feminist. Born and raised in the Bronx, she is a nationally renowned community organizer, journalist, hip-hop activist and educator. In 2008, Rosa was nominated by the Green Party as their vice presidential candidate. She and her running mate Cynthia McKinney made up the first women of color ticket in American presidential history. She is currently a doctoral student in the W.E.B. Du Bois Department of Afro-American Studies at the University of Massachusetts Amherst. She is also the very happy wife of her man Justice and lucky mother of Alicia-Maria.

Rushay Booysen (p. 206) is a blogger, speaker, community activist, and photojournalist. His interest in music has assisted him in facilitating larger discussions in his community on building racial bridges and developing education and awareness campaigns. Rushay was recently nominated for the International Visitor Leadership Program by the Department of State.

Sean Gethers (p. 164) was born and raised in Philadelphia, where he currently resides and works as a nurse.

Sembene McFarland (p. 170) was born in California, raised in Mississippi, currently lives in New Jersey, and works as a nurse in New York. She has lived with vitiligo for 18 years.

Sosena Solomon (p. 216) is a visual artist and filmmaker. Originally from Ethiopia, she currently resides in Brooklyn, N.Y.

Sumaya Ellard (p. 158) received her B.A. with honors from Trinity College and continued to University of Virginia to pursue a J.D. She now practices labor and employment law in Atlanta. Sumaya is interested in the intersection of race, culture, and religion and its impact on American life.

A channel of artistic expressions both visual and performance, **Tamara Thomas** (p. 230) is an anthropologist and writer with a keen interest in the artistic, spiritual, and environmental affairs of the Caribbean and the Diaspora.

Tigist Selam (p. 86) is an actor, writer, and filmmaker of Ethiopian and German descent. She received her M.A. in Communications, Culture, and Society at Goldsmiths University of London and currently resides in Harlem, N.Y.

Tony Muhammad (p. 214) has been teaching Social Studies in Miami-Dade County public schools for over 10 years and is currently involved in the MIA (Music Is Alive) campaign for the development of the National Hip Hop Day of Service. Tony is most noted for his work as publisher of *Urban America* newspaper (2003-2007) and co-organizer of the Organic Hip Hop Conference. He currently serves as a student assistant minister to Student Minister Rasul Hakim Muhammad at Muhammad Mosque #29 in Miami, Fla.

Born in the Dominican Republic, **Yahaira Pineda** (p. 240) is currently based in Riyadh, Saudi Arabia. She holds a bachelor's in International Business from Howard University and a master's in Global and International Education from Drexel University. She is a mother and wife and is currently an international educator who counsels and assists young women from the Middle East to pursue higher education.

Zun Lee (p. 90) is a street photographer, physician, and health care executive. Originally from Germany, he has lived in Atlanta, Philadelphia, and Chicago and currently resides in Toronto. His recent long-term project Father Figure was featured on the *New York Times'* Lens blog. It visually explores the lives of African-descended fathers, seeking to provide an intimate counterbalance to the public narrative around father absence in the Black community.

AUTHOR

Dr. Yaba Blay is a teacher-scholar of Africana Studies. She received a B.A. in Psychology (cum laude) from Salisbury State University, an M.Ed. in Counseling Psychology from the University of New Orleans, and an M.A. and Ph.D. in African American Studies from Temple University with a graduate certificate in Women's Studies. She is currently co-director and assistant teaching professor of Africana Studies at Drexel University.

While her broader research interests are related to Africana cultural aesthetics and aesthetic practices, issues of gender in Africa and the Diaspora, and global Black popular culture, her specific research interests lie within Black identities and the politics of embodiment, with particular attention given to hair and skin color politics. Her dissertation, *Yellow Fever: Skin Bleaching and the Politics of Skin Color in Ghana*, relies upon African-centered and African feminist methodologies to investigate the social practice of skin bleaching in Ghana. Among her many publications, Dr. Blay's ethnographic case study entitled "Pretty Color and Good Hair: Creole Women of New Orleans and the Politics of Identity" is featured as a chapter in the Hampton Press anthology *Blackberries and Redbones: Critical Articulations of Black Hair/Body Politics in Africana Communities* (2010).

Dr. Blay is the recipient of a 2010 Leeway Foundation Art and Change Grant through which she embarked upon *One Drop*. In 2012, she served as a consulting producer for CNN's *Black in America 5:* "Who is Black in America?" — a television documentary inspired by the scope of the One Drop project.

As a researcher and ethnographer, she uses personal and social narratives to disrupt fundamental assumptions and expectations about cultures and identities. As a cultural worker and producer, she uses images to inform consciousness, incite dialogue, and inspire others to action and transformation.

www.yabablay.com

DIRECTOR OF PHOTOGRAPHY

Noelle Théard is a freelance photographer and educator. She holds an M.A. in African Diaspora Studies from Florida International University, a B.A. in Journalism from the University of Texas at Austin, and a certificate in Advanced Studies from the Spéos Photographic Institute in Paris. She is currently pursing an MFA in Photography from Parsons The New School for Design.

Her photographic work on hip-hop culture has taken her to South America, South Africa, and Europe. Her images of Latin American hip-hop are featured in the *Miami Herald*'s award-winning series "A Rising Voice: Afro-Latin Americans," and her images of hip-hop in South Africa are published in the anthology *Native Tongues: An African Hip-Hop Reader*.

Her professional practices are wide-ranging and include co-directorship of FotoKonbit, a nonprofit organization created to engage and empower Haitians to tell their own stories and document their communities through photography. She also founded a photography program at the Miami Museum of Contemporary Art. Théard is currently an adjunct professor in the African Diaspora Studies program at Florida International University, where she teaches two classes: "Africa in Films" and "African Visual Arts."

www.noelletheard.com

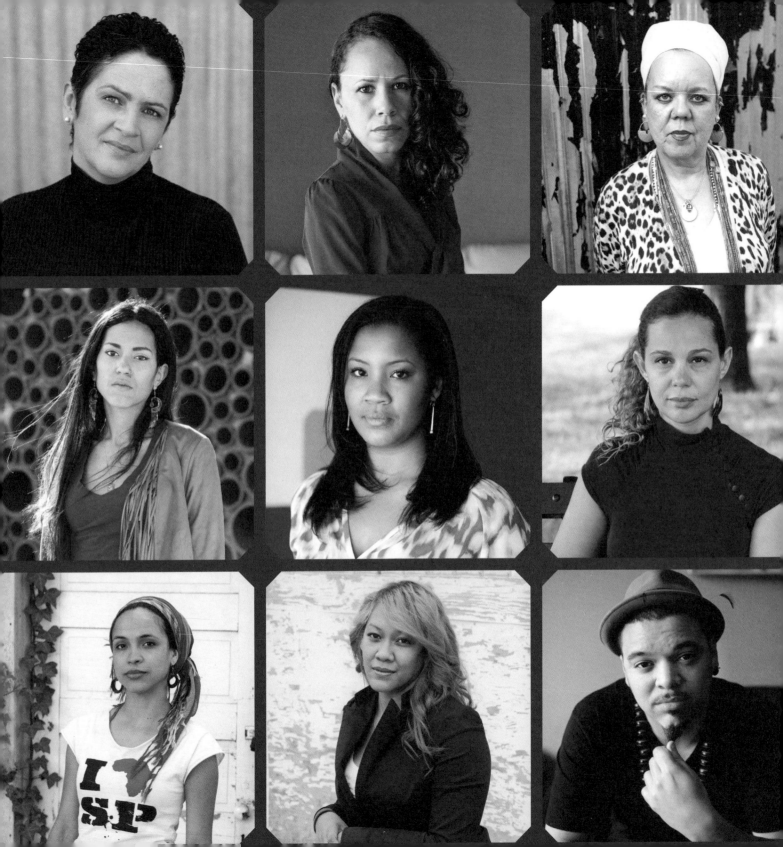

THE ALIEN VIS

RESEARCH INTO THE TECHNOLOGY AND PROPULSION
OF THE VEHICLES SEEN IN EARTH'S ATMOSPHERE AND
BEYOND.

RENE ERIK OLSEN

2019

Also by Rene Erik Olsen

Books:

The Royal Danish Ballet in Photographs – Published at Blurb.com – 2009

Interviews with ten ballet dancers – The Royal Danish Ballet – Published at Blurb.com - 2011

Mine Kunstværker fra 1940 til…. Ove Erik Olsen – Published at Blurb.com – 2011

(translated – My Artworks from 1940 to....Ove Erik Olsen (my father))

Mine Kunstværker fra 1983 til….Rene Erik Olsen – Published at Blurb.com – 2011

(translated – My Artworks from 1983 to....Rene Erik Olsen)

The George Adamski Story – Published at Blurb.com and Amazon - 2018

Magazines:

Beauties Of Fashion Magazine - 5 issues in 2017 - all published at Blurb.com

Art Nude And Erotic Magazine - 11 issues in 2017 – all published at Blurb.com

Art Nude and Erotic Magazine - 2 issues in 2019 - all published at Blurb.com

Front cover design by Rene Erik Olsen

Front cover painting by Rene Erik Olsen

Back cover design by Rene Erik Olsen

Homepage - www.olree.dk

Email - reneolsen27@gmail.com

Contents

Acknowledgments

The monochrome photos and the color photo from Mount Palomar (G. Adamski) used in this volume is courtesy of Glenn Steckling - of the Adamskifoundation.com. Also a big thanks to Paul Ruez for the scans. Enhancements done by the writer.

Also the Mexico film (taken by G. Adamski in 1957/58) is courtesy of Glenn Steckling - of the Adamskifoundation.com. Enhancement-stills done by the writer.

Film of "new type of craft" (the bluish-oval craft) (taken by G. Adamski in the 1957) is courtesy of G. Steckling - of the Adamskifoundation.com. Enhancement-stills done by the writer.

Spider web photos courtesy of Oksana Kniazeva.

The biggest thanks goes to those who pilot these amazing crafts shown in the photos and paintings of this book.

Introduction

I am sure that most people interested in the subject of "Flying Saucers" or "UFOs" have wondered how they are able to "fly" these crafts over such enormous distances and with such fantastic maneuverability and speed.

The crafts exhibit maneuvers and speeds that defy terrestrial science at its core. If they can maneuver like this with a crew inside, perhaps science should re-think their theories of almost everything – and perhaps they already have.

It is my hope that this book – in text and pictures – will explain something about the Universe, the Visitors and their technology and propulsion.

At some time years ago I was lucky, and took full advantage of an opportunity that presented itself.

Maybe you will find the same wonders and puzzles – solve them – and expand your views. I know, I am not the only one, who has researched these visitors and their technology.

I would encourage studying gravity, electromagnetism and the "forces of nature" in general. I am sure scientists will find many more "forces of nature" as terrestrial science evolves and matures.

I also recommend reading papers by Thomas Townsend Brown, F. E. Alzofon, and many others who have written about and researched "exotic propulsion" and general books on quantum physics. These writings will help you get a broader understanding of nature, the Universe and all things "out there". There is still much to be discovered.

Last but not least, I hope you will enjoy the book.

The Universe - at time 0.000000001 microsecond after creation

Image 1

Chapter One

The Beginning

Nothing. No sound. No light. Blackness.

This is what was before the creation of the known Universe. What began it all? A conscious thought? Rebirth of an old Universe? Or just a chance happening?

Try to picture the first moments of this "New Universe". From total blackness to an extraordinary massive brightness – and then the rush of immense heat in a sudden expansion filled with orange light. A trillion degrees – a wave of energy, containing a myriad of secrets about the design and architecture of the Universe to come – The Universe was born.

In a blink of an eye gravity, time, rotation and radiation were created – a white foam-like Universe took its beginning. The waves of space and time are in chaos, struggling in the newborn Universe. Microseconds later quarks, leptons and hadrons find order for a short time and then are constantly created and destroyed. A few microseconds later the quarks and leptons are joined into baryons and mesons. The radiation waves continue. Radiation is dominating over matter.

The hadron era is upon the Universe. Just before the hadron era is over the one single "state" of the initial creation becomes the four basic forces "known" today - the electromagnetic, the weak (nuclear force), the strong (nuclear force) and the gravitational force. They now rule the Universe. The relative chaos of the first 100.000 years of the Universe is playing out – meaning that matter and antimatter is created almost in equal amount, but the small difference between these – is what now constitutes the known Universe – with its galaxies, stars, planets and all living matter.

After half a million years atoms have not yet been created only electrons and nuclei are moving freely in this kind of plasma state of the Universe. Going forward the dominating light all around is reddish. Atoms are created and between 1 million years and 15 million years flickering of gasses and early black holes are surrounded by glowing areas of initial galaxy formation.

At around 100 million to 1 billion years the "very productive age" of galaxy formation begins. The enormous areas of gas is slowly turning into more coherent masses of early, slowly turning spiral galaxies – all much closer together than we are seeing today. Early disks of gas are turning into stars of different appearances and sizes.

At around 1 billion years the Milky Way galaxy was formed. Between 1 billion and 5 billion years the galaxies moved further apart and in that time period - when the young Universe was very productive - countless civilizations arose and perished, a high number evolving into higher states of development and may even be around today.

At approximately 9.4 billion years the solar system was born.

It has taken a long time to reach the present at age about 14 billion years – but here we are. The Earth – one of the very young planets around, with a very young human population. A fertile planet – one among billions in the spiral galaxy where Earth resides.

We live in a Universe which is difficult to understand and comprehend and which holds immense secrets about our past and future – and is also very intimidating when you think about it.

As adventurous as the human race is – we are always reminded of how small we really are - as individuals and as a planet. Just thinking about the Universe having no boundaries as such (it is still expanding), can make every one of us tremble with timidity.

On the next page is a picture of the intimidating look of a small part of the visible Universe – if that view does not make you feel very small, I do not know what will.

All of these "dots" are galaxies - each consisting of billions of stars - and this is just a small part of the known Universe - intimidating to say the least.

Image 2

Scientists have looked good and hard to find the next step in physics – a unification of the four observable forces of nature – electromagnetism, gravity, the strong and the weak nuclear forces (time is somehow omitted by science). They have not as yet been able to come up with a sensible theory.

Planet Earth has a magnetic field. Every human being, even nature has electromagnetic fields emanating from their atoms. Chemistry is based on electromagnetism – everything on this planet is effected by electromagnetic fields – that being light (radiation) hitting the surface in all forms. Muscles and nervous systems are sustained by currents of electromagnetism. The brain works via electromagnetism and the pulses sent to all parts of the human body.

The Visitors have found a way to use their knowledge of the Universe and the "connections" (between every particle (wave) in the Universe) to advance their technology. Electromagnetism and gravity, in addition to the Original Energy Source (dark energy), permeates the known Universe.

So no wonder why the visitors' space crafts have engines driven by electromagnetism (and their extensive knowledge of how gravity works) – in addition to the "dark energy" (repulsive gravitational energy of the universe) which is available everywhere in between the galaxies, stars and planets.

Spiral galaxy - with its "arms" stretching out from the "center" - compare this with the next image of a spider web - there are "connections" between everything in the Universe - where does the "design" of the spider's web come from?

Image 3

Notice the similarity between the grand design of the galaxy and the grand design of the spider web. If we study nature and the Universe we find the answers to many questions unanswered in life and physics.

Image 4

Chapter Two

Perhaps it would be a good thing to describe what the "Original Energy Source" *(OES) is. It has long been thought that the space between galaxies was empty. But at some point years ago, terrestrial scientists had ideas that quantum physics indicated something was missing, as only 5-10% of the Universe was filled with visible matter and 20% with dark matter, so a discovery was made that found that the "empty stuff" in the Universe was dark energy from the beginning of the Universe. The "dark stuff" is really there and it consists of 70% of the Universe – so now the Big Bang and the measurable Universe is explained. So empty space is not really "empty".

This "Original Energy Source" is essential particles (waves of energy) which were created from the beginning of time (when inflation of the Universe began) – waves which have a gravitational effect in that they repulse stuff – quite opposite the known gravity (which attracts stuff). This dark energy is causing the Universe to expand at an accelerated speed. Much faster than it would have done if only the original "material" effect of the creation was there. This repulsing and attraction between the dark energy and gravitation, can be and is being harnessed into useful energy.

The energy fluctuations between these two forms of gravity (and the force of time) is important in the Visitors ability to travel at "instant travel" (faster than the so-called "speed of light"). More on "instant travel" on page 39 and the following pages.

The fundamental principle of the Visitors technology is that all forces and energy created in the Universe, essentially, with the use of the right technology, can be converted into usable energy to aid in technology development and thereby also propel space crafts. The energy resource which is converted has a very high quality (effective propulsion when talking space craft technology).

*Original Energy Source - O.E.S - Dark Energy (repulsive gravity)

In the Universe, there is a tendency for all things to move in relations to each other, meaning that things attract and repulse each other. If matter is electrical or magnetically neutral, gravity is always influencing all matter in the Universe. Gravity is all-present.

As gravity is present everywhere in the known Universe – in every atom, on every planetary surface and in the vast space-time continuum, it will not surprise anyone that the Visitors have made their concentrated technological efforts in the field of gravity and letting this technology assist them in their advances. For a long time they had known about the O.E.S. energy (dark energy), but had not developed a good technology to put this "energy" to use. They did some time ago. This also improved their traveling speeds exponentially.

When they advanced so much so as to travel into space, they found that a combination of gravity and electromagnetism could yield the required energy. In their research of gravitational fields it was found that an important step was for their space ships (both large and small) to have separate shield* protection of their living quarters, crew cabins and repair areas (to maintain a physical comfortable work environment).

A lot of research was done to make the outer hull impenetrable to any outside threats (meaning natural elements – such as meteorites, meteors or debris in general in space). These shields are gravitational fields focused some distance outside the hull of the ship, in such a way as to repel any external threat, and at the same time are part of the main propulsion for the ships (gravitational fields can be controlled and focused at any given length (miles) from the main hull if need be).

The field/shield configuration is shown in Image 5, as well as the electromagnetism which "drives" the gravitational generators. All electronic equipment is also protected against external interference.

*In the rest of the text "shield" or "shields" means gravitational shield/shields (a bi-product of the gravitational fields) – likewise "field" or "fields" means gravitational field/fields

Gravitational Field setup for a large cruiser - two length-wise fields and seven ring-shaped fields
16 gravitational field generators and 16 reflectors - in addition two magnetic engines at the rear (left in the drawing)

///// = Electromagnetic engines

Image 5

The shuttle crafts

I have chosen to describe in detail the general setup of a shuttle craft (type as in image 7). I will show another one of their many different types of shuttle crafts, at the end of this chapter. The other types of shuttles have a similar field setup and the interior cabins are always built around a circular shaped form (see image below).

For the shuttle crafts a setup of three-four gravitational fields are required in order for a crew to man a craft. If three to four fields are not installed (but only one or two) the craft will be automatically controlled from a cruiser. What is necessary for a manned craft is typically two fields to protect and control the craft and two fields around the crew compartment (see image 6). It is also important to understand that a craft is always built to conform to their propulsion technology.

The gravitational fields in the shuttle craft are focused in such a way as to repel the surface, it is going to land on when in the final landing stages, and attract space when taking off. The rotation of two rings built into the underside of the craft ensures that the craft is stable on descent and take-off. Occasionally the shuttle crafts are seen "wobbling" on descent – or showing a motion as a "falling leaf" – This happens because of the adjustments of the fields output and the subsequent "fine tuning" during descent. None of this "movement" can be felt by the crew - more on this later.

Standard cabin design

Gravitational field reflectors - this is only one field setup shown - the fields can be adjusted in a myriad of configurations and stretched out very far from the hull (during high velocity turns and acceleration).

Image 6

17

Each field is powered as follows – The "controller" of the field is the central pole (and thereby the computers) which runs through the cabin of the craft and ends in the engine below the cabin floor. As matter attracts or repels other matter (let us say a planet surface or space) the bottom hull (part of the engine) and the top part of the hull (part of the ceiling) work as "focusing lenses" for the field generators (for the crew compartment) (see image 7 below).

= Gravitational field generators

= Gravitational field reflectors

Image 7

In essence the fields are increasing or decreasing the outside density in relation to the craft. This is what is moving the craft. The energy for this is found in the main engine (electromagnetic) and the gravitational generators inside the hull of the craft and the power is distributed through the central pole (via what can only be described as "quantum computers" - extremely advanced computers - nothing like terrestrial chip-controlled computers). The sensors installed on the outside of the hull transmit details of changing conditions to the computers which in turn send commands required to adjust the field alignment and strength.

When the fields are active and any movement (up, down, forward or backwards) is required a tilted position (some degrees of tilt) is initiated. At the same time the field strength in the direction of the movement is increased. Any adjustments are made automatically or can be controlled manually by the pilot, but most often adjustments/corrections are done automatically. The craft is much too sensitive to receive major inputs from the pilot (fine-tuning by the pilot is okay). As many, many calculations are done continually the slightest mistake by the pilot in a given situation (especially close to the surface) can quickly make the situation dangerous. The job of the pilot is mainly to input the route towards the arrival destination and time allotted for the transportation. After that has been done the pilots job is mainly supervision or observation of targets.

The gravitational field technology is a very old technology. They do adjust their technology at intervals (if they find that a smarter and better way is more efficient), but essential it was fine-tuned for most forms of transportation millennia ago.

That does not mean that accidents cannot or will not happen now and then. They are not free from making mistakes. Accidents have happened - to themselves and their crafts - also to outside observers - when they have made observations on planets – i.e. if people have been too close to their crafts and their active shields have burnt or injured – but these things happen rarely today. The "radiation" from an active shield/force field is mainly beams of static electricity and low effects from electromagnetic waves, and that combination can cause an unpleasant effect if exposed to it for a longer period of time and if one is not prepared for it.

The stages or steps in which the shuttle craft engage its field configuration is as follows – When the crew is in place and they are ready to travel/lift off – two of the fields to protect and lift the craft are engaged. Secondly the field surrounding the crew cabin is engaged. Now the take-off can be initiated. As the fields are "stretched out" or "focused" further (let us now take a view from the outside) – the outside view goes from 100 percent visible to a dark grey color (no matter what the "real" color of the craft is). This is due to the field power being turned up and the greyish color is seen when at 25 percent. The greying effect is due to the outer hull being engulfed in the power of the fields which tend to have a greying effect (in visible light - in infrared light it looks bluish). At 50 percent strength there will be seen some concentric, dark lines rotating around the craft. This is the field becoming partly visible due to atmospheric pressure. At 75 percent, a cloud like "structure" or "shape" is enveloping the craft. At 100 percent power the craft dissipate into a yellowish/whitish ball of light – or alternatively the pilot can decide on a 100 percent invisible appearance (depending on the desired effect of the field configuration) (it requires nothing more than a turn of a switch).

Inside the craft – while this process is going on – everything looks fully normal – the cabin is shielded from the external effects. The appearance of the functioning fields from the outside is caused by the static electricity and the waves of electromagnetism which interacts with the atmospheric conditions/pressure surrounding the craft. There also is a tendency for the air to move "with" the craft (see image 8 - 10)

Image 8

Image 9

Image 10

This is what a craft would look like when it accelerates at high velocity and the field strength is high (meaning the gravitational fields are focused at greater distance from the craft's hull).

The gravitational field generator is an extremely powerful tool both in providing the propulsion for the craft but also in generating the external and internal shielding of the craft.

The separate field around the cabin is always focused just outside the hull of the craft, at a maximum distance of 8-10 feet, so that when extreme acceleration is needed, no sense of acceleration is felt at any time for the crew.

Either just around the engine compartment or on the lower surface of the shuttle craft are two counter-rotating "rings" (built into the hull – not visible from the outside) which provide some of the stabilization for the craft. Other stabilizing sensors are also in function.

Basically all shuttle crafts are built around the circular or oval shape. This has been found to be the most stable platform for their purpose of planetary exploration and travel.

Just like terrestrial airplanes have navigation systems inside their flight computers, so does the crafts of the Visitors.

Actually the crafts could not get off the ground, so to speak, without such a system. The main difference between a terrestrial airplane flight system and an alien "flight" system is that there are many more different "dimensions of flight" which the alien craft (its computers) have to take into consideration while entering planetary atmospheres (or outside). So the spatial dimensions (three dimensions and time/duration of flight) of earth airplanes are pretty easy for the flight navigation system to calculate.

Imagine two magnets put together at the same polarity of magnetism – there will be a repelling force and this will keep them apart (however they can be forced together). This is what actually goes on when an alien craft using its electromagnetic force and gravitational fields and is getting close to the ground. That is one characteristic of the movements (erratically and with a "falling leaf" motion) because the two magnetic fields are moving close to each other (the planet's magnetic field and the craft's own generated field) thereby causing the instability. The craft is most vulnerable close to the ground and also the field protecting the craft is using a higher power (together with a slight tilt) to counteract the instability.

On the outside hull of their shuttles and the inner skins – adjustment sensors/field compensators are placed to assist the gravitational fields and the on-board computers in creating the most comfortable crew experience.

The main engine housing below the floor of the central cabin is stacked with magnetic wave generating tubes (a magnetic cluster) (see illustration section) powering both the field configuration and inject pulses/waves of electromagnetism (which works in collaboration with the gravitational field generators) to make the shuttle "fly". This engine leads energy up and down through the central pole - to the reflectors above, below and at the edges of the craft. The craft moves on a 90 degree angle tilt and when hovering it exhibits a 5 degrees tilt to counteract any disturbance in the gravitational forces between the fields and the containment field of the cabin. When standing or sitting inside the cabin the sense of g forces or movements is totally eliminated because of the cabins own field and if the crew choose to look at the landscape below, it will look like the craft is not moving, but the ground below is moving along as the craft moves over the area. This "feeling" is due to the gravitational field influencing the cabin and the crew within. This is actually a very comfortable feeling. The only time a slight pressure/movement may be felt is when moving from one gravitational field to another (landing or take-off from a body with its own gravity field – planetary surface or cruiser).

For the crew it makes no difference to their perception of the outside as they know they are moving – in actuality both the craft and the ground is moving (craft by itself and the ground because the planet has a rotational period around its own axis).

At any point (depending on the planetary surface gravity at any given destination) the gravity fields can be adjusted to suit that particular condition.

The central interior cabin is constructed with the control panels up against the cabin wall (or inside the cabin wall) and the cabin is built around the circular principle (see illustration). The central part of the cabin is occupied by a pole (partly translucent) running from the top of the craft down through the floor and into the engine compartment below. Depending on the type of shuttle craft and configuration, the central pole can have a diameter of two feet to as much as ten feet. Some crafts do not have a central pole. Their "controller" is of a different kind – not needing a central pole. Other types may have a viewing screen at the center of the cabin (in the floor), but newer crafts can display a viewing screen at any place along the cabin walls electronically (a sort of holographic screen). Such viewing screen can also be displayed in the air in front of anyone in the seating area. The top of the cabin (the ceiling) has a built-in viewing screen (which is also part of the top reflector for the cabin gravitational field).

The central computers are installed behind the cabin walls.

Around the central cabin – in the space between the outer walls and the walls of the central cabin, in some crafts – is where there are different rooms; one for dedicated research into atmospheric conditions, a rest room for the crew, a room for astronomy research, a biological research room and a repair room (see image 11).

Image 11

The type of shuttle craft just described, which from the outside looks exactly like the main shuttle previously described, is able to travel between planets without being transported by a cruiser. These crafts are approximately between 100 – 300 feet in diameter. Smaller shuttles are between 30 – 60 feet in diameter.

Some shuttle crafts - which are dependent on transportation by cruisers between destinations/planets, are able to stay in high planetary orbits (way out of the planetary body atmosphere) for a certain period of time - if need be (emergency situations).

Shuttle crafts can choose between a landing-mode with landing gear extended or landing on the lower part of the craft. By using landing gear, it will make it possible to land on sloping surfaces. A third landing-mode is – sort of not to land fully – but to remain hovering/floating. This involves not being able to turn off all the fields and thereby also the main engine, which can be desirable to do, therefore the fully extended landing gear-mode.

When the combined power of the gravitational fields and the electromagnetism engine are active, some static electricity is being created along the outer rim of the shuttle craft. The fields surrounding the craft can emit a signature of light refraction or light reflection, as the energy fields are constantly changing while the craft is moving/hovering (see illustrations and next page).

In certain types of shuttle crafts the pilot has the ability to make any part of the cabin wall/outer wall transparent/translucent. This "effect" is very useful, especially when in a partly stealthy mode (not wanting to be observed) – they have the ability/technology to control the appearance (at the atomic/electron level) of certain materials. Among these materials are metallic surfaces – which are a major part of the outer and inner skins/surfaces. They have the ability to let visible light through their building materials and control the transmission of light through these, and in their shuttles they can control this electronically by adjusting a switch/dial. This is why a glass cockpit or portholes are not necessary for the pilot in navigating the craft in any given situation scenario. An unobstructed view, however, is necessary when in hover-mode in a landing and/or take-off mode. It is also important in a partly covert observational-mode or with a particular purpose in mind (for the potential observer of the craft) (see illustrations – Mexico film).

Near the craft (and seen from the outside) there is a tendency to be created a fog-like effect, in addition to a lens-like/glass-like effect at every gravitational field point (four areas). In essence – light is reflected and polarized (due to the gravitational fields) and at certain viewing angles the craft will look somewhat distorted (see Illustrations - Silver Spring film-still). The air particles around the craft (effected by the fields) and the static energy generated from the craft, can make the hull of the craft appear both visible or invisible at certain wavelength of light (including the wavelength perceived by the human eye or emulsion film/digital sensors). They also are able to make their shuttles partly visible/invisible by using the generated heat radiation in the fields and use this at localized areas of the crafts.

Their vehicles moving in the atmosphere at high power and g-forces – will be surrounded by ionized air – which is thickest in direction of travel (a bow wave). A body under the force of gravitational acceleration will feel no strain on the body – meaning a field surrounding the cabin with the crew inside, will experience 1 g at all time even when the craft is standing on its head or up on its side. The fields generated by the crafts can be controlled with utmost precision thus the crafts can withstand accelerations and decelerations of enormous magnitudes. They can withstand extreme maneuvers – examples are 90 degrees turns, violent stops and reverse – all the time the occupants in the cabins will be unaware of changes in the flight patterns.

Watching a shuttle craft from the outside you will also be able to hear a very low humming sound from the engine. The denser the air is (temperature, pressure and humidity i.e. cold air is denser than warm air) the more pronounced is the humming sound.

The pilot has the ability to control the craft manually although it does take a heavy load on his/ hers abilities. All of the computations needed to move the craft are handled by computers and normally the pilot only makes adjustments if necessary. Manual control of "flight" is possible if computer malfunctions have occurred. These days every shuttle craft can also be remotely controlled from its cruiser (if need be). Instructions are sent to its computers (if crew has been incapacitated or an accident has occurred) and it will return to the cruiser by itself.

When a craft is lifting off from the ground or from its hover-mode it is NOT "flying" away as terrestrial science would understand it. The craft actually falls away or pushes away from the planet's gravity. At a certain point the technology of the crafts engine takes over and thereby uses its own gravity to "fly" away.

A possible view of the inside of a shuttle craft – lenticular shape – 50 feet in diameter

Walking up to and entering a lenticular shuttle is a daunting experience. The outside hull gives an appearance of being made of a metal which absorbs some reflections – it looks something like a combination of dull aluminum and stainless steel. It does reflect the surroundings, but not to a high degree. Walking up the short ramp (which actually also serves as an entrance hatch), you take three steps. Small vibrations can be felt under your feet – only when stepping up the ramp (this sensation is felt when the electromagnetic engine is active). Walking into the craft, if you look left – you see a door which leads to one of the gravitational field generators, one gravitational field reflector dish and also to the engine area. Looking right a similar door leading to an equipment room, another generator and the other gravitational field reflector dish (all four of these reflector dishes are an integral part of the secondary hull skin, but can be installed into the skin separately).
Access to the two remaining field reflector dishes and generators is only possible in connection with maintenance. They are situated – one in the cabin ceiling and one in connection with the engine casing. From the entrance hatch (the edge of the craft) directly in front of you approx. fifteen feet away is the entrance door to the central cabin.

All doors are electric doors which are opened by hand touch. They can be opened manually as well.

Going through the door you are immediately surprised by the uniform and bright light in the cabin (not uncomfortably bright) and the light is radiating from the ceiling (it is generated by light cells installed in the inner skin of the ceiling and is being distributed only from the ceiling area for an even and smooth lighting setup). That setup eliminates any need for additional lighting inside the cabin. The lighting feels like if you are outside on a sunny day and the sun is in zenith (vertically directly above you).

The diameter of the cabin is approx. 20 feet and the height is 8 feet. In addition the ceiling is 2 feet in height. Below the cabin is the engine housing taking up 5 feet in height and almost the full diameter of the cabin.

Inside the cabin is a seating area to the left of the entrance door (up along the curve of the cabin) and across the entrance is the pilot control board. To the right of the entrance are some computer screens and to the left of the pilot area and above the pilot control board are also some computer screens. In the center of the cabin is the four feet thick pole – running through the floor and up to the top of the ceiling. The floor is coated with a rough-like material (see illustrations).

If an outside view is wished for by the pilot a screen in the control board can show the outside view. If one of the other crew members want to generate a viewing screen it can be done anywhere in the cabin – either by a "floating holographic screen" or by pushing a key to generate a screen in the cabin wall.

The pilot also has the technical means to make the "skin" of the craft partly transparent/translucent by the touch of a dial. This is an effective way to observe a larger area or when observing a target in a stealthy mode. The skin can be made transparent/translucent from the inside viewing outwards only (like a one-way glass) or appearing transparent/translucent when viewed from the outside as well (almost like a piece of thick glass), if so chosen (see Mexico-film stills (illustrations)).

When the craft is "flying" no feeling of movement is experienced – quite a strange feeling. You can see on the outside viewing screen that some maneuvers are quite violent (like the craft is standing on its head (landscape is upside-down)), but no sense at all of this is being felt (because of the fields protecting the craft and the cabin).

Landings feel almost the same as "flight" – shortly before the craft touches down (either using the landing gears or the bottom of the craft) a certain "sense" of pressure in the lower legs is felt (like being pressed somewhat to the floor). It is not an overwhelming sense of pressure, but it is quite distinct – it lasts only a second or so.

Disembarking the craft, walking down the ramp, you again feel small vibrations under your feet.

Two types of shuttle crafts

1) Main shuttle craft (see images 12 and 13) (non-cruiser dependent - all shuttles (whether being cruiser dependent or non-cruiser dependent) can use the cruisers as facilitators for transportation and maintenance)

The hull is a three-layer metallic skin – layered on a light weight titanium/magnesium/silicon composite shell.

The inner central cabin is constructed by an aluminum/silicon composite material.

The gravitational field reflector dishes are made of titanium and installed in the second metallic skin.

Four gravitational field generators are installed. Two in connection with the cabin and two under the cabin floor.

The engine is a combined electromagnetic/gravitational engine.

Stabilizers (primary and secondary) are installed in the secondary outer hull walls.

Sensors (for "flight", gravity and a multitude of other things) are installed in the first outer hull walls.

Image 12

Craft on the left - seen from above - How the reflectors are placed in the skin of the shuttle craft

= Gravitational field generators

= Gravitational field reflectors

Gravitational Field Reflectors

Gravitational Field Generators

Image 13

32

2) A bell-shaped craft (magnetic/gravitational) (cruiser-dependent) (see images 14 and 15)

The hull is a two-layer metallic skin – layered on a light weight titanium/magnesium/silicon composite shell.

The inner central cabin is constructed by an aluminum/silicon composite material.

The gravitational field reflector dishes are made of titanium and installed in the inner metallic skin.

The gravitational field generators (two) are installed under the floor and two in connection with the cabin.

The engine is an electromagnetic engine.

Stabilizers (rotating rings) are made of titanium.

Additional stabilizers installed under the outer lower hull (three balls) – the three balls (hollow) each have small gravitational stabilizers and in addition work as dischargers of the generated static electricity – in addition to being a purposeful landing gear if needed. The balls are retractable and extendable (the balls can be retracted into the shell of the craft - see illustrations).

All-purpose sensors are installed in the outer hull/skin.

These are the two main shuttle craft mentioned in this book. I will show other shapes of crafts in the illustrations section.

Bell Shaped Craft - one configuration

— = Gravitational Field Reflectors

| = Gravitational Field Generators

))))) = Magnetic cluster engine

34

Image 14

Gravitational fields configuration - one possible configuration out of many.

Image 15

All three balls can move up and down as well as rotate - and they can swivel around the engine compartment - each having one specific spot where they can be fully retracted in up-position

Right ball
Standard configuration

Right ball down

Right ball up

Image 16

Chapter Three

The Cruisers

The large cruisers (popularly called motherships) can vary in sizes from 2000 feet up to 6 miles – most of the "flying cities" are 10 to 30 miles in sizes.

The smaller cruisers are mainly like aircraft carriers in that one of their main purposes is to be central hub (for transport, maintenance and as a base station) for the shuttle crafts. Of course they also have other functions, such as space observatories, research laboratories and observational platforms high in planetary atmospheres or in space.

Cruisers are essentially built around the same cylindrical structure and they are built with eight outer skins/layers made of titanium-magnesium-silicon composite material.

In the outermost layer, the sensors for navigation are installed, in addition to receptacles to interface with space energy.

One must remember that even though these ships move in space, they have no need for more protective types of building materials, as they never enter space before their gravitational field generators are installed and therefore their protective shields are active. These shields are their "protective shell" against all harmful radiation as well as space debris.

When they move in the atmosphere of a planet or moon, the outer hull just needs to be able to withstand the normal pressures for the local atmospheric conditions – if most or all of the protective shields are lowered.

Interior designs are variable depending on who is using the particular cruiser and for what purpose. Not all large cruisers are built for scientific exploration, but ships are also built for educational and recreational purposes.

The scientific cruisers and the planetary sponsored cruisers are built around a standardized setup of separate crew areas/navigation/pilot control areas and scientific areas (normally in the upper levels of the cruisers). Hangar areas for departing and landing shuttle crafts are situated in the lower sections of the cruiser – with one exception of a landing/take-off area in the forward upper part of the cruiser. Shuttle crafts from the upper floor area can be brought to a lower area for departures if need be. This is done automatically by use of elevator platforms. All other areas (i.e recreational areas) are situated in the upper floors. Middle floors are for machinery and gravitational field generators and other secure areas. As stated lower areas are landing and departure areas, as well as hangars and repair facilities.

The very large cruisers of 10 to 30 miles in sizes – are a different matter. They are a planetary matter. These cruisers are small cities and can easily travel for years without returning to their original base or home planet. For all cruisers traveling great distances, maintenance is performed at selected destinations during traveling – normally planned ahead of travel.

All personnel on these city-sized cruisers are specifically selected for these trips.

Mode of travel

The large cruisers (from the smaller to the very large city-size cruisers) use a combination of gravitational field propulsion (artificially generated by their own generators), electromagnetic drives and O.E.S. (repulsive gravity).

When talking about movement in space, they travel with the energy that is space. Traveling in such a manner means that they do **not** "fly" as terrestrial science understand it. When a craft is accelerated to the speed of light (which is a terrestrial term of speed – not really used when talking of space travel) several things happen. Space becomes "soft and penetrable" for "movement between places at extreme speeds" (instant travel) - Space and Time "curl up and distance and time become zero/null" – that is the best way I can describe the process of traveling at extreme speeds and with extreme precision (a graphical presentation and detailed explanations of this on pages 55-56).

They have developed ways to "predict with great precision quantum mechanics/fluctuations (waves) – that is quantum mechanics on a macro scale with a certainty of 100 per cent". So when arriving at the given destination there will be no surprises – if the "environment" has changed from departure-time to arrival-time – and therefore securing a safe journey from A to B. These facts (predictions with 100% certainty of the space and time state) allow them to make travels at the speed of "instant travel". They use this method of traveling if they need fast traverse to a destination with known habitable systems. "Instant travel" is all about being able to turn "matter into effective energy and understanding the conditions in space, gravity and time".

They use the "curling/curvature of space, gravity and time and their developed technology" to travel in space. There are no risks involved for their cruisers, but the shorter the time of travel (at "instant travel"), the better. Such modes of travel do put stress on their crafts, even though they have shielding. That is why maintenance stops are always planned ahead of travel.

The standard cruisers (up to 6 miles in length) have sixteen gravitational field generators (seven ring-shaped "bands" (each "band" consisting of two-interacting generators and two reflector dishes) along the cylindrical shape (see image 5) and two generators – one (with their dishes) at each end, distributed at intervals throughout the craft, in addition to two enormous electromagnetic engines. Gravity (both forms) is used in connection with the electromagnetic engines in creating the power. The "power" is in fact highly efficient gravity waves which "punches holes in the fabric of space to make it "soft" and thereby making it possible to traverse great distances in zero time (instant travel)". The "instant travel" can be more or less "drawn-out" - meaning the word "instant" is relative from zero time - to any time period (hours or days) whatever time frame is desired. However the shorter the duration of the "instant travel" the more stress is exerted on the hull/skins.

Since they have - what terrestrial science would term - an almost full knowledge of how the Universe works (in every aspect), they are able to utilize the full potential of their technology. They understand that there is a "connection" between every particle (wave) at both micro and macro level in the Universe from early time (even over enormous distances). Every particle (wave) existing has a common "knowledge" of their origin (when the Universe began) and therefore an eternal connection between each other, for as long as the Universe will exist.

Because of this "connection" it is possible to "pinpoint" the exact time and place in space (4D space - the three dimensions plus time) of a random destination/location in space and this is an invaluable asset to have in traveling across vast distances in space – in an extremely short period of time - as well as updated and correct navigational mapping for their advanced computers.

Even though they have an extensive knowledge of everything there is to know about how the Universe works, it is, however, **not** possible to travel in time (time travel "back in time" as we see it in science fiction movies). Traveling in any way, shape or form, is in its basic form a sort of "time travel", as we travel to a point in the future (i.e. I will see you in 10 minutes – actually we are saying – "see you 10 minutes into the future" - you can NEVER meet someone 10 minutes in the past!).

When you move from one place to another over great distances (as an example 100 light years) (the principle is the same whatever the distance is) the "time" (as it is called in terrestrial science) is the same for every particle/wave in the Universe. Time is not a "real measure" for a constant expanding Universe, as everyone in the Universe will have the same time and feel that "theirs is the right time", when in fact the "concept of time" is an imaginative perception. Just as any other force in the Universe so is time a force – consisting of particles/waves – more on this later.

So if your - departure time is twelve o'clock on your clock - and you use the transport mode of "instant travel", the arrival time at the destination will also be twelve o'clock (seen at the destination point), as both the departure point and the destination point have "moved" the same distance (expanding Universe* – the same expansion everywhere in the Universe) in "time" – and keep in mind that all particles/waves at both places are connected. Travel to any star system is possible.

It is a mind-boggling concept to wrap your head around, but this is the reason, they are able to travel far distances in space "without getting physically older when travelling great distances" – it is a principle terrestrial science need to get an understanding of in their theories of the Universe and theories of relativity and time.

*Expanding Universe - For the sake of making expansion of the Universe easier to understand I ONLY describe the Universe as uniformly expanding - i e. all places expand with the same speed - there are regions in space which are moving faster or slower than the speed of the expanding Universe (which is approximately 40 miles per second).

Maintenance stops

For the large cruisers to be able to make maintenance and repair stops during their travels, they have so-called inertia dampening generators installed. These create dampening fields so that the cruiser will be stable and no unnecessary stress will be influencing the hull during entry into an atmosphere of any kind. It requires care to land gigantic crafts like these, but normally landings are done in specific designated areas for such vehicles. If no landing areas are available, a large cruiser is able to use its own landing gear. It has two in the front and two in the rear.

Even though their gravitational fields prevent anything from penetrating their hull, stress will occur to the hull and to the generators – as well as the electromagnetic engines - during fast transits and therefore maintenance is of utmost importance at certain intervals. They carry replacement gravitational field generators and reflector dishes as well as much other technical support hardware.

These cruisers maneuver in the atmosphere or space by adjusting the fields in unison or separately, so as to change their trajectory and attitude easily.

Let us now take a look at how a cruiser takes off from a planet surface and move into space.

Take off

When a cruiser is prepared for take-off, a lot of things happen before. Take off/landing sites are most of the time equipped to hold a cruiser of up to 6 miles in length by magnetic locks – These magnetic locks are movable magnetic cranes (a little over 600 feet high) which are built to receive cylindrical cruisers specifically - two at the front and two at the back. This will fix the craft completely at any angle or height between 600 feet down to a few feet off the ground. This technique makes it easy for servicing and for the crew and all other occupants to easily board the craft from ground level.

When ready for departure, half of the gravitational fields will be activated at the same time as the electromagnetic engines are activated (at low power). This "partly energized mode" ensures that the magnetic locks are still holding the cruiser in place until a simultaneous "release" is agreed upon by the pilots and the releasing crew in charge at the ground station. When a simultaneous "OK" is received, the magnetic locks are released and the rest of the gravitational fields are powered on. This ensures a "repelling effect" so that the cruiser will rise from the ground. At that moment the "power up" mode for the electromagnetic engines is initialized by the pilots. These sequences of gravitational fields turning on and magnetic engines powering up are automatic functions initiated by the pilots, but all are done by computers automatically. This is a fine tuned process, so the less manual influence the better. These sequences require so many parameters to be automatically adjusted in a few seconds that any miscalculations would be catastrophic.

The gravitational fields adjust the repelling energy to ensure that the pilots have a good overview and can control the upwards speed of ascent. Its ascent can be compared to watching a hot air balloon rise slowly from the ground. It is a very controlled maneuver.

From the outside it would look something like this - A large silvery cruiser is being held in place by seemingly invisible force by four gigantic looking cranes. These are the magnetic locks. At a certain point while looking at this spectacular sight, the gigantic craft suddenly and slowly, almost like a weightless feather, moves upwards between the four cranes and very high up, when free of the cranes, it tilts its nose upwards and silently glides away.

Inside the pilot room (looking at their monitors) and when free of the four magnetic towers, the pilots initiates the departure tilt, which usually requires a sequence of maximizing the inertia dampening fields, to make the transition from planet bound gravitation to the cruisers gravitation as smooth as possible. It also stabilizes the cruiser. As the magnetic engines are used for the movement into space – in conjunction with the gravitational fields – the transition from planetary environment to space environment is at the pilots discretion. No movement is felt inside the cruiser so the tilt angle of the craft is decided by the pilots. Every parameter – gravitational fields strength, their focusing, the range of the focusing field and the power of the electromagnetic engines – are all controlled by the pilots and ultimately by the cruisers computers.

From the outside – after the cruiser is free of the gigantic magnetic towers – it tilts at a steep angle (45 degrees) and it becomes engulfed in a rotating (horizontally spinning) field, as the craft is getting more and more covered is a whitish cloud-like substance and finally as it moves upwards it suddenly fades away and disappears. This is when all gravitational fields are at the full power before entering the space environment.

A possible view of the inside of a cruiser

First seeing an enormous silvery cylindrical shaped craft hovering in midair on a sunny day with almost no cloud cover can be a fantastic sight. Stretching almost forever as it approaches the ground is a surrealistic sight. It seems unreal and totally misplaced that such a gigantic craft can stand still and silently float towards the ground. A truly amazing view. As it settles in between the gigantic magnetic cranes and the locks are grabbing the cruiser, you almost feel that the ground will crumble under the enormous pressure, but almost no sound is heard as it comes to rest.

As soon as it has landed, ground crew and vehicles are moving towards the front and middle of the cruiser. Here two enormous hatches begin to open. Loading ramps are taken to the hatches. Passengers boarding the cruiser are taken by a loading vehicle to the middle of the craft. At this instance only a few crew members are exchanged and so only one loading vehicle is filled with people. The vehicle has a built-in elevator platform (completely enclosed) which will be moved in place against the middle hatch.

In this way about 100 feet off the ground, people are boarding the cruiser via the elevator. The elevator takes you into the middle floors of the craft. There is a large reception area where the elevator platform joins the cruiser's own elevator system. Here all people disembark the elevator and go on their way to their respective working areas. Some take another elevator to the upper floors of the craft (pilots and navigators) while scientists and mechanics are moving towards their research areas and hangars (the lower floors).

Inside this reception area which is about 1500 square feet (30 feet by 50 feet area) there are seating areas as well as many different corridors leading away from the reception. The area is functioning like a hub for arriving and departing groups of people and is a very quiet area, even though a lot of people are there. Following one corridor (which are all marked) towards one side of the cruiser - you get to an area along the length-axis of the craft - an area, where some enormous one way "windows" show the view outside with remarkable clarity. These windows are not visible from the outside, but a technique to make materials see-through are used at these two windows. Windows can be created electronically at all areas where a view is wished for, but mainly at the leisure areas (see illustrations).
Walking to the end of this viewing area, there is a landing area for shuttles. You can see some shuttles parked through a thick glass-like wall.

Walking back to the reception area, taking the elevator some floors down, you come to the main engine area. This is a huge area. The combined magnetic engines – which consists of (as far as can be seen) eight enormous wheel-like structures – take up all of this area.

Walking to the elevator again and going almost to the top floor – another corridor leads to the navigation/ piloting area. Enormous rooms with charts of space, navigation screens, plot-boards (almost like radar-plotting on an aircraft carrier), sensing-screens and control tables are displayed all over these rooms.

Taking another corridor which leads to a laboratory, a test of a gravitational reflector is under way. No doubt a replacement reflector to be installed.

Going back and taking the elevator to the reception area again, boarding the elevator in the loading vehicle, you are taken back to the ground and outside the craft.

In some hours you will be able to see the enormous craft take-off, slowly rising from the ground and rising higher into the sky. A very low humming sound is heard and the craft is enveloped in a rotating field, becoming more and more hazy, and rising higher and higher at a steep angle. Suddenly it is gone.

Cruiser traveling in space with its gravitational fields aligned to give minimum shield protection (close to the ship hull) When fields were focused further away from the hull they will give maximum protection against space debris and radiation. They are configured closer to the hull when entering or leaving a planetary atmosphere.

Image 17

Chapter four

Time and Space

Most terrestrial scientists agree that the Universe began as a single point source of immense energy and at that point – the time/space-concept was born.

The Universe has continued from that first moment to expand continuously and have done so for approximately 14 billion years. Let us now look at two systems – i.e. the Solar System and another system - 20.000 light years from the Solar System - in the Milky Way galaxy. Both of these planetary systems were created approximately at the same time (4.6 billion years ago) and have been moving with the expansion of the Universe ever since. At both places the "universe-time" is exactly the same (calculated from the first moment of creation of the Universe) and their measurements of the Universe will show the same information about i.e. the background radiation of the Universe (approx. 3 degrees Kelvin). Small variations may occur at varying places in the Universe, but essential the background radiation is around 3 degrees Kelvin.

If all measurements and time are the same at both places, only the speed with which a craft moves between these two places (and how long it takes (how much time) to make the trip) will give a true calculation of how much real time was spent. Let us say that a craft makes the trip in 10 hours. If we look closer and resolves what time consist of, we will find that it has absolutely nothing to do with what terrestrial scientists call "the speed of light" (speed of electromagnetic radiation (photons)) – which equals approximately 186.000 miles per second. It is a part of the theory of special relativity (Einstein) that "time" (or the clock of a craft moving at light speed) will slow down to almost a stop for a moving object near the speed of light – compared to a non-moving clock. That is actually false. Time and the speed of light have nothing to do with each other. They are two different things. Time is a separate force and speed of light is the speed of electromagnetic radiation (also a force). Let me make an example.

A spacecraft leaves a planet to make a journey of 100 light years in 2 days. The crew will return after a week of working at the destination – The return trip will be done by "instant travel" (let us say 45 minutes – that is almost instantaneously). For training purposes the crew need 2 days of preparing for the arrival at the destination (work schedules, preparing for acclimatization, language training and logistics.). So in 9 days they will be back (actually 9 days and 45 minutes – 2 days plus 7 days plus 45 minutes).

In the control room of the department responsible for the crafts departure a person press the timer, when they confirm that the craft is departing with gravitational fields at full power. The craft disappears from viewing screens. A monitoring crew in the control room follows the progress of the craft and its passengers. Forty eight hours later the crew report back that they have arrived at the destination (how to communicate "instantaneously" anywhere in space over immense distances is for another book). The crew in the control room follows the daily check-ins by the away team and one week and forty five minutes later (what the ships computers calculated would be comfortable and almost "instant") the craft is back on their monitoring screens. They have returned. Nine days and 45 minutes have passed on the clock in the craft – just as on the clock in the control room back on the home planet.

Why does the terrestrial "theory of special relativity" not apply here (which theorizes that a space craft clock moving at the speed of light almost stop while a clock standing still (the control room clock) should have ticked happily – and thousands of years/if not millions of years should have passed in the control room)? And would terrestrial science ever be able to prove or disprove this theory?

The reason why only the exact time of 9 days and 45 minutes passed both in the space craft and in the control room on the home planet, is because the craft was being encapsulated in a gravitational field (just like a planet), and moved at speeds exceeding the speed of light - and thus the "time" or the clock will run at exactly the same pace as the clock back in the control room. You may say that – what about their one week on the surface of the destination planet?

If you stay at one planet or another in space – the "time of the Universe" does not change.

The original time and the expansion of the Universe is exactly the same wherever you are in the known Universe. How you calculate local time under different conditions (orbital motion, how long a "day" is on another planet and other factors) that is what are different conditions on different planets, but time as such never change (we are talking about "Universe-time"). "Local time" is a different matter – just take Earth as an example – there are 24 different "time-zones" – just on one planet! How weird is that?

The crew of a space craft visiting another environment than their home planet, will just have to make calculations to their own time-frame (i.e. years, days, hours and minutes). Their on-board computers will aid them in their calculations, so agreed times for departures/arrivals always are in synchronization with their home planet/destination time frame.

When terrestrial science begin to research the "force of time" it will learn that time consist of smaller "units" (let us call them "timeons") – just like matter consists of smaller "building" block - which all are wave states (molecules, atoms, protons, neutrons, electrons – which is made of quarks – which again consist of filaments of energy – which is based on waves and so on….).

Time is a very complex force – in that it is in constant motion and flow one way and one way only – forward (you cannot take a piece of time – like a piece of wood and hold it in front of you. In that way it is a very peculiar force – just like gravity). So time travel (going back in time) as depicted in science fiction movies will not be possible. Instances which have already happened in the natural expansion of the Universe, will never be able to be recreated or influenced after their actions have played out.

By understanding that time - just as matter, gravity, electromagnetism, the weak and the strong nuclear force and all things which make up the Universe, was created in that very first moment, and still holds secrets of immense importance, this fact, by researching the Universe diligently, will guide terrestrial science towards the fact that time also can be used, to traverse enormous distances quickly. Just as gravity and electromagnetism can be used to work "for" science and all aspects of building a society - so can "time" be used in transportation between stars (in connection with gravity and electromagnetism).

The Universe created three forces of utmost importance for space travel in those first moments of its beginning - time, gravity and electromagnetism.

Space travel – can be possible very fast and over great distances – but to develop that very advanced technology to do so, is one of the greatest challenges for any civilization.

Chapter five

Technology prospects – future research and development for terrestrial science

As have been seen in the previous text it is certainly worthwhile and it IS the future (technology and environment-wise) to do a lot of research in electromagnetism (wave technology) and gravitational waves, as these are the only alternatives to the present use of fossil fuels. The terrestrial environment is at its peak of a cycle (fossil fuel depletion, pollution and damaging CO_2 emissions) that viable replacements and a shift in energy supply is needed for future generations. Both for the human survival in the short and the long term, but also for the planet as a living entity (which it is). Earth could have done this many years ago, but the powers-at-be chose not to. It is imperative that the remaining fossil fuel stays in the ground and the energy supplies around the world "goes green" (solar, wind, electrical, water).

The most pressing technology which is needed, as long as fossil fuel is still being used, is CO_2 emission conversion – either by way of filtering to convert CO_2 to oxygen (photosynthesis or equivalent) or conversion to water vapor. Both these methods are obtainable with current technologies and should be implemented immediately (scientists have already developed both of these technologies). Conversion of salt water into fresh water should also be thoroughly researched. Also a general development of making clean drinking water around the planet. In addition a clean-up of the pollution of the seas. As can be seen there is plenty to do for science and the populations in general. There are many more fields which science could concentrate on. You probably already know a few more.

The long term ultimate development and research have to be looking into gravity. There are so many benefits by going in this direction. The visitors did this and their technologies expanded in so many ways and directions and supported their development and advancement.

Often times it has been asked - if the visitors know so much and has the technology to do all sorts of things (like solving all current environmental problems) – why don't they help?

If a presentation to terrestrial science of an unlimited and safe energy source (via technology), it may be used in the wrong way – i.e. in a destructive way. Technology-sharing (extraterrestrial technology) is at present not possible – except only in small and insignificant amount (such as suggestions as to solving certain planetary "technological problems" – i.e. CO_2 emission solutions) – as the danger is too great that important technology sharing (huge steps in development) would put at risk that it may not be used to benefit all humanity, but instead be used for military and destructive purposes.

 The visitors are very careful when they observe and interact with other civilizations - among those are Earth. They are not allowed to interfere and engage in direct technology transfer. The natural development of any civilization is a prerequisite for allowing contact with civilizations less developed during their exploratory trips.

--

One of the fascinating aspects of the Universe and quantum physics are the "connections" between different wave states (particles) – these "connections" happen over vast distances instantaneously – meaning they are not limited to the so-called "speed of light" (speed of photon waves).

Terrestrial scientific understanding of quantum mechanics stipulates that it is impossible to "know" (measure) the exact location (position) and velocity of a single particle (on a microcosmic level). The theory is that when you measure a particle - the "particle" changes its position or velocity or both. Something like - if there is nobody in the forest to hear a tree fall, does it really make a sound when it falls? Or if you don't "measure" (look) at the moon - is it really there if you don't look?

The knowledge of these wave states (particle states) is crucial in traveling deep space. Otherwise travelers would be facing major problems when using "instant travel" – they might "bumb into stuff" of which there were no knowledge. As the Universe is constantly changing, it is important to be able to locate destinations with utmost precision – which is where the knowledge of quantum physics and the "inter-connectivity" of everything in the Universe plays a major role. It is necessary to understand that in order to safely travel between the stars, an advanced knowledge of what constitutes particles is imperative (that they are actually waves in their ultimate forms). As matter in its original state also consists of waves of energy, transportation of all things in space is therefore done by understanding the nature of the Universe and thereby physics.

It is also vital to understand that any and all "wave states" can carry information. As an example radio waves (electromagnetic waves) carry information from a broadcast station to your radio – and via the Internet electrons carry information through the cables to your computer – and so on.

In short – particles are wave-states/energy with specific properties and they move THROUGH space.

Gravity is part of the GEOMETRY of space itself. That is why it is important to learn to use it for transportation purposes. Understanding is an important step in technological control. Thereby follows that control of technology paves the way for an advance in transportation mechanics.

Terrestrial science still clings to the belief that technology (and NOT physics) will forever make it impossible to travel to the stars (because of the energy required to reach the speed of light). How very wrong this premise is – it is exactly technology (and physics) which will propel Earth humans to the stars – but it requires an open mind and understanding from studies of physics and nature – to reach that point.

It is as if terrestrial scientists have already given up on the possibilities of technological developments (and thereby new forms of transportation in space), even before they have begun their research.

They are left in their beliefs that their understanding of physics as it is now, will never change (or very little). How is that for progressive thoughts and open minds?

Further explanations - Instant travel explained

Imagine the "space" between every moon, planet, star, galaxy, cluster of galaxies and so on is filled with a filament/network of "strands", just like an immense spider web (see illustrations). These "strands" are inter-connections between every body in the whole Universe. The entanglements between everything in the Universe are used when travelling at "instant travel" speeds. If the destination is 100 light years away and you know the destination "frequency" (every "body" in the Universe radiates a "signature") the crafts computers (and thereby engine and gravity propulsion) calculate the time needed/wanted for the transportation. These "connections" allow any speed (the space and time is nullified) to be used when the destination-lock is established. During the whole trip the destination system/star is focused and maintained by the on-board computers to guarantee the arrival at destination. Arrival in a star system is always done a good distance away from any planets, so as not to make gravitational disturbances to the planetary orbits.

Another graphical way to describe what happens is to hold a piece of string at arms length between your two hands. Hold the piece of string (which symbolizes a distance in space between home star (left hand) and point of destination (right hand)) between the thumb and the index finger. Now move your right hand to the left hand (or the other way around if so inclined) – what happens is the piece of string become "soft and bends" (hanging down) while the two ends meet and so the "distance" has been nullified. This is the simplest way to describe what happens during "instant travel" (see image on next page).

Instant Travel - graphic depiction

Step One - Tune in

Step Two - Space becomes "soft"

Step Three - Space is "elastic" and space ship moves with it

Step Four - Ships computers calculate time of "elasticity"

Step Five - Space craft arrives at destination

Chapter 6 - Final thoughts

Space, Time, Gravity and the speed of light – What's up!

If terrestrial science thinks that today's and yesterday's theories cannot be changed or disproved today or in the future, then maybe it is because the "viewing-angle" at which science tries to prove these theories or disprove them, is wrong. Try changing the premise of the problem and maybe, just maybe the results will look different.

Even though Albert Einstein in his theory of special relativity in 1905 (and in 1907 Hermann Minkowski) formulated/theorized that it is impossible to move faster in a vacuum than the speed of light (approx. 186.000 miles per second) – which is the speed of photon particles/waves (electromagnetic radiation) in a vacuum - terrestrial science has NEVER transported ANYTHING (a craft) at that speed through space (the fastest terrestrial space craft (New Horizons) so far has been moving through space at approximately 20 miles a second). Scientists have made calculations, but have never actually done it. Mathematics can be VERY forgiving. So where is the proof that a mass (a craft) CANNOT go faster than the speed of light? The premise of physics that mass increases with speed when moving in a vacuum is WRONG (and Einstein and Minkowski actually pointed to this possibility in their theories). Because the theories of relativity say that it is impossible to exceed the speed of light – does not mean that it IS impossible (some galaxies actually moves at faster than light speed away from each other).

It is almost the same as if science says that there is no LIFE outside the Earth, in that all theories point to the fact that there cannot be co-existing civilizations in the Universe – because they have not found any. Because science says that it is so, how do they know the answer to that question? Have they searched the entire known Universe? NO! I instead suggest looking objectively at the premise and come to your own conclusions. What is the likelihood that the Earth is the only technological developed planet in the vast Universe? Or just in the Milky Way galaxy for that matter – consisting of approx. 200 billion stars of which around 10 percent (20 billion) is sun-like stars? Just think about how unlikely it is.

Space and Time – as I have explained earlier – were created simultaneously when our Universe was created. So were Gravity and Light (electromagnetic radiation).

Space and Time are – contrary to what most of terrestrial science thinks (again derived from Einstein's and Minkowski's theories) – separate "entities". Space is the PHYSICAL CONSTRAINT of the Universe and Time is a FORCE within Space. Time, just as the other known forces in the Universe (Electromagnetism, Gravity, the Weak Nuclear Force and the Strong Nuclear Force) is consisting of waves - which consist of smaller units. Like I touched on in the previous pages – Time is important to fully understand (together with Gravity) when traveling at speeds exceeding the "terrestrial accepted" maximum speed (the speed of light) which terrestrial science postulate.

Progress will happen, at what costs and in what forms, only time will tell. It does, however, require a lot of effort - and an open mind - to reach a new and higher level of technology.

Final words.......

For a civilization - when sufficiently advanced to make interstellar travel – the next step is exploring and ultimately colonizing other habitable worlds in their galaxy - the ultimate survival step. It seems a natural thing to ensure the species survival by establishing colonies.

Those who travel among the stars – fearless and adventurous as they are – are doing so with the knowledge that even though they have been doing this for millennia, it is still dangerous and not for those lacking courage. Even though they have a tremendous knowledge of space and time – and what is to be gained from traveling among the stars – they are still humble about their technology and their abilities.

The grandeur of Space - A spiral galaxy showing all of the building blocks for life - hydrogen and helium - together with left overs from dying stars - carbon, oxygen, magnesium, iron, uranium and so on.

Image 18

Illustrations - photos and paintings

This section will show photographic corroborating evidence for what you have just read about the propulsion and technology of the visitors. All photos and films were taken by George Adamski. A man of much controversy, but a man who was exposed to an enormous amount of factual evidence of these amazing visitor-crafts. I have been extremely fortunate to have seen some of his original photos and been provided some digitized films and enhanced some of them for this book.

In addition I have painted more than 40 paintings showing what is described in the text and more. Painting is a way for me to show what I have seen or envisioned.

The paintings will give some indications of the technology behind these magnificent crafts.

The Mexico film - stills from film taken by George Adamski - in 1957/58. Showing their ability to make their crafts reflect and refract light and make part of their crafts transparent/translucent.

Copyright Permission by Steckling © Adamskifoundation.com

Zoomed image of the craft itself - the top part of the craft is visible - and the cabin is somewhat distorted (going at an angle from left to right) no doubt the fields active around the cabin are responsible for this kind of effect. The next two stills are from my previous book and show almost none of the above distortion to the outside view of the cabin area.

The two images on the left are from my previous book - The George Adamski Story. They show two still-frames from the Mexico film and show the few seconds it took for the upper portion of the craft to get from almost see-through (pages 60-61) to more solid (bottom left picture). In the film it takes around 5 seconds. The pilot of the craft has the ability to make parts of the hull transparent/translucent electronically as the crafts are built with the technology to manipulate the refraction/reflection indexes of the construction materials of which the crafts are built. The ability is to make the craft transparent/translucent as seen from inside the cabin or from the outside. Both abilities are possible simultaneously. (see page 26 in this book)

This is an enhanced still-frame from a film shot by George Adamski in the 1950'ies. It shows a new type of oval shaped craft - capable of interplanetary travel. This is the first of two frames from this piece of film - the craft shows the tendency to hover at an angle, to provide stability in hover mode - as described in my text. On the next page it also shows a "bow-wave" in the front direction of movement - also described in the text (page 27).

On top and on the right side of this craft a whitish bow-wave is seen. This is an atmospheric effect (ionized air).

66

A still-frame from the Silver Spring film - taken by George Adamski on 26th February 1965.

This image show some of the distortion-effects in connection with gravitational fields and an electromagnetic engine (see page 27)

The effect is like looking through a thick glass-lens - as the craft moves - things looks distorted.

67

Copyright Permission by Steckling © Adamskifoundation.com

Image taken in 1959 at Palomar Mountain in California by George Adamski (enhanced by writer). Several things are seen in the image – 13 smaller crafts are moving around in the sky.

A zoomed version of the left side of the image on the previous page - the lower white object is in the process of turning its gravitational fields to full power and rolling on it side to move away. It has no effect on the crew on board if the craft stand on its head or is lying on its side - the cabin crew is experiencing a 1 g effect all the time. Five darker objects are seen moving away from the larger craft. They have not yet turned on their full power.

Zoomed in at the upper right corner of the original photo - five dark objects have just exited the large craft and some ripple effects from their gravitational fields are seen. The two objects in top right corner are moving away - the lower of the two almost at full power (the white ball)

Copyright Permission by Steckling © Adamskifoundation.com

Taken by George Adamski in May 1950 through his 6 inch telescope - showing a large cruiser followed by 8 smaller crafts. Background is the Moon. All crafts are at full power and their gravitational fields powers at maximum. Image enhanced by writer.

Large cruiser - followed by four smaller crafts - with the Moon as background - taken in 1950'ies by George Adamski. All four smaller crafts and the large cruiser is at full power indicated by their luminous appearance.

Copyright Permission by Steckling © Adamskifoundation.com

Two shuttle crafts in transit high in Earth's atmosphere. Photo part of a larger photo taken by George Adamski in the 1950'ies. Craft on top left is a full power - completely surrounded by its gravitational shields.

Second craft at the right - is also at full power - but here the field configuration can be seen - the fields are aligned differently than the craft on the top left. Four separate fields are clearly indicated by the shape around the craft.

Another photo by George Adamski (the moon is in the background) - three crafts are seen in transit. Two crafts on the right is fully protected - complete engulfed in the gravitational field power - The craft on the left is displaying two clear signs of gravitational fields at full power - also enveloping the craft - again gravitational fields can be focused in many different ways to protect a craft.

Photo by George Adamski taken through his 6 inch telescope - four objects at full power in the upper right (an enlargement on the next page) and one solitary object just above the "m" in ".com".

Copyright Permission by Steckling © Adamskifoundation.com

Again a photo by George Adamski. Here are three objects - gravitational fields clearly seen focusing while crafts are in motion - the fields protrude from the central objects. Zoomed in view on the next page.

Copyright Permission by Steckling © Adamskifoundation.com

Copyright Permission by Steckling © Adamskifoundation.com

One of the photos by George Adamski from 13th December 1952.
This is a scan of the original negative - scanned by Paul Ruez - in 2019.

Two rotating rings are clearly visible below the hull (the darker color just on the outside of the landing gears). Reflections are clearly seen especially on the left part of the two rings.

Another one of the photos from 13th December 1952 taken by George Adamski.

This is a scan of the original negative (see film info on the right side of the photo) - According to my analysis this is the correct way for the picture to be viewed - according to light conditions on the other photos in this series. Sun is shining from the upper left. A detailed analysis of these images of 13th December 1952 will be forthcoming.

The left landing gear is being hit by the ray of the sun and the gear (ball) is reflected up into the landing gear-platform. A lesser reflection can be seen of the right landing gear (ball) as a light reflection of the right part of the landing gear-platform. This indicate that the landing gear-platform is highly reflective and metallic in structure.

Here is an example of a cruiser enveloped in the fields generated when the craft is powering up – just before going into space.

Several crafts airborne over city

Small personal transports are used when people need to go from one place to another. These crafts are having a gravitational generator and a magnetic engine to propel them around - maximum "flight" attitude is some few hundred feet above the ground.

Inside a bell-shaped craft. A view of the seating arrangements as well as the pilot area and the magnetic pole going through the glass-like lens in the middle of the floor.

View of a large facility for testing, maintenance and teaching purposes. Different crafts are seen in this picture – large cruiser on the right and on the left different shuttle crafts. Up above a shuttle is moving towards the outside (far end of the facility).

Gravitational shield generators are being tested (at a testing facility) before being installed into production crafts.

Shuttle craft just landed after test flight and pilot leaving craft. Two technicians wait by the craft, with one technician already inside inspecting the craft. Power has been turned completely off by technician inside the vehicle.

Here is a "bell shaped" shuttle – it has a fixed landing gear (three balls) – the three of which also are a part of the control of the craft. This type of craft "looks" to be a strange shape for a shuttle, but remember that the crafts are built to suit the propulsion – not the other way around. In this image small repairs are made to the landing gears.

Computer screen from the pilot room of a cruiser. It is showing the gravitational field strength, the magnetic engines power and how much energy is generated.

A cruiser has landed in the outskirts of a larger city. It is held in place by magnetic locks.

Shuttle before entering atmosphere – some indications of the shield configuration can be seen (dark grey rings).

This photograph of an impressive spider web filled with rain drops, actually is a very nice depiction of the "entanglement" in the Universe between everything. The photograph also shows a graphic representation of the "network/strands" which are possible to travel during "instant travel". The strands of the spider web could be compared to the "travel lanes" between everything in the Universe which radiates signals to tune into for travel. Nature can always enlighten your vision.

The inside of a large space craft

Entrance hatch of a large spacecraft. The oval shape next to hatch is a viewing screen.

Large oval craft during maintenance.

This is a test of the electromagnetic engine to be installed in a cruiser. The yellow light beam from the engine to the collection-dishes is the energy produced which in turn is distributed towards the gravitational propulsion systems. The small orange orbs are monitoring probes which collect data during testing. Some engineers and equipment can be seen around the beam going downwards from the collection-dishes.

View of a magnetic cluster engine being installed to the inner skin of a shuttle craft.

Control room inside large cruiser. The woman wearing an all-purpose communication helmet.

Pilot room inside a cruiser. Two pilots at their control panels, while other navigation crew are preparing their transit in space. The control panel is particular interesting in that it has some partly holographic screens which makes take-off and landing much easier as the view is displayed in three dimensions. Description of the take-off inside a pilot room see pages 42-44. Take a look around the room – there are lots of things to look at.

99

Crafts are drawn with cabin, floor and engine area shown

These crafts all have dual landing modes - meaning bottom of craft or mechanical landing gears

Three other shuttle type crafts

These are two types of remotely controlled probes - maximum sizes 6 feet

A large cruiser is taking off during late evening – the towers seen are the magnetic locks used to hold the cruiser in place. The take-off description is found on pages 42–44.

Here a cruiser – a "flying city" – has made a stop at a previously visited planet for supplies and maintenance. The visit also includes many tours around the planet for the people on-board.

Gigantic flying "city" – 25 miles long – preparing to land. Streaks of clouds are still enveloping the cruiser – sticking to the hull because of static electricity. Thousands of people are waiting to board the craft. High up above a "smaller" cruiser is preparing its landing sequence.

Two shuttles are being tested inside a large facility. Technicians are controlling the shuttles remotely and testing their gravitational fields.

As most shuttles can deploy their own landing gear – if need be – this picture shows a three-point landing gear – in the center (engine area) maintenance is performed by two technicians.

A four mile long cruiser has landed at a designated area in a large city and is being serviced.

Large recreational area inside cruiser. On the right is one-way views looking outside the cruiser at a nearby planetary system and on the left some large screen showing home scenes or other worldly scenes. At the end of this large area – is a landing area for shuttles – viewable through large glass-like walls.

Inside of the shuttle shown on the cover and described on pages 28-29.

This is an outside daylight test of a pair of newly delivered shuttles – they are put through different tests, concentrating mainly on reaction times, navigation, hovering, and gravitational field configurations. These tests are both remotely controlled tests and piloted tests.

This picture shows a visitors city – with a huge cruiser in the upper left corner – escorted by smaller shuttles. In the valley close to viewer two shuttles try to pull some difficult maneuvers above the rocky landscape.

Two large cruisers are returning after long journeys.

Landed cruiser is about to be serviced and on/off loading is in progress in preparation for departure. Different magnetically driven maintenance vehicles are moving towards the cruiser.

Cruiser navigating to designated landing area in a city. A magnificent view to behold for the people in the apartments nearby.

Large desert-city dome and base. Cruiser high above and two shuttles in landing mode.

Cruiser has just dispatched six shuttles for landing on the planet. The cruiser will stay in high planetary orbit.

Inside of a bell shaped shuttle

Rendition of a shuttle type - Magnetic pole runs through the craft

Previous page and this page - Three paintings of navigational screens during "instant travel" - the "streaks" are possible "exits" and the "shapes" are other space crafts. The central form in each picture is the destination star - depicted differently in each picture during transit. The top picture on previous page is the screen very close to the destination star (large orange form in the center).

Printed in August 2021
by Rotomail Italia S.p.A., Vignate (MI) - Italy